Bonjour, Monsieur Courbet!

D1304218

STERLING & FRANCINE
CLARK ART INSTITUTE

Réunion
des Musées
Nationaux

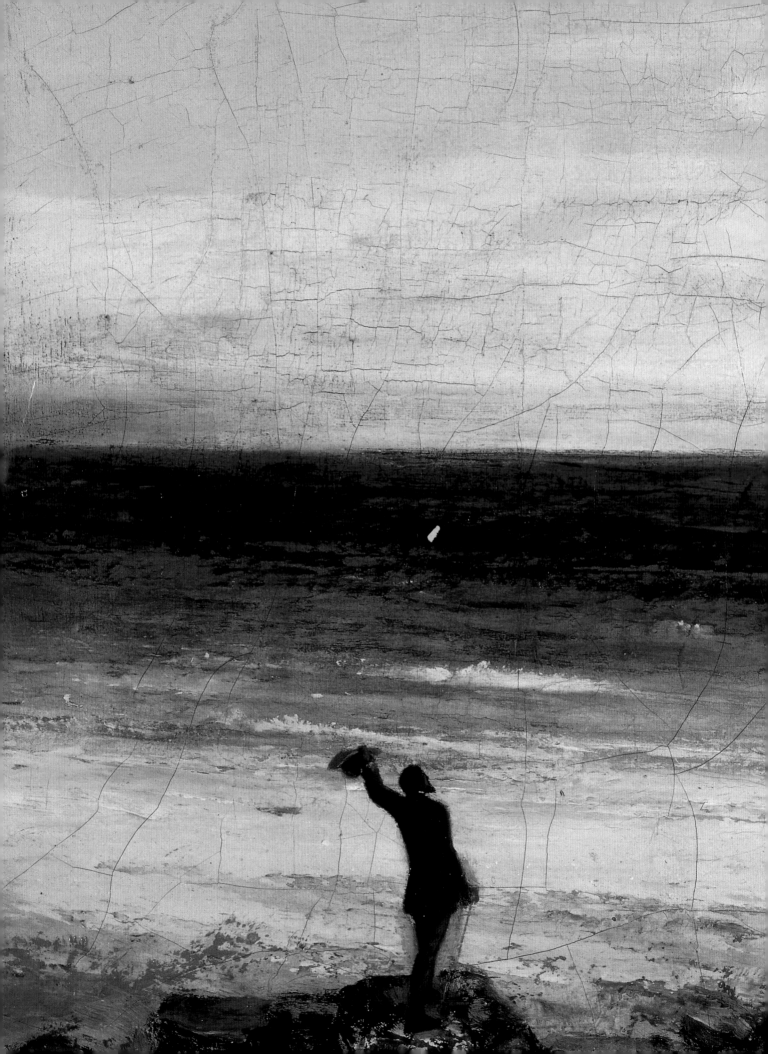

Bonjour, Monsieur Courbet!

The Bruyas Collection from the Musée Fabre, Montpellier

Catalogue edited by Sarah Lees
Exhibition curated under the direction of Michel Hilaire and Sylvain Amic

Réunion des Musées Nationaux, Paris
Sterling and Francine Clark Art Institute, Williamstown, Massachusetts

This catalogue is published on the occasion
of the exhibition *"Bonjour, Monsieur Courbet!"*:
The Bruyas Collection from the Musée Fabre, Montpellier

Virginia Museum of Fine Arts
Richmond, Virginia
26 March–13 June 2004

Sterling and Francine Clark Art Institute
Williamstown, Massachusetts
27 June–6 September 2004

Dallas Museum of Art
Dallas, Texas
17 October 2004–2 January 2005

Fine Arts Museums of San Francisco
California Palace of the Legion of Honor
San Francisco, California
22 January–3 April 2005

This publication was made possible in part by a grant
from the Robert Lehman Foundation.

This exhibition has been organized by the Musée Fabre,
Montpellier, the Virginia Museum of Fine Arts, Richmond,
and the Sterling and Francine Clark Art Institute,
Williamstown, Massachusetts, with the Dallas Museum of Art
and the Fine Arts Museums of San Francisco under
the auspices of FRAME (French Regional and American
Museum Exchange).

It is supported by an indemnity from the Federal Council
on the Arts and Humanities.

Curatorial committee:

Michel Hilaire Conservateur en chef du Patrimoine
and Director, Musée Fabre, Montpellier

Sylvain Amic Conservateur du Patrimoine,
Musée Fabre, Montpellier

James A. Ganz Curator of Prints, Drawings,
and Photographs, Sterling and Francine Clark Art Institute,
Williamstown, Massachusetts

Dorothy Kosinski Senior Curator of Painting and Sculpture
and the Barbara Thomas Lemmon Curator of European Art,
Dallas Museum of Art

Sarah Lees Assistant Curator of Paintings, Sterling
and Francine Clark Art Institute, Williamstown, Massachusetts

Kathleen M. Morris Associate Director for Exhibitions
and Collections Management, and Associate Curator
of European Sculpture, Decorative Arts, and Prints,
Virginia Museum of Fine Arts, Richmond

Lynn Federle Orr Curator-in-Charge of European Art,
Legion of Honor, Fine Arts Museums of San Francisco

Richard Rand Senior Curator and Curator of Paintings
and Sculpture, Sterling and Francine Clark Art Institute,
Williamstown, Massachusetts

© 2004 Editions de la Réunion des Musées Nationaux, Paris, and Sterling
and Francine Clark Art Institute, Williamstown, Massachusetts
All rights reserved. This book may not be reproduced, in whole or in part,
without written permission from the publishers.

Distributed by Yale University Press, New Haven and London

Title page: Detail of *The Sea at Palavas*, by Gustave Courbet (cat. 31)
Details used on divider pages: *Interior of Bruyas's Study*, by Auguste
Barthélémy Glaize (cat. 63); *The Meeting*, by Gustave Courbet (cat. 30);
Women of Algiers in Their Apartment, by Eugène Delacroix (cat. 44);
Solitude (The Covered Stream), by Gustave Courbet (cat. 33)

Color illustrations are reproduced by courtesy of the Musée Fabre,
Montpellier (photo Frédéric Jaulmes). Permission to reproduce other
illustrations is provided by courtesy of the owners as listed in the captions.
Additional photography credits are as follows: Bibliothèque Municipale
Centrale de Montpellier (p. 29); Bibliothèque nationale de France, Paris
(pp. 35, 51); Institut national d'histoire de l'art, Bibliothèque d'art
et d'archéologie Jacques Doucet, Paris (p. 48); All rights reserved,
The Metropolitan Museum of Art (p. 126); © Fitzwilliam Museum, University
of Cambridge, V&A Picture Library (p. 155); © Centre des monuments
nationaux, Paris (p. 178); © 2003 Museum of Fine Arts, Boston (p. 211);
© Roumagnac photographie, Musée Ingres, Montauban (p. 193); © Agence
de la Réunion des Musées Nationaux, Paris (pp. 37, 132, 135, 142, 151, 152, 188, 204)

This catalogue was produced by the Réunion des Musées Nationaux
in association with the Sterling and Francine Clark Art Institute.
Coordinated by Geneviève Rudolf (France) and Curtis Scott (USA)
Designed by Frédéric Celestin
Translations by Pamela Hargreaves, Sarah Lees, and Vivian Rehberg
Index by Kathleen M. Friello
Printed by Aubin, Poitiers (France)

ISBN 2-7118-4778-0 (paperback trade edition, France)
ISBN 0-931102-58-8 (paperback museum edition, USA)
ISBN 0-300-10523-1 (cloth trade edition)

Library of Congress Control Number: 2004090345
EK 38 0058

Printed and bound in France
10 9 8 7 6 5 4 3 2 1

Contents

Foreword 9

Preface 11

Introduction 12

Acknowledgments and Notes to the Reader 13

A Gallery of Living Artists: Alfred Bruyas as Patron 17
Michel Hilaire

Bruyas versus Courbet: The Meeting 33
Sylvain Amic

Bruyas, Paris, and Montpellier: Artistic Center and Periphery 45
Ting Chang

Signac's Visit to the Bruyas Collection 53
Françoise Cachin

Catalogue of the Exhibition 60

Chronology 242

Bibliography 243

Index 252

FRAME

French Regional and American Museum Exchange
www.on-frame.com

FRAME is supported by The Florence Gould Foundation, The Felix & Elizabeth Rohatyn Foundation,
The Foundation for French Museums, The Peter Jay Sharp Foundation, Sophie & Jérôme Seydoux, The Robert Lehman Foundation,
Michel David-Weill, Mr. & Mrs. Henry R. Kravis, and The Eugene McDermott Foundation.

bioMérieux, FedEx Corporation, Lafarge, Lagardère,
Publicis, Saint-Gobain, Suez, and United Technologies Corporation are the Corporate Sponsors.

FRAME would like also to express its gratitude for their generous participation to John & Mary Young,
Walter & Ursula Cliff, Daniel & Katoucha Davison, Alice Lobel, Barbara Walters, Constance Goodyear Baron,
Mrs. Lewis T. Preston, The Citigroup Foundation, The Leonard and Evelyn Lauder Foundation,
Nancy B. Hamon, Michael J. Horvitz, The Annenberg Foundation, The Perot Foundation, Mr. and Mrs. Peter O'Donnell,
Mr. and Mrs. George A. Schutt, The Fox Family Foundation, Mr. and Mrs. Henry Buchbinder, Emily Rauh Pulitzer,
The Boeckman Family Foundation, Steven D. Brooks, Bruce and Carol Calder, Jan Greenberg, S. Roger Horchow,
Mr. and Mrs. David Mesker, Mary Cronson, Striblings & Associates Ltd., Emily Summers, and The Gingko Group.

FRAME thanks the Communauté d'Agglomération de Montpellier for making this exhibition possible.

Montpellier
Agglomération

Raymond Barre Former Prime Minister of France
Bernadette Chirac

ADVISORY COMMITTEE
John Bryan Chairman Emeritus and CEO, The Sara Lee Corporation
David Caméo Directeur de la Manufacture Nationale de Sèvres
Michel David-Weill Chairman Lazard LLC, Chairman, Foundation for French Museums
Constance Goodyear Baron Trustee, Fine Arts Museums of San Francisco
Alain Mérieux Président Directeur Général, bioMérieux
Felix G. Rohatyn Former Ambassador of the United States of America to France
John Russell Art Historian and Critic

PRESIDENT
Francine Mariani-Ducray Directrice des Musées de France

CHIEF EXECUTIVE OFFICERS
Françoise Cachin Directeur honoraire des Musées de France, Co-founder
Elizabeth Rohatyn Vice President, Foundation for French Museums, Co-founder

DIRECTORS
Richard R. Brettell Professor of Aesthetic Studies and Director of the Center for the Interdisciplinary
Study of Museums, University of Texas at Dallas, Director (USA)
Sybille Heftler Director, Foundation for French Museums, Director (France)
Rodolphe Rapetti Conservateur en chef du patrimoine, Scientific Director

NEW TECHNOLOGIES COORDINATOR (USA)
Leonard Steinbach Chief Information Officer, The Cleveland Museum of Art, Coordinator

NEW TECHNOLOGIES COORDINATOR & COMMUNICATION (France)
Robert Fohr Chef de la mission de la communication, Direction des Musées de France

Foreword

"Bonjour, Monsieur Courbet!": The Bruyas Collection from the Musée Fabre, Montpellier is the sixth exhibition produced by FRAME (French Regional and American Museum Exchange), a consortium of nine French and nine American museums. Each exhibition has been a co-production of both countries, a practice that has had the advantage not only of making American art better known to the French public and French art to the American public, but also of allowing curators, art historians, educators, and registrars from the two countries to work together and to get to know one another better. FRAME is also both FRAnce and AMErica!

The FRAME consortium, founded in Lyon in 1999, has already realized its most significant goal: the reinforcement of reciprocal knowledge and friendships. This success has been virtually universal; since each exhibition appears in multiple venues, fifteen of our member institutions have already presented FRAME exhibitions.

The current exhibition will travel to four great American museums—the Virginia Museum of Fine Arts in Richmond, the Clark Art Institute in Williamstown, Massachusetts, the Dallas Museum of Art, and the Fine Arts Museums of San Francisco. It is different from previous exhibitions, which generally assembled works from FRAME institutions around a theme. This time, the masterpieces from a single French museum will be presented, works that were collected in the nineteenth century by Alfred Bruyas, a great art lover and patron from Montpellier. They demonstrate perfectly that, in France as in the United States, it is enlightened and generous collectors who support and enrich our museums.

This homage to the singular personality of Alfred Bruyas will put on view the image of the collector painted by the greatest French artists of his time, along with such famous and spectacular paintings as the work by Courbet that gives this exhibition its title, depicting as it does the meeting of the artist and his patron. But the viewer will also be able to discover exceptional paintings by Cabanel, Corot, Delacroix, Géricault, Ingres, and Millet, sculptures by Barye, and a fine collection of nineteenth-century drawings by many of the same masters.

The catalogue contains essays by art historians from both sides of the Atlantic—Michel Hilaire and Sylvain Amic, director and curator, respectively, of the Musée Fabre, Montpellier, and Ting Chang, professor of art history at McGill University in Montreal—as well as a previously unpublished commentary by Paul Signac, who visited the Bruyas collection at the end of the nineteenth century as Gauguin and Van Gogh had earlier done.

Complete entries on each work were written by American curators and art historians: Richard Brettell, Patrick Shaw Cable, Paul Galvez, James Ganz, Dorothy Kosinski, Sarah Lees, Kathleen Morris, Lynn Orr, Richard Rand, Lora Sariaslan, and Carl Wuellner. We thank them warmly, along with the French and American teams who contributed to the success of FRAME: Richard Brettell and William Barrett in the U.S., and Sybille Heftler, Rodolphe Rapetti, and Robert Fohr in France, as well as Geneviève Rudolf at the Réunion des Musées Nationaux and Curtis Scott at the Clark Art Institute, who oversaw the publication of the catalogue.

We must of course offer our sincerest gratitude to all the donors and patrons, without whom this co-production would not have happened, among them Georges Frêches, mayor of Montpellier, who allowed masterpieces from the municipal museum to be absent from his town for more than a year overseas, during the renovation of the museum that we will rediscover with joy in 2006. In the meantime, we wish a very successful voyage across the United States to these great works of nineteenth-century French art!

Francine MARIANI-DUCRAY
Directrice des Musées de France, President of FRAME

Françoise CACHIN and Elizabeth ROHATYN
Co-Founders and Chief Executive Officers of FRAME

Preface

As directors of four of the nine American FRAME museums, we are honored to host the exhibition *"Bonjour, Monsieur Courbet!": The Bruyas Collection from the Museé Fabre, Montpellier* during 2004–2005 in Richmond, Williamstown, Dallas, and San Francisco. We would like to recognize Montpellier as a great city of the arts and the Musée Fabre as a model member of FRAME. Under the dynamic leadership of its director, Michel Hilaire, the Musée Fabre has hosted both of the American FRAME exhibitions that have traveled to France, *Made in USA* (2001–2002) and *Sacred Symbols* (2002–2003), and has now lent the entire *Bonjour, Monsieur Courbet!* exhibition from its extraordinary permanent collection. In sharing such great masterpieces with us, the Musée Fabre has greatly enriched the experience of museum-goers across the United States.

At the heart of this project is a collector—Alfred Bruyas—who had the inspiration and foresight to assemble a collection of the art of his time and then donate it for the benefit of his fellow citizens to the Musée Fabre in Montpellier, through a gift in 1868 and a bequest upon his death in 1877. In doing so he not only proved himself to be a true patron of the arts, but he also highlighted the central role art museums play in bringing together works of art and the public in their great civic spaces. This exhibition will allow new audiences to appreciate a great suite of masterpieces by Courbet, Delacroix, and others, seen together for the first time in the United States, and to gain insight into the vision of the man who brought them together. Visited, studied, and even debated by the likes of Van Gogh, Gauguin, and Signac, the history of the Bruyas collection in Montpellier further reminds us how important art museums are to artists.

We are also very proud of the contributions made by the staff of our museums in the research, writing, and production of this formidable catalogue along with their colleagues at the Musée Fabre and the FRAME central offices. It is hoped this catalogue will become an invaluable reference to scholars in the field of nineteenth-century French art as well as a symbol of the great cultural riches of Montpellier and the Musée Fabre. It will certainly stand as clear proof of the extraordinary potential of the FRAME consortium, to which our art museums are so privileged to belong.

Michael BRAND
Virginia Museum of Fine Arts, Richmond

Michael CONFORTI
Sterling and Francine Clark Institute
Williamstown, Massachusetts

John R. LANE
Dallas Museum of Art

Harry S. PARKER III
Fine Arts Museums of San Francisco

Introduction

In the history of a museum there are a few privileged moments when, during renovation, the most beautiful paintings in the collection can leave the walls in large numbers for an extended period of time. This is the case in 2004–2005 with the exhibition *Bonjour, Monsieur Courbet!* which brings together for this exceptional occasion a selection of forty-nine paintings, forty drawings, and several sculptures in four American FRAME museums: the Virginia Museum of Fine Arts, the Sterling and Francine Clark Art Institute, the Dallas Museum of Art, and the Fine Arts Museums of San Francisco. This exhibition, shown in the Pavillon du Musée Fabre with great success in the summer of 2003, will allow a large public on the other side of the Atlantic to become familiar with one of the Musée Fabre's most prestigious holdings, a collection established thanks to the generosity of an exceptional Montpellier native: Alfred Bruyas. The son of a banker, passionately interested in art, and close friends with numerous artists, he expressed the desire toward the end of his life to offer his paintings to the museum of his native town, in the belief that "works of genius belong to posterity and should leave the private domain in order to be offered for public admiration." Familiar with the more traditional tastes of his compatriot François-Xavier Fabre, Bruyas was aware that he was suddenly introducing the contemporary art of his time into the Musée Fabre, especially with the "scandalous" work of his friend Gustave Courbet, work that was in its time the talk of the town. Bruyas had great foresight, and almost one hundred and fifty years after his death his collection still attracts the attention of the public and of specialists, who will no doubt be thrilled to see or to revisit so many masterpieces from a collection that is still little-known and fundamentally unique in the context of nineteenth-century French art. We are thus extremely pleased that this voyage will take place, and that it has also been the occasion for an exemplary scientific collaboration between the French and American specialists who contributed to the catalogue, not to mention for the important restoration work on the collection, particularly in the area of graphic art.

Michel HILAIRE
Conservateur en chef du Patrimoine
Director of the Musée Fabre

Acknowledgments and Notes to the Reader

Every exhibition requires the dedication and teamwork of a very large number of people. The Directors of FRAME and of the four institutions presenting this exhibition would like to thank all who contributed to the successful realization of this exhibition and its catalogue.

In addition to the catalogue authors, we wish to mention in particular Gerald Ackerman, Brian Allen, Jacqui Allen, Guillaume Assié, Christiane Azra, Esther Bell, Philippe Bordes, Katherine Cabaniss, Michael Cassin, Carol Casstevens, Frédéric Celestin, Marie-Christine Chase, Therese Chen, Maria Grace Conley, Krista Davis, Gail Davitt, Jean-Pierre Faye, Carter Foster, Georges Frêche, Suzanne Freeman, Kathleen M. Friello, Lindsay Garratt, Suzanne Hall, Aiesha Halstead, William Huggins, Emma Hurme, Jean Kane, Mattie Kelley, Pierrette Lacour, Barbara Lampron, Mark Ledbury, Murielle Le Guen, Mary Leonard, Dominique Lobstein, Keelan Loftin, Laure de Margerie, David Noyes, Valérie Ôzcan, Katherine Pasco, Michèle Pineau, Bonnie Pitman, Kathryn Price, Elizabeth Quarles, Mark Reach, Philippe Reitz, Susie Rock, Dan Rockwell, Alison Rooney, Geneviève Rudolf, Sandra Rusak, Lauren Schell, Curtis Scott, Brigitte Sélignac, Nancy Spiegel, Mary Sullivan, Gabriela Truly, Jacques Vallet, Martine Vanbiervliet, Alice Whelihan, Bill White, Allison Whiting, Fronia Wissman, Tamara Wootton-Bonner, Leanne Zalewski, and the staffs of the INHA—Bibliothèque d'Art et d'Archéologie Jacques Doucet and the Bibliothèque Municipale Centrale de Montpellier.

Within this publication, all quotations have been translated into English; the original French is provided in the notes only for unpublished sources. Catalogue entries include newly researched information on the provenance, exhibition, and publication history of each work. Within the Provenance section, brackets are used to indicate dealers. The Selected Exhibitions and References list exhibition and collection catalogues published during Bruyas's lifetime, as well as most of the major publications thereafter. Full references for abbreviated citations are given in the Bibliography. Individual catalogue entries are signed by their authors:

RB Richard R. Brettell, Professor of Aesthetic Studies and Director of the Center for Interdisciplinary Study of Museums, University of Texas at Dallas

PSC Patrick Shaw Cable, Curator of European Art, Art Gallery of Hamilton, Ontario

PG Paul Galvez, independent scholar

JAG James A. Ganz, Curator of Prints, Drawings, and Photographs, Sterling and Francine Clark Art Institute

DK Dorothy Kosinski, Senior Curator of Painting and Sculpture and the Barbara Thomas Lemmon Curator of European Art, Dallas Museum of Art

SL Sarah Lees, Assistant Curator of Paintings, Sterling and Francine Clark Art Institute

KMM Kathleen M. Morris, Associate Director for Exhibitions and Collections Management, and Associate Curator of European Sculpture, Decorative Arts, and Prints, Virginia Museum of Fine Arts

LFO Lynn Federle Orr, Curator-in-Charge of European Art, Legion of Honor, Fine Arts Museums of San Francisco

RR Richard Rand, Senior Curator and Curator of Paintings and Sculpture, Sterling and Francine Clark Art Institute

LS Lora Sariaslan, McDermott Curatorial Assistant, Dallas Museum of Art

CCW Carl C. Wuellner, The Lillian and James H. Clark Assistant Curator of European Art, Dallas Museum of Art

Bonjour, Monsieur Courbet!

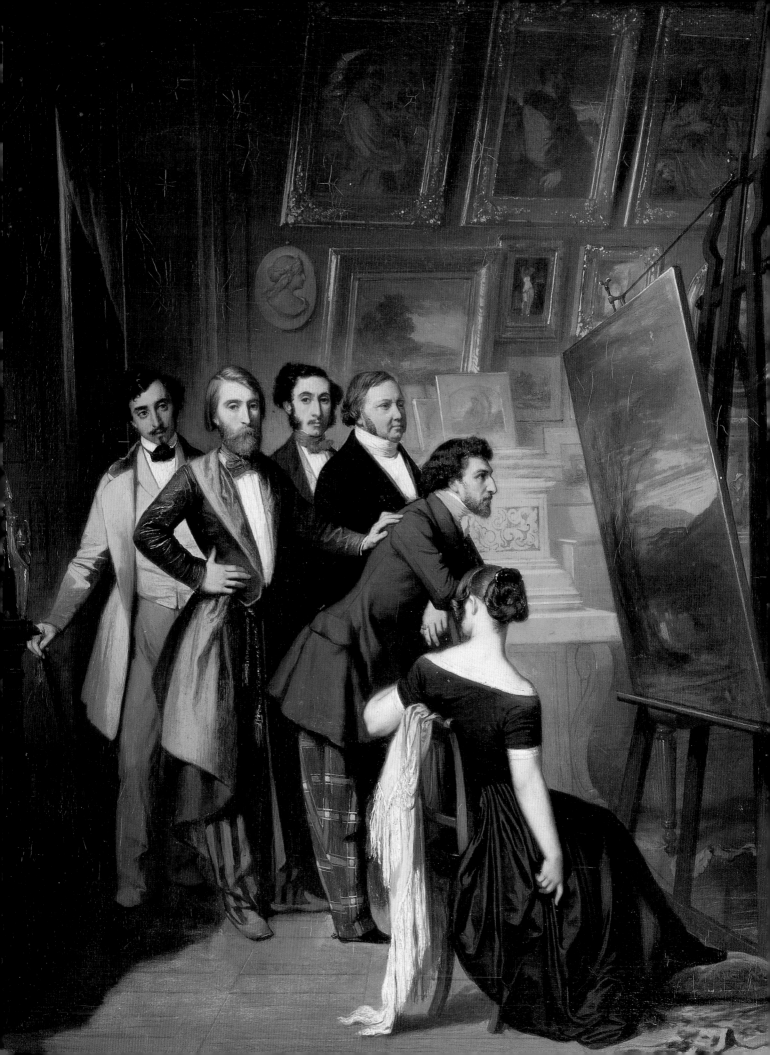

A Gallery of Living Artists:
Alfred Bruyas as Patron

MICHEL HILAIRE

Within the rich mosaic of French museums, the Musée Fabre in Montpellier holds a special place, thanks to the excellence of its collections. To a large extent, the museum's holdings reflect the tastes and choices of three men, all Montpellier-born, who had the courage of their convictions: Baron François-Xavier Fabre (1766–1837), Antoine Valedau (1777–1836), and Alfred Bruyas (1821–1877). The first, a neoclassical painter "exiled" because of his royalist sympaties for most of his life to Florence, where he moved in fashionable circles and led a studious, romantic existence, actually "made" the Musée Fabre—previously a modest, lackluster, municipal museum—by deciding, late in life, to donate his art collection to his hometown.[1]

Fabre's deep attachment to Italian and French painting from the Renaissance to the eighteenth century long shaped the character of the museum. His fellow countryman Antoine Valedau reinforced this "classical" image with his own donation, in 1836, though his personal preference was for the Northern European, Flemish, and Dutch schools. When Baron Fabre died in 1837, the already very prestigious museum looked as if it were to be suspended in Europe's glorious past for many years to come. The artistic upheaval then under way had scarcely any effect on the young institution. Only a few tentative loans from the French state represented the new trends that Fabre had failed to detect, so unbending was he in his devotion to the neoclassicism that had marked his youth and training.

Local artistic life revolved around the museum and the École des Beaux-Arts (School of Fine Arts), both run by Charles Matet (1791–1870), a former pupil of Louis Hersent who specialized in portrait painting, and around the Société des Amis des Arts (Society of Friends of the Arts), founded in 1845.[2] As elsewhere in France at this time, the goal of this Society was to support contemporary art by organizing exhibitions at which local artists could mingle with Parisians. Jean Joseph Bonaventure Laurens (1801–1890), an indefatigable draftsman with an interest in everything, especially music, and Jules Renouvier (1804–1860), Inspector of Monuments for the region and an acclaimed historian, were among the leading personalities who were members of the Society of Friends of the Arts.

At the Society's inaugural exhibition in 1845, a portrait by Matet attracted attention to its subject, Alfred Bruyas, a young man from Montpellier who had studied painting with him a few years earlier (fig. 1). Bruyas was shown seated in an armchair, wearing a ring on his index finger that depicted the struggle between Hercules and the Nemean lion. Although it was a poor likeness, this portrait, which Bruyas would later partially destroy (fig. 2), constitutes the first document relevant to the biography of this extravagant, even eccentric, personality. In a bold and unapologetic move, Bruyas brought the art of his own time into the muse-

1. Hilaire 1995, pp. 7–15.
2. Philippe Bordes, "Montpellier, Bruyas et Courbet" in Montpellier 1985, pp. 24–25.

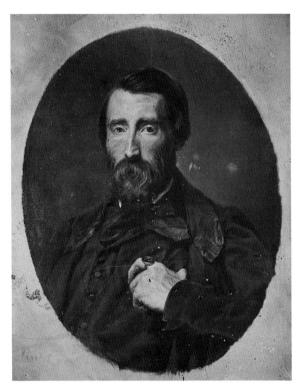

Fig. 1. Photograph, c. 1845–50,
of Charles Matet's *Portrait
of Alfred Bruyas*,
now partially destroyed.
Musée Fabre, Montpellier

um when he donated masterpieces by his universally acclaimed and admired painter friends, among them Eugène Delacroix and Gustave Courbet.

But who was this Alfred Bruyas whose omnipresent portraits presided over the nineteenth-century rooms of the old museum? He was born on 15 August 1821, in the family mansion at 5, Grand rue, the son of a stockbroker and associate of the Tissié-Sarrus Bank. Educated by the Dominicans at a school in Sorèze (Tarn), Bruyas soon showed signs of his keen interest in art. From 1840 to 1842 he studied painting with Matet; around the same time he began collecting drawings, notably those of Eugène Devéria.[3] Unwilling to follow the banking career chosen for him by his family, Bruyas fled to Italy, aided by his faithful friend, Louis Tissié-Sarrus, who would later help heal the breach between the father and son.[4] Bruyas was eager to discover Italy, birthplace of the arts, and he toured the cities of Naples, Perugia, Florence, and Venice before settling in Rome,[5] where he was a frequent visitor to the Villa Medici, site of the French Academy in Rome. There he mixed with resident artists, or *pensionnaires*, such as Léon Benouville, Eugène Guillaume (1822–1905), and his fellow Montpellierain Alexandre Cabanel, who had won the Prix de Rome in 1845 (along with Benouville) after garnering attention at the Salon of 1844 with *Christ in the Garden of Olives*, which was subsequently placed in the presbytery of the Church of Saint Roch, Montpellier.[6] The young Alfred Bruyas felt a new vocation awakening in him: that of a patron and collector.

Bruyas commissioned Cabanel to paint his portrait, the first painted likeness of the patron to have survived (cat. 15). In it, the twenty-four-year-old Bruyas poses outside the garden of the Villa Borghese, holding a lorgnette in his right hand. As he would often do in the course of his life, Bruyas formed a close friendship with the artist he intended to patronize. This was the case with Cabanel, whom he had met at Matet's studio, and for whose promising talent he had high hopes. On his return to Montpellier, Bruyas commissioned two more canvases from him, leaving the choice of subject open, much to the satisfaction of the painter, who thanked him for it.[7]

Cabanel first painted "Nourmahal the Redhead," a subject that was later entitled *Albaydé* (cat. 17), after

Victor Hugo's *Les Orientales*, and that evidently recalled the portrait of Madame Devauçay by Ingres.[8] The second commission, *A Thinker—Young Roman Monk* (cat. 19), was a lively study of a man "meditating on Rome and its former greatness."[9] In 1847, before his second visit to Italy, Bruyas commissioned a third work from the painter, *La Chiaruccia* (cat. 18), which represented a young Roman woman, drawn from life in a landscape near Naples, and completed the triptych on the themes of love and death, religion, work and life.[10]

Upon returning to Montpellier from Rome, Bruyas gave his patronage to another of his fellow countrymen, Auguste Glaize. A pupil of the brothers Achille and Eugène Devéria, Glaize had been singled out at the Salon of 1846 for his painting *The Blood of Venus*, which the State purchased and sent to the Musée Fabre, and upon which Baudelaire had commented in his first Salon review.[11] Bruyas gave free rein to his egotistical tendencies by commissioning the artist to paint several canvases that all represented scenes from his private and public life. First, *Interior of Bruyas's Study* (cat. 63), commissioned in 1848, shows the twenty-seven-year-old collector introducing his friends and family to his new acquisitions, which are still a far cry from the avant-garde painting of his day. The artist has judiciously arranged the collection—as yet modest in size—like a cabinet of curiosities, in line with the great Renaissance tradition. It contains the three Cabanels recently acquired by Bruyas and, on the piano, the drawing sent by the artist from Rome entitled *Angel of the Evening* (cat. 20). In *The Burnoose* (cat. 64), commissioned in 1849, Bruyas wears the shawl he was given by his friend, the artist Jules Laurens, on his return from an official expedition to the Near East during which he worked as a draftsman. The dedication on the painting, "*To Signor A. Bruyas, friend and instigator of the fine arts from your affectionate painter*," clearly indicates the kind of relationship Bruyas sought to establish with his protégés. Lastly, *Souvenir of the Pyrenees* (fig. 3), also known as *Afternoon Tea in the Country (Le goûter champêtre)*, commissioned the same year but completed shortly afterwards in 1850–51, recalls the happy memory of a sojourn at the house of Louis Tissié's uncle near Perpignan, on the way to the spa at Eaux-Bonnes. His memories of Italy and his frendship with Cabanel had prompted Bruyas to undertake

Fig. 2. Charles Matet,
*Fragment of the Portrait
of Alfred Bruyas*, c. 1845.
Oil on canvas, 9 1/2 x 7 7/8 in.
(24 x 20 cm).
Musée Fabre, Montpellier

3. One of the earliest signs of Bruyas's nascent collection is a letter of 27 Sept. 1842, in which a friend asked whether Devéria had finished the drawings Bruyas had commissioned from him. Reprinted in Bruyas 1854, pp. 70–71.
4. Chang 1996a, pp. 161–62.
5. Léotoing 1979, p. 4.
6. Ibid., p. 163.
7. Letter of fall 1847, Doucet MS 216, no. 54.
8. Léotoing 1979, p. 170.
9. Bruyas 1851, p. 7.
10. Montpellier 1985, p. 26.
11. Chang 1996a, pp. 168–69.

another Italian journey in 1849, but ill health made him return to the Pyrenees, where he had been going for several years to treat his tuberculosis and rheumatism.

Despite the privileged position he enjoyed within the small local arts society, Bruyas soon began to feel the limitations of provincial life. A young photographer friend of his, Huguet-Molines, writing in 1850, summed up the situation well: "Everything happens in Montpellier in its usual humdrum fashion. The arts lie dormant because their partisans do nothing to awaken them. I must admit that our town is also somewhat lacking in eminent artists, and if one occasionally comes across any of them, they swiftly disappear into the capital, where their talent finds warmer and more appreciative friends."[12] Toward the end of 1849, Bruyas left Montpellier for Paris, and thus began one of the most glorious chapters in his career as a patron of the arts. Ignoring the advice of his father, who was worried about him squandering a fortune that had already suffered during the political unrest of 1848, Bruyas indulged in his passion for collecting. He quickly made contact with the most progressive circles in the capital, dividing his time between the museums, the Salon, and artists' studios in the Notre-Dame de Lorette and Montmartre districts. Among the art dealers he frequented was Auguste Cornu (13, rue Laffite), from whom he purchased, in particular, Narcisse Diaz's *Claude Frollo and Esmeralda*,[13] a work inspired by a passage in Victor Hugo's *The Hunchback of Notre Dame* (book 8, canto 4). He added several other works by living artists to his collection, including Louis Adolphe Hervier's *Edge of the Wood*, Jean-Adrien Guignet's *Soldiers Playing Dice*, Jean-François Millet's *The Offering to Pan* (cat. 77), Théodore Rousseau's *The Pond* (cat. 85), Constant Troyon's *The Watering Place*, and Prosper Marilhat's *Study of a Village in Auvergne*.

As usual, Bruyas sought to make contact with living artists of some renown: thus in 1850, he posed twice in the studio of Thomas Couture, whose *Romans of the Decadence* (Musée d'Orsay, Paris) had attracted attention at the 1847 Salon, and who had a well-established reputation as a Parisian society portraitist. His meeting with Octave Tassaert turned into a much richer, longer-lasting, and more fruitful friendship. The "Correggio of Suffering," as the French historian Jules Michelet nicknamed him, owed his success to his 1850 painting *An Unfortunate Family*, which drew its inspiration from a passage in Felicité de Lamennais's *Paroles d'un croyant (Words of a Believer)*. Bruyas had no doubt seen it at the Salon, and he may have commissioned a replica of the work for his collection on the spot (cat. 93). For a while, Bruyas thought he had found the artist who was at once a "poet, philosopher, and painter," capable of implementing his own plans for contemporary art.

Happy to help a struggling artist, Bruyas multiplied his purchases and commissions from Tassaert: three portraits in the year 1852 alone and, above all, an ambitious, extremely personal, large-scale canvas on the theme of the Last Judgment which, in the catalogue of his collection in 1853, he entitled "France Troubled by Good and Bad Instincts, or Heaven and Hell."[14] Bruyas's use of a highly concerted religious metaphor, but one perhaps foreign to the painter, "testifies to the transcendental nature of his aesthetic ideas."[15] In *The Painter's Studio* (cat. 94), commissioned from Tassaert in 1852, Bruyas occupies a dominant position in the center of the painting, engaged in conversation with the artist, who is relegated to the left of the canvas, where he is seen busy preparing his paints. All around them are works recently purchased by Bruyas—*An Unfortunate Family*, *Heaven and Hell*—while, in the background, seated on a sofa, is the silent, pensive silhouette of his manservant, "little" Joseph Fontaigne. In contrast to the conventional iconography used in the depiction of an artist's studio, Bruyas boldly declares his mission as an enlightened patron capable of submitting elaborate programs to artists and of inventing a gallery of contemporary art to educate and delight the public.[16]

During his extended visits to the capital, Bruyas was able to purchase several works by Eugène Delacroix, the leading French Romantic painter, then at the peak of his career. Through the dealer Cornu Bruyas came into the possession of one of the artist's youthful mas-

12. Letter of 7 Dec. 1850; reprinted in Bruyas 1854, p. 131.
13. Chang 1996a, p. 196.
14. Bruyas 1853, p. 51; see also Haedeke 1980, p. 85.
15. Montpellier 1985, p. 27.
16. Léotoing 1979, p. 509.

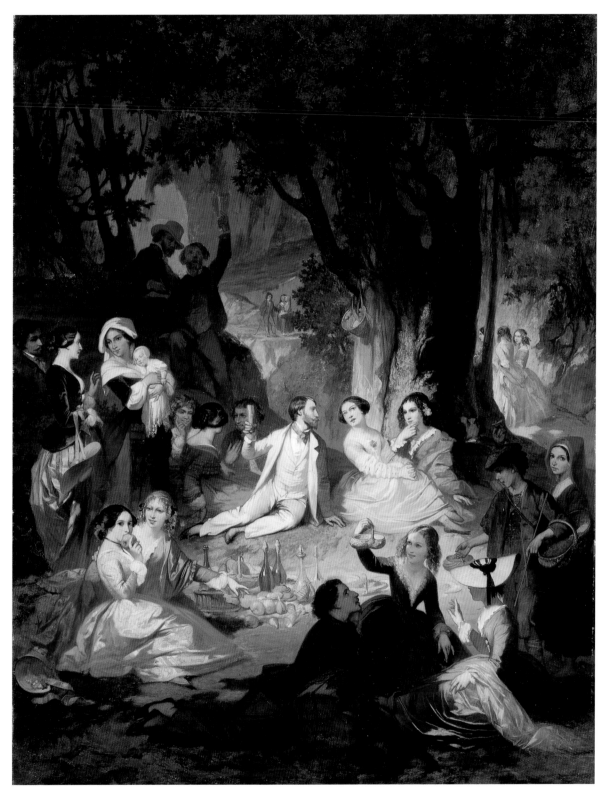

Fig. 3. Auguste Glaize,
Souvenir of the Pyrenees, 1850–51.
Oil on canvas, 57 1/8 x 44 7/8 in. (145 x 114 cm).
Musée Fabre, Montpellier

terpieces, *Moroccan Military Exercises* (cat. 41), which had been painted shortly after his visit to Morocco in 1832 and was owned by the diplomat Charles de Mornay, who put it up for sale (without the painter's consent) in February 1850. Several other purchases of Delacroix's works followed, namely *Daniel in the Lions' Den* in 1851 and *Michelangelo in His Studio* (cat. 45) in 1853. But the Bruyas collection did not really change direction until *Women of Algiers in Their Apartment* (cat. 44) joined its ranks. This well-known theme, a large-scale version of which was presented for the first time at the Salon in 1834 and purchased by the French state for the Musée du Luxembourg, was reworked by the artist in a new mood of sensuality and dreamy melancholy.[17] The painting, exhibited at the Salon of 1849, the year Bruyas arrived in Paris, may have appeared in Charles de Mornay's sale in January 1850, and was then given to a charity lottery, from which Bruyas purchased it by early 1850.

As the owner of several "liberated" works by Delacroix, then a very celebrated Parisian personality, Bruyas showed how determined he was to compete with the Musée du Luxembourg by building a "Gallery of Living Painters."[18] These ambitious purchases gave Bruyas added stature owing to the reputation enjoyed by Delacroix, whom he probably already knew, since they may have met in 1845 while at the spa resort of Eaux-Bonnes. But he did not really come into contact with the "illustrious master" until 17 January 1853, at an exhibition of modern paintings owned by the Duchess of Orléans. Théophile Silvestre witnessed the scene and described it as follows: "Suddenly turning on his heels, [Delacroix] recognized, standing before Ingres's *Antiochus and Stratonice*, M. Alfred Bruyas, the fervent admirer of his *Women of Algiers*. . . . Delacroix caught his attention with a tap on the shoulder and said to him, 'Come see me tomorrow, I want to do your portrait.'"[19] The following day, Bruyas began sitting for him in the studio on the rue Notre-Dame-de-Lorette. The pencil drawing that was given to Bruyas when the painting was delivered, in May 1853, enabled Delacroix to reduce the number of sittings for the model, whom he knew suffered from ill health. Fascinated by Bruyas, Delacroix "found in his model a classic example of physical weakness and nervous energy and saw in him much of his own nature and that of his favorite

heroes,"[20] including, of course, Hamlet. Many years later, on 18 February 1873, Théophile Silvestre confessed to Bruyas, "He had Hamlet, a great deal of his Hamlet, in mind when he was painting you."[21] This portrait is a far cry from Cabanel's or Glaize's slightly indecisive, affected likenesses, and, despite the air of suffering, a very different aspect of Bruyas's personality is brought into relief. At a time when the great Renaissance tradition since Titian was still being followed, this unparalleled portrait immediately placed the collector at the heart of the artistic preoccupations of his time.

As a result of his Parisian sojourns, Bruyas's knowledge of art had broadened considerably, thus adding new stature to his collection. His purchases of contemporary paintings caused quite a stir in Montpellier, as is clearly implied in a letter from his friend Louis Tissié, dated 11 June 1850: "Beware of visitors to your cabinet; not everyone shares your enthusiasm and, frankly, it is quite ridiculous to see subjects that one admires undermined by the often erroneous opinions of so-called connoisseurs. Enjoy your delightful sanctuary on your own, and don't subject yourself to the criticism of the outside world."[22] But Bruyas saw things differently and, despite the reservations of his family and friends, sought to make his gallery known to the public. In order to do so, on his visits back to his native region, he worked on a catalogue, published in 1851, which he entitled "Catalogue of Paintings, Portraits, Drawings, Sketches, and Studies painted from Life, by Leading Modern Artists, Comprising the Painting Salon of Monsieur Alfred Bruyas of Montpellier" and dedicated to his friends Tissié and Cabanel. The latter's name should not surprise us, since Bruyas had remained in contact with the artist, who had returned from Rome to Paris, where he moved into a studio on the rue de l'Oratoire du Roule and pursued a brilliant and prosperous career. In Bruyas's catalogue of eighty-six works (by forty-two artists), Cabanel had the lion's share, with five paintings, a watercolor, and three drawings. The catalogue, funded by Bruyas himself in order to promote his gallery, very clearly imitated those published by the Musée du Luxembourg which, since the restoration of the monarchy, had been dedicated to living artists. In direct emulation of the State, Bruyas confirmed his commitment to supporting modern artists in every possible way, including through the reproduc-

tion of their works by means of photography, assisted by his friend Huguet-Molines, for whose patience and perseverance he had only praise: "This book, the fruit of several months of study, will go down in history as the first attempt in this genre, for which others like Piot, Blanquart-Evrard, and Le Gray are today trying to win acclaim among men of the élite."[23]

Bruyas's commitment to modern art and the role that he intended to play among artists were reaffirmed with each new publication, and thus in 1852, "Among the themes or paintings that comprise the Salons of Mr. A. B., the majority, commissioned by him, have been the subject of study and sustained collaboration with the Artist, with the aim of combining the very fundamental issue of Painting with an interesting theme: Genre, Portrait, History, Landscape, the memory of an era or a journey; in a word, everything that constitutes the intimate and interesting aspect of art, which is nothing else but Feeling. . . . Likewise, through this closer contact with artists, and supported by them, one is initiated much better into the serious ways of art, which demands a rigorous effort of the mind rather than of the hand, when it is a matter of acquiring a deep and true conviction."[24] Bruyas felt that he was the contemporary of a brilliant generation of artists whose destiny he could guide. On several occasions, he believed he had discovered the right talent without, however, ever managing to fulfill all his aspirations, as with Delacroix, who was at once too brilliant, too well established, and too independent to be guided by the young collector.

In the same year that Delacroix painted him as a somewhat chilled, depressed collector, Bruyas reached a decisive stage in his career as a patron. His Parisian sojourn had coincided with the dazzling debut of a young painter from Ornans named Gustave Courbet, who burst into the art world at the Salon of 1849 with *After Dinner at Ornans.* "Have you ever seen anything like it?" declared Delacroix, "Or anything as powerful,

without being answerable to anyone? Here is an innovator, a revolutionary, too; he's emerged all of a sudden, without precedent; he's an unknown."[25] And then, at the Salon of 1850–51, Courbet presented three rural scenes, including the famous *Burial at Ornans.*

Bruyas's actual meeting with Courbet took place at the Salon of 1853, at which the artist presented *The Wrestlers* (Museum of Fine Arts, Budapest), *The Bathers* (cat. 28), and *The Sleeping Spinner* (cat. 27), a more "well-behaved" work, almost certainly intended to soothe ruffled feathers. *The Bathers* caused a sensation and forthwith entered the realm of legend: the empress, visiting the Salon the day before its official opening, is said to have stopped in front of the painting (after having viewed Rosa Bonheur's *The Horse Market*) and exclaimed, "Is that another Percheron?" And the emperor (which seems more unlikely) is said to have gestured as though with a riding crop. At any rate, the anecdote conveys the state of unease in which the critics found themselves. While the public flocked to see the painting, the curator, at one point, envisaged removing it for being "offensive to propriety and morality." Théophile Gautier acknowledged the artist's indomitable naturalism but deplored his deliberate cult of ugliness. "Is ugliness the only truth? The cabbage is real, but the rose is not a falsity; a beautiful marble vase exists as much as an earthenware dish," and concluded, "this unfortunate canvas is proof of a great talent gone astray."[26]

Such controversy was enough to arouse Bruyas's curiosity and make him purchase both *The Bathers* and *The Sleeping Spinner.* "Here at last is free art," he exclaimed, according to the critic Champfleury. "This painting belongs to me."[27] At long last, Bruyas seemed to have found an artist capable of bringing him nationwide recognition while also executing his most personal commissions. He tested his new prodigy by commissioning his portrait, known as *Painting-Solution* (cat. 29), on which Courbet began working in late spring

17. Michel Hilaire, "Un chef-d'œuvre du Cabinet Bruyas: *Femmes d'Alger dans leur intérieur* d'Eugène Delacroix," in Paris 2003, pp. 38–45.
18. Léotoing 1979, p. 317.
19. Bruyas 1876, p. 337.
20. Silvestre in Bruyas 1876, p. 339.
21. Doucet MS 215, no. 49.

22. Bruyas 1854, p. 101; see also Chang 1996a, p. 201.
23. Bruyas 1851, p. 19; see also Chang 1996a, p. 204. Eugène Piot, Louis Désiré Blanquart-Evrard, and Gustave Le Gray were all prominent photographers at the time.
24. Bruyas 1852, pp. 7–9; see also Montpellier

1985, p. 27.
25. Quoted by Francis Wey, describing the Salon of 1849 in an unpublished manuscript excerpted and reprinted in Courthion 1948–50, pp. 186–87.
26. Gautier, "Salon de 1853," cited in Bruyas 1854, p. 13.
27. Léotoing 1979, p. 224.

1853, in his Paris studio at 32, rue de Hautefeuille. This "Solution" was the keynote of the friendship that sprang up between the artist and the young son of the banker from Montpellier—they also went on excursions along the banks of the Seine and the Marne, and frequented the Brasserie Andler, in Paris. It was a sort of password, a secret code, which frequently recurs in the two men's correspondence and in which some have sought to detect a possible alchemical connotation.

What this Solution primarily meant to Bruyas was using his wealth to serve the cause of "a free, contemporary art, able to reconcile the whole of French society,"[28] and also to enlarge and enrich his collection. For Courbet, the Solution was, first and foremost, a realist solution. He wanted to impose Realism on painting, at a time when the critics were still extremely hostile to it and public approval was still a long way off. He knew immediately that Bruyas could help him live according to "his principle," that is, without having to give in to pressure from society or the government. The artistic and moral pact made between the two men is clearly expressed in the portrait by the way Bruyas's fist presses down energetically on a work entitled *Études sur l'art moderne. Solution. A. Bruyas* (*Studies on Modern Art. Solution. A. Bruyas*). In this decisive year of 1853, Bruyas also made the acquaintance of the art critic and writer Théophile Silvestre (1823–1876), first at Constant Troyon's studio, and then at Delacroix's. A native of Ariège, Silvestre was then working on a vast opus entitled *Histoire des artistes vivants français et étrangers* (*The History of Living French and Foreign Artists*), which included a chapter on Courbet alongside more established artists such as Ingres, Delacroix, Corot, Chenavard, Decamps, Barye, and Diaz, all of whom were represented in Bruyas's gallery of paintings.

At the end of the summer, Bruyas returned to Montpellier, and, as a letter from Tassaert informs us, considered transferring his collection to Paris.[29] Faced with the disapproval of his friends and family, however, he abandoned the idea. He invited Courbet to Montpellier, to which Courbet responded with several letters expressing his excitement and confidence in their mutual project. As the time of the visit to Montpellier drew closer, the two men's enthusiasm began to show more and more. In January 1854, Courbet wrote, "I am even more delighted at the prospect of coming to see you and working in Montpellier. I readily accept all your offers."[30] To which a delighted Bruyas replied, on 17 April 1854, "How good of you to have liked me in this way *without knowing!* You have guessed what I myself was unaware of. The force of my artistic life! At this moment, believe me, I assure you, ['the' crossed out] our Bruyas-Courbet solution is worth more than 100,000 francs! . . . Come then, please, leave everything! Prudence is needed, for, in many people's eyes, I'm crazy. Come then, if I'm wrong, you can still save me. If I'm right, we'll complete everything together." And at the end, he added, "Come, I'm expecting you, *your room at my house* is ready. Come soon. Medici ['is waiting for you' crossed out] is dead; you'll find the working man."[31] Courbet arrived in May 1854 and stayed in Languedoc until the month of September. He was quickly introduced to the Bruyas coterie: to his parents, sister, and friends like Louis Tissié and François Sabatier (1818–1891). The latter came from a wealthy family of landowners in the Languedoc region and had traveled extensively in Italy, especially to Rome, where he met Dominique Papety at the Villa Medici and became his patron. Heavily influenced by the utopian socialist ideas of Charles Fourier and an impassioned lover of art and literature, Sabatier was interested in contemporary art and in Courbet, whom he defended in a laudatory account of the 1851 Salon that was published in *Démocratie pacifique*.

The real aim of Courbet's visit to Montpellier was to strengthen the Bruyas-Courbet Solution, inaugurated the previous year in Paris. The artist had concluded an exclusive agreement with the patron. In a letter to his sister Zoé, sent from Montpellier, Courbet wrote, "The painting that I have done for him has made a tremendous impression here and his compatriots are green with envy. I have done him the favor of refusing all the commissions I have received so that he is the only one to have my painting."[32] His masterpiece, *The Meeting* or *Bonjour, Monsieur Courbet!* (cat. 30), one of the jewels of the Bruyas collection and one of the keys to understanding nineteenth-century modernism, was executed for his benefactor. Despite the advantageous position occupied by the artist in the painting, very different from the deferential attitude in Tassaert's painting (cat. 94), for example, *The Meeting* seems to have pleased the patron. As is suggested by the depiction of

the artist in this canvas (with paintbox, folded umbrella, and easel), Courbet took advantage of his visit to go to the coast, notably to a place called Les Cabanes, on the road to Palavas.[33] *The Sea at Palavas* (cat. 31), one of his most famous seascapes, was purchased by Bruyas that same year.

In September, Courbet returned to Ornans. After these weeks of intense artistic activity and intellectual ferment, Bruyas found himself alone, having to confront the incomprehension of his family and Montpellier's artistic circles. Courbet wrote from Ornans to reassure him of his affection, "You can rely on me at all times. When I have decided to like someone, it's for life. You're my friend, you ['know that' crossed out] can be sure of that, and I have done justice to your intelligence on every occasion. The people who feel and love on this earth are so unique that you could not escape me." In the same letter, sent in December 1854, Courbet tells his friend about the composition of his ambitious work, *The Painter's Studio* (p. 37, fig. 2): "This will be the most surprising picture imaginable: there are thirty life-size figures. It's the moral and physical history of my atelier, including all the people who serve me and who participate in my action."[34] Never sparing of compliments, on 14 March 1855, he continued, "You are in a magnificent position. You are in the same pose as in *The Meeting* but with a different feeling. You're triumphant and commanding."[35]

But the sustained criticism was beginning to take a toll on Bruyas's health, as could be felt in a letter dated 26 November 1854 from Tassaert, who had just received the photographs of Courbet's new paintings: "But how saddened I was by your letter! What, sick again! More complaints! What does this sentence ('seriously shake off those who are indifferent') mean?" He went on, "The task you have undertaken is no doubt a fine one, but if it must upset your entire life, cast it away from you and be happy. Stifle these sensibilities that trouble you. If Medici silenced those who were jealous, others exhausted themselves doing so. My dear M. Bruyas,

make up your mind, but forthrightly, and you'll find the repose that you need."[36]

In spring 1855, Courbet envisaged submitting his immense *Studio* and thirteen other canavases, including his *Self-Portrait* (cat. 26) and *The Meeting* to the jury of the Exposition Universelle. On 5 April 1855, he announced to Bruyas, "I'm at my wit's end! Terrible things are happening to me. They have just refused my *Burial* and my latest work *The Studio* along with the *Portrait of Champfleury*. They have made it clear that my tendencies in art had to be stopped at any price, as they were disastrous for French art. Eleven of my paintings have been accepted. *The Meeting* barely got by. They found it too personal and too pretentious. Everyone has urged me to hold my own exhibition; I've given in."[37] This celebrated exhibition, popularly known as the "Pavillon du Réalisme," was inaugurated on 25 June 1855, in a building on avenue Montaigne, not far from the Exposition Universelle (which had opened on May 15). Bruyas sent his notorious *Bathers*, and although absent from the capital, living quietly in his distant province, Bruyas became part of the legend surrounding these two Parisian exhibitions that featured both *The Studio* and *The Meeting*.

The two shows may have suddenly thrust Bruyas into the national limelight, but he was evidently overshadowed by the artist, to the great displeasure of his family, who were alarmed to see their son lampooned by caricaturists. "A lesson in manners given by M. Courbet to two bourgeois gentlemen," ridiculed Cham in *Charivari*. "At the sight of M. Courbet, the two bourgeois gentlemen merely take off their hats. At the sight of the two bourgeois gentlemen, M. Courbet takes off his hat, coat, and vest."[38] Bruyas responded to all these attacks by publishing, in 1856, a short, somewhat obscure pamphlet entitled *Letters on the Exhibition of "The Meeting," Salon of 1855*, in which he recalled the words Courbet himself had used in 1853, "Dear Bruyas, I have met you, it was inevitable; for it was not simply we who met but our solutions G. Courbet, 1853."[39]

28. Montpellier 1985, p. 29.
29. Letter from Tassaert to Bruyas of 30 Oct. 1853, cited in Bruyas 1854, p. 74.
30. Chu 1992, p. 120, no. 54-1.
31. Montpellier 1985, pp. 122–23.

32. Letter of mid-September 1854; Chu 1992, p. 125, no. 54-3.
33. Léotoing 1979, p. 13.
34. Chu 1992, p. 128, no. 54-7.
35. Ibid. p. 138, no. 55-3.

36. Montpellier 1985, p. 32; Doucet MS 216, no. 172.
37. Chu 1992, p. 139, no. 55-4.
38. Paris 1977, p. 126.
39. Chang 1996a, p. 253.

However, Bruyas's overly vague references and private literary style were not quite as successful at fending off criticism as he had expected.

After the events of 1855, Bruyas noticeably adopted a more withdrawn attitude, largely owing to his state of health, which worsened considerably in 1856. The collector began to make fewer purchases, but kept himself informed of the Parisian art world through his friend Jules Laurens, who encouraged him "to put together a collection of serious publications, essentially devoted to the propagation of art" and to make people more aware of the "plastic and moral beauties of the Galerie Bruyas."[40] With this in mind, Bruyas invited Théophile Silvestre to Montpellier again (he had visited the city two years earlier, at the same time as Courbet), asked him to compile a catalogue of his paintings, and authorized him to have it printed in Paris by Plon. The project was soon abandoned, but would be revived at the beginning of the next decade.

In June 1857, Courbet, who had not been in contact with Bruyas for a year, returned to Languedoc, accompanied by several hundred Parisian students, sponsored by the Botanical Society of Montpellier. His friend Champfleury (1821–1889), a steadfast advocate of Realism, was also a member of the group, and Bruyas showed him around his gallery. Courbet took advantage of being in the South to go on plein air painting excursions in the area around Montpellier and to look up his old friends Auguste Bimar, Pierre-Auguste Fajon, and Sabatier, for whom he executed while he was there *The Bridge at Ambrussum* and *View of La Tour de Farges* (fig. 4). Although Bruyas provided Courbet with accommodation and organized a banquet in his honor, the close relationship that they had shared on his previous visit seems to have ended. When Courbet left Montpellier at the end of June 1857, Bruyas was away from home on a fishing trip with his friend Tissié.

Courbet contented himself with saying goodbye in a letter: "I am very annoyed not to be able to see you before I leave. . . . I would have liked you to have seen what I did at the seashore."[41] On his return to Paris, Champfleury published an article entitled "The Sensations of Josquin. The Story of M. T." It ridiculed both Bruyas, under the guise of "Monsieur T.," and his collection: "M. T. was the Narcissus of a civilization that has allowed man to admire his own reflection in a canvas instead of in the limpid water of a fountain."[42] The article wounded the feelings of the collector, who had already been upset by the events of 1855 and the pressure exerted by his relatives, who are said to have wanted "to have him declared incapable of managing his own affairs" in order to stop him from squandering the family fortune. In a letter to Fajon, Courbet tried more or less to exonerate himself: "If M. Champfleury has been the least bit offensive to my friend Bruyas, I severely reprimand him for it, and I am very hurt that anyone could have thought that I had anything to do with it."[43] But the harm was done, and the two men would never again experience the enthusiastic complicity they had shared in 1853–54.

Deeply hurt and disappointed, Bruyas distanced himself from Courbet and gave up all idea of supporting the most avant-garde artistic trends of his day. Probably on the initiative of the municipality of Montpellier, a Salon of paintings was organized in May 1860 by the Society of Friends of the Arts, which had suspended its activities in 1854. Bruyas agreed to be a member of the exhibition committee, serving alongside others like Jean Joseph Bonaventure Laurens and Matet. In addition, he lent around fifty works, including nearly all the Courbets and Cabanels from his collection. Shortly afterwards, he left for Paris and took up residence at 10, rue du Helder. He revived his friendship with Cabanel, thanks to whom he purchased two more conventional works, Ary Scheffer's *Study of a Philosopher* and Léon Benouville's *The Wrath of Achilles* (cat. 12), painted in 1847 during the artist's residence at the Villa Medici.

All in all, the fervor, enthusiasm, and spirit of discovery that had driven Bruyas to action ten years earlier seemed to have evaporated. In a letter to the collector, his friend Jules Laurens protested, "And your splendid collection . . . what does it dream about in its isolated lodgings, untouched and lost in the midst of Montpellier's Philistinery? And you yourself, dispirited, discouraged, weary of war, do you sometimes go visit [your collection] with the gleam of intelligence and courage that brought it into this world?"[44] Bruyas was to miss his appointment with Impressionism: Frédéric Bazille, who was introduced to the collector by his father, told him about Monet, who was then in great

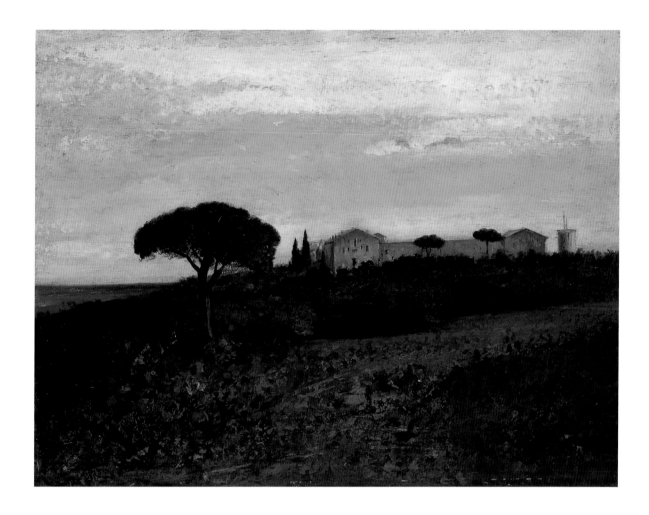

Fig. 4. Gustave Courbet,
View of La Tour de Farges, 1857.
Oil on canvas,
19 3/4 x 25 5/8 in. (50 x 65 cm).
Musée Fabre, Montpellier

financial hardship and producing seascape after seascape in Saint-Adresse. "These are not studies I'm sending you," Monet had written to Bazille, "but two paintings that I'm in the process of completing here after studies. I hope that you and this M. Bruyas, in particular, will be pleased with them. . . . So, my dear friend, give him the sales talk, try to place at least one canvas, for I'm in dire need of it, and what a life I'm going to lead in Paris afterwards."[45] But all this came to nothing.

On 13 August 1863, Bruyas's father died, leaving his son a comfortable fortune. Bruyas moved out of the family home on Grand rue and took up residence in the Impasse Rey. At about this time, Théophile Silvestre asked the collector to revive the project of publishing a catalogue of his collection that had been abandoned a decade earlier. Bruyas eagerly agreed since he was now increasingly considering the idea of imitating Fabre's and Valedau's benevolence by donating his prestigious collection to the museum of his hometown.

40. "Vous avez paru disposé à former un ensemble de publication sérieuse, dévoué essentiellement à la propagation de l'art . . . qui . . . montrerait . . . les beautés plastiques et morales de la galerie Bruyas." Letter of 8 Mar. 1857, Montpellier MS 405, no. 9.
41. Letter of 29? June 1857; Chu 1992, p. 156, no. 57-3.
42. Champfleury, reprinted in Montpellier 1985, p. 143; translated in Chang 1996a, p. 259.
43. Letter of Aug. 1857; Chu 1992, p. 157, no. 57-4.
44. Letter of 31 Mar. 1863; Montpellier MS 405, no. 57.
45. Bajou 1993, p. 62.

In January 1866, Courbet broke the silence that had settled over the two men, in the hope of reactivating their Solution. "There was a time when you took part, and quite effectively, in my political work in the world. . . . I would like to see you again. I would like to have the time and the means to come back to Montpellier and see my friends, the countryside, and the mall again. Thanks to you, I had a wonderful time."[46] To complete his collection, Bruyas bought a painting entitled *Solitude* from him. It was in fact a replica of *The Covered Stream*, a work owned by the Empress Eugénie and now in the Musée d'Orsay, which Courbet presented to him in the following glowing terms: "It is the most beautiful one I have, and perhaps even that I have done in all my life. It must be on a par with the paintings of mine you already have."[47] Forging ahead, Courbet intended to repeat his project of 1855 and, funded by Bruyas, to build a pavilion-studio at the Rond-Point de l'Alma, Paris, on the outskirts of the 1867 Exposition Universelle. In April 1867, Courbet asked Bruyas to lend him "*The Bathers, The Sleeping Spinner*, your portraits, mine." As though carried away by the same fervor as in the past, he wrote on 28 May 1867, "Bravo! My dear fellow, you have the courage of your convictions; we mustn't hide it from each other, our destinies are linked. You are a man of feeling like me; in my existence, you are my corollary."[48]

But Courbet's attempt to rally the collector to his cause again and get him to invest his fortune in a higher ideal—"Let us be men. Let us do some good," he commented in his letter—failed, and the Courbet-Bruyas pavilion was demolished at the end of the year without Bruyas having seen it. Deep down Courbet understood that he would obtain nothing more from the collector, in whose friendship he always continued to believe with a lingering nostalgia: "I can never stop telling you, at the risk of boring you, how useful you were to me when you came to the rescue of the freedom that I was expressing. I was just starting out then without means."[49] Despite Silvestre's negative opinion of Courbet's personality and political ideas, the patron remained loyal to the artist, whose reputation and fortune were subsequently ruined by the political turmoil of the Commune. As president of the commission for the preservation of the artistic monuments of Paris during the uprising, he was held responsible for the destruction of the Vendôme column. After the painter's arrest, his sister, Zoé Reverdy, asked Bruyas to intervene in his favor at the trial. Still suffering from ill health, the patron was unable to travel, but wrote to his lawyer, Maître Lachaud, saying: "I . . . had only an artistic relationship with the celebrated painter that enabled me to appreciate the nobility and honesty of his character. Consequently, I refuse to believe that he could have in any way participated in the horrors of Paris."[50] A final letter from the painter, in 1873, seeking to justify the role he played in the Commune, sounded the knell of an exceptional friendship. "What is certain is that I saved the arts of the nation. . . . It is a pleasure to see that you are well, as is the Solution. I believe that we have succeeded! . . . I will come see you one of these days."[51]

But new preoccupations had long taken precedence in Bruyas's life over this demanding and visionary friendship—the donation to the museum and its immediate corollary, the compilation of an extensive catalogue with the increasingly close collaboration of Théophile Silvestre. On 14 September 1868, Bruyas wrote to the mayor of Montpellier, Jules Pagezy, repeating in this way Fabre's initial donation in 1825, "I am fortunate to own several paintings by the best contemporary artists, and as I have always thought that works of genius, belonging to posterity, must leave the private domain to be submitted to public admiration, I hereby donate my gallery to the city of Montpellier, thus wishing to work, as far as I am able, toward the development of artistic progress."[52]

The municipal council accepted the donation on 27 October 1868. In exchange for the gift of eighty-eight paintings and eight drawings, Bruyas wished to be appointed lifelong curator of his collection, which was to be called the "Bruyas Gallery" in memory of his father. Inaugurated on 12 November 1868, the donation was housed on the first floor of the museum. It was hung according to the wishes of the collector, who arranged his masterpieces by Delacroix and Courbet in the first exhibition space, paying particular attention to *The Meeting*, the pivotal work of the collection (fig. 5).[53]

Like Fabre before him, when faced with the demands of a public collection, Bruyas took his role as a curator very seriously, going to the museum almost every day.

In the words of Ernest Michel, "Indifferent to everything that was happening in the other exhibition rooms, he stopped only in front of his paintings and was happy to explain to art lovers and foreigners the lofty goal he sought to attain in assembling these works; that is, the history of nineteenth-century art."[54]

Often assisted by Silvestre, Bruyas undertook to fill in the gaps in his collection. Evidently considering didactic purposes, the two men wanted to add artists or trends to the collection that until then had been absent or insufficiently represented. Bruyas remained faithful to the Romantic school and Delacroix: in 1864, at the posthumous sale of the painter's estate, with the help of his pupil Andrieu, he purchased *Wolf and Fox Hunt*, a watercolor after Rubens (cat. 37), and *Portrait of Aspasie* (cat. 38). The study *Spring* or *Orpheus and Eurydice* also joined the collection at this time. In the years that followed, several other paintings were purchased: in 1868, Eugène Isabey's *The Storm* (cat. 70), purchased by Jules Laurens from an art dealer in Paris, which Silvestre particularly admired: "It's tremendous and sublime . . . I said S.U.B.L.I.M.E.";[55] François Bonvin's *On the Pauper's Bench—Souvenir of Brittany* (cat. 13) purchased at the Marmontel sale; and in 1872, *Twilight—Landscape* by the Lyonnaise painter Louis-Hector Allemand who, flattered to be included in this already prestigious collection, offered the benefactor his services.[56] Silvestre advised Bruyas to buy a Millet, represented in the collection only by the small *Offering to Pan* (cat. 77), purchased in 1850. Despite the art critic's personal intervention, a commission given directly to the artist never came to fruition. However, on 18 July 1871, Silvestre announced that it would be "a view of the cliffs and the sea at high tide, a subject inspired by the artist's native village (Greville-Hague) . . . whose actual title should be *Land, Sky and Sea*."[57]

In 1874, at the Constant Dutilleux sale, Silvestre purchased two superb watercolors by Delacroix, *Bouquet*

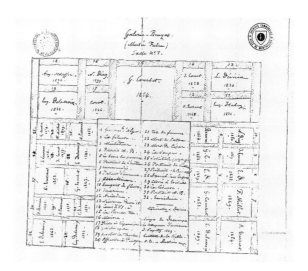

Fig. 5. Alfred Bruyas's plan for the installation of Room 1 of the Galerie Bruyas in the Musée Fabre, Montpellier, c. 1868
Archives municipales, Montpellier

of Flowers (cat. 42) and *The Porte d'Amont, Étretat* (cat. 43), which he presented to Bruyas in laudatory terms: "These two mere trifles (the *Flowers* and *Cliffs*) are nevertheless air, light, color, and fragrance; the breath of nature and the soul."[58] That same year, to fill in one of the large gaps in classical painting, Silvestre advised Bruyas to buy two studies by Ingres: *Studies for "Jesus Among the Doctors"* (cat. 69) and *Study for "The Apotheosis of Homer,"* with which the artist had never parted. Constantly concerned about the collection's harmony and balance, Silvestre urged Bruyas to make a more audacious purchase: *Study of a Severed Arm and Legs* (cat. 61), a painting by Géricault, who was as yet unrepresented in the collection. "It would make," he wrote to Bruyas on 7 December 1874, "a powerful impact hung near Courbet and Delacroix, and would add a vigorous complement to your Géricault section. And as for renown, it's a study for the [*Raft of the*] *Medusa*."[59]

46. Chu 1992, p. 273, no. 66-3.
47. Chu 1992, p. 275, no. 66-5.
48. Letter of 27 Apr. 1867; Chu 1992, p. 312, no. 67-11. Letter of 28 May 1867; ibid., p. 314, no. 67-17.
49. Letter of 7 Feb. 1868; Chu 1992, p. 327, no. 68-5.
50. Letter of 8 Aug. 1871; reprinted in Montpellier

1985, p. 139.
51. Letter of 1 Mar. 1873; Chu 1992, p. 492, no. 73-22.
52. Reprinted in Bruyas 1876, p. 9. See also Hilaire 1995, pp. 13–14.
53. Chang 1996b, pp. 586–91.
54. Michel 1879, p. xxx.
55. Silvestre letter of 1868, cited in Léotoing

1979, p. 439.
56. Léotoing 1979, p. 144; see Doucet MS 216, no. 7 and 8, letters of 19 and 23 Dec. 1872, on the purchase of this painting.
57. Doucet MS 215, no. 19.
58. Montpellier MS 365, no. 6.
59. Letter of 7 Dec. 1874; Montpellier MS 365, no. 12.

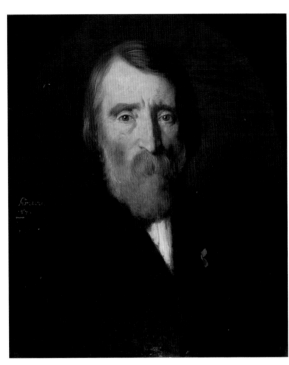

Fig. 6. Auguste Glaize,
Portrait of Alfred Bruyas, 1876.
Oil on canvas, 21 1/4 x 18 1/8 in. (54 x 46 cm).
Musée Fabre, Montpellier

The following year, Silvestre, still preoccupied with building an exhaustive collection, suggested acquiring a watercolor by Delaroche, *The Assassination of the Duc de Guise* (cat. 49), and added the following commentary, "It can make its effect on the public and on all those who are infinitely more impressed by fame than genius."[60] Gérôme's *Decorative Project for the Library at the Conservatoire des Arts et Métiers, Paris* (cat. 62), one of the patron's last purchases, shows how attentive Silvestre remained until the end to filling in the gaps in this "History of Modern Painting" by seeking to insert another famous name between Ingres and Delaroche. "I'm sending it to you," he wrote to Bruyas in January 1876, "only because of the artist's celebrity and the fashion that adds such value to this painting so dear to society, if not to our hearts."[61] Silvestre's interventions significantly modified the initial spirit of a collection that sought to support only living artists. Several historic figures thus also made their appearance. Gros, David, Géricault, and a number of more conservative artists, including Delaroche, Chenavard, and Gérôme, acted as counterweights to Delacroix or Courbet's more avant-garde works.[62]

Courbet's presence in the Bruyas collection became much less dominant, largely owing to Silvestre's prejudice against him. The critic nonetheless did recognize Courbet's talent and even helped Bruyas, in 1874, to purchase the remarkable *Portrait of Baudelaire* (cat. 25) from the poet's publisher, Poulet-Malassis. "The portrait," he told Bruyas in a letter dated 12 May 1874, "is rare, splendid and the only true and well-painted one that exists of Baudelaire. From these various points of view, your gallery is really fortunate to have it. The portrait of Baudelaire will earn you the regard of all men of talent and young people will be especially proud of you."[63] And again in February 1876, he wrote revealingly to Bruyas, "The paintings of said artist are valuable and you have the finest, God be praised! But the man and his family are of no interest to us, at least to your servant and friend."[64]

By and large, the repeated acquisitions made by Bruyas after his donation to the City of Montpellier in 1868 were used to complete the catalogue, a unique undertaking in that day and age. Thanks to the catalogue, the collection earned the reputation it deserved in places far removed from the provincialism of

Montpellier and the criticism and ridicule from which the collector had suffered all his life. On 6 April 1874, Silvestre wrote reassuringly to Bruyas, "And when the book is published, not only will Montpellier be won over, but so will Paris, which is not an indifferent judge lacking authority. . . . As for those who are indifferent, and, may I add, as for those who are jealous, who are muddleheaded, let them say and do what they want. He who laughs last laughs best. I already know that it will be the two of us."[65] Silvestre worked alongside Bruyas in a spirit of confidence, with a constant concern for accuracy and quality in the way the paintings were presented. He often cleverly advised Bruyas not to include textual contributions that he considered weak or inappropriate, for example those submitted by Jules Laurens, a close friend of the benefactor, or by the Goncourt brothers, whom he described as "literary hairdressers much in vogue."[66] Most of the texts were written by Silvestre, but considerable space was allocated to contributions by contemporary artists, writers, critics, and art dealers.

Silvestre also generously distributed Bruyas's name or initials throughout the catalogue, so as to underscore the patron's unique role in the constitution of the collection. As he wrote on 26 November 1872, "Your gallery is you yourself. You are incarnated in it; it is incarnated in you. . . . This gallery is your whole life."[67] He was, moreover, incapable of concealing his prejudices against artists such as Cabanel who, in his opinion, "despite his reputation is a deplorable painter,"[68] and particularly Courbet, whose early career he admired, but whose role he constantly played down in the collection and catalogue. His comments on the famous *Painting-Solution*, a cornerstone of the collection, are edifying in this respect: "It is not through intelligence, nor observation, nor feeling, nor even physical truth that this portrait shines. It is through pure execution."[69]

Lastly, Silvestre subtly anticipated the accusations of complacency and narcissism that would surely have arisen on the subject of the patron's personality. Far from wanting to analyze himself, Silvestre contended Bruyas on the contrary pursued a loftier, more selfless goal: "He was the one who wanted to get to know and thoroughly understand the particular intelligence and special style of each of the celebrated painters who por-

trayed him. He subjected himself to posing so many times for them to be able to judge, through this series of observations and personal experiences, the art of contemporary artists. He turned himself into the living target, so to speak, of their mind, gaze, and brush."[70]

Despite Silvestre's dedication to the project—he even unsuccessfully offered in 1872 to devote himself entirely to it in exchange for a monthly income of 1,000 francs—the immense task of compiling the catalogue remained unfinished at the time of the critic's death in October 1876. Before he died, however, Silvestre had taken the necessary steps—notably by contacting Philippe de Chennevières, then director of the fine arts administration—to ensure that Bruyas would be awarded the Legion of Honor. This request was seconded by the mayor of Montpellier and the Artistic Society of the Hérault Region, and in June 1876, Bruyas was made a Knight of the Legion of Honor. In the last portrait for which he sat, painted by Glaize in November 1876, a few weeks before his death on 1 January 1877, Bruyas appears wracked by ill health—despite being only fifty-five—but in his buttonhole he proudly sports the decoration that symbolizes his artistic achievement (fig. 6).

The patron had found the time to complete his donation of 1868 by a bequest, comprising sixty paintings, seventy-eight drawings, eighteen bronzes, and "diverse watercolors, drawings, lithographs, sketches, and engravings," made in order to "provide young artists with easier and sounder elements of instruction and appreciation in the presence of the diverse styles of our great modern painters."[71]

60. Letter of 17 Jan. 1875; Montpellier MS 365, no. 14.
61. Letter of 7 Jan. 1876; Montpellier MS 365, no. 19.
62. Chang 1996a, pp. 305–6.
63. Doucet MS 216, no. 117.
64. Montpellier MS 365, no. 27.
65. Doucet MS 215, no. 108.
66. Montpellier MS 365, no. 7.
67. Doucet MS 215, no. 36.
68. Doucet MS 215, no. 134.
69. Bruyas 1876, p. 176; see also Chang 1996a, p. 321.
70. Bruyas 1876, pp. 178–79; see also Chang 1996a, p. 322.
71. Bruyas's will, part II. Archives départementales de l'Hérault, Montpellier; quoted in Léotoing 1979, p. 43.

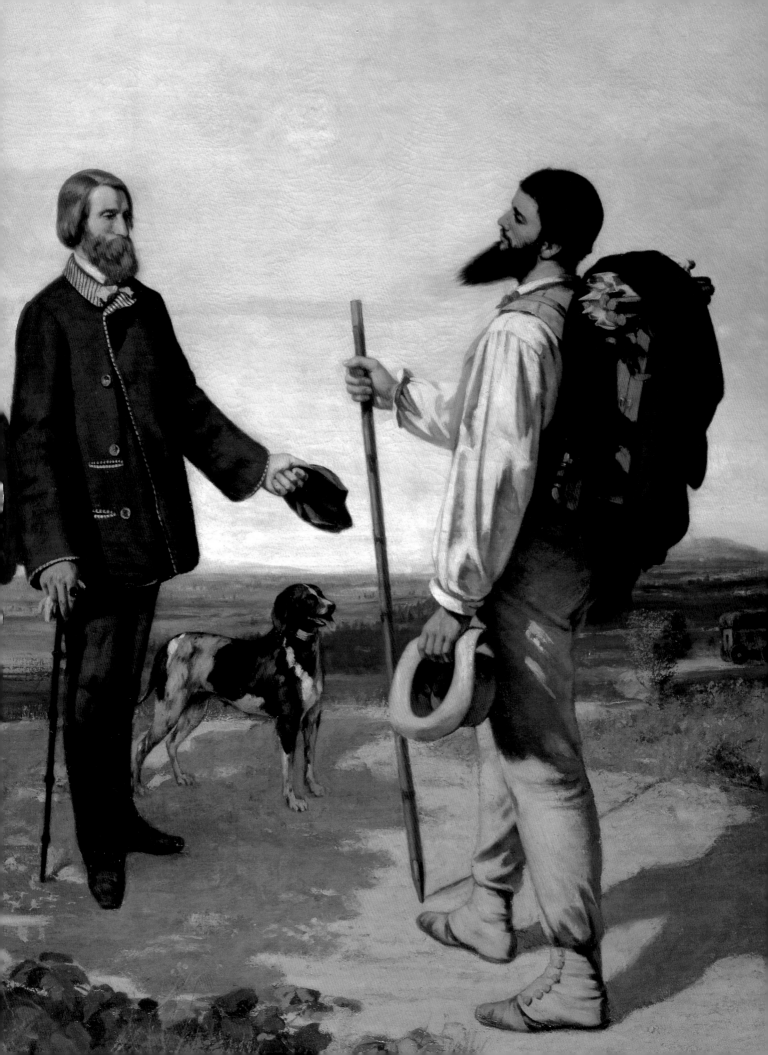

Bruyas versus Courbet: The Meeting

SYLVAIN AMIC

"It was inevitable."
Courbet

Few personalities seem to have been as different as those of Alfred Bruyas and Gustave Courbet. The former was sickly, secretive, melancholy, uncertain; the latter was a bundle of energy, effusive, colorful, sure of himself. Never had there been such an ill-assorted couple in the history of patronage, and never did such an ill-matched alliance cause such an upheaval in the history of art. The encounter between the two men was intense, but it was also brief: six months in 1853, four months in 1854, and one month in 1857 do not amount to much in view of the nine years of silence that lasted from 1857 to 1866, followed by occasional epistolary exchanges until 1873. It is also the story of a failure, the extent of which has not yet been fully measured: that of a painting in which both men placed their highest hopes for social reconciliation, and which provoked outbursts of laughter from the public. Although legendary, the relationship between the two men has by and large been little idealized, and critics have been swift to point out all the differences that eventually dampened their initial euphoria.[1] Only recently have we learned that the end of the story was a bitter one. Despite the fact that the Bruyas collection entered the Musée Fabre and its prestige continued to grow (Van Gogh went to see it in 1888, and Signac in 1897), the last years of their lives saw an agonizing reappraisal of their youthful ideals. While it triumphed on the historical plane, the "alliance of Fortune and Genius" treated its participants cruelly.

"It was not we who have met, but our solutions."[2]
Courbet to Bruyas, 1854

Before being commemorated as a painting, the meeting between Bruyas and Courbet occurred in another domain, that of thought and language. As the painter implied in his letter, it was under the aegis of the word "Solution," a concept that eventually epitomized their whole relationship, that the two men came together. Gérard de Léotoing noted that this word, "in widespread use at the time within intellectual and free-thinking circles, was a standard term employed to express a new idea."[3] It was especially used in Fourierist groups; Victor Considérant, for example, published *La Solution, ou le gouvernement direct du peuple* in 1851.[4]

I wish to thank Sarah Lees at the Clark Art Institute for the fruitful exchanges the exhibition has enabled us to make. Unless otherwise noted, all the works cited are from the Bruyas collection of the Musée Fabre, Montpellier.
1. One exception to this tendency is the attempt made by Pierre Borel, who based his *Lettres de Courbet à Alfred Bruyas*, on the premise of a "great and indissoluble affection." Borel 1851, p. 13.
2. Letter to Bruyas, Ornans, 3 May 1854, Chu 1992, pp. 122–23, no. 54-2.
3. Léotoing 1979, p. 64.
4. Rubin 1980, p. 17.

In the years preceding his discovery of Courbet, Bruyas wrote prolifically, in a style mixing personal references, dedications, letters, aesthetic essays, philosophical, transcendental, and social ideas. Delivered without any apparent order, set in the most diverse typography, and occasionally impenetrable, these musings nevertheless form an incomparably rich source for the collector's innermost thoughts. Following his use of the word "Solution" in this maze of writings is like attempting to follow the subtlety of a thought that outlines an absence, a latent expectation.

Bruyas first used the term in his introduction to the *Salons de peinture* of 1852, his only real attempt at theoretical writing.[5] In it, the word "Solution" is associated with the name of Octave Tassaert, an artist in whom Bruyas then placed great hope. Specializing in a slightly complacent sentimentality, Tassaert readily depicted scenes of bohemian life, to borrow Henri Murger's title, a world in which poverty and ideals coexisted, a crucible for reformist ambitions.[6]

The term "Solution" inevitably implies a "Problem," a word which also appeared in Bruyas's writings: "What interests us keenly today is . . . the innovative school of *Delacroix, Rousseau, Troyon* . . . offering, as a whole, a remarkable coming together of serious qualities, an unquestionable source of true, deep belief in Art, one which, with our modern-day celebrities (CHIEF AMONG THEM THE HEAD OF STATE), aims more and more every day to resolve so difficult and vast a problem."[7] This strange amalgamation peculiar to Bruyas, in which artist and head of state are associated within the same vision, highlights the nature of the problem at issue. As emphasized by James Henry Rubin, "The problem in need of a solution was the same for him as for all radical thinkers of early 1850s—the social problem."[8] Because it founded its art on principles of truth, the new school lifted the individual toward goodness. Painting was therefore a source of social harmony and contributed to the desire for progress upheld by the government. In the catalogue of 1854, the *Portrait of Alfred Bruyas*, known as the *Painting Solution* (cat. 29) would thus be dedicated "to progress."[9]

In the 1853 edition, Bruyas tried to provide a better definition of what he meant by "Solution": "we shall call solution a painting that unites everything through its wonderful poems. Simple, true nature, with exqui-site feeling." The author continued: "Art must attempt to find its humble solution everywhere," and later, "Tassaert, Troyon, and Corot form the solution."[10] In Bruyas's opinion, these three artists shared a manner of perceiving reality, and a faithfulness to the subject combined with nobility of sentiment. While he praised humility and feeling, Bruyas was apprehensive of weakness and prayed for the emergence of an energetic personality, who, in his view, might possibly be Thomas Couture.[11] "What is missing, in fact, in order to establish this truth, if ever we were deluded into thinking that certain artists had already succeeded (see the latest works by the painters Troyon, Tassaert, Hervier, Rousseau, Cabanel, etc.)? . . . May all these fine and distinguished individuals apply themselves directly to nature, in other words, may the powerful M. Couture, for example, be this same nature, true and powerful when it has to be."[12]

This rhetoric of vigor used by Bruyas recalled that of the new political regime, born of a coup d'état that the collector fully supported:[13] "Power and force come from great masters and from the gut. . . ; one is a painter on the same conditions because feelings need force! Only then is the struggle possible, the result noble, serious, and varying according to the nature of the individual."[14] The wait for a providential artist whose art would reconcile society was thus linked to the man of action who took the reins of the country. French art, too, needed a coup d'état, and it was to be Courbet and his *Bathers* (cat. 28).

In his 1854 catalogue, Bruyas completed his definition of the Solution. He published a definitive text, which he would never again modify: "Solution*—A Profession of Faith." (The footnote referred to "*The Bathers* by M. G. Courbet at the 1853 Salon.") Further on, Bruyas wrote, "the painting of *The Bathers* supports the solution." Everything had thus changed after the purchases he made at the 1853 Salon: the entire Solution was personified by the scandalous picture, and Courbet emerged as the "master painter"—the word "master" assuming its full force—the providential man guiding his fellow men toward freedom. "Let us know for a moment how to sacrifice form and henceforth we shall follow the path to freedom," Bruyas wrote of *The Bathers*.[15] On the frontispiece, Courbet's name appeared beneath the word "Liberty!" with the date 1853 (fig. 1).

Fig. 1. Alfred Bruyas, *Explication des ouvrages de peinture du cabinet de M. Alfred Bruyas* (Paris, 1854), pp. 6–7.

Although he met Bruyas in 1853,[16] Courbet did not use the word "Solution" until his letter of 3 May 1854, in which he revealed one of his principles of living that shed light on his acceptance of the term: "I hope to live by my art all my life without ever having departed an inch from my principles, without having betrayed my conscience for a single moment, without ever having made a painting as big as my hand to please anyone or to be sold. . . . I am sure to find men who understand me . . . They will keep me alive, they will save me."[17] Courbet's stay at Bruyas's home must have strengthened the painter's convictions: his existence was generously guaranteed, the patron's courtesy accorded him

complete freedom, and the quality of his painting soared to the highest peaks.

As Courbet put it so well, *The Meeting* (cat. 30), painted that summer of 1854, above all symbolized the joining of two Solutions; that is, less the adhesion of two men to the same ideal than the pooling of two different concepts for the sake of a common interest. Courbet conceded neither to Bruyas's transcendental aspirations, which placed God at the summit of his Solution, nor to his Bonapartist beliefs. Bruyas was less interested in Proudhon than in Fourier or Saint-Simon and would never comprehend the Paris Commune.

5. Bruyas 1852, p. 7.
6. See, for example, Octave Tassaert's *My Room in 1825*, a painting he gave to Bruyas (Musée Fabre, inv. 868.1.87).
7. Bruyas 1852, p. 12, typography in the original.
8. Rubin 1980, pp. 17 and 23.
9. Bruyas 1854, p. 30.
10. Bruyas 1853. The quotations come from pages 23, 21, and 26, respectively. The definition of "solution" had also appeared in Bruyas 1852, p. 13.
11. Thomas Couture executed two portraits of Bruyas in 1850 "in the style of Titian" and "in the style of Van Dyck." See discussion under cat. 35.
12. Bruyas 1852, p. 19, and Bruyas 1853, pp. 12–13.

13. In an essay published in the catalogue of 1853 and in an undated offprint, Bruyas placed the date of the coup d'état next to the word "truth," with the evocative title "Document supporting the Truth of December 2, 1851." He drew a parallel between the fortune the patron invested in art and the "deep-seated conviction" with which Napoléon's nephew served his country. He concludes "Doesn't the country's dazzling demonstration [i.e., the plebiscite] further support this truth? Only authority is understood and loved!"
14. Bruyas 1852, p. 12. Bruyas 1853, pp. 5–7.
15. References to *The Bathers* in Bruyas 1854, pp. [7], 34, and 12, respectively.
16. In 1852, the Bruyas collection included a work by Courbet listed under the title *Head* at

no. 25 in the catalogue (Bruyas 1852, p. 29). This portrait cannot be identified, and there is no subsequent trace of it, although the artist's name does appear in a list published in the 1853 catalogue as one of the "names of painters in 1852 . . . that largely compose the cabinet of M. Alfred Bruyas" (Bruyas 1853, p. 30). Note that the catalogues refer to the state of the collection approximately a year before the date of publication. Thus, the purchases made at the Salon of 1853 appeared in the catalogue of 1854.
17. Courbet, letter to Bruyas, [Ornans, 3 May 1854], in Chu 1992, p. 122, no. 54-2.

"Goodness advances,
the question needs you."[18]

Courbet to Bruyas, 1855

Bruyas's influence on Courbet is generally thought to be limited to his introducing the artist to the South of France and its light, which is supposed to have transformed the palette of the artist. It is surely time to rehabilitate the patron from Montpellier who played such a fundamental role in the radical choices Courbet made in the period 1853 to 1855.

First of all, it is significant that the painter chose Bruyas as a correspondent at certain key moments in these years. It was to Bruyas that Courbet gave a detailed account of the disastrous lunch with the director of the Fine Arts administration, Count de Nieuwerkerke, one of the high points of his correspondence.[19] Apart from the comic element ("'M. Courbet, you are quite proud!'—'I'm amazed . . . that you are only noticing that now, Sir. I'm the proudest and most arrogant man in France'"), this letter is, in fact, important for the way in which it testifies to Courbet's implacable opposition to any form of control. "I told him that . . . I had practiced painting not to produce art for art's sake, but rather to win my intellectual freedom." Once the heated dispute had subsided, Courbet made Bruyas witness to his formal commitment to abandon an officially sanctioned career in order resolutely to make his own way: "It will take courage. I've burned my bridges. I've broken openly with society. I've insulted all those who have served me poorly. And now, here I am, alone, facing that society. It is win or die." It may seem surprising that, in 1853, Courbet felt well-equipped enough to defy a government[20] that was responsible for the only two major sales that he had ever made: *After Dinner at Ornans* (Musée des Beaux-Arts, Lille), purchased by the French state in 1849 for the sum of 1,500 francs, and *Young Women from the Village* (Metropolitan Museum of Art, New York), acquired in 1852 by Charles de Mornay, Napoléon III's half-brother. Courbet was liberated by the decisive gesture of an independent, provincial collector, who, for the handsome sum of 3,000 francs, bore off *The Bathers*, a painting which the prince-president and his wife found distasteful.

Bruyas's liking for portraits is well known, and several critics have already drawn the obvious parallel with the narcissism of Courbet, who painted a remarkable series of self-portraits in the years preceding *The Meeting*.[21] This comparison is even more pertinent since the painter himself refers to it in a letter to the collector when describing his future acquisition, *Man with a Pipe* (cat. 26). "It is not only my portrait but yours as well. I was struck when I saw it; it's a terrific element for our solution."[22] From Courbet's point of view, in 1854, the empathy between the two men was so great that they shared the same psychological portrait, just as they shared the same jacket, which appears in *The Meeting*, *The Painter's Studio* (fig. 2), and *Self-Portrait with a Striped Collar* (cat. 32). It was as if the self-portraits marked the different stages in the life of the painter, who explained to Bruyas in the same letter: "I've done a good many self-portraits in my lifetime, as my attitude gradually changed; in short, I've written my autobiography." Beginning with *The Wounded Man* (Musée d'Orsay, Paris), a "portrait of a man in the throes of death," Courbet then described a veritable artistic rebirth via Romanticism (*Man with a Leather Belt* [Musée d'Orsay, Paris], a "portrait of a man searching for an ideal and absolute love"), and a bohemian lifestyle (*Man with a Pipe* [cat. 26], "a fanatic, an ascetic . . . the portrait of a man disillusioned by the nonsense that made up his education"). Courbet decided to complete the series with a final painting: "I have one left to do, of a man confident in his principles, a free man."[23] That was to be the *Self-Portrait with a Striped Collar*, a sort of companion piece to *Painting Solution* (cat.29), in which Courbet depicted the patron equally "confident in his principles," his hand resting firmly on the Solution, which has taken the form of a hefty book on modern art.[24] It was thus with Bruyas that Courbet realized he would attain the freedom he so desired and could put an end to "a seven-year phase of [his] artistic life," and create *The Painter's Studio*.

Bruyas therefore played an instrumental role in the genesis of this painting which is central to the painter's oeuvre,[25] and it was he, significantly, who received the first description of it: "It is the moral and physical history of my studio, including all the people who serve me and who participate in my action. *The Bathers* and *Return from the Fair* [Musée des Beaux-Arts et d'Archéologie, Besançon] will be in the background of my painting. On my easel, I'll be doing a landscape."[26]

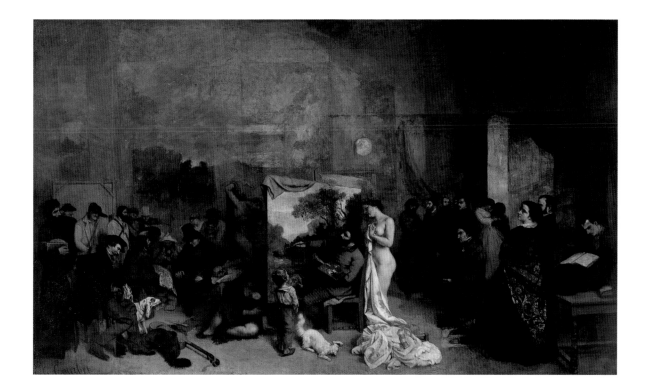

The presence of this landscape in the center of *The Painter's Studio* has seemed incongruous on several counts.[27] Yet the painting in question recalls another: the landscape (also depicted on an easel) in Auguste Glaize's *Interior of Bruyas's Study* (cat. 63). While acknowledging the generic nature of some of the details, other coincidences can be pointed out, such as the presence of the conventional female figure in the center of the composition, the child, the medallion hanging on the wall, the open window and its curtain, or even the still life arranged on the floor. If one accepts the idea that these few symbols forge links between two paintings that differ in every other respect, from ambition to format and handling, this can tell us something

Fig. 2. Gustave Courbet,
The Painter's Studio, 1855.
Oil on canvas,
11 ft. 9 3/4 in. 19 ft. 9 in.
(361 x 598 cm).
Musée d'Orsay, Paris

18. Courbet, letter to Bruyas, [Paris, 5 Apr. 1855], in Chu 1992, p. 139, no. 55-4.
19. Courbet, letter to Bruyas, Ornans [Oct.? 1853], in Chu 1992, pp. 114–18, no. 53-6.
20. "I immediately replied that . . . I too was a government and that I defied his to do anything at all for mine." Ibid., pp. 115–16.
21. On this subject, see Paris 1973.
22. Courbet, letter to Bruyas, [Ornans, 3 May 1854], in Chu 1992, p. 122, no. 54-2.
23. Courbet effectively never repeated this exercise except for the last *Portrait of the Artist at Sainte Pélagie*, 1871–72 (Musée départemental Gustave Courbet, Ornans).

24. As Bernard Dorival noted: "While painting the portrait of his client and friend, it was actually his own that he depicted." Dorival 1946, p. 8. And André Joubin asked: "Isn't it rather his own portrait that Courbet has painted, which for form's sake, he gave a vague resemblance to Bruyas?" Joubin 1926b, pp. 554–55. Far from wanting to contradict these critics, on the contrary, we can consider this portrait as symptomatic of the fusional relationship between the painter and his model.
25. See J. H. Rubin's illuminating analysis of the similarity between the intellectual program of the catalogues drawn up by Bruyas and

Courbet's *The Painter's Studio*. Rubin 1980, p. 28.
26. Letter to Bruyas, Ornans, Nov.–Dec. 1854, in Chu 1992, p. 129, no. 54-7.
27. Critics have noted, among other things, the apparent contradiction between Courbet's desire for realism and the fact that he is painting a landscape inside his studio; the presence of the nude model who is unrelated to the subject he is working on; and the modest role allocated by the painter to landscape in these "seven years of artistic life," which this canvas is supposed to epitomize. On this subject, see Fried 1990, p. 161.

about the position of the collector in *The Painter's Studio*. The short sentence Courbet wrote to Bruyas, "You're triumphant and commanding,"[28] has always been perceived by the critics as an exaggeration intended to make the collector accept a relatively unobtrusive role in this vast composition. In the specific context of the two men's relationship, and taking into account their mutual knowledge of Glaize's painting, Bruyas, on the contrary, appears quite literally very much at home in *The Painter's Studio*. In this metaphorical equivalent, he is the master of both his own rooms and Courbet's studio and therefore occupies an eminent position—practically identical to the one in Tassaert's *The Painter's Studio* (cat. 94)—at the heart of the site of creativity, admittedly in the background, but nevertheless reminiscent of the position occupied by the Muses in classical art.

"The execution"

The splendid harmony between Bruyas and Courbet would be sorely tested by two events: the 1855 Exposition Universelle and the publication of a short story by Champfleury in 1857.

The impact of these events must be understood in the context of the high hopes Bruyas placed in the exhibition of *The Meeting* (cat. 30). As we have seen, the goal of Bruyas's Solution was immense: giving priority to realistic art was nothing less than tantamount to creating the right conditions for universal harmony. One painting alone epitomized the patron's project, and that was *The Meeting*. Its acceptance by the jury

meant that it had been admitted into the quintessence of international art and would show its glorious face to five million visitors. It was a veritable harmonic bomb that would irradiate the entire globe. The painting attracted a great deal of attention, as Courbet, for once without exaggerating, wrote: "*The Meeting* is an enormous success; everyone in Paris calls it 'Bonjour, Monsieur Courbet.'"[29] But since few people understood it, it was also a total failure. The painting was ridiculed, and the patron's reputation was torn to pieces. Courbet, always eager for publicity, was untroubled by the controversy; but Bruyas, whom many now regarded as a wealthy but naïve man, was profoundly disappointed. He held the painter responsible for the disaster and would think twice before exhibiting the painting again. Notably, it did not appear in the catalogue of a major exhibition held in Montpellier in 1860, a project sponsored primarily by Bruyas.[30]

Courbet's second visit to Montpellier in June 1857, which no preparatory letter announced, could hardly be compared to the eagerly awaited sojourn of 1854. Although the artist executed several seascapes there, no new painting was added to the Bruyas collection. In August, the critic Champfleury, who had stayed at Bruyas's house with Courbet, published "The Story of M. T. . . ." This thinly veiled satire of Bruyas, which appeared in *La Revue des Deux Mondes*, was a disaster for the collector, both locally and nationally.[31] Courbet clumsily expressed his disapproval, but to Bruyas's friend Pierre-Auguste Fajon rather than to the collector himself. Bruyas received some support from friends such as the artist Jules Laurens,[32] who reacted angrily

28. Letter to Bruyas, Ornans, 14 Mar. 1855, in Chu 1992, p.138, no. 55-3.
29. Letter to Bruyas, Paris, 4 June 1855, in Chu 1992, p. 144, no. 55-7.
30. On the other hand, Bruyas lent *Man with a Pipe* (no. 62), *The Bathers* (no. 63), *The Sleeping Spinner* (no. 64), *Self-Portrait with Striped Collar* (no. 65), *The Sea at Palavas* (no. 66), and *Study of a Woman (Portrait of Henriette Bonion)* (no. 67). See Montpellier 1860, p. 10.
31. Champfleury especially ridiculed the large number of portraits of himself "Monsieur T." had commissioned.
32. Born in Carpentras in 1825, Jules Laurens attended the Montpellier École des Beaux-Arts

from 1837 to 1842, where he met Bruyas and Cabanel. All three were together in Rome in 1846 and remained friends for life. For Bruyas, Laurens was a careful observer of the Parisian art market and helped build up the Bruyas collection with a certain eclecticism. He is notably responsible for the additions by Didier, Doré, Flandrin, Bonvin, Boulanger, and Devéria, as well as Delacroix's *Orpheus and Eurydice*. It was probably through him that Bruyas first made the acquaintance of Diaz, Millet, and Rousseau around 1850, and thus began to take an interest in more innovative art of the period. See Haedecke 1980, p. 94ff. and p. 179ff. I wish to thank Silke Schragner for the work carried out

on this subject during an internship at the Musée Fabre.
33. "Je cherche à faire paraître, avec quelques soins, un travail de réponse à un article de la *Revue des Deux Mondes* du 15 août, qui nous a tous bien douloureusement émus." Jules Laurens, letter to Bruyas of 17 Sept. 1857, Montpellier MS 405, no. 15. Laurens apparently did not manage to get this article published: "Will it be published? Many brave souls decline responsibility, make the sign of the cross to ward off the scandal of truth, beauty, and justice" (Laurens, letter to Bruyas of 27 Oct. 1857, Montpellier MS 405, no. 16); and "The few steps that I have taken, up to now, to ensure its

to the publication and planned a counterattack: "I'm going to some lengths to publish a reply to the article in *La Revue des Deux Mondes* of August 15 which so greatly upset us all."[33] Bruyas would never recover from this blow, as Laurens realized in 1860: "I'm very sad to see that the wound that you allowed certain people to make in your side is not healing, and will perhaps gnaw away at you forever."[34]

Letters from the critic Théophile Silvestre show that Bruyas never ceased to regard Courbet as the guilty party, and his fault could simply be added to the quirks and meanness of his visit in 1854. "You know what I think of that fellow's protestations," wrote Silvestre. "What you have told me, moreover, about his sojourns at your home with you, for four months, and about his nastiness which you were ready to forgive, I already knew about. . . . As for what you call, ironically, no doubt, 'the Champfleury execution,' I hadn't read it before... The only interesting thing about his article is the part in which he quotes you."[35] One would like to think that, along with Silvestre and Laurens, the artistic community turned its back on the tactless writer: "Monsieur Français . . . has given Courbet the cold shoulder (like everyone else, and mainly on your account), and has broken off relations with Champfleury, whom he called a scoundrel."[36] But the truth is probably more tragic, and Bruyas had to rebuild his reputation on his own and limit his actions to a local scale. The exhibition held in Montpellier in 1860 reveals how carefully he had pondered Champfleury's cruel lesson about his immoderate taste for portraits: no likeness of him was displayed, and only his closest friends could recognize him depicted as Christ by Verdier, or as a Christian in the catacombs by Tassaert. Furthermore, as Ting Chang has demonstrated, the plans for the Galerie Bruyas after the 1868 donation (see p. 29, fig. 5) show how the benefactor skillfully arranged the installation of his paintings so that no other figure rivaled the representation of his own personality, which the visitor would discover in the portraits distributed at regular intervals on each wall.[37]

"I arrived from Ornans the day before yesterday."[38]
Courbet to Bruyas, 1861

The sentence is short, but it is the entire contents of the only letter Courbet and Bruyas exchanged between 1857 and 1866. In the period that followed the Champfleury affair, communication between the two men seems to have been broken off completely. The Courbet machine rolled on at top speed during these years: traveling (he spent the whole year of 1858 in Brussels and Frankfurt), taking part in numerous exhibitions in France and abroad,[39] enjoying successes, failures, and scandals at the Salon.[40] Jules Castagnary succeeded Champfleury as his friend, although that was apparently unrelated to the publication of the article in the *Revue des Deux Mondes*. Through him, Courbet met Étienne Baudry, a wealthy young connoisseur who, like Bruyas in 1854, gave the artist hospitality at his home in the Château de Rochemont, near Saintes, from May to October 1862. Courbet was still a prolific writer of letters, but in them Bruyas's name almost ceased to appear.

publication have not been very successful" (Laurens, letter to Bruyas of 9 Nov. 1857, Montpellier MS 405, no. 17). The text was eventually published in his memoirs, Laurens 1901.
34. "Je vois avec bien de la peine que la plaie que vous vous êtes laissée faire en plein flanc par certaines gens ne cicatrise pas, et vous rongera peut-être toujours." Laurens, letter to Bruyas, of 23 Oct. 1860, Montpellier MS 405, no. 34.
35. "Vous savez ce que je fais des protestations de ce gaillard-là. Ce que vous me dites d'ailleurs, de ses séjours chez vous et avec vous, durant quatre mois, et des misères que vous avez bien voulu lui pardonner, je le savais, . . . Quant à ce que vous appelez, sans doute par ironie, 'l'execution de Champfleury,' je ne l'avais pas encore lue. . . . Son article n'a le moindre intérêt que dans la seule partie où il vous fait parler." Silvestre, letter to Bruyas, 14 Feb. 1874, Montpellier MS 365, no. 3.
36. "M. Français. . . bat très froid (ainsi que tout le monde, et grandement à votre sujet) à Courbet, et a brisé avec M. Champfleury qu'il qualifie de galfâtre." Laurens, letter to Bruyas, 23 Nov. 1860, Montpellier MS 405, no. 41.
37. Chang 1996b, pp. 586–91.
38. Courbet, letter to Bruyas, Paris, 16 May 1861, in Chu 1992, p. 196, no. 61-7.
39. His exhibitions in these years included those in Le Havre in 1859; Besançon in 1860; Antwerp in 1861; London in 1862; Paris in 1863; and Brussels in 1864.
40. *Stags Fighting* (Musée d'Orsay, Paris) was unanimously admired at the Salon of 1861, but the emperor refused to award Courbet a prize; *The Return from the Conference* (Paris, former Leroux Collection, destroyed), far too anticlerical, was rejected at the Salon of 1862, as was *Venus and Psyche* (Kunstmuseum, Bern), judged improper at the Salon of 1864.

Despite his precarious state of health, Bruyas led a relatively busy life: he received Cabanel in 1859, Tassaert in 1865, played an active role in mounting the Montpellier exhibition in 1860, and had a relationship with Berthe Anthon, by whom he had a child. From 1863 onward, he prepared the donation he intended to make to the City of Montpellier,[41] notably by purchasing other paintings. He was also an untiring correspondent, and in contrast, Courbet's name came up frequently in his letters, especially in those he wrote to Laurens. From 1859, the latter kept Bruyas discreetly informed of Courbet's movements: "At the moment, *he* is in the country, the father, too, hunting. I saw . . . an admirable study of a head . . . by him. Furthermore, everyone agrees on the *charm* of this very fluid and voluptuous painting. Believe me, on this moral and artistic subject, I shall never forget the particular interest that may make you eager for news."[42] With the assistance of Émile Vernier, who had made engravings of Courbet's *Stonebreakers*, Laurens even went so far as to secretly enter Courbet's Parisian studio while the artist was in Ornans: "M. Courbet is still not back yet, but recently, led by M. Vernier, candle in hand, I entered the cave of this Minotaur of Realism, on the rue Hautefeuille."[43] Laurens, whose benevolent neutrality evolved into unconcealed annoyance, thus reported several times a year on Courbet's actions until 1866, the year when the correspondence between the painter and his patron was resumed.

It was apparently Courbet who took the initiative to write to Bruyas, still walled in an obstinate silence: "My dear Alfred, I just saw M. Causse, who . . . gave me some news of you. I ask everyone . . . I wrote you once or twice. I sent you my poor friend P.-J. Proudhon's book, and the photograph of *The Priests* [*Return from the Conference;* destroyed], and still no answer. I would be justified in believing you dead."[44] The tone is friendly, but the short sentences denote a certain discomfort, and their friendship is evoked in the past tense: "There was a time when you took part, and quite effectively, in my political work in the world. I am still most grateful to you for that." Some have regarded this renewed correspondence as being motivated by self-interest on Courbet's part in an effort to sell a landscape, which he would effectively do a month later with *Solitude* (cat. 33). But this viewpoint should be qualified: since 1865,

Bruyas had wanted to acquire a landscape by Courbet, as is evidenced by several letters from Laurens, who was trying to negotiate the purchase of a work with a Parisian gallery on the collector's behalf.[45] Courbet probably heard about the deal and took the opportunity to make contact with Bruyas again without any intermediary. Bruyas reacted eagerly to the painter's proposition. Within a few weeks he had sent 2,000 francs for *Solitude* and the sum of 500 francs to help Proudhon's widow. After this business had been neatly concluded, silence once again descended over the two men until 1867, the year of the Exposition Universelle.

On this occasion, Courbet hoped to repeat the sensation he had caused in 1855 by setting up a sort of studio-museum that would definitively spare him the necessity of exhibiting at the Salon. Courbet, who attempted to persuade the collector to invest in his project, seemed to revive the passionate tones of yesteryear: "Bravo! My dear fellow, you have the courage of your convictions; we mustn't hide it from each other, our destinies are closely linked. . . . Think it over. Your existence is becoming very honorable and you deserve it. You will belie the slanderers."[46] Well aware of the collector's situation, Courbet evoked in three short sentences not only the unfavorable criticism received at the first Exposition Universelle, but also the slow winning back of his dignity and the freedom of action the patron recovered after the death of his father in 1863. However, as in 1855, Bruyas limited himself to lending works from his collection, *Man with a Pipe* (cat. 26), *The Bathers* (cat. 28), *The Sleeping Spinner* (cat. 27), *Painting Solution* (cat. 29), *The Meeting* (cat. 30) and *The Sea at Palavas* (cat. 31), while *Self-Portrait with a Striped Collar* (cat. 32)was exhibited at the Exposition Universelle. Though the press still caricatured the paintings on display ("Old acquaintances who we are always happy to see again," ran the caption under Randon's cartoon of *The Bathers* in *Le Journal amusant*),[47] it was nothing like the uproar of 1855. The letter Courbet sent to Bruyas when the exhibition closed took stock of their relationship: "We have been bound by our feeling for art. When such bonds happen to occur, they are unbreakable. . . . I cannot cease telling you . . . how important you were to me when you came to the rescue of the freedom that I was expressing. I shall never forget the lift that you gave me."[48]

"I still love Gustave like a brother."[49]

Alfred Bruyas, 1871

In the years that followed, Bruyas tried to acquire other canvases by Courbet but avoided all direct contact with the painter. At a public sale in 1869, for example, Jules Laurens tried to buy a work by Courbet on behalf of the collector,[50] and in 1874 Bruyas was able to purchase the *Portrait of Baudelaire* (cat. 25) through Théophile Silvestre.

Courbet's situation, however, changed completely after his involvement in the Commune, the lawsuit brought against him for having incited the "dismantling" of the Vendôme Column, his ensuing exile, and the exorbitant fine he was ordered to pay.[51] From then on, it was "patriotic" to heap reproaches on Courbet, who was evidently not to be associated with, and was summarily excluded from the 1872 Salon. The strategy used to redeem the painter in the eyes of the public at his two trials, in 1871 and 1874, has been examined in detail by historians.[52] His defense consisted of an effort to "depoliticize" Courbet and emphasize his genius as a painter rather than become involved in the controversy surrounding his role in the Parisian uprising. To this end, Bruyas sent a letter testifying to his support for the painter: "I am completely foreign to politics and had only an artistic relationship with the famous painter that enabled me to appreciate the nobility and honesty of his character. Consequently, I refuse to believe that he could have in any way participated in the horrors of Paris."[53]

It should nevertheless be noted that such a separation between art and political objectives signifies, as far as the relationship between the two men is concerned, nothing less than the end of the Solution, much of which was based on the utopian ideals for social reform that had inspired the Commune of Paris. Yet in 1873, a few months before he fled to Switzerland, Courbet still seemed to hope that Bruyas would save the Solution: "I regret nothing, and I fear only one thing, that is to end up like Don Quixote, for lies and egotism are invincible. . . . It is a pleasure to see that you are well, as is the Solution. I believe we have succeeded!"[54] It's hard to believe the optimism expressed by Courbet, who ended this terrible last letter with the words, "I'll come and see you one of these days." Just as the painter on the road to exile could never envisage returning to Montpellier, Bruyas, for his part, had no desire to see the Solution that they had constructed together come to fruition. On the contrary, he had been methodically deconstructing it for several years, removing, with Silvestre's help, any moral or philosophical connotation from his writings, so as to draw up a catalogue based solely on a critical and historical approach.

Recruited in February 1873 to write *La galerie Bruyas*, the catalogue that was published unfinished in 1876, Silvestre, who, for several years had already been acting

41. One of the earliest references to this donation appears in a letter from Laurens: "Nothing, you may believe me, could be more praiseworthy or better than your plans for the donation to the Montpellier Museum." Letter to Bruyas, 28 Nov. 1863, Montpellier MS 405, no. 59.
42. "Actuellement *on* est au pays, le père aussi, en chasse. J'ai vu de lui. . . une admirable tête d'étude. . . . Tout le monde d'ailleurs tombe d'accord sur la *charme* de cette peinture pleine, souple, et voluptueuse. Croyez qu'à ce sujet, morale et artistique, je ne perdrai jamais de vue l'intérêt particulier qui peut vous en faire désirer des nouvelles." Laurens, letter to Bruyas, 31 Dec. 1859, Montpellier MS 405, no. 27.
43. "M. Courbet n'est pas encore de retour mais dernièrement, conduit par M. Vernier, j'ai pénétré une chandelle en main, dans la caverne, rue Hautefeuille, de ce Minotaure de Réalisme." Laurens, letter to Bruyas, 10 Feb. 1861, Montpellier MS 405, no. 45.
44. Letter to Bruyas, Paris, Jan. 1866, in Chu 1992, p. 273, no. 66-3.

45. Thus on 10 Nov. 1865: "A very fine study of a landscape currently exhibited at Cadart's reminds us of Courbet." Montpellier MS 405, no. 76. And on 17 Mar. 1866, "At Cadart's, where I went to see if there were any means of sending you the Courbet in question, I could arrange nothing. This issue is thus unresolved and postponed." Montpellier MS 405, no. 79.
46. Letter to Bruyas, [Paris], Thursday, 28 [*sic* for 30] May [1867], in Chu 1992, pp. 314–15, no. 67-17.
47. *Le Journal amusant*, no. 598 (1867), p. V.
48. Letter to Bruyas, Paris, 7 Feb. 1868, in Chu 1992, pp. 326–27, no. 68-5.
49. Letter from Bruyas to Zoé Reverdy, sister of Gustave Courbet, published in Borel 1922, p. 120. Doucet MS 216, no. 128.
50. "The Courbet collection in question comes from a dealer whose business is ruined. . . . I thus went to look with great care at the 14 landscapes (2) and marines (12) by the Master of Ornans. There's nothing really noteworthy as far as size and perhaps subject are concerned. But very high-class painting, powerful, varied

and *poetic* (This will surprise the Idealists in contrast with the Realists!) . . . But this sale has been postponed." Jules Laurens, letter to Bruyas, 17 Dec. [1869], Montpellier MS 405, no. 99.
51. On this subject, see Walter 1973, pp. 173–84, which objectively exonerates the artist, and Desbuisson, "Citizen Courbet," in Paris 2000a, pp. 9–27.
52. Chang 1998, pp. 105–20, and Nochlin 1982, pp. 65–78.
53. Bruyas, letter to Ernest Lachaud, the artist's attorney, 8 Aug.1871, Doucet MS 216, no. 126. The fact that Bruyas did not attend the trial in person is not significant: he had been shaken by the death of his mother on 10 March, and he was prevented from traveling by his precarious state of health. On this subject, see the letters from Bruyas to Zoé Reverdy, published in Borel 1922, pp. 115–20.
54. Letter to Bruyas, Ornans, 1 Mar. 1873, in Chu 1992, pp. 491–92, no. 73-22.

as artistic director, guiding the collection in a new direction, now exerted even greater influence over the collector. An ardent supporter of the Second Empire and a friend of Delacroix, he constantly used his writing to tarnish Courbet's image in Bruyas's eyes by fueling his resentment, and denigrated the painter in order to confine acknowledgment of his talent to that of a brilliant craftsman. Under Silvestre's influence, the catalogue of the collection diminished Courbet's importance substantially (29 pages for twelve works) in favor of Delacroix (135 pages for eighteen works), to whom he accorded long passages, commenting upon the master's humblest objects, such as his palettes.[55] Even more remarkable was that, in this catalogue of over 600 pages, the word "Solution" was only used in the description of Courbet's *Portrait of Bruyas* (cat. 29), known as the *Painting Solution*. It would have been difficult to do anything less (since the word is written in full on the painting itself), but Silvestre's text is edifying: "Happy to have found such support when the struggle was at its most intense, Courbet involved him heart and hand in his Realist SOLUTION, while involving himself, through his paintings, in what he also called M. Bruyas's SOLUTION, that is, in the development of his gallery, founded on the principle of inclusiveness."[56] As has already been discussed, it was Bruyas who "invented" the word "Solution," and the term did not in any way encompass the definitions provided by Silvestre. The latter apparently undertook to rewrite history, deliberately ignoring the unique relationship that existed between the painter and his patron.

Géoghéghan versus Champfleury

The correspondence between Bruyas and Silvestre shows that the writer submitted everything he wrote to the collector and respected any corrections that he made. In one vindictive essay, Silvestre recalled Courbet's role in the Vendôme Column affair and tried to direct Bruyas in his editing of it, "You . . . can . . . mark on the pages what you want to change. From the bottom of my heart I nevertheless advise you to use all the necessary firmness if not strictness. . . . Think of the future, which will see only your actions and not take purely personal relationships into account. Be impassive in your truthfulness."[57] The essay was censored by Bruyas, and in its place, only a footnote mentioned that one abstained, out of Christian charity, from giving any biographical details on the artist.[58]

Not only was Bruyas accountable for the opinions he allowed to be published, since he edited the texts, but he was also responsible for two articles published under a pseudonym. Scholars have analyzed in various ways the writings of an enigmatic art critic, Edward Géoghéghan, who took an exclusive interest in the Bruyas collection, into whose mysteries he had surprisingly subtle insight.[59] A mention in one of Silvestre's letters explicitly identifies him: "Edward Goegheghan [*sic*] sounds too much like a pseudonym and is hard to read. Couldn't you sign it differently?"[60] It therefore seems that Bruyas, despairing of finding an author who believed in his cause, used this pseudonym in the utmost secrecy, as early as 1860.[61] Géoghéghan became

55. See Chang 1996a, pp. 318–19.
56. Bruyas 1876, p. 177.
57. "Vous. . . pourrez. . . marquer sur les épreuves ce que vous voulez changer. Du fond de l'âme je vous conseille pourtant toute la fermeté sinon toute la rigueur nécessaires. . . . Pensez à l'avenir, qui ne voit que les actes et ne compte pour rien les relations purement individuelles. Soyez impassible dans le vrai." Letter from Silvestre to Bruyas, Paris, 22 Feb. 1874, Montpellier MS 365, no. 5.

58. Bruyas 1876, p. 196.
59. Léotoing 1979, pp. 16 and 31, considers it to be Bruyas's pseudonym. Chang 1996a, pp. 310ff., considers him to be a local art critic.
60. "Edward Goegheghan [*sic*] sent trop le pseudonyme et est d'une lecture difficile. Ne pourriez-vous signer autrement?" Letter from Silvestre to Bruyas, Valmondois, 5 Jan. 1874, Doucet MS 215, no. 69. In their correspondence with Bruyas, Silvestre and Laurens on other occasions speak of Géoghéghan as a third

person. In my opinion, this should be put down to epistolary prudence, understood by those who shared the secret. My thanks to Sylvie Patry, who checked these passages in Silvestre's correspondence.
61. "I believe and hope that Mr. Géoghéghan will write something good and interesting about your gallery for the public, drawing inspiration above all from you to see from and be in tune with a normal viewpoint, far removed from his religious, artistic, and social dogmas: [which

in some sense the collector's authorized voice when he commented upon the 1860 exhibition in Montpellier or the 1868 donation.[62] In the catalogue of 1876, he severely criticized Courbet's *The Bathers* (cat. 28): "This protuberant creature would have certainly been a big hit in the New Zealand butchery trade. But what a charming landscape surrounds her with its opulent vegetation, and how much one regrets seeing it used just as a pretext for gigantic sirloin steaks!"[63] The rather coarse accusation aligned itself without originality with those made in the Salon reviews of 1853.

Even more astonishing was the attack on *The Sea at Palavas* (cat 31): "Master Courbet, the pupil of Nature, no doubt sees the Mediterranean only as a splendid blue tablecloth . . . and you can be sure that his salute to the sea came from a grateful stomach that appreciates the good fish caught by the fishermen of Palavas. M. Courbet has again proven here a remarkable material talent, but none of Charles Baudelaire's fine poetry: 'Free man, you will always cherish the sea!'"[64] His determination to reduce this masterpiece to a trivial evocation of Courbet's legendary appetite is astonishing, as is his attempt to strip it of any poetry to which it may legitimately lay claim. Each word of the text concealed a treacherous thrust, such as the term "Maître Courbet," which not only recalls La Fontaine's fable ("Maître Corbeau," or Master Crow, in *The Crow and the Fox*) but also pokes fun at the title bestowed upon the artist in the 1850s, "Courbet, maître-peintre" ("Courbet, Master Painter"). Nature was seen as nothing more than a provider of food, thus Realism the art

of consuming it. The comparison between Courbet and Baudelaire evoked the quarrel about the power of the imagination that put an end to the two men's friendship: Géoghéghan, like the poet, reduced Courbet to a "material talent." The final cruel stroke was to identify the artist with the figure waving at the sea and then deny him any kinship with Baudelaire's "free man"; that was an insult to Courbet's deep-seated, unchanging determination, since, all things considered, the painter's sense of freedom seems to have been his one implacable merit.

Through Silvestre's prejudices and Géoghéghan's attacks, Bruyas thus purged in 1876 the feelings of resentment that had lingered since the Champfleury affair. Certainly, the publication of the *Galerie Bruyas* catalogue testified to a new, well-balanced collection and to the respectability it had gained on entering the museum. But a year before the deaths of both the painter and his patron, it also seemed like an old man's final goodbye to his colorful past, like a weary disavowal of the utopian ideals that had inspired his youth. Included in this denial was also the end of a relationship between two exceptional people who had dared to defy the society of their age and had dearly paid the consequences. In his sublime obstinacy, the exiled Courbet resembled Don Quixote much less than Bruyas who, like the gentleman of La Mancha, awakened at the last moment and repented of his madness.

are] poles apart from truth and justice."
Jules Laurens, letter to Bruyas, 21 Aug. 1860, Montpellier MS 405, no. 33.
62. Two other texts were written by Géoghéghan about Delacroix's *Daniel in the Lions' Den* and the Courbet's *Portrait of Bruyas*, known as *Painting Solution*. First published in *Le messager du midi* in 1868.
63. Edward Géoghéghan in Bruyas 1876, p. 174.
64. Ibid., p. 186.

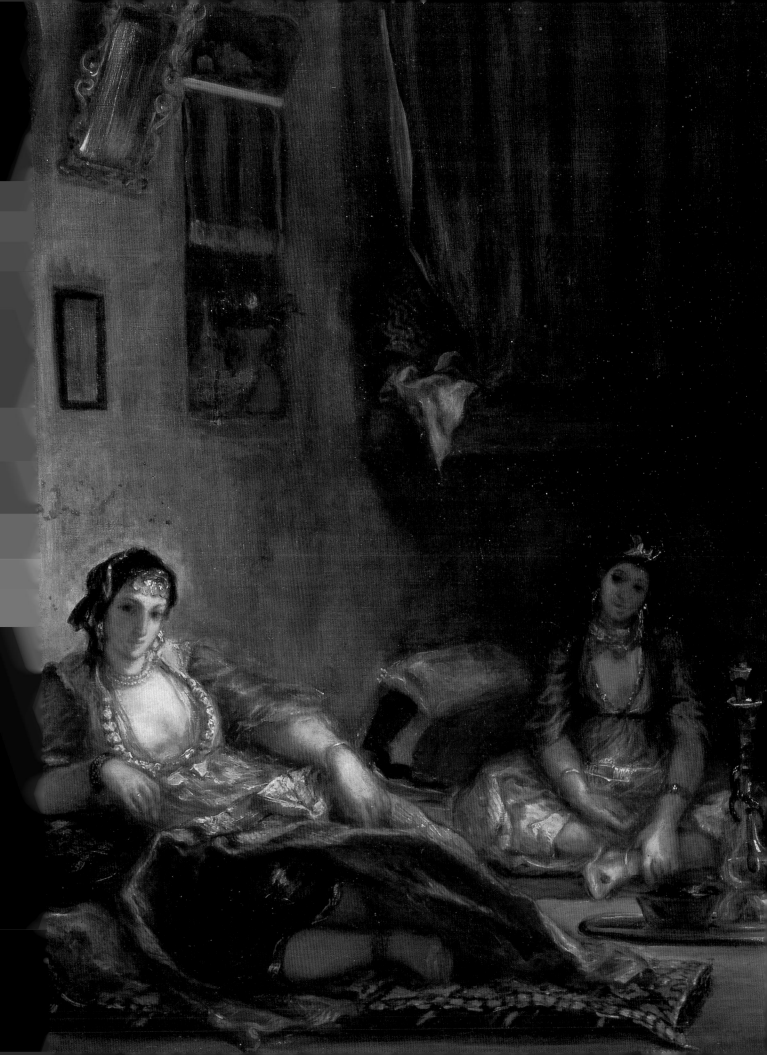

Bruyas, Paris, and Montpellier:
Artistic Center and Periphery

Ting Chang

The pursuit of success in Paris was a mandatory ritual for ambitious young provincials in nineteenth-century France. Nowhere was this preoccupation more evident than in the literature of the period. Balzac's Lucien de Rubempré, Flaubert's Frédéric Moreau, and Stendhal's Julien Sorel are among the best known characters to migrate to Paris in search of professional fulfillment. So recurrent is the theme of *la montée à Paris* in the nineteenth-century French novel that it amounts to a structural invariant. The accepted view of the itinerary is, of course, from the provinces to the capital, and any movement in the opposite direction could only be failure and renunciation.

Yet what if a return to the periphery were not defeat but rather a crucial maneuver in an alternative strategy? The history of French art in the later nineteenth century points to its compensations: Monet, Cézanne, Van Gogh, and Gauguin each made decisive moves in this counter-strategy through their displacement from the metropolis to the margins. But such shifts were never simple or unambiguous. Letters written by Monet and Gauguin to dealers and colleagues demonstrate that these artists were always attuned to Parisian reactions to their work.[1] The migration to the periphery involved an eye perpetually fixed on the shifting trends of the metropolitan marketplace. Provinciality became a commodity.

Gustave Courbet is a case in point.[2] Upon his first official success in Paris in 1849, when his *After Dinner at Ornans* (Musée de Beaux-Arts, Lille) was given a medal and purchased by the government, the artist deliberately withdrew to Ornans. In the following months, between late 1849 and mid-1850, Courbet had his most prolific season, in which he painted *The Stonebreakers* (destroyed), *The Burial at Ornans* (Musée d'Orsay, Paris), and *Peasants of Flagey* (Musée des Beaux-Arts et d'Archéologie, Besançon). When he introduced to the Salon ambitious paintings of his remote village, so unfamiliar was the terrain that one Parisian commentator referred to "The Burial of Peasants at Ornus."[3] Courbet went on to elaborate a physiognomy of his province in paintings that chal-

I wish to thank Thomas Crow, Brian Grosskurth, Richard Rand, and Sarah Lees for their roles in the publication of this essay.

1. From the 1870s onward, Monet moved his home further away from Paris to Argenteuil, Vétheuil, and finally Giverny. Paul Tucker argues that Monet's painting expeditions throughout France were intended to dissociate Impressionism with the capital in order to build a national network of buyers. Nonetheless, Monet was often anxious about Parisian reactions to his paintings of provincial locations such as Antibes, among others. See Boston 1989, p. 40. Not only was Monet attuned to the Paris market, he was deft in manipulating his dealers Durand-Ruel, Petit, and, later, Valadon and Boussod. See Boston 1989, pp. 97–99. Gauguin, whether in Denmark, Brittany, or Tahiti, was constantly worried about selling his work in Paris. From Pont-Aven in June 1888, he wrote to Emile Schuffenecker about the rise of Monet's prices and its positive impact on his own rates. See Merlhès 1984, p. 181. In Tahiti, Gauguin corresponded with Daniel de Monfried about all aspects of his production in the South Pacific and his sales in Paris. Gauguin wrote in April 1900, "if Vollard puts on an exhibition at the time of the Exposition Universelle, I would like it to be done with discernment, that is, along with the recent canvases some good older canvases should be shown." Gauguin 1950, p. 158 and *passim*.

2. See Clark 1973a, pp. 115–16.

3. Ibid., p. 140.

lenged the artistic and cultural hierarchies of the capi-
tal. Whatever ambivalence he felt about his regional
origins and his standing in Paris, frequent returns to
the Franche-Comté consolidated his artistic program.
Personal as well as collective tensions between the
metropolis and the periphery formed a critical element
of the painter's enterprise.

This essay argues that Alfred Bruyas pursued an
analogous strategy: his art-collecting practices also
challenged the institution of Paris. Like Courbet, the
collector was drawn to the many rewards of the capital
and took every advantage of his long periods of resi-
dence. In Paris Bruyas made important acquaintances
and key acquisitions for his collection of contemporary
art. But upon each return to Montpellier, the collector's
undertakings announced an original, vanguard project
that was situated in the provinces. By inviting to his
home the enfant terrible of the Paris art scene, Bruyas
momentarily diverted the focus from the capital. In
addition to Courbet, Bruyas also brought the Parisian
artist Octave Tassaert to paint in Montpellier. In this
manner the patron attempted to reverse the pilgrimage
to the capital. Bruyas was successful in his ambition
insofar as his hospitality of 1854 enabled Courbet to
expand his provincial cartography: to Ornans the artist
now added representations of Montpellier and its envi-
rons, most evident in *The Meeting* (cat. 30), also known
as "*Bonjour, Monsieur Courbet!*" In this way both
patron and artist enlarged their regional platform to
create a triangulated relationship between Paris,
Ornans, and Montpellier. Drawing upon his provin-
ciality in positive terms, Bruyas increasingly developed
a counter-Parisian space in Montpellier for the spon-
sorship of contemporary art. His commitment to liv-
ing French artists and his gift of his art collection to the
Musée Fabre in 1868 formed a parallel and local version
of Paris institutions. One can chart in this manner a
structural homology between Courbet's artistic project
and the collecting practice of Bruyas, his major patron
in the 1850s. Both men tested the monolith of the cen-
ter with counterweights on the periphery. For Bruyas
and Courbet the affirmation of provinciality formed
part of an intricate strategy of reversal and resistance.

In Montpellier others shared the same impulse.
Resentment of metropolitan domination is evident in
a series of articles written in 1852 by a local critic,

Georges Olivier, in the newspaper *Le Messager du Midi.*
The ephemeral work of Olivier has been absent in pre-
vious studies on Bruyas and his gallery, yet the critic's
opinions provide insight into the aspirations of this
affluent town in the mid-nineteenth century. In a
review of the annual Salon de Montpellier, Olivier
called for a rebellion against Paris. It was vital, he
argued, to resist the academic dogma and distant
Greco-Roman models imposed by the capital. The
writer pointed to the unhappy example of
Mademoiselle Malzac, a student of sculpture in
Montpellier, forced by her teachers to copy the bust of
Hippocrates in the mode of artistic training in Paris.
"What inspiration," Olivier demanded, "does one
expect a young girl to find in torturing a block of clay
in order to reproduce as closely as possible the head of
a Greek doctor whose name she barely knows?"[4] To
remedy the stifling of art by Parisian doctrine, he urged
a proliferation of local artistic societies. Only such
groups could nurture regional artists to produce new
work for provincial museums.[5]

It is a further measure of Olivier's aspirations for the
Salon de Montpellier as an alternative, if not serious
rival, to its Parisian counterpart that he decried the
absence of history painting among the two hundred
submissions.[6] The critic believed that, even in the
provinces, grand history painting should be attempted
with conviction. At the same time Olivier wanted an
art that drew exclusively upon the contemporary reali-
ties of southern France. To this end it was the duty of
municipal governments, he stated, to defy Parisian
trends in order to encourage the treatment of themes
specific to each province.

Interest in local art and culture was a matter of civic
responsibility and pride in Montpellier. In this climate
collecting and patronage were highly regarded. The
Société des Amis des Arts, founded under the auspices
of the municipal government in 1845, "aimed to put the
public in contact with the work of artists, and to offer
the latter a new opportunity to produce."[7] In 1850 the
Société published its goal to encourage the support of
art through an annual exhibition.[8]

Both the stated objectives and actual practices of the
Société in Montpellier were similar to its many coun-
terparts in provincial centers in nineteenth-century
France.[9] The group organized exhibitions that showed

the work of regional artists as well as older paintings lent by private collectors. Like the Paris Salon, this local version took place in May of each year. At the Salon de Montpellier the sponsors bought contemporary works that were distributed by lottery. The exhibition-goers also had the opportunity to purchase directly from the artists.

Bruyas was a member of the Société that encouraged the local production, display, and purchase of art through the institution of the Salon. But whereas most Montpellier collectors preferred consecrated artists, Bruyas was willing to risk the uncertainties of contemporary art. As we shall see, he both conformed to and departed from collecting practices in Montpellier. While supporting Alexandre Cabanel, Auguste Glaize, Jules Laurens, and other, lesser-known artists of local origin, Bruyas did not reject Paris altogether, as Olivier had urged. Despite Olivier's antimetropolitan discourse in the Montpellier press, Bruyas repeatedly looked to the capital for the enrichment of his gallery. It was in Paris in the 1850s that he made his most spectacular acquisitions. Indeed, the very tensions between the self-conscious provinces and the domineering capital motivated his decisions. Rather than denying the power of Paris, Bruyas went to claim some of its most controversial and avant-garde paintings as his own. The long journeys to the capital between 1849 and 1853, to collect and commission the advanced art of his generation, made Bruyas unique among his peers in Montpellier.

Before Paris, Bruyas first went to Italy in 1846 at the age of twenty-four. In Rome he frequented Léon Benouville, Eugène Guillaume (1822–1905), and Cabanel, at the Villa Medici.[10] Known as "pensionnaires," these young artists had won the coveted Prix de Rome scholarship which entitled them to four years of training in Rome. Bruyas at this time had no more than

a vague notion of sponsoring what he termed "serious painting," but in the company of these artists he expanded his ambition. His first commission to Cabanel, a portrait of the collector, (cat. 15) foreshadowed the privileged role that his own image was to occupy in his future conception of advanced art.[11] Bruyas would soon form the plan to collaborate with artists and to participate fully as a collector and patron in the making of contemporary art. In 1846 he commissioned three more paintings from the same artist in Rome.[12] The four canvases by Cabanel and Guillaume's portrait medallion of Bruyas represented the beginning of the collection.

In December 1849 Bruyas went to Paris. One of the most fruitful contacts during this first visit was Auguste Cornu, a picture dealer located at 13, rue Laffitte, who sold paintings by Philippe Tanneur (1795/96–1873) and Narcisse Diaz to the young collector. He also acquired a small early work by Jean-François Millet (cat. 77) and Théodore Rousseau's landscape *The Pond* (cat. 85). Over the next six months in the capital Bruyas met artists, bought pictures, and commissioned Thomas Couture and Tassaert to paint his portrait (see cats. 35 and 94).

Sheer luck allowed Bruyas to acquire his first Delacroix canvas, *Moroccan Military Exercises* of 1832 (cat. 41). The work belonged to the Count Charles de Mornay, with whom the artist had earlier traveled to North Africa. In 1850 Mornay put up for sale a part of his art collection, including seven paintings by Delacroix. Despite the artist's formal objection to the disposal of his work at unfavorable prices, the auction took place in January 1850, and *Moroccan Military Exercises* was sold at a quarter of the reserve price demanded by Delacroix.[13] The painting changed hands two more times before Bruyas was able to acquire it from the dealer Cornu in June of 1850.[14]

4. Georges Olivier, "Le Salon de Montpellier II," *Le Messager du Midi*, 10 May 1852. Olivier wrote four articles on 'Le Salon de Montpellier II,' published in *Le Messager du Midi* on 26 and 29 Apr., 2 and 10 May 1852.
5. Ibid., 26 Apr. 1852.
6. Ibid., 2 May 1852: "That is an important lacuna and one that we strongly wish to see overcome in the future."
7. Thomas 1845, p. 242.
8. Société 1850.
9. See Sherman 1989, pp. 132–34 and *passim*.

10. Léotoing 1979, p. 4.
11. Letter from Cabanel to Bruyas, 10 Oct. 1846, Doucet MS 216, no. 49.
12. In 1848 during a second visit to Rome by Bruyas, Cabanel delivered the three paintings entitled *A Thinker—Young Roman Monk* (cat. 19), *La Chiaruccia* (cat. 18), and *Albaydé* (cat. 17).
13. For Delacroix's efforts to stop the auction, see Joubin 1936–38, vol. 3, p. 4, and Delacroix 1960, vol. 1, p. 331. Johnson 1981–89, vol. 3, p. 162, suggests that it may have been recovered by Delacroix himself or someone acting on his

behalf at the auction to prevent its sale at an even lower price.
14. Auguste Cornu's letter to Bruyas, 6 June 1850, Doucet MS 214, no. 2: "I have the painting by Eug. Delacroix with me, which I cleaned because it was very dirty. I told Monsieur Collot that he let you have it for 400 francs although he paid more for it." (J'ai le tableau de Eug. Delacroix chez moi, que j'ai netoyé [*sic*] car il était très sale. J'ai dit à Monsieur Collot qu'il vous l'avait laissé à 400 francs, quoiqu'il l'a payé plus cher.)

Fig. 1. Title page from *Catalogue des tableaux, portraits, dessins, esquisses, études peints d'après nature par les principaux artistes modernes, composant le salon de peinture de M. Alfred Bruyas de Montpellier* (Montpellier, 1851)

The following year Bruyas proceeded quickly to buy another canvas by Delacroix, a half-size variant of the great *Women of Algiers in Their Apartment* (cat. 44). The magnificent first version, now in the Louvre, was acquired by Louis Philippe and displayed in the Musée du Luxembourg.[15] In bidding for the smaller version at a charity auction in Paris, Bruyas must have wanted both the canvas itself and the prestige associated with a work in the national collection. Enriched by his acquisitions of work by well-known artists, Bruyas left the capital in June 1851.

In Montpellier he embarked on a striking project of publishing a catalogue of his collection. He gave it the title *Catalogue des tableaux, portraits, dessins, esquisses, études peints d'après nature par les principaux artistes modernes, composant le salon de peinture de M. Alfred Bruyas de Montpellier* (fig. 1). In this publication Bruyas listed all his holdings: eighty-six works by forty-two artists. The collection comprised almost entirely nineteenth-century French art, except for four canvases by Tiepolo, Velázquez, and Andrea del Sarto. As the title of the catalogue indicated, the emphasis was on modern painting. Bruyas underscored his focus by listing on the last page leading contemporary practitioners of history, landscape, and genre paintings. The familiar names of Ingres, Delacroix, Corot, Rousseau, Isabey, and Meissonier, among others, were duly included.

The publication was exceptional insofar as no individual collector to date had issued such a catalogue at his own expense. Bruyas went even further: he also adopted the format of catalogues of the Musée du Luxembourg. The Paris institution, created in 1818 as a national museum of contemporary French art, had major canvases by Jacques-Louis David, Anne-Louis Girodet, Antoine-Jean Gros, and other modern artists. A catalogue had been regularly issued under the invariable title *Explication des ouvrages de peinture et de sculpture de l'école moderne de France, exposés dans le Musée national du Luxembourg, destinés aux artistes vivants* (fig. 2). Bruyas used the official publication as a model for his catalogue of 1851. Three years later he produced another publication, this time entitled *Explication des ouvrages de peinture du cabinet de M. Alfred Bruyas* (fig. 3). The intended parallel and rivalry to the state institution was unmistakable. Bruyas meticulously followed every aspect of the official pro-

totype in the 1851 catalogue. The content, layout of materials, and even the changes in typeface of the Montpellier edition were faithful to the Luxembourg catalogues of the 1840s. Rather than being subordinate to an official model, however, the Bruyas catalogue can be seen as an act of defiance. The project was a bold announcement of his aim to sponsor modern French painting in the manner of a public institution and to participate in the making of a history of art. His private collection, he declared through the publications, would become an independent version of the Musée du Luxembourg. Montpellier would rival Paris.

These high ambitions were manifest in the unusual production of an accompanying volume of photographs (now lost) that reproduced each item in the 1851 catalogue. A Montpellier photographer named Huguet-Molines was commissioned for the task. Although similar efforts were being made by photographers in Paris, Bruyas's initiative was unique among art collectors, as he well knew. "This work," he wrote, "the result of several months of study, will be unique in history as the first attempt in this direction."[16] As a rule, catalogues of private collections were made only to advertise a forthcoming sale; limited illustrations typically took the form of engravings and lithographs.[17] Until the end of the nineteenth century photographs were rarely published in catalogues. Bruyas, however, repeatedly made an exceptional commitment to publicize his collection. His choice of a costly reproduction technique was yet another measure of his high aims. His desire to shape the production of contemporary art in France was only beginning.

By December 1851 Bruyas had almost a hundred works in his collection and a striking publication. He returned to Paris for long sojourns in the early 1850s that produced more acquisitions, including Delacroix's *Daniel in the Lions' Den* (Musée Fabre, Montpellier), bought from the Parisian picture dealer J. Thomas. Bruyas also had his portrait painted by Delacroix in 1853 (cat. 46), a considerable prize in light of the artist's venerable standing.

The most important event was his encounter with Courbet in Paris. Bruyas purchased *The Bathers* (cat. 28) and *The Sleeping Spinner* (cat. 27), two paintings shown by the artist at the Salon of 1853.[18] In the same period Bruyas commissioned Courbet to paint his por-

Fig. 2. Title page from *Explication des ouvrages de peinture et de sculpture de l'école moderne de France, exposés dans le Musée national du Luxembourg, destinés aux artistes vivants* (Paris, 1848)

15. Johnson 1981–89, vol. 3, 1989, pp. 192–93.
16. Bruyas 1851, p. 19.
17. For a sumptuously illustrated example in large-folio format, see Reiset and Villot 1859. This volume reproduced a number of works belonging to the two authors, both well-known collectors. Another prominent and extremely wealthy collector, the comte de Pourtalès-Gorgier, paid for the publication of a scholarly text and catalogue of his collection of antiques, also richly illustrated with engravings (Panofka 1834). Neither collection was for sale.

trait, entitled *Painting Solution* (cat. 29). A brief but intense period of association began, culminating in the painter's visit to Montpellier in 1854 and the completion of several important canvases, most notably *The Meeting* (cat. 30), during his four-month residence in the collector's home.

The exhilaration of meeting such leading artists as Delacroix and Courbet, among others in Paris, led Bruyas to consider removing his collection from Montpellier. He, too, wanted a permanent *montée à Paris*.[19] Not only did his father veto the project, but Courbet's actions also made the move impracticable. The artist's challenge to the authority of Paris was intensely driven on multiple fronts, and regular controversy was a part of the strategy. The interests of Bruyas, on the other hand, were poorly served by such public antagonism. At the 1855 Exposition Universelle, Courbet's self-promotional tactics so eclipsed the collector that Bruyas chose not to attend the event in Paris. Instead, the collector remained in Montpellier to reinvest his energy in the local Salon.

At home Bruyas worked to revive the lapsed exhibition of the Société des Amis des Arts in 1860. He volunteered on three juries to examine submissions and lent more than sixty canvases to the Salon de Montpellier. On display were almost all his paintings by Courbet and Cabanel, and other works of contemporary art from his private collection.[20] Bruyas was by far the most important lender and art collector in town. His effectiveness in creating a provincial counterpart to metropolitan institutions can be gauged by a rare account in the *Gazette des beaux-arts*. The preeminence of Paris was such that little notice was normally paid to artistic and cultural endeavors elsewhere. An exception was made when Xavier Nogaret reported on the Salon de Montpellier in June 1860. The writer singled out Bruyas for elevating its quality above the daubs and bibelots typical of provincial exhibitions: "The collection, formed with a lively passion for the most innovative painting, with a taste as original as it is commendable, in contrast to the bourgeois habits of his milieu, deserves a separate examination which the *Gazette des beaux-arts* could provide one day in its series of articles on private galleries."[21] Nogaret's highest praise for Bruyas was that his collection was the equal of the best Parisian galleries.

Bruyas made another trip to the capital later that year, renewing his friendship with Cabanel and acquiring the work of Dutch painter Ary Scheffer (1795–1858) as well as that of Benouville. Upon the death of Bruyas's father, the paternal interdiction against the *montée à Paris* finally disappeared, at least at first glance. Yet his father's prohibition had a lasting effect. Rather than leaving for the capital, Bruyas had a house built for himself in Montpellier. He settled into his own home and continued to enlarge and to lend his holdings to regional exhibitions.

In 1868 Bruyas donated his collection of eighty-eight paintings and eight drawings to his community. In doing so, he participated in a local tradition of private endowment. As early as the seventeenth century, the town had an academy of drawing directed by Jean de Troy (1638–1691) and possibly the Montpellier artist Jean Ranc (1674–1735).[22] By 1780 the Société des Beaux-Arts had public displays of art, which were soon suspended by lack of funds. After the Revolution there was an attempt to revive the defunct gallery. The opening of the Musée du Louvre in 1793 led to the desire for smaller museums all over France, and municipal officials turned to the central government.[23] In 1798 an administrator named Marc Antoine Bazille requested the largesse of Paris: "[Montpellier] has no claims to the masterpieces of Raphael and Rubens," he stated, "but it does want some paintings by our local masters, such as Coypel, Mignard, Vouet, Lemoine, Restout, Carle Vanloo, Natoire, Vien, Doyen, some academies copied by the *pensionnaires* in Rome, and a few good, original drawings."[24] Bazille's first petition was unheeded, but his second attempt was rewarded by thirty paintings from Paris in 1802. Within a few years, however, this local museum was dismantled.[25]

It was only in 1828 that a permanent art museum was established. François-Xavier Fabre (1766–1837), an artist and native of Montpellier, donated his collection and library to the town.[26] Appointed lifelong curator of the Musée Fabre, the eponymous donor made a triumphant return after forty years in Italy. Inspired by Fabre's gift, a year later Jean-Pierre Collot, the Montpellier-born director of the Royal Mint in Paris, bestowed to the museum a generous annuity, which he further augmented in 1852.[27] Antoine Valedau, another son of Montpellier residing in Paris, gave his entire col-

lection in 1836.[28] Much of the collection comprised Dutch and Flemish paintings by Adriaen van Ostade, Jan Steen, Gerrit Dou, Peter Paul Rubens and Philips Wouwerman, among others, as well as drawings, watercolors, engravings, sculptures, and *objets d'art*.[29]

It is noteworthy that the founder and benefactors of the Musée Fabre were all sons of Montpellier who achieved success elsewhere. The role of Paris was vital: the Musée Fabre was sustained and enriched in the nineteenth century by private donations—the most valuable of which were acquired in the capital. Not only did the Musée Fabre benefit from Parisian dispatches, the museum was also susceptible to the values of the metropolis, as the critic Olivier lamented. The Musée Fabre, like the public collections of Paris at the time, had rich galleries of consecrated art, but almost nothing by living artists.

The donation by Bruyas introduced contemporary art to the museum at last. In Paris the news was reported in a specialist art journal: "M. Bruyas has just given his collection of paintings to the town of Montpellier. This collection, very rich in modern paintings by Delacroix, Courbet, Corot, Rousseau, Couture, Troyon, Decamps, Cabanel, and Scheffer, will be known as the Galerie Bruyas, and the donor will become its curator for life."[30]

Among the many artists in the gallery Courbet was certainly the star. In addition to *The Meeting* (cat. 30), the painter was represented by *The Bathers* (cat. 28), *The Sleeping Spinner* (cat. 27), *Self-Portrait (Man with a Pipe)* (cat. 26), a large landscape entitled *Solitude* (cat. 33), *The Sea at Palavas* (cat. 31), and several portraits of Bruyas (including cat. 29). No other collection could equal the abundance or the caliber of paintings by Courbet. Although fewer in number, canvases by Delacroix in the gallery were no less impressive.

Fig. 3. Title page, Alfred Bruyas, *Explication des ouvrages de peinture du cabinet de M. Alfred Bruyas* (Paris, 1854)

18. Courbet showed a third work, *The Wrestlers*, at the Salon of 1853.

19. During his extended visits in Paris in the 1850s, Bruyas arranged for parts of his collection to be sent to him from Montpellier. See Montpellier 1985, p. 26. See also Chang 1996a, p. 220.

20. See Montpellier 1860.

21. Nogaret 1860, p. 303.

22. Kühnholtz 1830, p. 18.

23. The entire procedure of forming a national museum in Paris with many satellites across the country produced frictions between the central government and the provinces. See Pommier 1986, pp. 451–95, and also Sherman 1989, pp. 97–120 and *passim*.

24. Marc Antoine Bazille's letter to the Minister of Interior, 1798, reprinted in Michel 1879, p. II.

25. Michel 1879, p. IV.

26. Thomas 1857, p. 209.

27. Archives municipales de Montpellier, dossier 2R/3, no. 4, letter written by Collot's representative and brother-in-law, Fajard, to the mayor of Montpellier, 16 Mar. 1829.

28. Michel 1879, p. XXII, reprints Valedau's will.

29. As a gesture of appreciation, the mayor of Montpellier proposed to the Valedau family the establishment of a gallery named after the donor. See Archives municipales de Montpellier, dossier 2R/3, no. 4, letter from mayor to the Valedau family, written shortly after 16 Mar. 1829.

30. *La Chronique des arts et de la curiosité* 45 (8 Nov. 1868), p. 2.

After its transfer to the Musée Fabre, the Galerie Bruyas remained the donor's daily preoccupation.[31] In the early 1870s Bruyas commissioned the Paris art critic Théophile Silvestre to write a catalogue of the gallery. Not content with this limited assignment, however, Silvestre decided to reformulate the collection. He wished to expand the Galerie Bruyas in such a way as to create a less personal and a more representative selection of modern art, one that would befit its status as a public collection in the museum. For a number of reasons, Bruyas agreed to an aggressive campaign of new acquisitions in the 1870s.[32]

The critic was given remarkable license to buy works in Paris, which he would then dispatch to Montpellier for Bruyas's approval. Among them were canvases by Ingres, Delacroix, Géricault, Delaroche, and Gérôme. Silvestre's selections resulted in a more encyclopedic assembly of paintings, a didactic array of French art extending over half a century. His intervention departed from the donor's initial goal of sponsoring only contemporary art and living artists. Now David and Gros were included, and more conservative artists such as Chenavard and Gérôme were put alongside the avant-garde works of Courbet and Delacroix. In Silvestre's vision, the Galerie Bruyas illustrated the history of nineteenth-century French art.

The critic's principal assignment was to write a new catalogue of the collection. To emphasize the objective and comprehensive nature of the collection, the critic used a standard format to present every artist through biographical information, entries on each work in the Galerie Bruyas, a compilation of contemporary observations, and a final notice.[33] In citing commentaries by others, Silvestre wanted to create the effect of an impartial, collective text whose authority was derived from the multitude of voices, sometimes in discord and disagreement. As writer and editor, Silvestre ensured the coherence of both the new acquisitions and the tapestry of quotations included in the text. He assigned each artist in the Galerie Bruyas a place within the history of nineteenth-century French art and valorized every work in the collection as a specimen unsurpassed in its category. In this way the catalogue, resembling an unbiased dictionary of modern French painting, suggested that the Galerie Bruyas encompassed all major movements.

Silvestre was the author, but he was attentive to the collector's priority. The writer repeatedly inserted the full name or initials of Bruyas to suggest his authorship. Much discussion between the collector and his advisor was devoted to the matter, and it is certain that Bruyas did not write all the words attributed to him in the catalogue. On one occasion Silvestre explicitly assured Bruyas that "the [initials] A.B. will be put in the right places, with authority."[34] And Bruyas indeed had final control. Only when he was satisfied with every sentence and paragraph did he give written permission to set the typescript in Paris. Crossing the country back and forth between Silvestre's home near the capital, Bruyas in Montpellier, and the publisher in Paris, every page of the catalogue had the approval of the collector. The result was a history of nineteenth-century French art that appeared to have been sponsored by a single, enlightened patron and realized by a team of partners.

While Silvestre's interventions in the 1870s might appear to be a deviation, they ultimately aided the collector in his original ambition. The program of expansion brought the Galerie Bruyas closer to the Musée du Luxembourg, the starting point of reference. The reformulated collection of the 1870s was indeed more comprehensive and less idiosyncratic. By creating a regional alternative to the metropolitan institution, Bruyas inscribed the Musée Fabre on the itinerary of major museums in France. Against the magnetic pull of Paris as the art capital, Bruyas created a rival space in Montpellier, unique in its emphasis on contemporary French art. Through a complex logic of mimesis and reversal the collector assured for the Galerie Bruyas a domain of its own.

31. Michel 1879, p. xxx: "Indifferent to everything that was happening in the other exhibition rooms, he stopped only in front of his paintings and was happy to explain to art lovers and foreigners the lofty goal he sought to attain in assembling these works, that is, the history of nineteenth-century art."
32. For more on the acquisitions of the 1870s see Chang 1998, pp. 105–20.
33. Bruyas 1876.
34. Letter from Silvestre to Bruyas, 7 Mar. 1874, Doucet MS 215, no. 86.

Signac's Visit to the Bruyas Collection

FRANÇOISE CACHIN

After Alfred Bruyas's association with Courbet in the 1850s and the inauguration in 1868 of a series of galleries within the Musée Fabre to display his collection, the collector's fame began to spread beyond his native town. Many artists made a point of visiting the Galerie Bruyas, often recording their thoughts about both individual works and the collector himself. Vincent van Gogh, Paul Gauguin, and Paul Signac each stopped in Montpellier to see the Bruyas collection, and their observations and preferences provide revealing insights into the reputation of the man and the works he brought together.

When the twenty-five-year-old Paul Signac visited Van Gogh on 23 and 24 March 1889 at the hospital in Arles, they had long conversations about painting. It is more than likely that Van Gogh brought up the recent trip he had made with Gauguin, three months before, to the Musée Fabre, a trip he mentioned several times in his letters to his brother Theo. After this visit, Signac went down to Cassis on the Mediterranean coast to paint, and although he did not stop in Montpellier, he must have been quite interested by his friend's remarks.

The episode of the memorable visit by Van Gogh and Gauguin, on 16 or 17 December 1888, to see the museum in Montpellier and in particular the "Brias" collection, as they both called it in their letters,[1] has been thoroughly studied, notably in the recent catalogue *Van Gogh and Gauguin: The Studio of the South.*[2] Gauguin, who had visited the museum when he was younger proposed the expedition to Van Gogh. And while both men responded favorably to Delacroix, their opinions sometimes differed with respect to other artists. While Gauguin especially admired Courbet, Van Gogh never mentioned *The Meeting* (cat. 30), but instead praised Cabanel, whom Gauguin "hated." One senses that Gauguin was judging the works as paintings and that

Van Gogh's reactions were, above all, emotional. He was particularly fascinated with the personality of Bruyas, expressed through the innumerable portraits of the collector. "He is a gentleman with a red beard and hair, who bears an amazing resemblance to you or to me," he wrote to his brother Theo, "and he made me think of that poem by [Alfred de] Musset: 'Wherever I touched the earth / a miserable fellow in black / sat down next to us / and looked at us like a brother.'"[3] He associated Bruyas, in his "mission" as a collector defending the art of his time, with his brother, who, as a dealer, supported unrecognized artists (including Gauguin and Van Gogh himself) and with himself, a "missionary" of modern art. This identification is one of the strangest features of Van Gogh's visit, and must have exasperated Gauguin, whose view of the collector and his paintings was more objective. The trip to Montpellier, planned by Gauguin to soothe the growing conflicts between the two men, as well as to calm Van Gogh's agitation, clearly did not have the intended effect. Less than a week later, Van Gogh was hospitalized with an attack of dementia—marked by the famous cutting of his ear—and Gauguin was back in Paris.

It was in a very different state of mind that, seven years after Van Gogh's death, Paul Signac left, from Saint Tropez on 1 November 1897, "to go visit the Musée Bruyas in Montpellier." He was in the middle of writing his theoretical book, the definitive title of which would be *D'Eugène Delacroix au néo-impressionisme (From Eugène Delacroix to Neo-Impressionism)*,

1. See Van Gogh's letters to his brother, including those of 22 Dec. 1888, 7 Jan. 1889, and 30 Apr. 1889: (Van Gogh 1958, vol. 3, nos. 564, 568, and 588); and Gauguin 1923, pp. 220–23.
2. Chicago 2001, pp. 253–55.
3. Letter of 22 Dec. 1888, cited in note 1.

and he undoubtedly felt compelled to see the only nearby examples of the Romantic master's painting. Signac's book in progress depicted Delacroix as a pioneer of pure color, and in this regard he was at first "a bit disappointed" on seeing the collection, that "these are not the master's colorful works." But he was quickly overcome by enthusiasm, finding that Delacroix's portrait of Bruyas was the most beautiful of the seventeen there. Of course, he admired numerous other works in the collection, particularly those by Courbet, which he considered to be among "the painter's finest," as well as works by Bonvin, Diaz, and the lesser known Marcel Verdier, whose portrait of a woman "has the grace of a Renoir." His visit ended in anger directed at Cabanel, whose somber palette and academic drawing made him, in Signac's eyes, the prototype of the artist from the École des Beaux-Arts.

This previously unpublished extract from Paul Signac's diary comes from the notebook dated November and December 1897 (IV B). Here, only the sections concerning the Bruyas collection have been excerpted. Signac was less loquacious about the rest of the works in the museum, with the exception of those by Poussin, Zurbarán and David; but the Bruyas collection evoked for him a "little shiver caused by beautiful things." And in a letter written from Venice in May 1904 to his friend Charles Angrand,[4] he recalled the five greatest "art induced emotions" of his entire lifetime: the Tintorettos in San Rocco, which he had just discovered, the Delacroix in Saint Sulpice, the Puvis de Chavannes in the Pantheon, Rembrandt's *Night Watch*, and "the Museum in Montpellier."

1 November (18)97
Left from Saint Tropez to go visit the Musée Bruyas in Montpellier[5]
Going to sleep in Nîmes

Leave in the morning for Montpellier; a gray city in this gray weather
The museum doesn't open until 11. I am going to walk around the courtyard where the fair is taking place. It isn't the Parisian [Foire du] Trône or Neuilly Fair, but a good old fair put on by the sub-prefecture.

Tableaux Vivants: the protagonists that figure in the sideshow are done well enough to attract visitors: a nun, a French colonel, an Alsatian woman. One can anticipate the jingoistic scenes that must take place on the inside. . . .

11 O'clock! To the Museé Fabre. As soon as one enters the room in the back that holds the Bruyas collection, one feels that little shiver caused by beautiful things.

To the Delacroix. I am a bit disappointed; these are not the master's colorful works, and there is not much to get out of them except the lesson that one must dare, dare!

One always knows enough in order to execute; what's lacking is the audacity to create, to organize. Staying until 12:30 to enjoy this collection as a whole. I will go eat quickly and come back right away to study it in more detail.

Delacroix. Among the numerous portraits that Bruyas had done by so many painters—-he is represented at least seventeen times—-the most beautiful is certainly the one painted by Delacroix (1853) [cat. 46].[6] He has rendered best the character of this "gentleman"; this elegant red-haired romantic

has an English air about him. The very divided and very worked painting is hardly colorful.[7] It is hot and blond, like Titians are.

The extraordinary expression of melancholic and unhealthy finesse is admirably rendered and recalls Manet's portrait of Moore.[8] One senses that Delacroix was more concerned with the character of his model than with color!

The hatched facture in small strokes adds even more to the expression.

This portrait is life; next to it, the flat and dull one painted by Cabanel [cat. 15] is death.

One sees that Delacroix took pleasure in his model's hair and red beard; Couture made a dark brunette out of this handsome redhead [cat. 35].

Arab horsemen charging [cat. 41]. Great movement in a simple Rubens-style arabesque. Dark.

Michelangelo in his studio [cat. 45]. Michelangelo as an athlete!

The death of Cato: a nude that one would think was by Géricault.[9]

A mulatto woman [cat. 38]: black, gray, marked. Point of departure for Manet.

A reduction of the women of Algiers in their interior [cat. 44]. Much darker and flatter than the painting in the Louvre. Here, he has eliminated all of the details of ornament and color that make the Louvre painting vibrate. The accessories are much less bright; almost more of the sought after optical mixture;[10] the green trousers, the white shirt, the cushion are unified and flat. No mosaics in the background or on the floorboards, they are gray, dirty, and flat. One sees that Delacroix was bored with this repetition, which is not, however, identical to the painting. There are two points of light here: one on the head of the woman in green pants and the other on the chest of the one reclining on the left. The lighting is different; the black woman is backlit.

Daniel in the lion's den—-dark and dull.

A sketch of Orpheus and Eurydice—-fresh, pink, and blue, the most exquisite note of color in the collection.

A sketch of the education of Achilles, very divided, in small hatched strokes, even the shadows, which are rather bituminous.

And a frame containing his commander's cross [of the Legion of Honor], his palette, and his paintbrushes!

The hatred and incomprehension of Delacroix's genius persists. Even today I hear laughter in front of his paintings, however tame, on view here:

"Just look at these feet!" "Ah, ah what heads!" "The horses look like they are made out of wood!" cried a young girl in front of the admirable small Arabian horses of the *Charge des cavaliers*!

Even in the catalogue preface one senses that Bruyas was not completely approved of for having loved such painters! [11]

4. Cited in Cachin 2000, p. 374.

5. The official name was already the Musée Fabre, but Signac's slip of the tongue demonstrates the aim of his visit.

6. All of the works Signac mentions are in the Musée Fabre, Montpellier. Reference will be given only to those in the present catalogue.

7. "Divided" refers to the concept of divisionism, the separation of colors into contrasting strokes or dots of paint, that Signac developed and employed.

8. *Portrait of George Moore*, c. 1878 (Metropolitan Museum of Art, New York). Signac

must have seen it in the Manet retrospective in 1884. Moore, like Bruyas, had a red beard.

9. The work is now attributed to François André Vincent (1746–1816).

10. "Optical mixture," a component of the color theory Signac espoused, refers to the juxtaposition of discrete touches of color so that the viewer perceives a final color of the desired hue and brilliance.

11. This refers to Michel 1879, a comprehensive catalogue of the museum collection that appeared in at least nine editions, up to 1890. Signac's remark is a bit excessive, but he could only have

been annoyed by the insistence of the author on the youthful friendship in Rome between Bruyas and Cabanel, who had not yet become the *pompier* painter despised by the young modernist artists of the end of the century, such as Signac. "A few canvases by Cabanel . . . formed the beginnings of his gallery, but on arriving in Paris, M. Bruyas could not resist the current of Romanticism, and began to collect the painting of this school," wrote the author of the preface (p. xxvi), with what Signac no doubt took for condescension. I wish to thank Sylvain Amic for having provided me with this document.

And still, these "terrors"—who were and are still reviled—are the glory of Montpellier today, making us change our plans in order to come to this city.

The Courbets here are certainly the most splendid works by the painter, whereas Delacroix is not well represented. There are no finer canvases to be seen than the *Sleeping Spinner* [cat. 27] and the *Bathers* [cat. 28].
This is flesh as only Jordaens and Rubens knew how to represent it. The most beautiful pair of buttocks that one might see! Courbet himself was surprised when Bruyas bought this painting that had caused such an uproar!
A singular portrait of Baudelaire [cat. 25].
The shaved head of a galley slave, with a lock of hair like Paulus's,[12] pipe in his mouth, blue shirt, orange cravat; here we really have the mystifying and cynical Baudelaire who must have gone to sit on the couches of Courbet's studio.
Another beautiful canvas: *The Meeting*, or *Bonjour Mr. Courbet* [cat. 30], a meeting between Bruyas and Courbet on the road to Montpellier—an exquisite landscape with grays, blues, greens—sharp and lively.
Man with a pipe [cat. 26]. Self portrait of Courbet—terrific execution.

A very beautiful Bonvin: woman reading.

Dante's Inferno—by Chenavard [cat. 22]—very literary, perhaps, but really ugly, almost ridiculous. And to think that it is by the painter who held such logical discourse on art and beauty!
Three ordinary Corots, one without a silhouette [cat. 24], the second black and lacking in his habitual finesse [cat. 23], and the third, acquired later, a model of those referred to as commercial.

Some brilliant Diaz! A bouquet of flowers of exquisite freshness.

By Glaize: M. Bruyas's interior [cat. 63]. Amusing to see the dress suits worn by these elegant people of 1848! One M. Bricogne is wearing a butter-colored frock coat lined in pink!

Then a portrait of Bruyas (1876).
No longer the romantic. He is old, suffering, decorated, sad.
An early Henner.
An entire series of superb Tassaerts.

An abandoned Ariadne, stretching, all vibrating with passion. Beautiful curved forms. Marcel Verdier: portrait of a woman who has the grace of a Renoir and lovely coloring.

4 Boningtons, not extraordinary, bituminous juice and white! In one with a fog effect, one feels the first attempts at Impressionism. . . .

The corner with drawings and watercolors from the Bruyas collection is exquisite.[13]
Gouaches and watercolors by Bonington, Isabey, and Fielding—pure watercolors, colors thinned with water. He [Bonington] was one of the creators of watercolor and taught this process to Delacroix, who was an intimate friend.

A beautiful drawing of a boat by P. Puget.

A drawing by Papety, a student of Cogniet, about whom he speaks in his memoirs. Charlet.

Watercolor by Besnard . . . a student of Cabanel . . . shows the fraudulent student of the École, adaptable to any system.

An entire room of drawings by Cabanel shows how his angular drawing, dear to the École, is opposed to the traditions of beautiful Antique and Renaissance forms, to the circles and arabesques used by all of the masters: Rubens, Delacroix, Daumier, Degas; (opposition of two drawings: the curve, the angle—art and the opposite of art).

A very beautiful drawing by Michelangelo[14] reproducing the gesture of the *Last Judgment* with its geometric lines, rays of a circumference, corresponding to the other rays of an ellipse—the meaning of which I am trying in vain to understand. [sketch with annotation added: the same at Oxford].

3 beautiful drawings by Raphael.

A caricature by da Vinci, very similar to Puvis's.[15] A drawing by Ingres showing that his forms are, in their own way, as caricatural as Delacroix's.

A watercolor by Millet (Vichy) [cat. 80 or 81]; a drawing: *La Soupe* [cat. 79].

An ink drawing by Rousseau [cat. 88 or 89].

A series of bronzes by Barye, from those with the lovely patina [see cat. 4–8].

A drawing by Courbet: one might say [Maximilien] Luce reading.

A watercolor by Delacroix: Socrates and his [illegible] muse.

A woman of Algiers [cat. 39]—sepia line highlighted with color, recalling Manet's watercolor sketches. In the margins, written notes indicating the flowerets of the trousers and shirt. Another woman of Algiers with a black scarf on her head [cat. 40].

A seascape of Dieppe [cat. 43]; flowers [cat. 42].

A watercolor after one of Rubens's hunting scenes [cat. 37], with a horse's leg, flayed [cat. 48]—with the names of the muscles; a drawing for the portrait of Bruyas [cat. 47], from which the painting [cat. 46] was done: the model having posed very little . . . and under a glass case all of Cabanel's decorations and his shitty palette!

12. Paulus was a very popular café-concert singer of the end of the century.
13. The drawings of the Bruyas collection, those of François-Xavier Fabre, the other great donor to the museum, and those of other donors of drawings including Bonnet-Mel and Jules Canonge, must have been presented together.
14. In fact, the drawing is after Michelangelo, though it was considered a signature work at the time.
15. Now considered to be after Leonardo da Vinci.

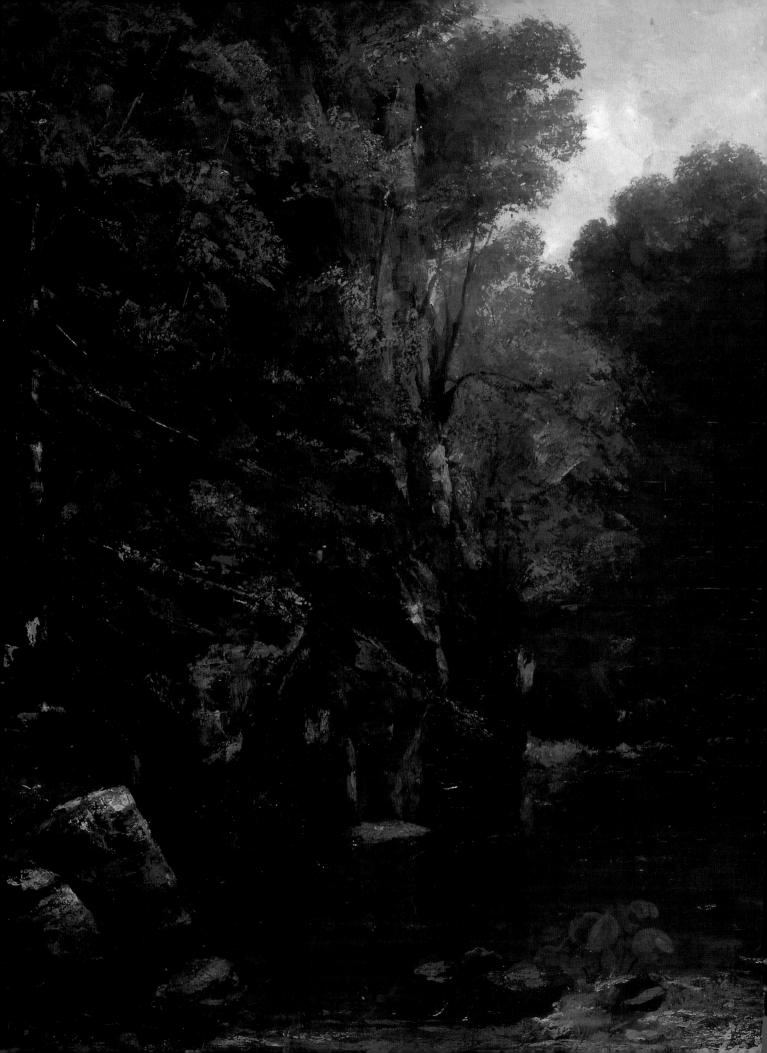

Catalogue of the Exhibition

Louis-Hector Allemand

Lyon 1809–1886

1. *View of Grangeau,*
at Saint-Jact-sur-Loire

1868
Pen and brown ink, brown and purple wash,
over graphite on paper
7 5/8 x 12 1/8 in. (19.5 x 30.9 cm)
Signed and dated in brown ink, lower left: hr A 68
Signed in brown ink, upper right: Hr Allemand
Inscribed in black ink, upper right, below signature:
avril 1873; in black ink, upper left: à son ami
A. Bruyas; Musée Fabre stamp in blue ink,
lower left (Lugt 1867)
Bruyas Bequest, 1876
876.3.132
Exhibited Dallas and San Francisco only

Provenance
Alfred Bruyas, Montpellier
(gift from the artist, June 1873).

Selected References
Bruyas 1876, p. 85, no. 4, as *Vue prise de Grangeau,
à Saint-Jact-sur-Loire*; Claparède 1962, no. 6, ill.,
as *Vue prise de Grangeau, à Saint Jact sur Loire*.

The son of amateur painters, Louis-Hector Allemand practiced drawing, etching, and painting as an avocation until the age of thirty-six, when he sold his business and set himself up as a professional artist in his native city of Lyon. In part through the distribution and exhibition of his prints, and the publication of his treatise *Causeries sur le paysage* (1877), he established a reputation as a painter-etcher specializing in the open-air landscape.[1] "I never had a teacher other than nature," he wrote to Bruyas in 1872,[2] but an examination of his painted and graphic oeuvre finds a clear debt to the great Dutch landscapists of the seventeenth century as well as Claude Lorrain (1600–1682); among his contemporaries, his work was closest to Barbizon artists Théodore Rousseau and Camille Corot.

Although the Bruyas collection catalogue of 1851 lists a landscape painting by Allemand, it is apparent from correspondence between the painter and the collector during the fall and winter of 1872–73 that the object in question—*Paysage: Vue du département de l'Ain*—was no longer in his collection by that time.[3] Bruyas's correspondence with Allemand began in September 1872, after the artist's son, who was also a painter and veteran of the French army, paid him a visit.[4] During the

2. *Landscape at Ain*

1870
Pen and brown ink, brush and brown wash,
and white gouache over graphite, on blue paper
9 5/8 x 13 3/8 in. (24.4 x 34.1 cm)
Signed and dated in pen and brown ink, lower left:
H. Allemand 1870
Inscribed in pen and brown ink at lower right:
à son ami A. Bruyas / H Allemand
Bruyas Bequest, 1876
876.3.92
Exhibited Dallas and San Francisco only

Provenance
Alfred Bruyas, Montpellier
(gift from the artist, Jan. 1873).

Selected Exhibitions
Montpellier 1996, no. 3, ill., as *Paysage de l'Ain*.

Selected References
Bruyas 1876, p. 85, no. 3, as *Paysage*; Claparède
1962, no. 3, ill., as *Paysage de l'Ain*.

3. A Riverbank

1873
Black and white chalks with stumping
on blue-gray paper
8 3/4 x 11 3/8 in. (22.2 x 28.8 cm)
Signed in brown ink, upper left: H^er. Allemand 1873
Inscribed in black ink, lower left: à son ami Bruyas
Bruyas Bequest, 1876
876.3.93
Exhibited Dallas and San Francisco only

Provenance
Alfred Bruyas, Montpellier
(gift from the artist, June 1873).

Selected References
Bruyas 1876, p. 85, no. 5, as *Dessin d'après nature;*
Claparède 1962, no. 5, ill., as *Paysage.*

next few months, Allemand fretted over the selection of an appropriate painting to offer Bruyas. On 26 December 1872, he sent by rail three paintings, of which Bruyas chose *Twilight-Landscape* (1865) at a price of 1,500 francs.[5] The sale was an important one for Allemand, who was suffering from various ailments including deterioration of his vision and an increasing paralysis in his right arm. As a gesture of thanks, and an effort to bolster his relationship with Bruyas, Allemand presented him with a succession of gifts, including drawings, etchings, and a second painting.

The first drawing given to Bruyas in mid-January 1873 was the *Landscape at Ain*, a freely sketched pen-and-brush landscape study. The drawing is signed and dated 1870 at lower left, with a dedication at lower right, presumably added at the time of the gift: "à son ami A. Bruyas / H Allemand." The artist boasted that "it is one of my best and the expert [Paul] Chenavard, upon seeing it, told me that it was superb and deserving to figure at the Louvre under glass among the masters."[6] Bruyas's telegram acknowledging receipt of the drawing is lost, but Allemand's response, mailed from Lyon on 18 January 1873 hints that the gift was not fully appreciated: "I am afraid that you did not find it to your taste as being too rough a sketch," he wrote, "so I want to make a better choice and I am ready to send you another more finished drawing."[7]

Two more gifts of drawings followed in June 1873, the *View of Grangeau, at Saint-Jact-sur-Loire* and *A Riverbank*,[8] both inscribed with dedications to Bruyas. One might conclude, based on the technical diversity of the three drawings given by Allemand to Bruyas, that their selection was motivated by a desire to show off the artist's virtuosity as a draftsman. The *View of Grangeau* is striking in its rugged depiction of the rocky terrain, the nervous pen lines modulated by washes of brown and purple ink. According to Allemand, it was drawn in two hours.[9] The *Riverbank*, in contrast, is a luxurious exercise in velvety luminosity. Allemand wrote to Bruyas of this delicate sheet, "since it is made of nothing but a breath you should avoid rubbing it."[10] **JAG**

1. For a catalogue raisonné of Allemand's etchings, see Prouté and Bidon 1977, pp. 5–22.
2. "Je n'ai jamais eu de maitre que la nature." Doucet MS 216 no. 4, 15 Dec. 1872.
3. Bruyas 1851, p. 6, no. 1.
4. Doucet MS 216, no. 2, 12 Sept. 1872.
5. Doucet MS 216, no. 1. This letter is misdated 26 Dec. 186[7?], but must have been sent in 1872. *Twilight-Landscape* remains in the Musée Fabre's collection, inv. 876.3.14.
6. "C'est un de mes meilleurs et le savant Chenavard en le voyant m'a dit qu'il était superbe et digne de figurer au Louvre sous verre a coté des maitres." Doucet MS 216, no. 10, 11 Jan. 1873.
7. "Je crains que vous n'ayez pas trouvé cela a votre gout comme traité trop en croquis, j'ai cependant cru bien choisir et je suis prêt a vous en addresser une autre plus terminé." Doucet MS 216, no. 11, 18 Jan. 1873.
8. Doucet MS 216, nos. 17 (5 May 1873), 18 (5 June 1873), and 19 (10 June 1873).
9. Doucet MS 216, no. 17, 5 May 1873.
10. "Comme il n'est fait que d'un souffle il sera bien d'eviter le frottement." Doucet MS 216, no. 18, 5 June 1873.

Antoine-Louis Barye
Paris 1796–1875

4. Lion with a Serpent

First edition c. 1838, first version with this base
c. 1845; this cast c. 1872–75
Bronze
10 1/8 x 13 15/16 x 7 1/8 in. (25.8 x 35.4 x 18 cm)
Signed on base: Barye
Bruyas Bequest, 1876
876.3.80

Provenance
Alfred Bruyas, Montpellier
(purchased from the artist, 1872 or 1875).[1]

Selected References
Bruyas 1876, pp. 91–94, no. 9A, as *Le Lion
et le Boa, réduction du fameux groupe du jardin
des Tuileries*; Poletti and Richarme 2000, p. 175,
no. A52, as *Lion au serpent, no. 1.*

5. Seated Lion

First edition c. 1847, this cast c. 1872–75
Bronze
14 1/4 x 6 1/8 x 11 1/2 in. (36.3 x 15.5 x 29.2 cm)
Signed on base: Barye
Bruyas Bequest, 1876
876.3.83

Provenance
Alfred Bruyas, Montpellier
(purchased from the artist, 1872 or 1875).[2]

Selected References
Bruyas 1876, p. 95, no. 9B.[3]

Toward the end of his life, Bruyas acquired at least twenty-two bronzes and three watercolors by Antoine-Louis Barye, the most famous of the French *animalier* sculptors.[6] We are fortunate to have extensive documentation on many of these purchases in letters dating between 1872 and 1875, from Barye and his son to Bruyas outlining details of the transactions.[7] The letters provide information on eighteen different bronzes acquired by Bruyas; of these fourteen were part of Bruyas's bequest to the Musée Fabre. The 1876 bequest included a total of eighteen Barye bronzes, including four for which there is no purchase documentation.

The correspondence shows a concentrated buying campaign on the part of Bruyas, who evidently made use of one of Barye's sales catalogues in selecting works to purchase.[8] Bruyas sent at least one photographic portrait of himself to Barye[9] and must have told him something of the nature of his collection, as Barye referred to it as "your gallery."[10]

Barye conceived of many of his bronzes as pendants, and it is clear that Bruyas was particularly interested in

6. *Theseus Battling the Minotaur*

First edition 1857, date of this cast unknown
but before 1876
Bronze
17 7/8 x 11 7/8 x 7 in. (45.4 x 30.2 x 17.9 cm)
Signed on base: Barye
Bruyas Bequest, 1876
876.3.72

Provenance
Alfred Bruyas, Montpellier.

Selected Exhibitions
Paris 1939, no. 172.

Selected References
Bruyas 1876, pp. 101–2, no. 90, as *Thésée
vainqueur du Minotaure*; Champion 1998, no. 580,
ill.; Poletti and Richarme 2000, p. 108, no. F32, as
Thésée combattant le minotaure, seconde version.

obtaining the sculptures as pairs. Of the twenty-two Barye sculptures he acquired, at least fourteen were clearly intended by Bruyas as pairs—the two versions of the *Turkish Horse*, the Asian and African elephants, the *Seated Lion* and the *Lion with a Serpent*, the walking lion and walking tiger, the Algerian and Senegalese lions, and the two rearing bulls (one attacked by a tiger). Others may well have been paired by Bruyas, such as the *Jaguar Devouring an Agouti* and the *Jaguar Devouring a Crocodile* (listed by Bruyas as a tiger).

Although *Theseus Battling the Minotaur* is often paired with the *Theseus Battling the Centaur Biénor (sketch)* (often referred to as the *Lapith and the Centaur*), Bruyas does not seem to have acquired them specifically as a pair. With the exception of the *Theseus Battling the Minotaur,* all of the Barye sculptures in his collection were mounted with matching wooden bases (although some have squared and some rounded ends). The wooden base provided for the *Theseus Battling the Minotaur* is a different shape and size. Assuming that this base is not a later replacement, it may be that at some point Bruyas thought of this sculpture as a stand-alone display. Unfortunately, no documentation related to the acquisition of the *Theseus Battling the Minotaur* is known. It is possible that he purchased it at a different time, perhaps before his concentrated Barye acquisition campaign.

Bruyas included sixteen of the eighteen bronzes and all three Barye watercolors from the 1876 donation in *La galerie Bruyas*, in which Barye is accorded a total of twenty-five pages. The catalogue was only half completed before Bruyas's death; of the thirty-four artists covered, only three other artists are granted entries of twenty-five pages or more. The order of the entries reinforces Bruyas's interest in pairing the sculptures, as like subjects are grouped together, and often relationships between them are noted in the commentary. Of the two *Turkish Horses*, he claims that they are infinitely better seen together than separately, and that as sculptures they are as inseparable as "verse and rhyme in poetry."[11]

The bronzes in this exhibition provide a sampling of the diverse group that comprises the Bruyas collection. The *Lion with a Serpent* and the *Seated Lion* were of particular importance for Bruyas. He purchased two versions of each of these, perhaps intending one for his collection and the other for his personal use. Barye's interest in the two lion sculptures is evident in their treatment in *La galerie Bruyas*, where they lead the section on Barye bronzes and are accorded a total of four pages of commentary. In comments credited to Bruyas he notes that together the *Seated Lion* and the *Lion with a Serpent* form a perfect contrast between the power of the beast at rest and in action.[12]

The quality of the casts in the Bruyas collection is very high, and the correspondence from Barye's son reveals the care and concern felt by the artist regarding the quality of casting and finishing of the bronzes that joined the Bruyas collection.[13] The patinas tend to be dark browns and greens, in keeping with the *vert antique* patina that Barye typically employed in the 1870s.[14] Altogether, Bruyas's selection of bronzes, the content of the correspondence, and the treatment in *La galerie Bruyas* provide an important glimpse into the intent and interest of one important collector of Barye sculptures in the 1870s.

Barye's extensive and varied training explains the mixture of classicism, romanticism, and realism that characterizes his style. After working in the shop of a metalworker and engraver, Barye studied with the classical sculptor François Joseph Bosio (1768–1845) and with the Romantic painter Antoine-Jean Gros (1771–1835), and then gained admission to the École des

7. Turkish Horse

First edition c. 1857, this cast c. 1874
Bronze
11 1/4 x 11 1/8 x 4 in. (28.6 x 28.3 x 10.2 cm)
Signed on base: Barye
Bruyas Bequest, 1876
876.3.82

Provenance
Alfred Bruyas, Montpellier
(purchased from the artist, 1874).[4]

Selected References
Bruyas 1876, pp. 98–99, no. 9I or 9J (one of a pair);
Poletti and Richarme 2000, p. 267, no. A129,
as *Cheval turc no. 2, antérieur droit levé, terrasse
ovale.*

Beaux-Arts in 1818. This education and his continued study in private collections and museums, including the Louvre, gave Barye a thorough understanding of artistic tradition. An equally ardent student of nature, Barye became a frequent visitor to the Jardin des Plantes, which included a zoo and museums of natural history, zoology, and comparative anatomy. He and Eugène Delacroix often went to the zoo together to draw animals from life; they also occasionally performed dissections.

Barye's knowledge of the anatomy and locomotion of wild animals, knowledge widely admired in his time, is evident in his bronzes. This realism and accuracy made his sculptures all the more vivid and disturbing, and therefore all the more challenging to prevailing ideas about art, about art's proper subjects, and about the depiction of nature unrestrained. For certain viewers, Barye's depictions of stark violence, devoid of moral comment or allegorical interpretation, were unsettling and even shocking.

Barye was not the first artist to turn to animal themes, but his unconventional approach to the subject made him the most notorious, and perhaps the most influential, of the nineteenth-century *animaliers.* The word *animalier* was first used as a slight, to express contempt for the lack of importance of Barye's chosen subjects. Barye persevered, however, and it was largely through his repeated challenges to artistic convention that the theme of animals gained legitimacy as a subject for serious sculpture. Although Barye's scenes of animal violence remained controversial, he received many honors and appointments and became internationally famous. Younger artists found in Barye's powerful animals "what they had vainly sought in the works of their elders, the true perception of life, of truth, of liberty," said Charles Blanc, writing soon after the artist's death in 1875.[15] **KMM**

1. According to letters from Barye, Bruyas purchased two casts of this sculpture, each time along with a cast of the *Seated Lion*. The first pair of casts is mentioned as being shipped in a letter of 15 Apr. 1872 (Doucet MS 216, no. 33), and the second is mentioned as being shipped in a letter of 18 Feb. 1875 (Doucet MS 216, no. 43). Bruyas paid 200 francs for each of the four sculptures. In the entry in this catalogue for *Alfred Bruyas in His Study* by Marsal (cat. 76) I hypothesize that Bruyas bought one set for inclusion in his *galerie* and one for his personal use.
2. See note 1.
3. Although omitted from the listing of known casts, this corresponds to Poletti and Richarme 2000, p. 181, no. A56, *Lion assis no. 1.*
4. Barye shipped a pair of *Turkish Horses* to Bruyas on 21 Mar. 1874 (Doucet MS 216, no. 40). Bruyas paid a total of 220 francs for the pair.
5. Barye shipped the inkwell to Bruyas on 24 Oct. 1874 (Doucet MS 216, no. 42) and noted the price of 150 francs.
6. The works of art by Barye known to have been owned by Bruyas are three watercolors, all of which are included in this catalogue, and

8. *Inkstand with an Owl*

First edition c. 1870, this cast c. 1874
Bronze
5 7/8 x 13 in. (15 x 33 cm)
Gift of Colette Alicot, 1998
98.6.2

Provenance
Alfred Bruyas, Montpellier (purchased from the
artist, 1874;[5] until d. 1877, presumably bequeathed
to Alicot); Louise Clarisse Bruyas (Mme Alicot),
his sister, Montpellier (from 1877); by descent to
Colette Alicot, her granddaughter-in-law,
Montpellier.

Selected References
Poletti and Richarme 2000, p. 393, no. D37, fig. 414.

eighteen sculptures donated to the
Musée Fabre in 1876. It is clear
from the correspondence that
Bruyas would have purchased
more bronzes but for the death of
the artist.
7. Doucet MS 216, nos. 31–44. I am
grateful to Sarah Lees for locating
and transcribing these letters.
Nos. 31–33 are signed by Barye;
nos. 34–43 are signed by one of his
children, due to Barye's increasing
illness. Although relations between
Barye and his son Louis-Antoine
were marred by the younger
Barye's attempts to capitalize on
his father's reputation, there is
reason to believe that Louis-

Antoine signed the letters. The
signature appears to read
"H Barye," but could be a
monogram of LA. It is clear that
Bruyas was under the impression
that the author was Louis-Antoine
Barye, as confirmed by the entries
in *La galerie Bruyas* for the Asian
and African elephants, which are
credited to L.A. Barye and which
are taken directly from a letter of
19 Feb. 1874 signed with the
distinctive "H" (Doucet MS 216,
no. 39). Barye's widow signed no. 44.
8. Doucet MS 216, no. 36, of 17
Dec. 1873, includes: "The Algerian
Lion that is number 50 in the
Catalogue is the one that has the

front paw forward." This sculpture
was later shipped to Bruyas in April
of the next year, along with
Senegalese Lion; see Doucet MS
216, no. 41, 13 Apr. 1874.
9. On 6 Nov. 1872 Louis-Antoine
Barye wrote on behalf of his father:
"Thank you very much for having
so kindly sent me the portrait-card;
it was doubly pleasing since it was
a magnificent photograph." Doucet
MS 216, no. 34. On 19 Feb. 1874
the younger Barye again thanks
Bruyas for a photograph he had
sent. Doucet MS 216, no. 39.
10. Doucet MS 216, no. 37, 10 Jan.
1874: "votre galerie."
11. Bruyas 1876, p. 99.

12. Ibid., p. 95.
13. On 10 Jan. 1874 his son reports,
"The proofs of the *Centaur* that are
presently available [are] not
beautiful enough, in my father's
opinion, to appear in your gallery,"
and he notes that creating a
satisfactory sculpture would take
about three weeks. He further
remarks: "Since good foundries
have become very rare, it is difficult
to get a flawless proof that exactly
renders the artist's work." Doucet
MS 216, no. 37.
14. Poletti and Richarme 2000,
p. 48.
15. Blanc 1876, pp. 383–84.

9. *Senegalese Lion and Python*

Before 1872[1]
Watercolor and gouache with resin or varnish
on paper
11 5/8 x 18 7/8 in. (29.6 x 48 cm)
Signed in black gouache at lower left: BARYE
Unidentified circular stamp in black ink at lower left
Bruyas Bequest, 1876
876.3.95
Exhibited Richmond and Williamstown only

Provenance
Alfred Bruyas, Montpellier
(purchased from the artist, Apr. 1872).[2]

Selected Exhibitions
Paris 1900, drawings section, no. 688; Paris 1939,
no. 132, as *Le Lion et le boa*; Paris 1956, no. 135,
pl. 16, as *Lion en arrêt devant un python*; London
1959, no. 606, as *Lion and Snake*; Paris 1996b
(Lyon only), no. 107, ill.

Selected References
Bruyas 1876, pp. 88–89, no. 6, as *Lion du Sénégal
en arrêt devant un Serpent python*; Laurens 1875,
pl. 13, as *L'Arrêt* (lithograph after the drawing;
reversed); Zieseniss 1954, p. 61, no. A37, pl. 6,
as *Lion en arrêt devant un python*; Claparède 1962,
no. 13, ill., as *Le Lion et le boa*.

10. *Lion in the Desert*

Before 1873
Watercolor and gouache with resin or varnish
on paper
10 5/8 x 15 1/8 in. (27 x 38.4 cm)
Signed in black gouache at lower right: BARYE
Bruyas Bequest, 1876
876.3.94
Exhibited Dallas and San Francisco only

Provenance
Alfred Bruyas, Montpellier
(purchased from the artist by Alfred Robaut as
agent for Bruyas, Apr. 1873).[3]

Selected Exhibitions
Paris 1939, no. 134; Paris 1956, no. 134; Paris 1996b
(Lyon only), no. 109, ill.

Selected References
Bruyas 1876, p. 89, no. 7, as *Lion cherchant
une proie*; Zieseniss 1954, p. 60, no. A32, pl. 5;
Claparède 1962, no. 11, ill.

9

10

In addition to his fame as a sculptor, Antoine-Louis Barye was well recognized in his lifetime for his exquisite watercolors featuring animals in landscape settings. Barye considered his watercolors to be finished works and exhibited them in the Salon as early as 1833.[5] We know from his correspondence that Bruyas undertook a concentrated campaign of acquiring sculpture by Barye during the years 1872 until the artist's death in 1875 (see cats. 4–8). Similarly, a series of letters preserved at the Bibliothèque Doucet in Paris allows us to trace the acquisition of all three of the watercolors that Bruyas acquired from Barye.

The finest of the three, the *Sengalese Lion and Python*, is also the first he acquired. The artist selected this watercolor for Bruyas and sent it to him on approval in April of 1872. Several subsequent letters refer to the great admiration both patron and artist felt for this particular work.[6]

The theme of the lion stopped before a snake appears in at least one other Barye watercolor (The Walters Art Museum, Baltimore), and recalls his famous bronze group of the *Lion with a Serpent*, of which the original large-scale plaster was acquired by the French state in 1833 and subsequently cast in bronze and installed in the Tuileries gardens. In the Bruyas watercolor the tension and opposing power of the two creatures is forcefully expressed. The lion, standing at attention and rendered with tradition-sanctioned nobility of pose, is seen against a broad expanse of sky. The python, its fabulously patterned body undulating in and out of sight amongst the low-lying rocks and brush, opens its mouth to capacity as it challenges the approaching great cat. The masterful handling of color and texture, combined with the electric tension of the confrontation, makes it clear why Bruyas would have chosen this watercolor to lead the section on Barye in his 1876 catalogue, and why this work is one that he selected for lithographic reproduction by Jules Laurens and publication in a portfolio of thirty prints in 1875.[7]

Bruyas acquired the pair of watercolors *Tiger on the Watch* and *Lion in the Desert* with assistance from Alfred Robaut (1830–1909). Bruyas had asked Barye to

select one or two more watercolors for his collection, but Barye's son wrote to inform Bruyas that his father was away from Paris and would not be able to make the selection until his return.[8] Two days after this letter was written, Robaut wrote to Bruyas to say that he happened to be at Barye's place on other business, and that one of the artist's daughters mentioned that Bruyas was interested in acquiring a few watercolors. Robaut reported that Barye was still away from Paris, and quite ill, and offered to act as an intermediary in the acquisition of watercolors, indicating great concern that the remaining watercolors would sell very quickly.[9] Robaut included a sketch of two watercolors with this letter; one is of a walking tiger, and one is of a lion in very similar pose to the *Sengalese Lion and Python* already owned by Bruyas.[10] The collector informed him that he wanted only the *Tiger*,[11] and Robaut wrote back saying he had obtained that watercolor and encouraged him to consider purchasing a second of a walking lion, which he said was of equal size and would make a good pendant. Robaut again sent a sketch of this watercolor in his letter.[12] Bruyas ended up purchasing both, for a

price of 2,000 francs apiece.[13] Interestingly, the *Tiger on the Watch* acquired by Bruyas is not the exact watercolor Robaut had indicated. Robaut must have switched it with a very similar work in the course of acquiring Barye watercolors for various clients.[14] Taken together, the two watercolors acquired by Bruyas recall the complementary bronze pair of the *Walking Lion* and *Walking Tiger*, also in his collection. Given Bruyas's interest in pairing Barye sculptures, it seems likely that his acquisition of these two subjects was consciously intended to form a pair, complementing his collection of bronzes.

The anatomy, pose, and coloring of the beasts are worked out with extreme care and detail. Their sculptural forms are set against vague landscapes of smoky tonalities. Barye's watercolor technique was intuitive and idiosyncratic, much like his working approach to wax studies, which he freely modeled over minimal armatures. In his watercolors, his repeated scraping and layering of color sometimes resulted in muddiness, but at its best produced images of great vitality and beauty such as these.[15] **KMM**

1. These three watercolors probably date to late in the artist's career. They are consistent with the style of other watercolors Zieseniss dates to the 1850s and later. Zieseniss 1954, pp. 22–23.
2. Doucet MS 216, nos. 31–33, trace the acquisition of this watercolor, as discussed in more detail below.
3. The acquisition of this watercolor can be traced in the Doucet letters as outlined below.
4. The acquisition of this watercolor can also be traced in the Doucet letters.
5. Martina Roudabush Norelli, "The Watercolors of Antoine Louis Barye," in Robinson and Nygren 1988, p. 61.
6. In a letter to Bruyas of 19 Mar. 1872 (Doucet MS 216, no. 31), Barye writes that he has chosen a watercolor to send to the collector and will have it shipped as soon as it has been framed. In a

subsequent letter of 4 Apr. 1872 (Doucet MS 216, no. 32), Barye notes that the watercolor has been shipped on approval to Bruyas, and that the purchase price is 2,000 francs. On 15 Apr. 1872, Barye writes that he is happy to learn of Bruyas's satisfaction: "and I thank you for your praise of my work." Barye wrote further on 6 Nov. 1872 to say that he had forgotten to send the title of the watercolor, which is "*Lion de Senegal en arrêt devant un serpent python*" (Doucet MS 216, no. 34). Finally, on 10 Jan. 1874, Barye's son writes to Bruyas about the watercolors in his collection, and notes that these watercolors—and especially the *Lion en arrêt devant un Serpent*, "chosen above all others by my father"—are deserving of a place in a collection as noteworthy as Bruyas's (Doucet MS 216, no. 37).
7. Laurens 1875, pl. 13.

8. Doucet MS 216, no. 35, 7 Apr. 1873.
9. Doucet MS 214, no. 31, 9 Apr. 1873.
10. Robaut's sketch of the lion conforms exactly with the composition of Zieseniss A38, now in the Baltimore Museum of Art.
11. Bruyas's decision not to buy the lion is clear from a letter Robaut wrote to him on 14 Apr. 1873: "I showed your watercolor of the TIGER by Barye to dear papa Corot; he was so taken with it that he asked me to procure him a similar one. Since you have declined the LION, I am going to have it brought to him." Cited in Borel 1942, p. 10.
12. Doucet MS 214, no. 32, 11 Apr. 1873. This sketch corresponds with the watercolor acquired by Bruyas.
13. Robaut wrote to Bruyas on 21 Apr. 1873 regarding the shipment of the *Lion in the Desert*, the reimbursement of the funds he had fronted for the purchase of the

watercolors, and several other works on paper he was encouraging Bruyas to acquire. Doucet MS 214, no. 33.
14. The sketch in Robaut's letter corresponds to Zieseniss B44, now in the Baltimore Museum of Art. See note 10, above, which quotes a letter from Robaut in which he reports that he showed Bruyas's watercolor of a tiger to Camille Corot, who requested that Robaut find him a similar one. Robaut states his intention also to show Corot the watercolor lion that Bruyas had declined. As it turns out, these exact two works (Zieseniss B44 and A38) ended up in the collection of George Lucas, and are now in the Baltimore Museum of Art.
15. For more on Barye's watercolor technique, see Norelli in Robinson and Nygren 1988, pp. 61–65.

11. *Tiger on the Watch (Tigre à l'affût)*

Before 1873
Watercolor and gouache with resin or varnish
on paper
10 11/16 x 15 1/16 in. (27.2 x 38.3 cm)
Signed in black gouache at lower left: BARYE
Bruyas Bequest, 1876
876.3.96
Exhibited Dallas and San Francisco only

Provenance
Alfred Bruyas, Montpellier (purchased from the
artist by Alfred Robaut as agent for Bruyas,
Apr. 1873).4

Selected Exhibitions
Paris 1939, no. 133; Paris 1956, no. 138; Paris 1996b
(Lyon only), no. 136, ill.

Selected References
Bruyas 1876, p. 89, no. 8; Zieseniss 1954, p. 67,
no. B36, pl. 14; Claparède 1962, no. 12, ill.

Léon Benouville

Paris 1821–1859

12. The Wrath of Achilles

1847
Oil on canvas
61 1/2 x 37 3/16 in. (156 x 94,5 cm)
Gift of Alfred Bruyas, 1868
868.1.1

Provenance
Alfred Bruyas, Montpellier (bought for 2,000 francs from Sophie-Marguerite Benouville, the artist's widow, March 1860).[1]

Selected Exhibitions
Rome 2003, pp. 180–81, 378, no. 30, ill. p. 195.

Selected References
Isnard 1848, p. 61; Bruyas 1876, pp. 114–15, no. 10, as La colère d'Achille, académie; Aubrun 1981, pp. 86–87, no. 47, ill.; Haedeke 1980, p. 174; Montpellier, 1985, p. 98, no. 5, ill. p. 109.

Léon Benouville began his brief career working in an idiosyncratic style that brought a forceful realism to the austere vocabulary of French classicism.[2] This unique fusion characterizes Benouville's prize-winning Prix de Rome entry Christ in the Praetorium (1847; École nationale supérieure des Beaux-Arts, Paris). Léon and his older brother Achille (1815–1891) had received their early training in the studios of Léon Cogniet (1794–1880) and François-Edouard Picot (1786–1868). In 1837, the brothers entered the École des Beaux-Arts, and remarkably, in 1845, both won the Prix de Rome in their specialization: Léon for history painting and Achille for historical landscape. Together they traveled to Italy with Alexandre Cabanel and Eugène Guillaume (1822–1905), the prizewinner for sculpture.

Traditionally, winners of the Prix de Rome spent five years in Italy, supported by the École des Beaux-Arts and housed at the French Academy, which since 1803 had occupied the Villa Medici in Rome. As pensionnaires, the artists followed a predictable course of study designed to orchestrate and optimize their exposure to the Eternal City's artistic monuments, ancient and modern. In Benouville's case, the study of early Italian masters, particularly Masaccio (1401–before 1428), is discernable in his evolving style.[3] Each artist was required annually to demonstrate progress through a presentation piece, or envoi, sent to Paris for evaluation and exhibition.[4]

Benouville's envoi of 1847, The Wrath of Achilles, draws upon the tradition of the académie, a detailed study from life of a nude figure.[5] Such exercises formed the underpinning of the academic tradition and the basis of École competitions. The pose of Achilles would have been determined through a series of figure studies; however, in finished paintings, the academic artist was obligated to perfect and regularize the figure, creating an ideal type removed from the specifics of the individual model. In the Achilles Benouville has integrated the immediacy of the figure study, with its stark realism and simplified composition, with the conventions of academic figure painting—classic physiognomy and graceful athletic physique realized in a flawless finish. Benouville anticipated that the classicizing elements, combined with the archaeological furnishings, would transform his contemporary model into a noble mythological figure.[6] For some of Benouville's critics, however—and perhaps for modern audiences as well—the transformation remained incomplete.[7] The physicality of the image is startling; and although skillfully composed and rigorously executed, the figure of Achilles is so realistic that it prohibits the required detachment that imbues serious history painting with dignity.

With this bold image Benouville presents the ancient Greek warrior Achilles, protagonist of The Iliad. Homer's epic poem centers on Achilles and the tragic consequences of his grievance against the Greek general Agamemnon. In a protracted rage Achilles neglected his military duties, endangering the Achaean troops, including his closest friend, Patroclus, and affecting the progress of the Trojan War. Artistically, through various compositional devices—such as the restricted field of vision, lack of narrative context, and confinement of the heroic body within the massive chair—Benouville succinctly conveys Achilles' debilitating anger.

In 1860, Alfred Bruyas purchased The Wrath of Achilles from the artist's widow. Bruyas had met Benouville during his own Grand Tour pilgrimage to Rome in 1846. Cabanel, who knew Bruyas from Montpellier, probably introduced them. In the context of Bruyas's evolving taste, the purchase of Benouville's Achilles proved a prescient acquisition. Stylistically, it

referred back to Bruyas's early parochial taste and his patronage of Cabanel (cats. 15–21). By 1860, however, the character of the collection had shifted to feature several major paintings by Gustave Courbet (cats. 26–32). More than just a belatedly acquired souvenir, the painting by Benouville provided a counterbalance to the collection's emphasis on realism. When installed in 1868, *The Wrath of Achilles* and Courbet's *Bathers* (cat. 28) were hung on adjacent walls in the second room of the Bruyas galleries. It was a classic confrontation of two diametrically opposed interpretations of the human body; their aesthetic and technical divergence could hardly be greater. The contrasts multiply rapidly: male versus female; one figure seen from the front, the other from the back; one artist creating classical forms, the other portraying the ungainly reality of a contemporary model given heroic proportions. Yet, in his preface to the Benouville monograph, Bruno Foucart acknowledges the similarity between Benouville and Courbet in their striving for different types of authenticity, of realism.[8] Realism in its various forms was part of a series of challenges that would irreparably weaken the academic system—with its prescribed procedures, classical vocabulary, conventional subject matter—and its entrenched hierarchy. In fact, the juxtaposition of Benouville's *The Wrath of Achilles* and Courbet's *Bathers* in the Bruyas galleries at the Musée Fabre encapsulates the stylistic and theoretical struggles then underway in the wider French art community.

LFO

1. See letters dated 10 Mar. 1860 and 7 Apr. 1860 from Achille Benouville, the artist's brother, to Bruyas. Doucet MS 216, nos. 47 and 48. Both Achille Benouville and Alexandre Cabanel, the Benouville brothers' fellow *pensionnaire*, acted as intermediaries in this sale. Cabanel sent a receipt for this painting to Bruyas in a letter of 12 Apr. 1860. Doucet MS 216, no. 49.
2. A serviceable catalogue raisonnée exists: Aubrun 1981.
3. Benouville had a prolonged opportunity to study the Masaccio frescoes in Florence at the time of the French Academy's exile in Florence, during the civil unrest in Rome, part of the mid-century struggles for Italian unification.

4. See Rome 2003, p. 53.
5. A contemporary illustration of the 1848 exhibition, in which *The Wrath of Achilles* is visible, is reproduced in Rome 2003, p. 140, fig. 2. The artist's name (. . . VILLE) is partially visible on the frame plaquette.
6. For an excellent discussion of the painting and Benouville's sources for the antique details, see Olivier Bonfait in Rome 2003, p. 378.
7. Isnard stated briefly in *L'Artiste*: "Parts of M. Benouville's figure are broadly composed and well executed, but this is not Achilles." Isnard 1848, p. 61.
8. See Foucart in Aubrun 1981, p. v.

François Bonvin

Paris 1817–1887

13. *On the Pauper's Bench—Souvenir of Brittany*

1864
Oil on canvas
21 5/8 x 14 5/8 in. (55 x 37 cm)
Signed and dated lower right: F. Bonvin 1864
Gift of Alfred Bruyas, 1868
868.1.2

Provenance

Antoine François Marmontel, Paris (by 1865; sold for 650 francs, Hotel Drouot, Paris, 11–14 May 1868, no. 96, to Bruyas);[1] Alfred Bruyas, Montpellier.

Selected Exhibitions

Paris, *Salon*, 1865, no. 238, lent by Marmontel; Paris 1939, no. 9; Cleveland 1980, no. 85, ill.; Tokyo 1982b, no. 12, ill.

Selected References

Laurens 1875, pl. 27, as *Le Banc d'Eglise* (lithograph after the painting; reversed); Bruyas 1876, p. 128, no. 14, as *Le Banc des Pauvres (Bretagne)*; Weisberg 1979, pp. 79–80, 179, no. 36, ill. pp. 77, 179; Montpellier 1985, p. 98, no. 9, ill. p. 109; Yeide 1998, p. 42, fig. 5.

François Bonvin received his earliest training at the École de Dessin in Paris, a school primarily for the decorative arts. In 1843 he attended the Académie Suisse, an open-enrollment studio in Paris where he met Gustave Courbet, who also studied there. Bonvin spent time looking at paintings in the Louvre during the same period, having been encouraged by François-Marius Granet (1775–1849), a prominent artist and museum curator to whom he had been introduced, to study the Dutch and Flemish masters. This training, along with his association with the emerging group of realist artists headed by Courbet, largely determined Bonvin's subsequent style and subject matter. Beginning in 1847 he regularly submitted work to the Salon, where his paintings were generally well received.

On the Pauper's Bench depicts two women seated in a shadowed church interior, separated by a blank wall from the brightly lit nave visible in the background. Although the painting's subtitle seems to suggest that it depicts a site in Brittany, the church has been identified as Saint Germain des Près in Paris.[2] In an earlier painting of 1855, *The Low Mass* (formerly Musée des Beaux-

Arts, Saint-Lô; destroyed 1944), Bonvin represented precisely the same location from a slightly different angle, showing more of the long, horizontal mural painting in church's central space and describing the architecture of columns and ribbed vaults in greater detail.[3] While that painting depicts a diverse group of worshipers in the middle distance, the present work focuses on two women isolated in the foreground. These women, one younger and one older, appear in several charcoal drawings dated 1864, each time clothed in simple dresses, aprons, and white bonnets.[4] One of the drawings served as a preliminary sketch for *On the Pauper's Bench*; it shows the women posed much as they appear in the final work and includes the copper pail at their feet. Bonvin clearly executed the drawing in his studio, however, for the women are seated on a simple rectangular box, surely a studio prop, and the setting is indicated only with bands of lighter and darker shading.

The painting is thus composed of different elements made at different times, and its link to Brittany, suggested somewhat generically by the women's bonnets, is tenuous.[5] But it represents a type of realism, inspired by earlier French models such as the Le Nain brothers and Jean-Siméon Chardin (1699–1779) as well as by

Dutch painting, that took rustic simplicity as its subject. Provincial culture, easily indicated in visual art by the costumes characteristic of specific regions, was presented by artists like Bonvin or Jules Breton (1827–1906) as stable and virtuous, particularly in contrast to the urban development of the period. By invoking poverty, piety, and regional identity, *On the Pauper's Bench* presents a reassuring image of exemplary rural morality, of people who posed no threat to an urban audience even if, as in this painting, they were literally transported to the very heart of the city. Bonvin's realism, "honest, conscientious, and true . . . a realism without stridency," as one critic put it,[6] clearly appealed to Bruyas, who had collected similar genre scenes by Octave Tassaert even as he supported the more provocatively realist art of Courbet. **SL**

1. Probably sold to Jules Laurens as agent for Bruyas.
2. See Paris 1939, pp. 20–21.
3. Illustrated in Weisberg 1979, p. 169, no. 16. The space above the arcades in the nave of Saint Germain was decorated with frescoes by Hippolyte Flandrin, executed between 1854 and 1863; this may be the painting Bonvin intended to indicate.
4. See Weisberg 1979, pp. 280–82, nos. 281–84.
5. Bonvin did travel to Brittany and spent two months there in 1853, well before making either the painting of 1855 or the present work.
6. Claude Vignon, "Salon of 1852," cited in Weisberg 1979, p. 47.

Louis Boulanger

Vercelli (Italy) 1806–Dijon 1867

14. *Mazeppa*

1825
Oil on canvas
9 x 16 1/8 in. (23 x 41 cm)
Bruyas Bequest, 1876
876.3.17

Provenance
Eugène Devéria (d. 1865); M. E. Baudouin (given to Bruyas); Alfred Bruyas, Montpellier.

Selected References
Bruyas, 1876, p. 131, no. 16, as *Supplice de Mazeppa*; Marie 1925, p. 110; Montpellier, 1985, p. 98, no. 11, ill. p. 110; Babinski 1974, p. 61, n. 28; Haedeke 1980, pp. 200–201, fig. 43.

After six years at the École des Beaux-Arts, the twenty-one-year-old Louis Boulanger burst onto the Parisian stage in 1827.[1] His debut Salon offering, the massive *Punishment of Mazeppa* (fig. 1)—measuring 17 1/2 by 13 feet—brought Boulanger acclaim and a second-class medal. As a result of this success, both the story of Mazeppa and Boulanger, who treated the subject many times,[2] became identified with French poet and novelist Victor Hugo (1802–1885).

The artist and writer met in 1824, and their long and productive friendship is evidenced in the extensive Boulanger holdings at the Maison de Victor Hugo, Paris. Boulanger illustrated many of Hugo's writings, including *Notre-Dame de Paris* and *Les Orientales* of 1829, the poetry collection in which Hugo first published his "Mazeppa," itself influenced by and dedicated to Louis Boulanger.

The source for both Boulanger and Hugo was Lord Byron's 1818 poem "Mazeppa," which had inspired a previous generation of Romantic artists. A historic figure, the Ukrainian Cossack "hetman" (leader) Ivan Stepanovich Mazepa (1632/44–1709) fought for Peter the Great of Russia against the Swedish king Charles II.[3] But when Peter threatened to dismantle the hetmanate, Mazepa changed allegiance and committed his forces to Charles. Russia's subsequent victory at Poltava in 1709 set in motion the political demise and eventual partitioning of the Ukraine. Byron, elaborating a passage in Voltaire's *Histoire de Charles XII* (1731), spun a dramatic and apocryphal tale of the young "Mazeppa."

Byron's Mazeppa is discovered embracing the wife of the aged Count Palatine. The bizarre punishment that follows provided the subject of Boulanger's Salon painting: nude, Mazeppa is tied to a thrashing stallion, the struggling man and animal bound back-to-back. The frenzied horse then charges off through the wilderness. Encapsulating the dramatic and eternal conflict between entrenched authority and youthful passion, the Mazeppa myth popularized by Byron captivated authors, playwrights, composers, and artists, including Géricault (1791–1824), Delacroix, and Horace Vernet (1789–1863).[4] Hugo further colored the narrative to emphasize the antipathy between authority and

artistic genius.[5] Ultimately, for the Romantics, Mazeppa's hellish ride "symbolized the transports of the poet carried away by inspiration."[6]

In contrast to the operatic dimensions of Boulanger's multifigured Salon painting, the small Bruyas painting represents a different moment in the story and focuses on the corpse-like body of Mazeppa, left, as Voltaire described, "half-dead from exhaustion and hunger." The vulnerable male form, draped awkwardly in the desolate landscape, is skillfully brushed in a broad, loose style and dramatically evocative. Though the figure bears essentially no direct relation to the Salon painting, and the composition lacks what is visually

Fig. 1. Louis Boulanger, *Punishment of Mazeppa*, 1827. Oil on canvas, 17 ft. 6 in. x 13ft. 1 in. (525 x 392 cm). Musée des Beaux-Arts, Rouen

Mazeppa's defining attribute, the wild horse, this painting has been titled *Mazeppa* since its appearance in the 1876 catalogue of the Bruyas collection, probably as much for the strained, twisting pose of the model and the dramatically barren landscape as for Boulanger's fame as a painter of the subject.

Part of the 1876 bequest, but not noted on Bruyas's 1868 gallery plan, the painting was probably acquired during the interim. Recalling Boulanger's masterwork—the artist never equaled that early performance—this *Mazeppa* furthered Bruyas's evolving plan for a balanced overview of French nineteenth-century painting. However, given Bruyas's attempts to distance himself from the Communard Courbet, one wonders if the collector considered the close association of Boulanger and the Mazeppa narrative with Victor Hugo, who was himself embroiled in post-Commune politics, pleading amnesty for the convicted insurgents.

LFO

1. For Boulanger's life and career, see Marie 1925 and Dijon 1970.
2. For the various related painted and graphic works, see Marie 1925, pp. 108–10, 122.
3. See Babinski 1974.
4. See Rouen 1978.
5. Mainardi 2000, pp. 345–46.
6. Paris 1974–75, p. 653.

Alexandre Cabanel
Montpellier 1823–Paris 1889

15. *Portrait of Alfred Bruyas*

1846
Oil on canvas
29 1/8 x 24 7/16 in. (74 x 62 cm)
Signed and dated lower right: A. Cabanel / Rome 1846
Gift of Alfred Bruyas, 1868
868.1.4

Provenance
Alfred Bruyas, Montpellier (commissioned from the artist, Oct. 1846).[1]

Selected References
Bruyas 1851, p. 6, no. 4; Bruyas 1852, p. 24, no. 4; Bruyas 1853, p. 40; Bruyas 1854, p. 42, no. 89; Bruyas 1876, pp. 142–43, no. 19; Montpellier 1985, p. 87, no. 4, and p. 98, no. 12, ill., p. 90.

This portrait, representing the twenty-four-year-old Bruyas against a backdrop of the Villa Borghese gardens in Rome, is one of the first works he commissioned. In July 1846 Bruyas left Montpellier to travel through Italy, spending an extended period in Rome and returning to France in the fall. During his trip he became friendly with several of the young artists resident at the Villa Medici, the site of the French Academy in Rome. Among them was Alexandre Cabanel, a fellow Montpellierain who had begun his training with Bruyas when the latter briefly studied painting in their native town. Although Bruyas soon gave up the idea of painting as a profession, the precociously talented Cabanel met with growing success, entering the École des Beaux-Arts in Paris in 1840 and winning the Prix de Rome in 1845.[2] This painting thus marks the early stages of both men's respective careers as patron and artist. It also represents a "souvenir of Italy," as Bruyas described it in his catalogue of 1851, a memento of his immersion in the artistic milieu of the city, and of the first of the collaborative relationships with artists that he would continue to pursue in the following years.

The painting is executed in a hard-edged, highly finished style, evidence of Cabanel's academic training. Bruyas poses in a shallow space defined by the ledge behind him, his hand almost reaching out toward the viewer while a tendril of ivy trailing over the ledge links the foreground with the distant landscape. In a letter to his patron, Cabanel expressed qualified satisfaction with this work, commenting, "I find [your portrait] to be rather successful. The background of the Villa

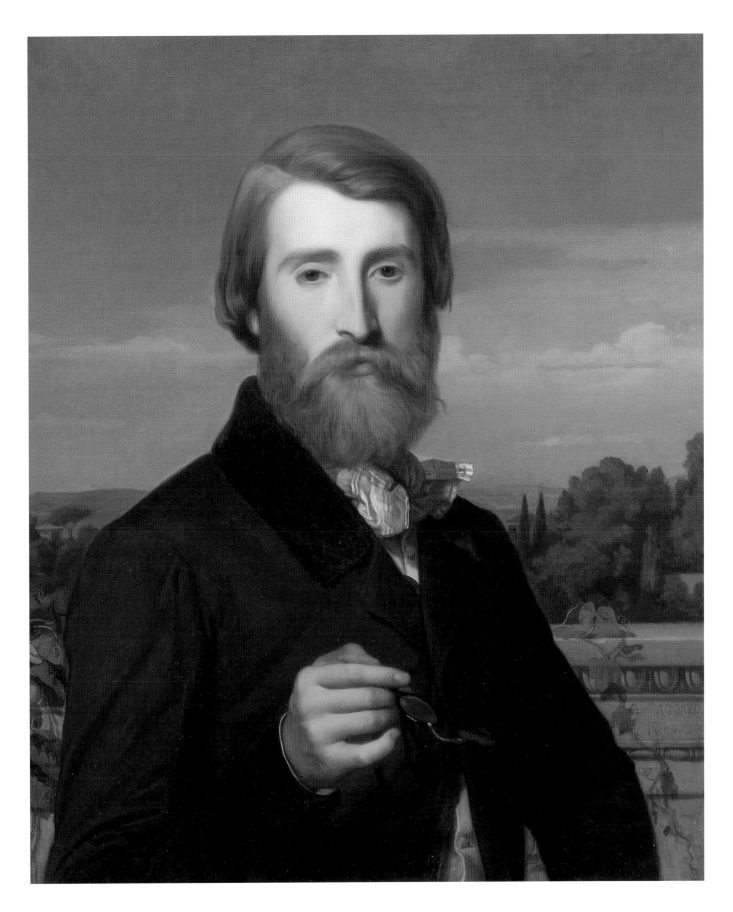

Borghese, the suit, the hand, are at least as successful as the head, which has gained greatly from its surroundings."[3] He went on to note that along with the painting he was sending back the suit, vest, cravat, and glasses in the same crate, items he kept presumably to insure the greatest possible accuracy in their depiction.[4] The sitter's habitual dark jacket creates a sharp silhouette against the sunny Italian landscape and sets off his fiery red beard, while the striped cravat gives him a slightly more dandified air than usual, and the spectacles seem to point to his powers of discernment as a connoisseur. Indeed, if Courbet's *Painting Solution* (cat. 29) depicts a powerful, resolute man, and Delacroix's portrait (cat. 45) suggests a more inward-turning person, Cabanel's portrayal, painted at the earliest and perhaps most promising stage of Bruyas's project to advance modern art singlehandedly, suggests a youthful self-confidence that is hard to attribute to the subject of most of the portraits that were to follow.

The choice for his first commission of an artist who was still completing his training implies that from the outset Bruyas sought painters who were open to the idea of collaboration. That he chose a *pensionnaire* at the Villa Medici perhaps also indicates a desire to find collaborators who had, or would have, a degree of renown. Although his collection has come to be closely associated with masterpieces by Courbet, the majority of the artists Bruyas favored studied at the highly traditional École des Beaux-Arts, among them eight winners of the Prix de Rome.[5] Like Cabanel, they were practitioners of an academic art directly opposed to Courbet's radical realism.

During the late 1840s and early 1850s, Cabanel was one of Bruyas's closest friends. Bruyas made a second trip to visit him in Rome in 1848 and commissioned three further paintings (see cats. 17–19). In their extensive correspondence, they related the details of daily existence to each other, Cabanel describing parties, the political unrest in Rome, and his efforts to complete his paintings, and Bruyas sending, according to Cabanel's letters, frequent encouragement and "details . . . on [his] hopes, and the current course of [his] life."[6] Bruyas dedicated the 1851 and 1852 catalogues of his collection to Cabanel and to another Montpellier friend Louis Tissié. The families of the two men must also have been on good terms; the artist often asked

16. *Mother of Alfred Bruyas*

1851
Graphite with touches of white gouache on paper
14 x 11 1/8 in. (35.5 x 28.3 cm) maximum (oval);
17 1/2 in. x 12 in. (44.6 x 30.4 cm) (sheet)
Signed and dated at right: Alex.^re Cabanel / 1851
Claparède 1962 records an inscription on the verso of the previous mount, no longer present: Portrait de Mad. Bruyas, née Deidier, mere de M. Alfred Bruyas, par M. Alexandre Cabanel, Montpellier, 1851
Bruyas Bequest, 1876
876.3.97
Exhibited Richmond and Williamstown only

Provenance
Alfred Bruyas, Montpellier (by 1851).

Selected Exhibitions
Montpellier 1989, no. 2.

Selected References
Bruyas 1851, no. 11, as *Portrait de Madame Bruyas mère (croquis)*; Bruyas 1854, p. 24, no. 32, as *Portrait de madame Bruyas mère*; Bruyas 1876, no. 26; Claparède 1962, no. 31.

Bruyas to let the Cabanel family know he was well, and in 1851 he drew a portrait of Madame Bruyas, the collector's mother. This is a simple image, the body lightly and softly sketched in, while greater attention is given to the face, drawn in sharply focused detail. Only the crisp double row of ruffles on her bonnet and her lightly indicated wedding band ornament the sitter's otherwise sober, even severe, appearance. Madame Bruyas's taste for understated dress recalls that of her son, and in writing of the drawing Théophile Silvestre was struck in this and other respects by the family resemblance. He compared Cabanel's portrayal of Madame Bruyas to Delacroix's painting of her son (cat. 45), similarly seated and holding a handkerchief, and he found their somewhat elongated facial features and penetrating but pensive gazes remarkably alike.[7] Cabanel probably made the drawing, inscribed and dated "Montpellier 1851," during a stay in the town after his return from Rome. He soon established himself in Paris, however, and not long thereafter his relations with Bruyas began to diminish. They exchanged letters only rarely after 1850, and perhaps most notably, Bruyas commissioned his last two paintings from Cabanel in 1852. The collector subsequently turned to other artists to promote his vision.
SL

1. Bruyas paid 400 francs. See Doucet MS 216, no. 68, dated "10 Oct. 46" (misdated in a different hand "49"), in which Cabanel wrote to Bruyas, "Your portrait is leaving the same day as my letter, and should be in Montpellier a few days later. . . . As for the value of my work, we will set it at four hundred francs, which you will kindly send to me in Rome." This letter is reprinted in Bruyas 1854, pp. 189–91, where it is clearly dated "10 Octobre 1846."

2. He was awarded second place, but a vacancy at the Villa Medici allowed him to go to Rome along with Léon Benouville, the first-place winner whom Bruyas also befriended and whose *Wrath of Achilles* (cat. 12) he later purchased.

3. Doucet MS 216, no. 68; cited above, note 1.

4. Noted in Chang 1996a, p. 166.

5. These include not only Benouville, Cabanel, and the sculptor Eugène Guillaume, who Bruyas met during his trips to Rome, but also Court, Didier, Hippolyte Flandrin, Ingres, and Papety, each winners of the Prix de Rome at different periods. See Grunchec 1983.

6. Undated letter from Cabanel to Bruyas, of fall 1847. Doucet MS 216, no. 54. Very few of Bruyas's own letters are known.

7. See the entry on the drawing in Bruyas 1876. In a letter of 4 Mar. 1874, Silvestre commented that, aside from differences of age and gender, he found the representations of mother and son to look almost identical. Doucet MS 215, no. 83.

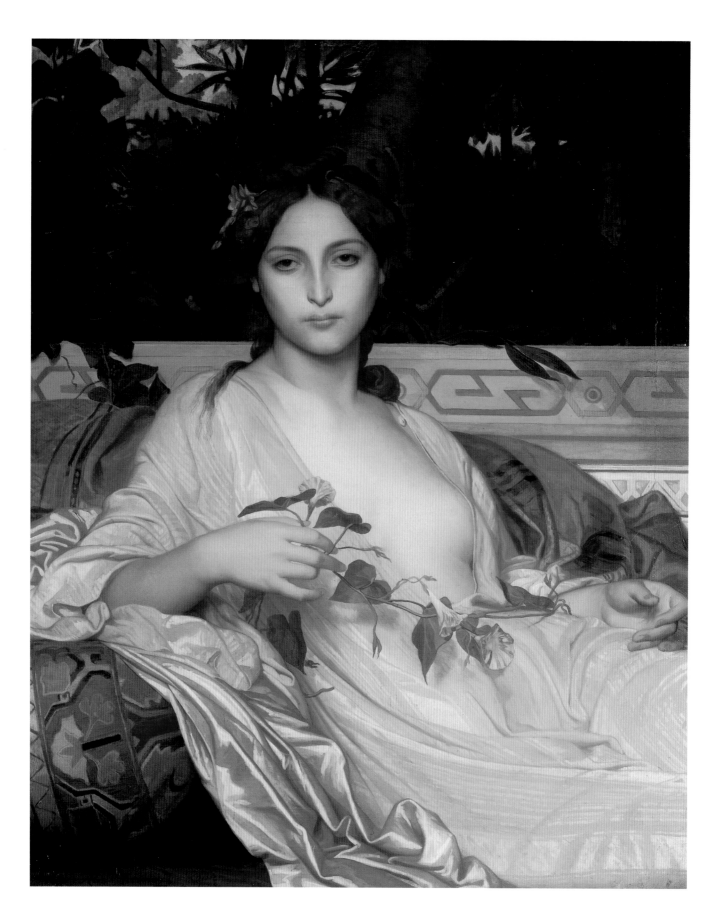

17. Albaydé

1848
Oil on canvas
38 3/16 x 30 11/16 in. (97 x 78 cm)
Signed and dated lower left: Alexandre Cabanel /
Rome 1848
Gift of Alfred Bruyas, 1868
868.1.7

Provenance
Alfred Bruyas, Montpellier
(purchased from the artist, 1848).[1]

Selected Exhibitions
Montpellier 1860, no. 43, as *Albaydé (Orientale)*,
lent by Bruyas; Paris 1900, no. 71; Paris 1939,
no. 14; Rome 2003, no. 175, ill. p. 325.

Selected References
Bruyas 1851, no. 7; Bruyas 1852, no. 7; Bruyas 1854,
no. 35; Bruyas 1876, pp. 144–45, no. 21; Haedeke
1980, pp. 39–42; Montpellier 1985, p. 99, no. 15,
ill. p. 110.

Fig. 1. Léon Benouville,
Esther (detail), 1844. Oil on canvas.
Musée des Beaux-Arts, Pau

If the first room of the Musée Fabre's Bruyas galleries was installed to showcase Courbet's *The Meeting* (cat. 30), the second room presented a different aspect to the visitor. Although dominated by Courbet's *Bathers* (cat. 28), the paintings designated for Room Two produced an intriguing visual dialogue from the juxtaposition of the Realist school and proponents of the "high art" of the French Academy, as represented by artists who trained at the Villa Medici in Rome. Academic conservatism is epitomized by Benouville's *The Wrath of Achilles* (cat. 12) and three works by Alexandre Cabanel: *La Chiaruccia, A Thinker—Young Roman Monk*, and *Albaydé*. These paintings date from Cabanel's years at the French Academy in Rome, and, while not conceived as a threesome, they quickly became known as "the triptych."

Cabanel won the Prix de Rome under most unusual circumstances. Having first studied with the Montpellier artist Charles Matet (1791–1870), curator at the Musée Fabre, Cabanel received a scholarship enabling him to study in Paris. He entered the École des Beaux-Arts in 1840 and later the studio of François-Edouard Picot (1786–1868). Cabanel's Prix de Rome entries of 1843, 1844, and 1845 showed promise, but he failed to finish in first place. Transcripts of the 1845 jury deliberation show that Cabanel had almost as much

support as did first-place winner Benouville: "The contest is not a battle, it is a solitary combat, and the two champions are MM. Cabanel and Bénouville [*sic*], or MM. Bénouville [*sic*] and Cabanel; because for my part, I must confess that they are of equal worth and that they seem to me to be equally worthy of being crowned."[2] Therefore, a special effort was made to secure a place for Cabanel in Rome; fortuitously, a vacancy at the Villa Medici arose as there was no winner in music that year. So, in late 1845, Cabanel set off for Rome with the brothers Benouville. Cabanel's response to the artistic and social milieu of Italy permeates his early works, but most specifically the three paintings that constitute the triptych.[3]

In 1847 Cabanel received the commission for a pair of paintings from his former acquaintance Alfred Bruyas, who had reestablished contact with Cabanel when he visited Italy himself in 1846. New to the game of art patronage, Bruyas delegated the choice of subject to Cabanel, which delighted the young artist.[4] Cabanel then paired an unlikely duo—a brooding monk (cat. 19) and an exotically alluring woman, which he eventually entitled *Albaydé*. The moral extremes that these two characters represent are underscored through formal devices, including reversed light-dark patterns and contrasting color schemes.

86 CABANEL

18. *La Chiaruccia*

1848
Oil on canvas
38 3/16 x 30 11/16 in. (97 x 78 cm)
Signed and dated lower right: Alexandre Cabanel /
Rome 1848
Gift of Alfred Bruyas, 1868
868.1.6

Provenance
Alfred Bruyas, Montpellier (bought from the artist, 1848).

Selected Exhibitions
Montpellier 1860, no. 42, lent by Bruyas.

Selected References
Bruyas 1851, no. 8, as *Chiaruccia (Modèle de Rome)*; Bruyas 1852, no. 8, as *Chiaruccia (Modèle de Rome)*; Bruyas 1854, no. 33, as *Chiaruccia, modèle de Rome*; Bruyas 1876, pp. 145–46, no. 22; Montpellier 1985, p. 99, no. 14, ill. p. 110; Rome 2003, p. 405, ill. p. 259.

At first Cabanel identified his languid female subject as Nourmahal la Rousse, the eponymous character in a Victor Hugo poem that speaks of the destructive power of love and women. However, prior to delivery, the artist wrote to Bruyas announcing a new title: *Albaydé*, another exotic beauty also taken from the pages of Hugo's *Les Orientales* (1829), a collection of poems cast in the Arab world.[5]

I sit night and day, my forehead flushed
My cheek streaming with tears,
Since in the tomb Albaydé closed
Her beautiful gazelle-like eyes. . . .

For she was fifteen – she smiled with simple charm,
And loved with pure devotion,
And when she crossed her arms upon her naked breast,
She looked just like an angel![6]

Except for the gazelle-like eyes and nude breast, the fifteen-year-old ingénue mourned in the poem seems an unlikely model for the worldly seductress presented in *Albaydé*. But the mood of death that pervades both poems has colored Cabanel's image. Based on the voluptuous nudes of Ingres, this figural type appeared frequently in contemporary French art, including Thomas Couture's *Romans of the Decadence* (Musée d'Orsay, Paris), the smash hit of the 1847 Salon, and Eugène Delacroix's *Women of Algiers in their Apartment* of 1834 (Musée du Louvre, Paris), a later version of which is in the Bruyas collection (cat. 44). But more precisely, Cabanel's composition is a refinement of Benouville's *Esther* (fig. 1), seen by Cabanel at the 1844 Salon. Esther, protagonist of the Old Testament book of the same name, was the Jewish wife of the Persian king Ahasuerus. Fearing persecution, Esther hid her religious faith from the king and court, only to reveal it later in an effort to save the Jews from general slaughter. Benouville's modestly clothed Esther is the biblical heroine, her exotic surroundings appropriate to a story set in the Middle East. Cabanel has removed the sanctioning biblical context, accentuating the woman's sexuality and delighting in the expanse of luminous skin against which the heart-shaped leaves of the morning glory play. Cabanel also shifts the gaze so that his figure confronts the viewer. With hooded eyes, Albaydé seems to offer some narcotic pleasure.

While Bruyas designated the woman portrayed in *La Chiaruccia* as a Roman model, he specifically noted that the model for *Albaydé* came from Trastevere.[7] As Carol Ockman noted in her discussion of Ingres's 1848 portrait of Baroness de Rothschild (Private collection, Paris), this statement can be, and would have been at the time, understood as coded language.[8] The reference to Trastevere—the Roman district inhabited since ancient times by Near Eastern commercial communities, including Jews—identifies Cabanel's model as Jewish. In fact, the precise combination of oriental beauty and sensuality found in the *Albaydé* conformed to an ethnic stereotype widely accepted at mid-century. Many examples from contemporary literature seem more suited to Cabanel's characterization than the Hugo poem, such as this passage from Balzac's *Illusions perdues* (1837): "Coralie was the sublime type of the Jewess, the long oval face of a blond ivory tone, a mouth red like pomegranate, a thin chin like the edge of a cup. Under eyelids burnt by a jet-black pupil under curving lashes, one sensed a languid gaze where the heat of the desert sparkled. These eyes shaded by an olive circle were topped by arched brows . . . beauty of a truly oriental poetry."[9]

In Cabanel's *Albaydé*, the sensuous atmosphere created by the bared female form and the direct gaze is augmented by several formal, artistic elements, including a sophisticated control of hue in the tone-on-tone fabrics and the repetition and coordination of the tertiary colors throughout the decorative components—flowers, draperies, and patterned pillow and architectural backdrop. Cabanel's change of title from one beautiful woman to the next suggests that he was not invested in a precise iconography. Rather, and not unlike Hugo's remark that *Les Orientales* was something "useless" and of "pure poetry," Cabanel's interest lay in creating a mood through the sheer beauty of his formal means—line, color, and pattern.[10] Such an attention to surface effects at the expense of a recognizable storyline would become part of the visual vocabulary of "art for art's sake" of the next decade.

The remaining components of the triptych, *A Thinker—Young Roman Monk* and *La Chiaruccia*,[11] present colorful Italian types that had been popular with artists since the seventeenth century. Such figures belonged to a repertoire of picturesque, contemporary stock characters that formed a "sort of anecdotal corollary to the noble ruins of antiquity."[12] Like postcards, such Italianate paintings evoked the charms of the Italian peninsula. Several French artists specialized in

this genre, including Jean-Victor Schnetz (1787–1870), director of the French Academy in Rome at the time of Cabanel's arrival at the Villa Medici.

A Thinker—Young Roman Monk and *La Chiaruccia* form a natural pair, their forthright characterization at odds with the sphinx-like beauty of *Albaydé*. The monk, self-contained, stationary, and brooding, stands before a cityscape that juxtaposes pagan and Christian monuments. In contrast, the "delicious"[13] *Chiaruccia*, who turns and looks over her shoulder to engage the viewer, seems to embody an idealized conception of Italian agrarian life. Following Bruyas's arrangement,[14] the Cabanel triptych celebrates three aspects of life—the communal arena of "work," the spiritual realm of "religion," and the physical world of human "love." In the context of the second room of the Bruyas galleries in 1868, the triptych represents the style of an entrenched academic hierarchy, which itself had, like *Albaydé*, slipped into decadence. **LFO**

19. A Thinker—Young Roman Monk

1848
Oil on canvas
35 7/16 x 27 15/16 in. (90 x 71 cm)
Signed and dated lower left: Alexandre Cabanel / Rome 1848
Gift of Alfred Bruyas, 1868
868.1.5

Provenance
Alfred Bruyas, Montpellier
(bought from the artist, 1848).

Selected Exhibitions
Montpellier 1860, no. 41, lent by Bruyas;
Rome 2003, no. 110, ill. p. 259.

Selected References
Bruyas 1851, p. 7, no. 6, as *Un penseur, un jeune moine*; Bruyas 1852, p. 25, no. 6, as *Un penseur, un jeune moine*; Bruyas 1854, p. 11, no. 1, as *Un jeune moine, pauvre de Jésus-Christ*; Bruyas 1876, pp. 143–44, no. 20; Haedeke 1980, p. 42; Montpellier 1985, p. 98, no. 13, ill. p. 110.

1. In a letter to Bruyas of 27 June 1848 Cabanel mentioned that he would send this painting along with the two related works (cats. 18 and 19): "Je les laisse secher encore huit ou dix jours et je vous enverra tout cela comme vous avez demandé." Doucet MS 216, no. 56.
2. Delécluze in *Journal des Débats*, 25 Sept. 1845, p. 3; translated in Washington 1984, p. 99. Further commentaries are quoted at length, pp. 99–102.
3. For Sylvain Amic's excellent discussions of the three works, see Rome 2003, pp. 404–6.
4. Cabanel expressed his thanks in a letter of fall 1847. Doucet MS 216, no. 54.
5. Cabanel added the words "mon amour" (my love) between the lines of his letter, perhaps intending to translate the name Albaydé. Doucet MS 216, no. 56 (27 June 1848).
6. "Je veille, et nuit et jour mon front rêve enflammé / Ma joue en pleurs ruisselle / Depuis qu'Albaydé dans la tombe a fermé / Ses beaux yeux de gazelle. / Car elle avait quinze ans, un sourire ingénu / Et m'aimait sans mélange / Et quand elle croisait ses bras sur son sein nu / On croyait voir un ange!" From "Les Tronçons du Serpent" (Segments of a Snake), in *Les Orientales*, no. 26.
7. Bruyas 1854, no. 35.

8. Ockman 1991, pp. 521–39.
9. As translated in ibid., p. 537, n. 28.
10. In his preface to *Les Orientales*, Hugo wrote: "of what importance is this useless book of pure poetry?" Hugo 1966, p. 20. This of course is one of the first murmurings of the philosophy of "art for art's sake."
11. Between December 1847 and June 1848 *La Chiaruccia*, a third painting, had been added to the commission. All three are represented in Glaize's 1848 painting *Interior of Alfred Bruyas's Study* (cat. 63).
12. Rome 2003, p. 404.
13. In a letter to Bruyas written at the Villa Medici on 27 June 1848 (Doucet MS 216, no. 56), Cabanel states he had finished *La Chiaruccia* the day before and that she had become "délicieuse." He mentions his figure is based on a model at the Villa Medici; however, in the painting's background waves break against the coastline near Naples, where Bruyas and Cabanel had traveled together in the summer of 1848.
14. When arranging the triptych for display, Bruyas gave *A Thinker* the central position; see Glaize's painting (cat. 63) and the gallery plan for the 1868 installation at the Musée Fabre. This seems to follow the artist's intention, as *A Thinker* is on a slightly smaller canvas than the other two.

20. *Angel of the Evening*

1848
Brown ink, graphite, watercolor, and gouache
on paper
7 5/8 x 9 1/16 in. (19.4 x 23.1 cm),
maximum (arched sheet)
Signed and dated at lower right:
Alex.re Cabanel / Rome 1848
Bruyas Bequest, 1876
876.3.110
Exhibited Richmond and Williamstown only

Provenance
Alfred Bruyas, Montpellier (gift of the artist, 1848).[1]

Selected Exhibitions
Montpellier 1989, no. 21, ill.

Selected References
Bruyas 1851, p. 7, no. 5, as *L'heure de l'Ave Maria, à Rome. Rêverie. Souvenir du Monte-Pincio*; Bruyas 1852, p. 25, no. 5, as *L'heure de l'Ave Maria, à Rome. Rêverie. Souvenir du Monte-Pincio*; Bruyas 1853, p. 44, as *Souvenir du Monte Pincio, à Rome*; Bruyas 1854, p. 11, no. 3, as *L'heure de l'Ave Maria, à Rome. Rêverie. Souvenir du Monte-Pincio*; Laurens 1875, pl. 25 (lithograph after the drawing; reversed); Bruyas 1876, pp. 146–47, no. 23; Claparède 1962, no. 30, ill.

Cabanel wrote to Bruyas in 1848 of the magnificence of the Roman autumn, celebrating the superb weather and the view from his window at the Villa Medici.[2] The artist described his response to the closing moments of the day: "The view of Saint Peter's, silhouetted against the sky after sunset, is always something splendid and irresistibly gripping. One never tires of admiring such beauty."[3] The lovely drawing sent to Montpellier captures this sentiment. Bruyas initially gave the work a long descriptive title that made reference to Cabanel's letter, before settling on a simpler title, *The Angel of the Evening*, for his 1876 catalogue.

The image of a solitary, seated angel had figured in Cabanel's painting *The Fallen Angel* (Musée Fabre, Montpellier), his 1847 *envoi*.[4] In the Bruyas watercolor, Cabanel juxtaposes a contemplative figure and the approaching evening—a conventional motif imbued with a set of traditional associations. Indeed, as William Hauptman has noted, early nineteenth-century images frequently linked "melancholy reverie, the inevitable passing of time, lost illusions, and the evening hours of the day."[5] At the 1843 Salon, for example, Charles Gleyre (1806–1874) had exhibited *The Evening*—alternately known as *Lost Illusions* (Musée du Louvre, Paris); the principal figure, a seated man silhouetted against the evening sky, was quickly recog-

nized as an allegory of melancholy. Cabanel certainly knew this celebrated painting and the similarity of his figure to Gleyre's has been noted.[6]

Cabanel's poetic image embodies the response of the romantic spirit to the powerful sensations of natural and artistic beauty. Flushed with the last rays of the sun, the angel contemplates Rome's physical present and remembered past. Architectural silhouettes punctuate the darkened horizon: the Colosseum of imperial Rome; a medieval tower, perhaps the campanile of the early Christian church of Santa Maria in Cosmedin; and the unmistakable, baroque outline of Saint Peter's. In Rome—the Eternal City—as perhaps nowhere else in Europe, the surviving monuments of successive cultures give material form to the continuum of history. **LFO**

1. In a letter of 9 Sept. 1848 Cabanel wrote to Bruyas, "The title you have given to the little drawing I had the pleasure of offering you indeed fits the purpose for which I made it; I think it suits it well," probably a reference to this drawing. See Doucet MS 216, no. 57.
2. From the Pincian Hill above the Piazza del Popolo, the city stretches out toward the west and the Tiber.

3. Quoted in Bruyas 1876, p. 147.
4. Winners of the Prix de Rome were required annually to send a demonstration work (an *envoi*) to Paris for evaluation. *The Fallen Angel* also happens to appear in an illustration of the 1848 exhibition of these works, reproduced in Rome 2003, p. 140, fig. 2.
5. Hauptman 1978, p. 323.
6. Ibid. Hauptman also discusses Gleyre's sources, including Dürer's *Melancholia*.

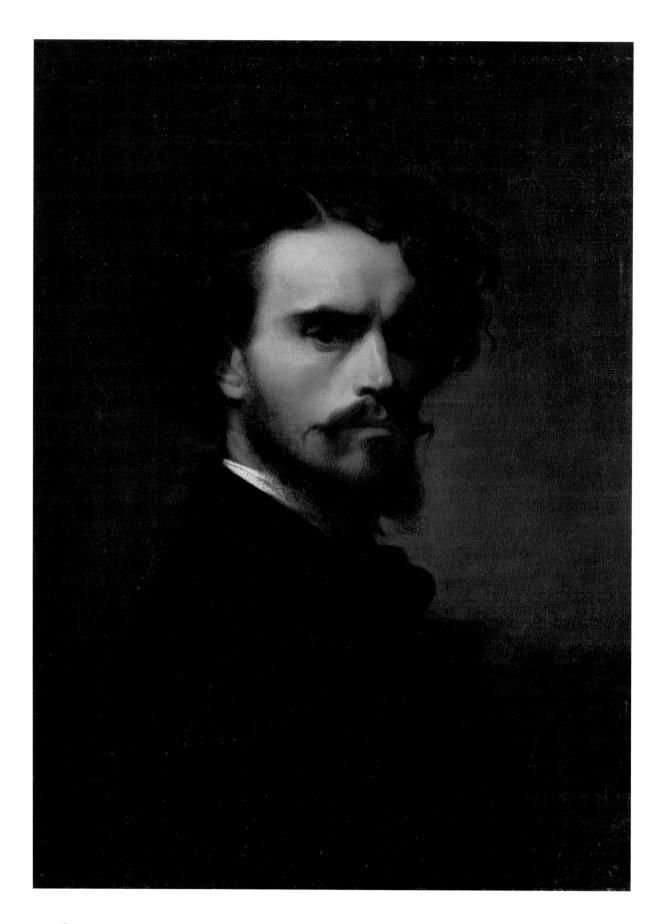

Works by Alexandre Cabanel figure prominently in the Bruyas collection, reflecting a friendship established early in the Montpellier studio of Charles Matet (1791–1870) and strengthened through shared experiences in Rome. Bruyas proved to be Cabanel's first significant patron, commissioning and acquiring several works from the young artist. By 1868, when the Galerie Bruyas opened, Cabanel had established himself in the Parisian art world, holding important positions at the Institut de France and the École des Beaux-Arts and gaining the patronage of Napoléon III.[3] He wielded particular influence as a regular member of the Salon jury and together with Bouguereau (1825–1905) and Gérôme formed the so-called "bourgeois triumvirate," who promoted their own conservative students at the expense of the avant-garde, including the Impressionists.[4] The three shaped official policy and popular fin-de-siècle taste. Cabanel's prominence in the Bruyas rooms reflected both his success as an artist as well as the collector's personal connections with the official hierarchy.

As a Prix de Rome winner, Cabanel added to the collection of self-portraits at the Villa Medici.[5] His own self-portrait is typical, particularly in its light back-ground, fashionable among the *pensionnaires* of the 1840s.[6] The genre obviously fascinated Cabanel, who created a series of self-portraits chronicling his transformation from tentative adolescent to accomplished artist.[7] This initial interest was fed by his visits to the unique collection of artists' self-portraits in the Uffizi in Florence.[8] In a much-quoted letter written from Florence, Cabanel shared with Bruyas his excitement at viewing "sublime" portraits by Raphael, Titian, and Andrea del Sarto.[9]

The present *Self-Portrait*, dated 1852, incorporates the darker palette used by these Old Masters, as well as by the neo-baroque adherents of Romanticism. Cabanel has also exchanged the frontal view and solid, pyramidal form of the Villa Medici self-portrait for a three-quarter pose, the figure partially emerging from a darkened, atmospheric background. Artfully placed but seemingly erratic brushstrokes create an image infused with nervous energy. The light-dark modeling of the face is less aggressive here, but the intensity of the expression is nonetheless confrontational. The viewer feels challenged by Cabanel's image of himself as an artist of romantic intensity and creative verve.

LFO

21. *Self-Portrait (Portrait de l'artiste par lui-même, à 29 ans)*

1852
Oil on canvas
24 9/16 x 18 1/2 in. (62,4 x 47 cm)
Signed and dated lower right: Alex. Cabanel 1852
Gift of Alfred Bruyas, 1868
868.1.9

Provenance
Alfred Bruyas, Montpellier
(gift from the artist, 1852).[1]

Selected Exhibitions
Montpellier 1860, no. 40, lent by Bruyas;
Montpellier 1979, no. 53.

Selected References
Possibly Bruyas 1852, p. 26, no. 10;[2] Bruyas 1854, p. 24, no. 31; Bruyas 1876, pp. 149–50, no. 25; Montpellier 1985, p. 99, no. 17, ill. p. 110.

1. In Bruyas 1854 this is listed as "Son portrait, offert à son ami Alfred Bruyas (Paris, 1852)."
2. Both Bruyas 1851 and Bruyas 1852 list a self-portrait by Cabanel, but since the present work is dated 1852, it seems unlikely that Bruyas owned it in 1851. In a letter of 24 May 1849, however, Cabanel wrote that he would try to begin work on "il ritratto del maestro Stesso [the portrait of the master himself] which you have so graciously asked of me." Doucet MS 216, no. 64. Perhaps Bruyas listed a self-portrait in 1851 in anticipation of a work he had been expecting to receive for two years.
3. Remarkably there is no Cabanel catalogue raisonné. Presently Leanne Zalewski is preparing an extensive study of Cabanel at the Graduate Center, City University of New York. I thank her for her assistance.
4. Albert Boime in Hempstead 1974, n.p.

5. On the collection of self-portraits from the French Academy in Rome, see Rome 2003, p. 201.
6. This work is in the Académie de France, Rome, and is illustrated in Rome 2003, p. 238.
7. For a discussion of Cabanel's early self-portraits, see ibid., p. 404, no. 87.
8. This astounding collection of more than 2,000 artists' self-portraits, begun in 1664 by Cardinal Leopoldo Medici (1617–1675), is housed in the passageway that spans the Arno River, linking the Uffizi with the Palazzo Pitti. During Cabanel's years in Italy, the French Academy was temporarily situated in Florence at the outbreak of civil unrest in Rome, part of the mid-century struggles for Italian unification.
9. Quoted in Bruyas 1876, pp. 149–50.

Paul Chenavard

Lyon 1807–Paris 1895

22. *Dante's Inferno*

1846
Oil on canvas
47 5/8 x 46 3/16 in. (121 x 117,3 cm)
Bruyas Bequest, 1876
876.3.18

Provenance
Alexandre Auguste Ledru-Rollin, Paris (bought from
the artist for 4,000 francs, 1848; returned 1849);
Paul Chenavard, Paris (1849–75, given to Bruyas); [1]
Alfred Bruyas, Montpellier.

Selected Exhibitions
Paris, *Salon*, 1846, no. 363, as *L'Enfer*; Lyon 2000,
no. 40, ill.

Selected References
Sloane 1962, pp. 185–86; Montpellier 1985, p. 99,
no. 18, ill. p. 110.

When Paul Chenavard exhibited *Dante's Inferno* at the Salon of 1846, the painting prompted the following comments by Charles Baudelaire in his review of that year's Salon: "M. Chenavard is an eminently learned and hardworking artist. . . . This year [he] has given further proof of taste in his choice of subject, and of cleverness of drawing. But when you are contending with Michelangelo, would it not be fitting to outdo him in *colour*, at least?"[2] The artist shortly thereafter wrote in a letter to the noted art critic, Théophile Thoré:

This composition, though not overly charming, is truly closely packed and worked out in every sense, in a style hard to achieve, and holds for certain that a lofty style joined to strength is what is most rare. In its case, one can then speak of something other than color. If, in addition, one could show the idlers [my] copious mass of compositions, of more or less finished pictures—and those in the most varied gestures—one would see that if I am not a very hardworking man, I am even less an accomplished lazy one A man must then think of something more than painting, for if he studies nothing else, he will put almost nothing of value on his canvases, and heaven knows there are enough mental daubers.[3]

Both commentaries highlight a number of the peculiarities Chenavard's contemporaries perceived in the artist and his works: a parallel between art and high-mindedness (even a tendency toward a certain preachiness); the suspicion that Chenavard, who was of independent means and did not need to paint for a living, was not working as hard as he could be; the artist's sharp disdain for any criticism of his art based on its lack of superficial color; and his defense of his work as an art that appeals to the mind rather than the eye, which helped explain his disinclination toward the use of bold, attractive, but potentially distracting color.

Chenavard was, indeed, a complex artist and individual. A learned scholar of history and philosophy, he was famous in his day as a thinker as well as a painter, and he resolutely believed in the pedagogical value of art. He was a firm believer in the complex philosophy known as palingenesis, a doctrine based on the belief in the transmigration of the soul and a cyclical interpretation of history that was fashionable in the second quarter of the nineteenth century. His philosophical beliefs are often strikingly reflected in his art. For Chenavard, Dante's *Divine Comedy* served as the interpretation of mankind's penultimate destiny, to be followed by a final ennoblement of humanity that would embrace all peoples of all faiths for all time, completely in accord with his own system of philosophical beliefs.[4]

Chenavard primarily drew from Cantos XXIII, XXV, and XXXIX of Dante's epic poem for his painting. Nonetheless, the artist's aim was not to create a literal illustration of any particular passage from Dante's verses. Chenavard studiously built upon Dante's iconography by adding themes borrowed from classical antiquity to produce a summary of heroic suffering and torment.[5] The composition and the violent contortions of the powerfully built figures immediately recalled Michelangelo to Chenavard's contemporaries. Indeed, the painting echoes the Renaissance master's *Battle of Cascina* and even more closely recalls the *Last Judgment* in the Sistine Chapel, a work Chenavard apparently copied while he was in Rome.[6] General influences from the painters of the Nazarene school in Rome have also been noted; we know, for example, that Chenavard was familiar with the frescoes in the Casino Massimo in Rome, which were painted by Joseph

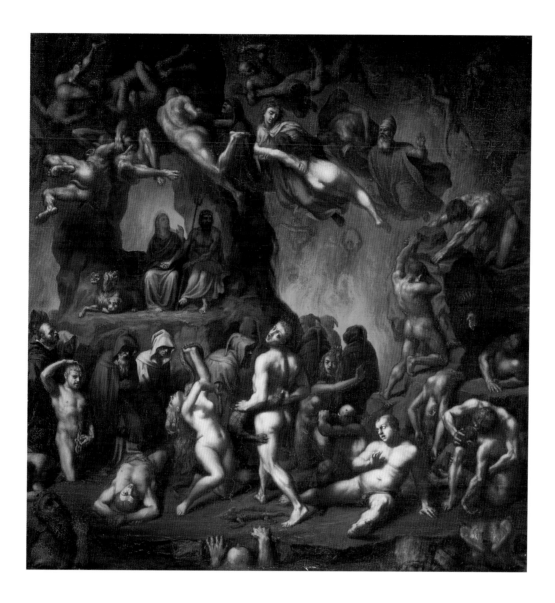

Anton Koch (1768–1839) and prominently feature Dantesque subjects, and he would certainly have known of works by Peter Cornelius (1783–1867), especially after the latter's successes at the Exposition Universelle in Paris in 1855.[7]

Chenavard was not a prolific painter, and this is the only work by him in the Bruyas collection. Although Bruyas generally preferred to maintain a personal association with artists whose work he brought into his collection, and we know that the two had a number of friends in common (Chenavard was a close friend, for example, of Eugène Delacroix, whose works Bruyas avidly collected), it remains unclear whether or not Chenavard and Bruyas ever had any direct relationship. *Dante's Inferno* entered the Bruyas collection through

the agency of Théophile Silvestre, who began working as Bruyas's artistic advisor three years before the painting entered the collection. It is thus conceivable that the acquisition of the painting reflected Silvestre's enthusiasm as much as that of Bruyas.[8] **CCW**

1. See letter from Chenavard to Bruyas, Paris, 25 May 1875 (Doucet MS 216, no. 9).
2. Quoted in Baudelaire 1965, p. 102. The emphasis is original.
3. Chenavard, cited in Sloane 1962, pp. 185–86.
4. As pointed out by Sloane 1962, p. 52.
5. A brief description of the figures Chenavard incorporated in *Dante's Inferno* is found in Lyon 2000, p. 62.

6. See Grunewald 1986, pp. 80–86.
7. See Lyon 2000, pp. 59, 63. For Cornelius's fresco projects, see Büttner 1980; and Büttner 1993, pp. 293–304. For Koch, see Lutterotti 1985. For a general study of the Nazarenes see Andrews 1964 and Bachleitner 1976.
8. Some indication of the transformation the Bruyas collection underwent after Bruyas hired Silvestre is indicated in Chang 1998, pp. 105–20.

Jean-Baptiste-Camille Corot

Paris 1796–1875

23. *Evening (Fishing with Nets)*

c. 1847
Oil on canvas
12 5/8 x 9 1/2 in. (32 x 24 cm)
Signed lower left: Corot
Gift of Alfred Bruyas, 1868
868.1.13

Provenance

Alfred Bruyas, Montpellier
(probably acquired by 1851).[1]

Selected Exhibitions

Possibly Paris, *Salon*, 1847, no. 380, as *Paysage*;[2]
Montpellier 1860, no. 61, as *La Pêche à l'épervier*,
lent by Bruyas; Paris 1939, no. 17; Tokyo 1989,
no. 15, ill.; Paris 1996a, no. 95, ill., as *Fishing with
Nets, Evening*.

Selected References

Probably Bruyas 1851, p. 10, no. 20, as *Paysage*;
Bruyas 1852, p. 29, no. 24, as *Paysage*;[3] Bruyas
1853, p. 29, as *Paysage*; Laurens 1875, pl. 6
(lithograph after the painting; reversed); Bruyas
1876, pp. 157–58, no. 29, as *Effet du soir: la Pêche
à l'épervier*; Robaut 1905, vol. 2, pp. 366–67,
no. 1136, ill., as *Pêche à l'épervier, le soir*;
Montpellier 1985, p. 99, no. 21, ill. p. 111.

This canvas is the more famous of the two works by Corot purchased by Bruyas. Its appearance as "paysage" (landscape) in publications of 1851 and 1852 suggests that, since it did not need to be identified more precisely, it was also the first of the two he purchased. Bruyas identified the small work as having been exhibited in the Salon of 1847, quoting the lengthy description by Théophile Thoré of a painting by Corot in the catalogue of his collection published in 1876. Yet, Michael Pantazzi has conclusively proven that the Bruyas painting did not appear in this Salon, and even a cursory reading of Thoré's eloquent description in his review makes this clear. The work in no way first seems to be a "confused sketch," as Thoré began one sentence, and the viewer certainly does not "plunge into a diaphanous fog which floats on the water, merging far, far away into the greenish touches of the sky at the horizon."[4]

What is remarkable about this otherwise unremarkable painting is that it was one of Bruyas's earlier purchases, acquired around 1850, suggesting that, as a collector, he was already warming to the landscape aesthetic of the generation of 1830, of whom Corot was the most important member. Pantazzi even suggests that the confusion of the work with the Salon painting of 1847 perhaps suggests that Bruyas purchased it in that year, well before the 1848 revolution and the radical Salon of 1849. Yet, this is surely not the case, as Bruyas didn't make his first trip to Paris until December of 1849. In any case, its modesty and its suggestion of a quotidian activity in the Île de France give us no hint of the shift that was to come in Bruyas's taste in 1853, when he became a radical patron of radical art. **RB**

1. In Bruyas 1851, no. 20 is listed as "Paysage." According to records at the Musée Fabre, the designation refers to this work.
2. See Paris 1996a, for a discussion of this question; it seems likely that the present work was not exhibited in this Salon.
3. Annotated in both 1851 and 1852 "Paris 1851," presumably indicating the date of purchase.
4. Thoré quoted in Bruyas 1876, pp. 157–58.

24. *Morning, Fog Effect*

1853
Oil on panel
9 7/8 x 13 3/4 in. (25 x 35 cm)
Signed lower right: Corot
Gift of Alfred Bruyas, 1868
868.1.14

Provenance
Alfred Bruyas, Montpellier (by 1853).

Selected Exhibitions
Possibly Paris, *Salon*, 1853, no. 289, as *Matinée*;
Montpellier 1860, no. 60, as *Effet de brouillard*,
lent by Bruyas; Paris 1939, no. 18; Trento 1993,
no. 128, ill., as *Il cavaliere, sole al tramonto (Mattino)*;
Montpellier 1996, no. 45, ill. p. 98, as *Matinée*.

Selected References
Bruyas 1854, p. 26, no. 42, as *Paris brouillard
(paysage)*;[1] Bruyas 1876, p. 158, no. 30, as *Effet de
brouillard*; Robaut 1905, vol. 2, pp. 378–79, no. 1201,
ill. (after a drawing by Robaut), as *Le cavalier, soleil
levant*; Montpellier 1985, p. 99, no. 22, ill. p. 111.

The second work by Corot acquired by Bruyas, this small panel may have been purchased after the Salon of 1853, where it has long been thought to have made its first appearance under the title *Matinée* (Morning). It would be wise, however, not to accept this notion unequivocally. Anyone familiar with the modern Corot literature knows the perils of precise identification of paintings in Salons and exhibitions held during the artist's lifetime. In fact, Corot's paintings have been subjected to title changes so often that any hope of retrieving an "original" title is slight. Even this modest work, when it made its first documented appearance in 1860 at the Salon de Montpellier, was entitled *Effet de Brouillard* (Fog Effect), and there would have been no reason for a change in title if Bruyas himself bought it at the Salon.

Effects of natural phenomena like sunrise, sunset, wind, fog, or hoar frost were highly prized among connoisseurs of Romantic landscape painting. This is surely understandable because they are of such short duration and, hence, difficult both to observe and to entrap pictorially. The present work has been consistently admired since its gift to the Musée Fabre in 1868. Bruyas himself is quoted as saying that Corot made this "little masterpiece," although he was not a "little master." And its characteristic style and small scale prompt-

ed one writer in the 1930s to refer to it as a "calling card."[2] The warmth of the light-filled fog does indeed make one think of a morning effect, before the fog has burned off in the heat of the day. The view of a distant city with three domed churches shrouded in morning mist is evocative at once of Rome and Paris, and Corot surely intended this ambiguity. The eventual identification of the three domes as the Invalides, the Panthéon, and Val de Grâce viewed from the hills around Sèvres is not crucial to the understanding of an image that emphasizes atmosphere more than precise location. And a casual viewer is almost encouraged to think that the figures are peasants from the Campagna Romana looking at their holy city.

Interestingly, the painting has recently been published as a work of the late 1860s and related to a landscape by Corot in the Taft Museum in Cincinnati, Ohio.[3] Given its exhibition in 1860 in Montpellier, this is not possible, although this type of atmospheric landscape is a subject Corot returned to often throughout his career. **RB**

1. Annotated "1853," presumably indicating the date of purchase.
2. Espezel 1939.

3. *Outside Paris: The Heights above Ville d'Avray* (1931.454). Taft 1995, vol. 1, p. 250.

Gustave Courbet

Ornans 1819–La Tour de Peilz 1877

25. *Portrait of Baudelaire*

c. 1848
Oil on canvas
20 7/8 x 24 in. (53 x 61 cm)
Signed lower left: G. Courbet
Bruyas Bequest, 1876
876.3.21

Provenance
Auguste Poulet-Malassis, Paris (bought from the artist,
1859; sold to Bruyas, Apr. 1874);[1] Alfred Bruyas, Montpellier.

Selected Exhibitions
Paris 1855a, no. 8; Paris 1939, no. 21; Paris 1977, no. 15, ill.;
Montpellier 1985, pp. 45–46, no. 7, ill., and p. 99, no. 24.;
Brooklyn 1988, no. 7, ill.; Paris 1993b, no. 109, ill. p. 194;
Munich 1996, no. B27, ill.; Besançon 2000, no. 76,
ill. (overall and detail); Ornans 2002, ill. p. 73; Tochigi 2002,
no. 2, ill.

Selected References
Fernier 1977, vol. 1, pp. 70–71, no. 115, ill.; Bowness 1977,
pp. 195–97; Fried 1990, pp. 116, 167, 220, 252, fig. 65;
McPherson 1996, pp. 223–36, fig. 1 and ill. on cover;
Haddad 2000, pp. 19–24, ill. p. 18; McPherson 2001,
pp. 16–37, fig. 4.

This small portrait of the great poet-critic Charles Baudelaire was the final work by Courbet to enter the Bruyas collection. Bruyas's friend and advisor Théophile Silvestre visited its first documented owner, the publisher Auguste Poulet-Malassis, on 26 April 26 1874, to persuade him to sell the painting and to agree upon a price. Although the painting's provenance is largely known, certain aspects of its earliest history remain unclear, for it seems that Baudelaire himself never owned the work. Alan Bowness wrote that "the portrait is an arresting image, but it pleased neither the painter nor the poet, who rejected it as a gift."[2] Unfortunately, this assertion is undocumented, as are most aspects of the relationship between Courbet and Baudelaire.[3]

Scholars have long argued about when the portrait might have been painted. In 1869 Félix Bracquemond made an etching after the portrait, which he inscribed "painted in 1848," while its first appearance in Courbet's 1855 Pavillon du Réalisme listed the painting with a date of 1850.[4] The poet Paul Valéry, in his catalogue on the masterpieces of the Musée Fabre published in 1939, suggested a span of 1848–50, but later scholars have pushed the date back further, to the late part of 1846 or early 1847, when the two men seem first to have met.[5] Toussaint tentatively suggested a date of 1847, when Baudelaire is known to have cut off his long hair and appeared shorn in the manner of Courbet's representation.[6] In fact, there is little that documents their encounters during the late 1840s. We know that the two friends witnessed the radical uprisings of February 1848 together, but nothing of this portrait suggests political engagement of any sort, and it is therefore unlikely that the painting is related to the February revolutions.

The friendship of Baudelaire and Courbet cooled considerably in the early 1850s; moreover, the style of the painting has much more in common with Courbet's portraits of 1847–50 than it does to the work of the next decade. It is also clear that Courbet had the portrait in his possession in Ornans in 1854, when he painted a similarly posed and identically "young" Baudelaire in *The Painter's Studio* (Musée d'Orsay, Paris). Taken together, these points support the idea that the painting was made in 1848 or 1849 and that Courbet retained it until he sold it to the publisher in 1859, as records indicate. Finally, as Anthea Callen noted, the painting was left unfinished by Courbet at a relatively advanced stage; one might therefore infer that it was signed later, perhaps only when it was sold by the painter.[7]

Courbet represents the poet alone in a small room. He appears to be seated near a desklike table on which rests a portfolio, a sheaf of papers, and a leather-bound book next to an inkwell with a sprightly white feather pen. Baudelaire is reading a large, worn book (suggesting a historical text of some length and authority), and holds an unlit pipe in his mouth. His left hand rests on a large upholstered chair, sofa, or cushioned daybed, whose soft, warm orange pillows fill the lower right of the composition. The poet's actual position is ambiguous. Is he sitting on the orange upholstered object or an invisible chair or stool behind it? Is the curved orange form near his legs the arm of the upholstered furniture? Courbet is said to have commented on his difficulties in finishing the painting, stating, according to the writer Champfleury, that "I do not know how to finish the portrait of Baudelaire; his appearance

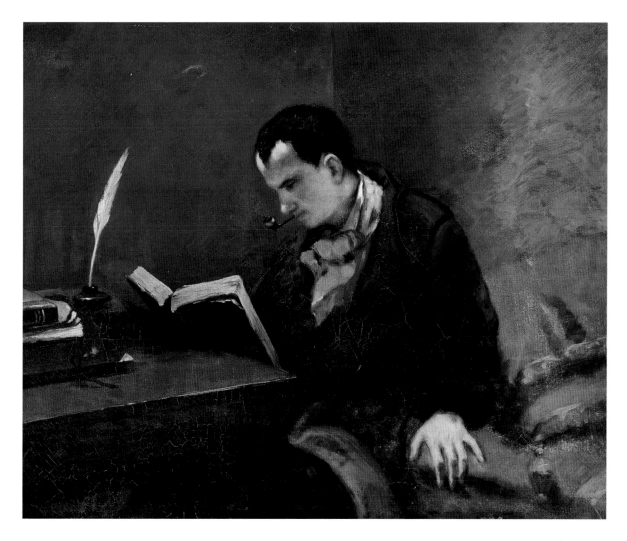

changes every day"—a remark as revealing of the poet's character as it is of the painting's composition.[8]

In many ways, this is an anti-portrait. It seems, instead, to be a realist genre painting representing an intellectual worker in his modest Parisian apartment. There are no luxury items, no works of art on the wall—only necessities, except, perhaps, the large piece of upholstered furniture with its tasseled pillow. Because there are neither light fixtures nor a window, we have no idea whether the painting was intended to represent the artist at night or during the day, but the general spread of light suggests the latter. What does seem clear is that Baudelaire is completely absorbed in his reading, unaware that he is being represented. In this way, the painting in no sense represents the friendship of painter and poet, but, rather, the poet alone, seemingly engaged with others through the medium of words. **RB**

1. In a letter dated 10 Aug. 1859, Courbet wrote to Poulet-Malassis, stating that he had received from him 500 francs in payment for this painting. See Chu 1992, pp. 167–69, no. 59-3. Bruyas purchased the painting from Poulet-Malassis for 3,000 francs. See letter from Poulet-Malassis to Bruyas, 28 Apr. 1874 (Doucet MS 216, no. 114) and receipt dated 12 May 1874 (Doucet MS 216 no. 117).
2. Bowness 1977, p. 195
3. See McPherson 1996, p. 226, who notes (p. 235, n. 39) that since Courbet exhibited the portrait in his 1855 exhibition, he must not have considered it a complete failure.

4. Bracquemond's etching was made to illustrate Charles Asselineau's *Charles Baudelaire, sa vie et son oeuvre* (Paris, 1869). See also Henri Beraldi, *Les Graveurs du XIXe siècle*, vol. 3, *Bracquemond* (Paris: L.Conquet, 1885), no. 13.
5. Paris 1939, p. 21; Bowness 1977, p. 191.
6. Hélène Toussaint in Paris 1977, pp. 91–92.
7. Callen 1980, p. 48.
8. "Je ne sais comment 'aboutir' au portrait de Baudelaire; tous les jours il change de figure." Champfleury, cited in Bowness 1977, p. 195.

26. *Self-Portrait (Man with a Pipe)*

1846–47
Oil on canvas
17 3/4 x 14 5/8 in. (45 x 37 cm)
Signed lower left: G. Courbet
Gift of Alfred Bruyas, 1868
868.1.18

Provenance
Alfred Bruyas, Montpellier
(purchased from the artist, 1854).[1]

Selected Exhibitions
Paris, *Salon*, 1850–51, no. 669, as *Portrait de l'auteur*; Paris 1855b, no. 2807, as *Portrait de l'auteur*; Montpellier 1860, no. 62, as *Portrait de l'auteur*, lent by Bruyas; Toulouse 1865, no. 187; Paris 1867b, no. 80, lent by Bruyas; Paris 1939, no. 20; Paris 1977, no. 19, ill.; Montpellier 1985, pp. 42–43, no. 3, ill., and p. 99, no. 25; Brooklyn 1988, no. 8, ill.; Munich, 1996, no. B26, ill.; Tokyo 2002, no. 1–06, ill., and ill. on cover.

Selected References
Bruyas 1854, p. 40, no. 82, as *Portrait de l'artiste M. G. C. (tête d'étude)*; Bruyas 1876, pp. 168–70, no. 32; Clark 1973, pp. 42–46, pl. 2; Fernier 1977, vol. 1, pp. 24–25, no. 39, ill.; Fried 1990, pp. 76–78, 172, 236, fig. 39; McPherson 2001, p. 21, fig. 5.

Courbet's languorous self-portrait, called *Man with a Pipe*, is an image of intimacy and mystery. The painter's idealized features are bathed in light, while his large, heavy-lidded eyes are cast in dramatic shadow. The pipe is not clenched rigidly but seems to hang from the painter's gently smiling lips, a rather ambiguous visual trope for male vigor. Most arresting is the subject's half-waking state. The painter is lost in dream. We are led to wonder if his mind is clouded in a hashish-derived stupor, or gently transfixed by some erotic fantasy. There is something irritating in these unexplained ambiguities, as though the image folds in upon itself, disguising truths. Théophile Silvestre described the painting thus: "He dreams of himself as he smokes his pipe."[2]

The painting must be considered within two major elements of Courbet's oeuvre: depictions of sleep and the theme of self-portraiture. Aaron Sheon contextualizes Courbet's interest in sleep within popular contemporary scientific notions about the unconscious, dispelling the self-constructed myth of the artist-rustic and providing a clearer understanding of Courbet's engagement with intellectual issues of his time.[3] In an enlightened reading of Courbet's self-portraits, Michael Fried enumerates a set of common characteristics in the early paintings: reverie; exaggerated physical proximity of the painted image both to the picture surface and to the beholder; as well as a contortion of the body so as to avoid the face-to-face confrontation typical of the traditional self-portrait. For Fried, the oddly compelling power of Courbet's self-portrait derives from his deviation from tradition, communicating instead a phenomenological truth of himself, "his bodily liveness," body "as actually lived," "body experienced from within rather than as observed from without."[4]

In this context reverie is not simply sleep; rather it represents "the body's liveness in its simplest, most elemental form—as a 'primordial presence.'"[5] The half-closed eyes, deeply shadowed gazes, averted eyes evoke a "'primordial' or somatic order of activity,"[6] an expression of sensations deeply internal but more elemental or physical rather than psychological or emotional.

In this self-portrait the painter's body is awkwardly contorted, presenting an odd contrapuntal torsion that defies convention and seems to convey something quite basic and physical about the painter's movement back and forth between mirror and easel. The figure is, moreover, pulled close to the picture surface, almost uncomfortably near to the viewer.[7]

Courbet's strangely compelling self-portrait is therefore in many senses a complicated attack upon the conventions of the self-portrait. He works to collapse his roles as painter/beholder/sitter. Courbet wants to achieve something more than a mere representation of himself, desiring rather to communicate his own internal experience, reality from within his own skin.[8] An understanding of this audacious enterprise helps us immeasurably in deciphering the painting and in understanding Courbet's own dramatic words about the picture in his letter to his patron, Bruyas: "It's the portrait of a fanatic, of an ascetic. It is the portrait of a man who, disillusioned by the nonsense that made up his education, seeks to live by his own principles."[9] Courbet's description and his painting are the expressions of a young and ambitious artist who is mightily conscious of the bold program that he has set before himself. **DK**

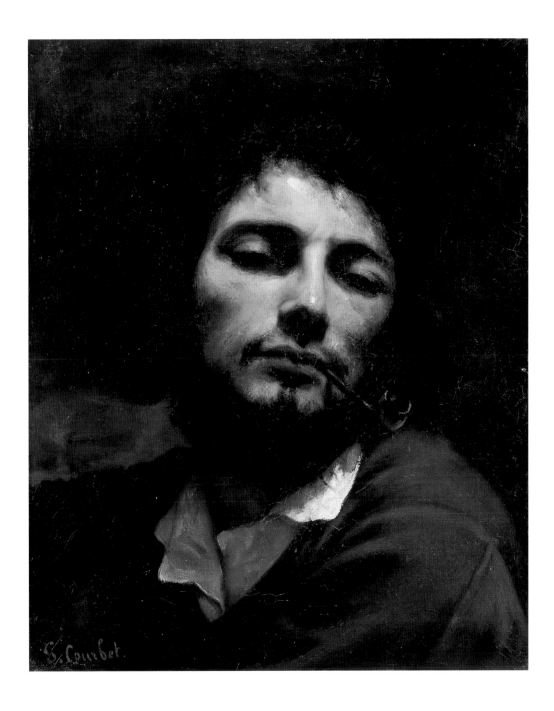

1. See letter from Courbet to
Bruyas, 3 May 1854; Doucet MS
216, no. 94, reprinted in Chu 1992,
pp. 122–24, no. 54-2. Also see letter
from Courbet to Champfleury,
Nov.–Dec. 1854: "my portrait with
pipe, which Bruyas just bought
from me for 2,000 francs"; Chu
1992, p. 133, no. 54-8.

2. Théophile Silvestre, "Courbet
d'après nature," as quoted in
Courthion 1948–50, vol. 1, p. 44.
3. Sheon 1981a, pp. 114–28. An
interesting debate between Linda
Nochlin and Michael Fried is
published in Brooklyn 1988. Nochlin
stresses the gender difference
between the female sleeping

figures—frequently nude—and the
clothed somnolent men.
4. Fried 1990, pp. 64, 65, 78.
5. Ibid., p. 66.
6. Ibid., pp. 76 and 79.
7. Fried points to this often-
repeated phenomenon in Courbet's
treatment of body and interprets
this as an expression of the artist's

questioning the "ontological
impermeability of the picture
surface." Ibid., pp. 75 and 59.
8. Fried describes this perspective
as Courbet communicating "his own
bodily being." Ibid., pp. 69 and 79.
9. Letter of 3 May 1854, cited in
note 1.

27. The Sleeping Spinner

1853
Oil on canvas
35 7/8 x 45 1/4 in. (91 x 115 cm)
Signed and dated lower left: G. Courbet / 1853
Gift of Alfred Bruyas, 1868
868.1.20

Provenance
Alfred Bruyas, Montpellier (purchased from the artist for 2,500 francs, 1854).[1]

Selected Exhibitions
Paris, Salon, 1853, no. 301, as La fileuse; Paris 1855b, no. 2805, as La fileuse, lent by Bruyas; Montpellier 1860, no. 64, lent by Bruyas; Toulouse 1865, no. 188; Paris 1867b, no. 91; Paris 1889, no. 200; Paris 1939, no. 23; Paris 1977, no. 31, ill.; Hamburg 1978, no. 237, ill., pl. 3; Montpellier 1985, p. 51, no. 12, p. 99, no. 26, ill. p. 51; Brooklyn 1988, no. 16, ill.; Munich 1996, no. B31, ill.; Lausanne 1999, no. 34, fig. 1; Besançon 2000, no. 12, ill.; Tochigi 2002, no. 3, ill. (overall and detail).

Selected References
Laurens 1875, pl. 26 (lithograph after the painting); Bruyas 1876, pp. 180–81, no. 35; Fernier 1977, vol. 1, pp. 82–83, no. 133, ill.; Hoffman 1978, pp. 212–22, fig. 6; Fried 1990, pp. 192–94, 196, 197, 205, 241–42, pl. 9; Chang 1996b, p. 590.

Théophile Silvestre, highly critical of Courbet after the painter's involvement in the Commune, referred to The Sleeping Spinner as the "well-behaved" painting of the three that Courbet exhibited at the 1853 Salon.[2] Indeed, in contrast to The Bathers (cat. 28) and The Wrestlers (Museum of Fine Arts, Budapest), The Sleeping Spinner fits far more easily into established iconographic categories; it especially recalls seventeenth-century Dutch genre scenes of figures asleep at their tasks. Silvestre's comment is in fact a critique of Courbet's work in general as much as it is faint praise for the Spinner. Many other critics were more overt in their disparagement, finding the figure heavy and awkward and the colors of the painting somber, though like Silvestre they often praised some aspect of the work. But this depiction of a provincial woman in a plain, if comfortable, interior must have appealed to Bruyas's taste for truth in art just as the realism of The Bathers did. As another writer put it, "we've had enough of these painters of Greeks and we are very happy that someone wants to paint for us peasants as the good Lord made them."[3]

The reading of the woman as a peasant rather than a bourgeoise, possibly modeled by one of Courbet's sis-

ters,[4] overlooks details of the costume and setting that differ substantially from the standard iconography of plainly dressed peasants hard at work. These details seem to point to a less easily categorized person, a woman living in a pre industrial setting with sufficient means to wear a full-skirted, flower-sprigged dress and richly decorative shawl but still perform a task like spinning in a domestic interior that is, she represents a member of an emerging middle class outside the capital, a woman likely to raise controversial issues in the minds of Parisian critics.[5] The interpretation also relates to the general perception of Courbet as a painter of peasants, an artist whose realism consisted of purposely choosing ugly or coarse models for the sake of provocation. Several caricatures published during the painting's numerous exhibitions make clear the equivocal nature of the woman's status. Most portrayed the spinner as dirty and slovenly, with blackened, mitten-like hands, but one showed her as being too elegant for her task, accompanied by the caption "you've given your spinner the hands of a duchess. If that's realism, thank you very much!"[6]

The focus of the painting, however, is less the spinner's social status than her physical state of having just fallen asleep. Courbet regularly depicted sleeping figures, almost always women, most notably in The Sleepers of 1866 (Musée du Petit Palais, Paris). His treatment of the theme of sleep may have been linked to scientific interest in unconscious states prevalent in the 1840s and 1850s, but, perhaps more importantly, it allowed the artist a close, intimate approach to his subject. Such images have clear voyeuristic overtones, implying the woman's availability to being observed unimpeded and suggesting by extension sexual availability—despite, in this instance, the spinner's fully clothed state.

Courbet heightened the work's sensual aspect through his use of lighting and color, as the strongest highlights in the painting fall on the soft folds of the woman's neck, the only place where her body is exposed, and pick up the reddish glints in her hair and the flush in her cheek. Further, the intensely red ribbon, the brightest color in the painting, calls attention to the distaff covered with wool that the spinner has let fall across her lap, to which critics like Michael Fried have ascribed sexual connotations. The wool itself is

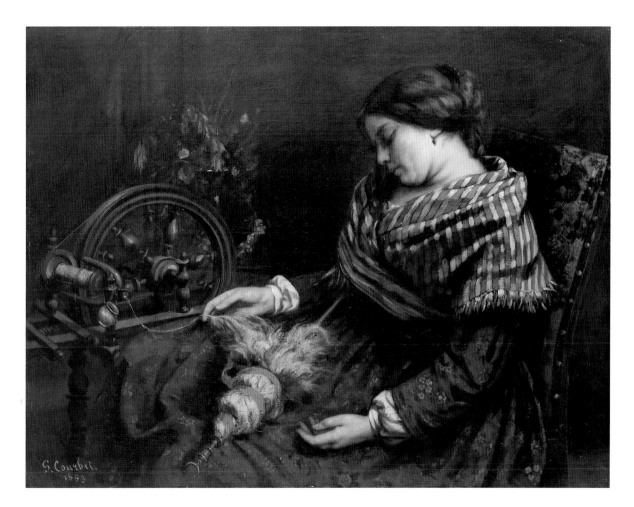

painted with remarkably thick, tactile strokes of paint, qualities underscored by the placement of the spinner's own hand, still resting on her work at the precise point that the wool is spun into yarn. All these elements contribute to the painting's erotic atmosphere.

Judging by Bruyas's intended placement of the work in the Galerie Bruyas at the Musée Fabre, the collector appreciated its sensual as well as its realistic qualities. *The Sleeping Spinner* appears in his plan of the first of three rooms dedicated to the collection,[7] its prominence perhaps an indication of its importance as one of Bruyas's earliest purchases of a work by Courbet. It was hung between Eugène Delacroix's *Women of Algiers* (cat. 44) and his *Aspasie* (cat. 38), a portrait of a dark-skinned woman with partially bared breasts, both paintings with more or less overt erotic content. That he brought these and several similar paintings together in his gallery suggests that they formed a significant component of the complex statement of artistic vision that his collection represented. **SL**

1. The date of purchase of this painting is uncertain. Petra Chu suggests that an offer of 2,000 francs that Courbet rejected before the opening of the Salon came from Bruyas (see Chu 1992, pp. 111–12), though given Bruyas's account of his discovery of Courbet's work at the Salon, this seems unlikely. According to a letter from Silvestre to Bruyas of 1 Aug. 1854, Bruyas wished to purchase this painting in late summer 1854. Silvestre had already tried to place it with another collector, but expected to get it back shortly (see Montpellier 1985, p. 31). By the end of that year, Bruyas had arranged with Courbet to buy the work; see Chu 1992, p. 133, no. 54-8, Courbet to Champfleury, Nov.–Dec. 1854. The painting was only returned to Courbet in April 1855, when it was slated to appear in the Exposition Universelle, with Bruyas acknowl-

edged as the lender. See Chu 1992, p. 139, no. 55-4, 5 Apr. 1855.
2. In Bruyas 1876, p. 181.
3. H. de la Madeleine, *Le Salon de 1853*, quoted in Paris 1939, p. 31.
4. The sitter's identity has not been determined, though writers have proposed both Zoé and Zélie Courbet as possible models.
5. The suggestion that the model was one of Courbet's sisters provides a link to *Young Women from the Village* (1851; Metropolitan Museum of Art, New York), a work that more explicitly investigates issues relating to the rural middle class, and one that met with a storm of criticism when it was exhibited in Paris.
6. Randon, published in *Le journal amusant*, 1867; reprinted in Hamburg 1978, p. 226.
7. Archives municipales de Montpellier; published in Chang 1996b, p. 591.

28. The Bathers

1853
Oil on canvas
89 5/8 x 76 in. (227 x 193 cm)
Signed and dated lower right: G. Courbet 1853
Gift of Alfred Bruyas, 1868
868.1.19

Provenance
Alfred Bruyas, Montpellier (bought from the artist, 1853).

Selected Exhibitions
Paris, *Salon*, 1853, no. 300; Paris 1855a, no. 4, lent
by Bruyas; Montpellier 1860, no. 63, lent by Bruyas;
Paris 1867b, no. 6, lent by Bruyas; Paris 1939,
no. 22; Paris 1977, no. 32, ill; Montpellier 1985,
pp. 47–49, no. 10, and p. 100, no. 27, ill. pp. 16, 48;
Brooklyn 1988, no. 17, ill.

Selected References
Bruyas 1854, pp. 12–13, 32–34, no. 8; Bruyas 1876,
pp. 171–75, no. 33; Farwell 1972, pp. 64–79, ill.;
Fernier 1977, vol. 1, pp. 86–87, no. 140, ill.; Rubin
1980, pp. 14, 23–24, 68–69, 93, fig. 13; Fried 1990,
pp. 164–67, 175, 190–91, fig. 63.

Alfred Bruyas's decision to purchase *The Bathers* marked a major turning point in his collecting career. The painting was one of three works by Courbet accepted at the Salon of 1853, of which Bruyas purchased two, *The Bathers* and *The Sleeping Spinner* (cat. 27), spurning the highly charged painting of near-nude male wrestlers now in Budapest. If the negative reception of *The Spinner* and *The Wrestlers* was relatively muted, *The Bathers* received intense criticism. Perhaps the most infamous—though surely apocryphal—critique was Napoléon III's gesture of striking the painting with a riding crop, as though the principal woman were a horse.[1] If this suggests the figure's animal nature, Edmond About (writing several years later) described her as an inanimate object, "a rough-hewn tree trunk, a solid . . . a woman of bronze," while Théophile Gautier saw her as, among other things, dirty, a remark frequently made about Courbet's figures. Eugène Delacroix wrote of the painting in his journal on 15 April 1853, deriding the "vulgarity and uselessness of the conception," and calling the woman a "fat bourgeoise.[2] Such visceral reactions suggest that *The Bathers* challenged conventions at many levels.

The scale not only of the principal figure but of the painting itself was perhaps foremost among these challenges. Such a large canvas was usually reserved for paintings of history, religion, or mythology. Instead, Courbet presented two resolutely unidealized figures gesturing in ways that seem to suggest some narrative but that ultimately resist any definitive interpretation.[3] Even the social status of the woman was difficult for contemporaries to pinpoint, for while her clothing, carefully depicted on the branches beside her, and her accompanying servant imply the middle-class identity that many commentators attributed to her, no respectable bourgeoise would have actually gone bathing in such a manner. Indeed, details like the earring still worn by the primary figure and the half-shed stocking of the secondary one parallel popular erotic images and hint that the woman was in fact not "respectable."[4] In this sense, part of the critics' discomfort with *The Bathers* perhaps arose not because the subject matter was unfamiliar, but because Courbet alluded to a type common in mass-produced erotica within a high art context.[5] Furthermore, the models he chose did not conform to classical ideals in their proportions: he depicted them with careful attention to the contours and weight of their forms, to the contrast between the pallor of their necks or shoulders and the ruddiness of their faces, and to the dirt still clinging to the bottoms of their feet. Finally, as Delacroix noted, if the landscape was beautifully rendered, it was also worked up from a study made outdoors and combined with a depiction of a model in the studio, a combination whose artifice Courbet made little effort to hide.

For all these reasons *The Bathers* prompted exaggerated critical language, signaling the reviewers' difficulty in assimilating the work to any existing prototypes, and at times simply their horror at the figure's physical presence. Still, almost all of the critics, even the most vociferous, were forced to concede Courbet's painterly skills. "To be fair," Gautier wrote, "this monstrous figure holds some passages of very fine tone, firmly modeled . . . this unfortunate canvas is proof of a great talent gone astray." And About suggested that "men of taste who have overcome their initial repugnance . . . will go to the Louvre in a hundred years to render justice to the *Bathers* by M. Courbet."[6] The artist's virtuoso treatment of the finely modeled bodies and the

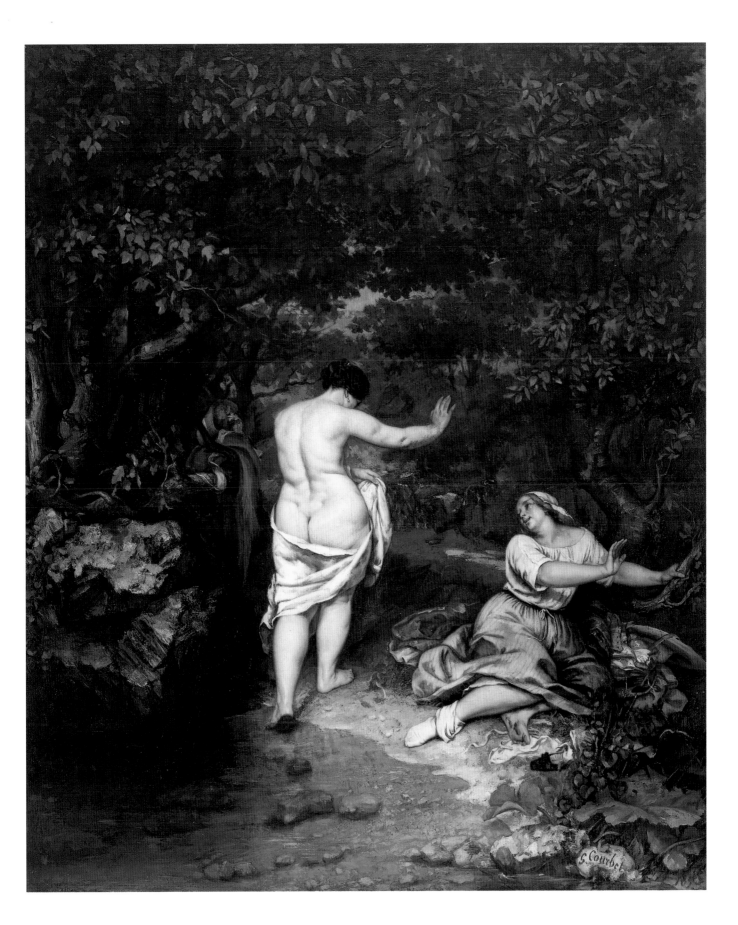

widely varied surfaces and textures of the landscape was evidence of a talent to contend with.

Bruyas purchased *The Bathers*, probably sometime after the opening of the Salon in May 1853, with a full appreciation of its powers to challenge and shock.[7] In fact, he valued the painting precisely for this power. The collector had already sought out Cabanel, Glaize, and Tassaert as collaborators, and Couture and Delacroix as artists with both more naturalistic styles and greater renown. After visiting the Salon, Bruyas realized that Courbet potentially combined all of these qualities, for *The Bathers* embodied his ideals of contemporaneity, truth, and freedom in art. Reprinting and referring explicitly to Gautier's 1853 review, Bruyas labeled the painting the prime example of his "solution," with its "inopportune and afflicting truth," and he said of the artist that he was at liberty, that he "wanted, with his work, to show that emotion still makes hearts beat under the petty costumes of our age. . . . After that, suffer," Bruyas concluded, "the painting *The Bathers* lends support to the solution, the present collection, 1854."[8] But the collector's self-assurance and dedication to his solution proved to be short-lived. Bruyas's ability to recontextualize a negative critique as support for his aims could not be sustained when the subject of criticism was not a Realist nude but Bruyas himself—when, that is, his reputation and collecting habits came under attack after the exhibition of Courbet's *The Meeting* (cat. 30), in 1855. As a result of the change in his opinion of Courbet that this event

prompted, Bruyas's final assessment of *The Bathers*, in his 1876 catalogue, was closer to that of the critics. Bruyas excerpted passages from the same review he had reprinted in 1854, and added other comments that had been published in the interim, but presented them essentially at face value, so that the figure was ultimately a "protuberant creature" framed by "opulent vegetation," however skillfully both were painted.[9] **SL and RB**

1. Toussaint relates the incident in Paris 1977, pp. 117–18, noting that the source of the story was probably Courbet himself.
2. About, "Nos artistes au Salon de 1857," cited in Fernier 1977, vol. 1, p. 86; Gautier, "Salon de 1853," *La Presse*, July 1853, cited in Bruyas 1854, pp. 12–13; Delacroix 1960, vol. 2, pp. 18–19.
3. Writers have long tried to explain the central figure's gesture, from Georges Riat (*Gustave Courbet, peintre*, 1906, cited in Fernier 1977, vol. 1, p. 86), who described her as slipping on the riverbank and putting her hand out to steady herself, to Farwell 1972, p. 75, who suggested that the image derived from a photograph in which the model rested her hand on a prop, to Fried 1990, p. 166, who saw the gesture as conveying a sense of modesty.
4. Philippe Bordes discusses these points in Montpellier 1985, pp. 47–49. Farwell 1972 traces the links between Courbet's *Bathers* and eighteenth- and nineteenth-

century popular prints and photographs.
5. If Courbet likely employed this practice in a general way in the *Bathers* (though Farwell 1972, p. 75, proposes a specific photograph as a possible source), he used popular imagery more directly in other works including *The Meeting* (cat. 30) and *The Sleepers* (Musée du Petit Palais, Paris).
6. Gautier and About, both as cited in note 2.
7. The exact date of purchase is not known, though Bruyas's description of "finding [himself] for the first time in the Salon of 1853 before the *Bathers* by M. G. Courbet and . . . imposing upon [himself] the duty to acquire it," suggests that he purchased it soon thereafter. Bruyas 1854, p. 32.
8. Ibid., pp. 32–34.
9. The phrases come from a review by Edward Géoghéghan, quoted in Bruyas 1876, p. 174. Géoghéghan was probably a pseudonym for Bruyas himself.

29. *Portrait of Alfred Bruyas (Painting Solution)*

1853
Oil on canvas
35 3/4 x 28 3/8 in. (92 x 74 cm)
Signed and dated lower left: G. Courbet / 1853
Gift of Alfred Bruyas, 1868
868.1.21

Provenance
Alfred Bruyas, Montpellier
(commissioned from the artist, 1853).

Selected Exhibitions
Paris 1867b, no. 75, as *M. A. Bruyas*, lent by Bruyas; Paris 1939, no. 24, as *Portrait de Bruyas*; Paris 1977, no. 33, ill.; Hamburg 1978, no. 227, ill.; Montpellier 1985, pp. 51–52, no. 13, ill., and p. 100, no. 28; Brooklyn 1988, no. 18, ill.; Paris 1994b, no. 164, ill. p. 249.

Selected References
Bruyas 1854, p. 30, no. 65, *Portrait de M. Alfred Bruyas (dans les données de Vélasquez, école espagnole)*; Bruyas 1876, pp. 176–79, no. 34; Fernier 1977, vol. 1, p. 88, no. 141, ill.; Rubin 1980, pp. 23–24, fig. 15; Hilaire 1997, pp. 22–24, ill.; Chang 1998, pp. 117–18, fig. 2.

This is Courbet's first portrait of Bruyas, painted in Paris in June 1853, shortly after the collector had purchased *The Bathers* (cat. 28), one of the artist's most notorious paintings, from the Salon of that year.[1] The "meeting" of Bruyas and Courbet at this Salon occurred at a fortuitous moment for both. In the previous five years the collector had commissioned fourteen portraits from five different artists.[2] He had developed collaborative relationships with three of them,

Alexandre Cabanel, Auguste Glaize, and Octave Tassaert, but he continued to search for other artists who could further his goals through their work. During the same period, Courbet's *Burial at Ornans*, *The Stonebreakers*, and *Young Women from the Village* were among the most talked about, and most harshly criticized, works at the Salon, and the artist had begun a long and contentious relationship with the newly formed government of the Second Empire. When

Bruyas saw Courbet's *Bathers* in the Salon, he saw the work of an artist dedicated to the truthful depiction of nature and the human form. By purchasing the painting, and immediately commissioning a portrait from the artist, he was furthering the cause of contemporary art, allowing it to "ground itself and grow in liberty."[3] These are just the sorts of ideals also held by Courbet, who had already begun to express his radical political sympathies and to seek financial support and exhibition opportunities outside those provided by the state.[4]

Despite both men's dedication to the innovative principles of Realism, the present painting is in many respects a conventional portrait. The sitter is shown elegantly dressed, standing nearly full length and turned to the left in three-quarters view. The painting's undefined background and dark tonality recall the style of acknowledged masters of previous eras. Bruyas himself noted this resemblance when he described the work in his 1854 catalogue as a portrait "in the style of Velasquez, of the Spanish school." Nonetheless, certain details give Courbet's depiction a forceful naturalism, from the large vein visible in Bruyas's hand to the bright orange of his beard, which the artist rendered with perhaps the most animated brushwork in the whole composition.

Bruyas rests his hand on a book or portfolio inscribed "Studies in modern art. Solution. A. Bruyas."[5] This points to the source of the alternate title of the painting and serves as the key to the work as a whole: both men's conviction that the support of living artists by private capital was the best way to advance the social and moral mission of contemporary art. The word "solution" was frequently used in the writings of utopian social theorists including Claude-Henri de Saint Simon, Charles Fourier, and Pierre-Joseph Proudhon, whose ideas were adopted to varying degrees by both Bruyas and Courbet. Though Bruyas's formulation of his own views was tinged with mysticism and often difficult to decipher, his unprecedented effort to create a private gallery of contemporary art attests to the strength and sincerity of his convictions. This portrait probably reinforced the usage of the term in their shared vocabulary; in a letter of 17 April 1854, Bruyas wrote to Courbet, "At this very moment, believe me, I promise you our solution *Bruyas-Courbet* is worth more than 100,000 francs,"[6] a concept echoed by Courbet in his reply of 3 May 1854: "it was not we who have met, but our solutions."[7]

This painting, the most formal of Courbet's three portraits of Bruyas, embodies a meeting of the minds, evident not only in its ideological context but also in the depiction itself. The imposing mass of the sitter and his intense gaze place him on an equal footing with the artist and the viewer. Even the artist's signature and the book inscription, presumably written by Bruyas, are given similar prominence. Théophile Silvestre, as part of a larger effort to downplay the significance of Bruyas's many portraits, gave a negative interpretation to this sense of identity between artist and sitter, critiquing the work as being an expression of the artist's own coarse personality. Bruyas's appearance, he wrote, reveals "the invading individualism . . . of the 'Master-painter,' to the point that M. Bruyas is shown as though half part of Courbet."[8] This, however, is a later assessment of a relationship initially based on shared aspirations by a writer who had become sharply critical of the artist. The conceptual encounter this portrait represents appears in more literal form in the painting Courbet produced the following year, *The Meeting* (cat. 30), an image that places the status of artist and patron in a similar delicately calibrated balance.　**SL**

1. The Salon opened on 15 May 1853. A letter of 18 June 1853, in which Courbet asked Bruyas to postpone the date of his sitting for this portrait, gives an approximate date of the painting. See Chu 1992, p. 114, no. 53-5. Bruyas later purchased another painting that had appeared in the same Salon, *The Sleeping Spinner* (cat. 27).
2. Based on the chronological list given in Montpellier 1985, pp. 87–88. This tally omits several drawings and includes a painting of *Christ Crowned with Thorns* by Antoine Verdier, for which Bruyas was the model.
3. Bruyas 1852, p. 20.
4. Courbet was a strong supporter of the radical Republicans during the revolutions of 1848, though he did not himself fight. And as he wrote to a friend in July 1850, after an unsuccessful effort to exhibit his work in Dijon, "even in our so civilized society, I must lead the life of a savage. I must break free even from governments." Chu 1992, pp. 98–99, no. 50-4.
5. This does not represent a published volume, although Bruyas seems to have published a one-page pamphlet in 1853 titled *Solution d'artiste. Sa profession de foi* (Paris, 1853). The only known copy, at the Bibliothèque Nationale, is currently missing.
6. Montpellier 1985, p. 122.
7. Chu 1992, pp. 122–23, no. 54-2, 3 May 1854.
8. Bruyas 1876, p. 177.

30. *The Meeting* ("*Bonjour, Monsieur Courbet!*")

1854
Oil on canvas
50 3/4 x 58 5/8 in. (129 x 149 cm)
Signed and dated lower left: 54 G. Courbet
Gift of Alfred Bruyas, 1868
868.1.23

Provenance
Alfred Bruyas, Montpellier
(commissioned from the artist, 1854).

Selected Exhibitions
Paris 1855b, no. 2803, lent by Bruyas; Paris 1867b, no. 130;[1] Paris 1900, no. 143; Paris 1939, no. 26; Paris 1977, no. 36, ill.; Montpellier 1985, pp. 53–55, no. 15, ill, and p. 100, no. 30; Brooklyn 1988, no. 19, ill.

Selected References
Nochlin 1967, pp. 209–22, fig. 1; Clark 1973, pp. 156–60, pl. 7; Fernier 1977, vol. 1, pp. 92–93, no. 149, ill.; Rubin 1980, pp. 7, 22–23, fig. 17; Herding 1991, pp. 67, 69, 136–38, figs. 30, 56 (detail); Chang 1996b, pp. 586–91, fig. 10; Hilaire 1997, pp. 24–25, 30–33, ill. (overall and several details).

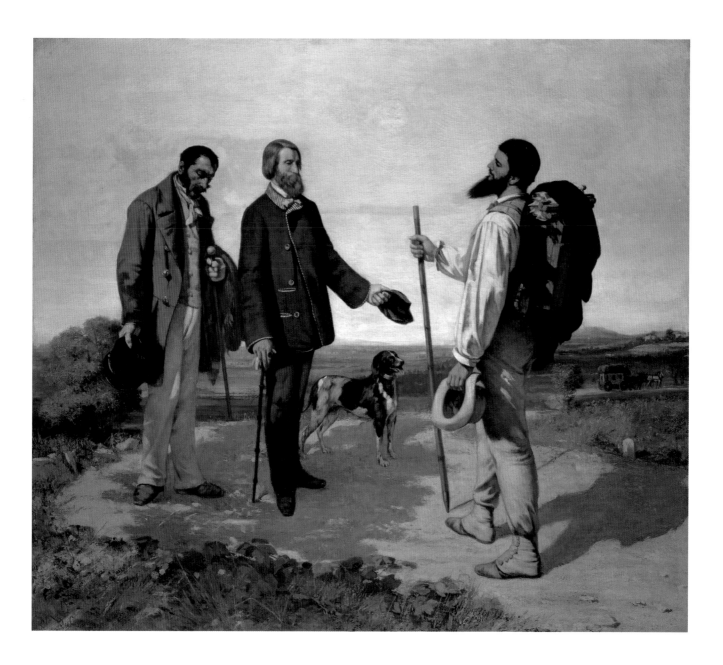

In late May 1854, Courbet arrived in Montpellier at Bruyas's invitation. Although some of the earliest descriptions of this painting, including the mocking review by Edmond About from the 1855 exhibition, suggest that it depicts the moment of Courbet's initial arrival, subsequent investigation has determined that the image more likely shows Courbet's return from a painting excursion somewhat later in his four month stay in the south.[2] The landscape, rendered with great clarity and precision particularly in the foreground, is surely the result of Courbet's careful observation of a particular location, the junction of the roads to Sète and Saint Jean de Védas at Lattes, and the figures are depicted in similar detail. But the meeting of patron and painter is as much conceptual as literal. The subject allowed Courbet to combine portraiture and landscape on a grand scale as he had done in his 1851 *Young Women from the Village* (Metropolitan Museum of Art, New York) and as he would continue to do in paintings such as *Young Women on the Banks of the Seine* (1856–57; Musée du Petit Palais, Paris). In each of these works the artist followed the traditional practice of integrating separate elements into a single painting in the studio. That the composition of *The Meeting* also derives directly from a cheaply produced wood engraving depicting the wandering Jew, a form of popular art that interested Courbet greatly at the time, further supports the understanding of the image as a construction of the artist's imagination rather than as a faithful record of an actual event.[3]

In contrast to the somber palette of his previous portraits of Bruyas (including cat. 29), *The Meeting* is painted in bright, clear tones that capture the sunlight and southern atmosphere of Montpellier. For Courbet, this approach was part of his larger project of realism; while a portrait in an interior or a forest landscape required dark colors and tones to be faithfully rendered, a hot, bright day in the Languedoc could only be effectively conveyed with the intense shades of blue, green, and yellow-white seen in this work. Painting outdoors in order to capture the effects of sunlight on form, however, soon became a goal in itself for other emerging artists. *The Meeting* reveals affinities particularly with the work of Frédéric Bazille (1841–1870), who grew up in Montpellier and knew the painting in the Galerie Bruyas.

The Meeting commemorates and gives visual form to the alliance between artist and collector initiated the previous year. As the exchange of letters leading up to Courbet's visit confirms, both men were eager to pursue their shared philosophy of the private patronage of modern art, if for different reasons. Bruyas wrote to Courbet on 17 April 1854, "Please come, drop everything! . . . If I'm right, we will accomplish everything together."[4] Courbet replied, "I'm ready, I'm leaving for Montpellier. . . . once there I will do everything you wish and everything necessary. I'm in a hurry to leave, for I'm looking forward to the journey, to seeing you, and to the work we will do together."[5] If *The Meeting* represents these aspirations, it also reveals just as clearly the two men's differences. In the same letter of 17 April, Bruyas sent a reproduction of *The Painter's Studio* by Octave Tassaert (cat. 94), a painting that depicts the patron directing the work of the subservient artist, with the annotation, "Dear Courbet, think about it, reflect on the subjects I'm sending you. It's the true poem of modern art." If Bruyas hoped for a similar relationship with his new associate, Courbet balked at the idea of such a role.[6] He made clear his desire to be independent, to "live from [his] art throughout [his] life, without ever straying an inch from [his] principles . . . without ever having to make a painting as big as a hand to please anyone, or to be sold,"[7] even before arriving in Montpellier, and he embodied this viewpoint in the prominence he gave himself in *The Meeting*.

Criticism of the painting, when it was exhibited in 1855, focused precisely on the emphasis Courbet gave to his self-portrait. About referred to the work as "Fortune Saluting Genius," noting that "there is a shadow only for Monsieur Courbet, for he alone can block the rays of the sun,"[8] and a caricature by Quillenbois depicted Bruyas, his servant Calas, and his dog Breton all on their knees before the imperious artist.[9] To a certain extent this criticism is justified, for while each figure's head reaches the same level, Courbet appears taller and closer to the viewer, and his solid physique, forthright stance, and proudly upturned chin contrast distinctly with Bruyas's posture as he balances himself on his cane and doffs his hat in greeting. But the critics' comments should also be understood as a reaction to Courbet's already well-established reputation as

much as a response to the visual evidence of the painting. Certainly Bruyas himself was surprised and even wounded by the negative opinions of this work. He never made the trip to Paris to see the 1855 exhibition, despite several invitations from Courbet, and he wrote an equivocal letter to the artist in August of that year, congratulating him on his success but commenting, "glory to you, dear friend, who for the sake of liberty has sacrificed us for the good."[10] Despite Bruyas's disappointment and Courbet's proclamations of independence, there is a hint that Courbet sympathized and even identified to some degree with the collector, for the jacket that Bruyas wears in *The Meeting* is the same jacket Courbet portrayed himself wearing in his *Self-Portrait with Striped Collar* (cat. 32)[11] and again in his manifesto-painting *The Painter's Studio* (1855; Musée d'Orsay, Paris).

As Ting Chang has demonstrated, Bruyas ultimately had the last word on how the relation between artist and patron should be perceived, at least during his lifetime. He placed *The Meeting* in the center of the first room in his 1868 plan for the Galerie Bruyas, surrounded by the other masterpieces he had purchased. Among these were three more portraits of the collector,

commissioned from Eugene Delacroix (cat. 45), Tassaert, and Courbet himself (cat. 29).[12] Placed in this context, the author of *The Meeting* became simply one of a number of artists who benefited from Bruyas's enlightened patronage, and each painting served as concrete evidence that its creator had indeed made the work to please the collector, and to be sold. **SL**

1. From a handwritten list added to the printed catalogue; listed as "La rencontre, commandé par Mr. Bruyas de Montpellier."
2. Paris 1977, p. 124. See also Montpellier 1985, pp. 53–54.
3. The relation between *The Meeting* and images of the wandering Jew is discussed in Nochlin 1967.
4. Reprinted in Montpellier 1985, p. 122.
5. Letter of 3 May 1854; Chu 1992, p. 123, no. 54-2.
6. Chang 1996b, pp. 588–89, discusses the role Tassaert's painting played in the relation between Bruyas and Courbet.

7. Letter 3 May 1854; Chu 1992, p. 122, no. 54-2.
8. About 1855, p. 205.
9. Published in *L'Illustration*, 21 July 1855; reprinted in Hamburg 1978, p. 209.
10. Letter of 30 Aug. 1855; reprinted in Montpellier 1985, p. 131.
11. Both *The Meeting* and *Self-Portrait with Striped Collar* were shown in the Exposition Universelle of 1855, so this detail could have been noticed at the time.
12. Chang 1996b. The plan is in the Archives Municipales de Montpellier and reproduced in Chang 1996b, p. 591.

31. *The Sea at Palavas*

1854
Oil on canvas
14 9/16 x 18 1/8 in. (37 x 46 cm)
Signed lower right: G. Courbet; dated lower left: 54
Gift of Alfred Bruyas, 1868
868.1.24

Provenance
Alfred Bruyas, Montpellier (acquired from the artist, 1854).

Selected Exhibitions
Montpellier 1860, no. 66, as *Les bords de la mer*, lent by Bruyas; Paris 1867b, not in cat., as *Marine. Méditerranée*, lent by Bruyas;[1] Paris 1939, no. 29, as *Le bord de la mer à Palavas*; Paris 1977, no. 38, ill.; Hamburg 1978, no. 226, ill.; Montpellier 1985, p. 55, no. 16, ill. and p. 100, no. 32; Edinburgh 1986, no. 52, ill.; Trento 1993, no. 156, ill.; Montpellier 1996, no. 46, ill. p. 99, as *Le Bord de mer à Palavas*; Paris 2000b, no. 15, fig. 1.

Selected References
Bruyas 1876, p. 186, no. 38, as *Les Bords de la mer*; Fernier 1977, vol. 1, pp. 94–95, no. 150, ill.; Fried 1990, p. 261, fig. 108.

t is a man who succeeds in spite of wind and tide."[2] This is how Courbet, in a letter to Bruyas written shortly before departing for Montpellier in 1854, described a self-portrait he intended to paint for his patron. We know that the painter had in mind the work that has since come to be known as the *Self-Portrait with Striped Collar* (cat. 32). However, these words, along with further allusions in the same letter to a "man confident in his principles, a free man," apply just as well, one could argue, to the foreground character of the modest *Sea at Palavas*.

The image of the fiercely independent man of ideals was for Bruyas and Courbet a shared passion, and the artist seems to have chosen the gesture of doffing a hat in greeting as one of its visual incarnations. The pose of the lone figure gazing out to sea recalls, if not directly borrows from, the salutations of Courbet and Bruyas in *The Meeting* (cat. 30), and the unidentified figure (probably Courbet himself) in the so-called *Homecoming* (Private collection). The similarity of

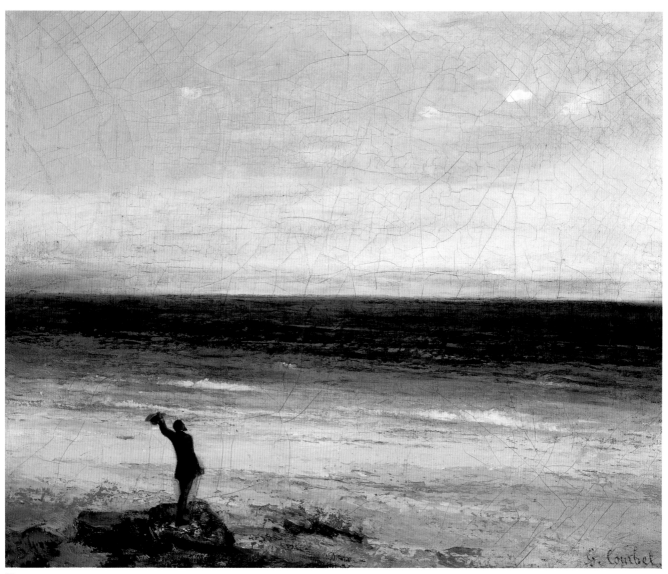

31

these gestures suggests some sort of common purpose or motive.

For many, this ultimate end is Courbet's desire to stage his own defiance toward the world at large. Accordingly, earlier writers identified *The Sea at Palavas*'s lone human being as the artist himself. While Courbet had indeed depicted himself numerous times—a practice that earned him sharp criticism when he exhibited *The Meeting* along with two self-portraits at the 1855 Exposition Universelle—such a reading presents certain difficulties in *The Sea at Palavas*. The figure's cane and jacket more closely recall the costume of Bruyas, and not Courbet, who more often portrayed himself outdoors in the garb of the working artist, as the two other outdoor paintings from this period attest.

Possible confusion over the identity of the figure on the beach becomes less problematic once one realizes that Courbet's defiant attitude is something that he also wished to attribute to his patron. Perhaps this is why the foreground figure seems to combine elements of both personalities, something that could not happen in *The Meeting*, where Courbet made Bruyas's gesture less dramatic than his own so that his patron did not appear to be surpassing the artist at his own game. In *The Sea at Palavas* Courbet grants the figure the full expression of his will, and consequently a much more sweeping wave of his hat than either figure in *The Meeting*.

To render the effects of Mediterranean light, Courbet divided the scene into roughly horizontal bands, each with its own color scheme. The sky (occupying about half of the painting) is light blue and white, the sea blue and gray, the shore ochre and brown. The application of the paint is not nearly as subtle as that of his later seascapes, and perhaps we should consider this work as a first attempt at a manner of working that would come to fruition a decade later. At this particular moment, it seems that Courbet was either approaching the piece as he would a sketch, or else was not yet as adept at rendering light effects and natural texture on such a small scale.

Either way, the noticeably physical handling of paint distinguishes *The Sea at Palavas* from the other marine in the Bruyas collection, Eugène Isabey's *The Storm* (cat. 70), an image that draws upon the clichéd romanticism of an earlier era. Never does one get the feeling in *The Sea at Palavas* of being consumed by a torrent; never does one approach the awe-struck state of the sublime. These were the defining qualities of the romantic seascape, and their absence from the present work makes the invocation of such sentiments seem out of place.[3]

In fact, contrary to more recent opinion, Edward Géoghéghan, a nineteenth-century Montpellier critic, noted his disappointment at *The Sea at Palavas*'s decided lack of romantic feeling, in a 1868 text from the *Le Messager du Midi* which was later republished as part of Silvestre's 1876 catalog of the Bruyas collection.[4] He compared it unfavorably to a poem of Baudelaire's from *Les Fleurs du mal*: "Free man, you'll love the ocean endlessly! / It is your mirror, you observe your soul / In how its billows endlessly unroll— / Your spirit's bitter depths are there to see!"[5] This comparison is quite perceptive, for Géoghéghan implies that what lies at the heart of romantic passion, and what is missing from Courbet's seascape, is a sense of looking at oneself in a mirror. His comments thus align Isabey's and Baudelaire's tempestuous seas with Bruyas's series of portraits, which Champfleury famously derided for their narcissicism.[6] In this light, works like *The Meeting* and *The Sea at Palavas* signal a break with the conventions of romantic painting, not only because they pay closer attention to the physical details of the local surroundings, but also because they suggest that the modern self is the product of an external manifestation in the real world, not of angst-ridden meditation transpiring in the mirror of one's soul. **PG**

1. According to a pencil notation in the catalogue reprinted in Léger 1929, p. 130.
2. Courbet to Bruyas, 3 May 1854, in Chu 1992, p. 122, no. 54-2.
3. See for instance, the young painter's highly romanticized description of his 1841 trip to Le Havre or, in a similar vein, his exuberant 1864 letter to the exile Victor Hugo. Courbet to his family, 1841, in Chu 1992, p. 38, no. 41-2, and Courbet to Hugo, 28 Nov. 1864, in Chu 1992, p. 249, no. 64-18.
4. Bruyas 1876, no. 38, p. 186. On the original publication of this text, see the entry of *The Sea at Palavas* in Montpellier 1985. Géoghéghan was probably a pseudonym for Bruyas himself.
5. Translated by James McGowan as "Man and the Sea" in *The Flowers of Evil* (Oxford, 1993), p. 33. The original (as quoted by Géoghéghan) reads: "Homme libre, toujours tu chériras la mer! / La mer est ton miroir; tu contemples ton âme / Dans le déroulement infini de sa lame; / Et ton esprit n'est pas un gouffre moins amer!"
6. Champfleury, "Histoire de M.T.," *Revue des Deux Mondes*, 15 Aug. 1857, pp. 863–85; reprinted in Montpellier 1985, pp. 141–53.

32. *Self-Portrait with a Striped Collar*

1854
Oil on canvas
18 1/8 x 14 5/8 in. (46 x 37 cm)
Signed and dated lower right: G. Courbet 54
Gift of Alfred Bruyas, 1868
868.1.22

Provenance
Alfred Bruyas, Montpellier
(purchased from the artist, 1854).

Selected Exhibitions
Paris 1855b, no. 2806, as *Portrait de l'auteur*;
Montpellier 1860, no. 65, as *Portrait de l'auteur*,
lent by Bruyas; Paris 1939, no. 27; Paris 1977,
no. 37, ill.; Montpellier 1985, p. 53, no. 14, ill.,
and p. 100, no. 31; Lausanne 1998, no. 1, ill. as
frontispiece; Ornans 2002, ill. p. 83; Tochigi 2002,
no. 4, ill. (overall and detail).

Selected References
Bruyas 1854, p. 39, no. 80, as *Portrait de maître
peintre Gustave Courbet, par lui-même*;[1] Bruyas
1876, pp. 181–83, no. 36, as *Autre portrait de
Courbet, profil*; Fernier 1977, vol. 1, pp. 98-99, no.
161, ill.

Courbet's portraiture claims an iconographic and aesthetic place at the heart of this exhibition devoted to the painter's great patron, Alfred Bruyas. For Courbet, who executed over a dozen major self-portraits in oil, the self-portraits were particularly central to his own artistic enterprise, powerful revelations of his struggle to capture the truth of his own identity.

Self-Portrait with a Striped Collar shows the artist in profile, his face and neck aglow in a bath of golden light, highlighting what he himself described as his "Assyrian profile."[2] A resemblance to figures from the ancient relief sculptures from Nineveh would surely have appealed to Courbet, who deeply appreciated this sense of masterful stylization and noble lineage. In this painting, Courbet wears a jacket with a distinctive striped collar. The same jacket with striped trim appears in *The Meeting* (cat. 30), Courbet's famous depiction of himself and Bruyas—though in that case the jacket was worn by Bruyas, portrayed as the bourgeois patron, while Courbet showed himself as the rugged, itinerant artist. The easily recognizable jacket serves to remind us that this self-portrait was also the basis for the central element—Courbet's depiction of himself at his easel—in his programmatic masterpiece, *The Painter's Studio, A Real Allegory Summing up Seven Years of My Artistic Life* (Musée d'Orsay, Paris), painted a year later. This shared costume seems intended to imply the closeness of their relationship, as though artist and patron are "of the same cloth." Courbet wanted to reinforce their shared participation in the "solution" of which he wrote to Bruyas on 3 May 1854.[3] The portraits and, in a minor but specific way, the jacket reinforce the artist's and collector's conviction in their mutual aspiration for truth in art and life.

In his *Realist Manifesto*, Courbet's introduction to the catalogue accompanying his one-person exhibition in 1855, he explained this moral-aesthetic agenda: "To be in a position to translate the customs, the ideas, the appearance of my epoch, according to my own estimation; to be not only a painter but a man as well; in short, to create living art—this is my goal."[4] One is tempted to couple this search for truth with his preoccupation with the self-portrait. In his 3 May 1854 letter to Bruyas, Courbet described his early self-portraits as autobiography: "I have done a good many self-portraits in my life, as my attitude gradually changed. One could say that I have written my autobiography."[5] We step back, however, from a naive identification of truth and autobiography. Baudelaire had already cautioned against identifying the portrait as purely factual.[6] Taking the poet's lead, we search for the dissimulation, the tension between truth and fiction in this self-portrait. In the same letter, Courbet elucidated the various psychological states reflected in his various self-portraits of this period. The *Self-Portrait with a Striped Collar* is presumably the work that he described as a portrait "of a man confident in his principles, a free man."[7] **DK**

1. This is also annotated "Ornans, 1854," suggesting it was painted after Courbet's return to Ornans from Montpellier that summer.
2. Alexander 1965, p. 451.
3. Chu 1992, p. 122, no. 54-2.
4. Nochlin 1966, pp. 33–34.
5. Chu 1992, p. 122, no. 54-2.
6. Baudelaire, "Salon de 1846," in *Oeuvres complètes*, p. 248, as quoted in McPherson 1996, p. 231.
7. Chu 1992, p. 122, no. 54-2.

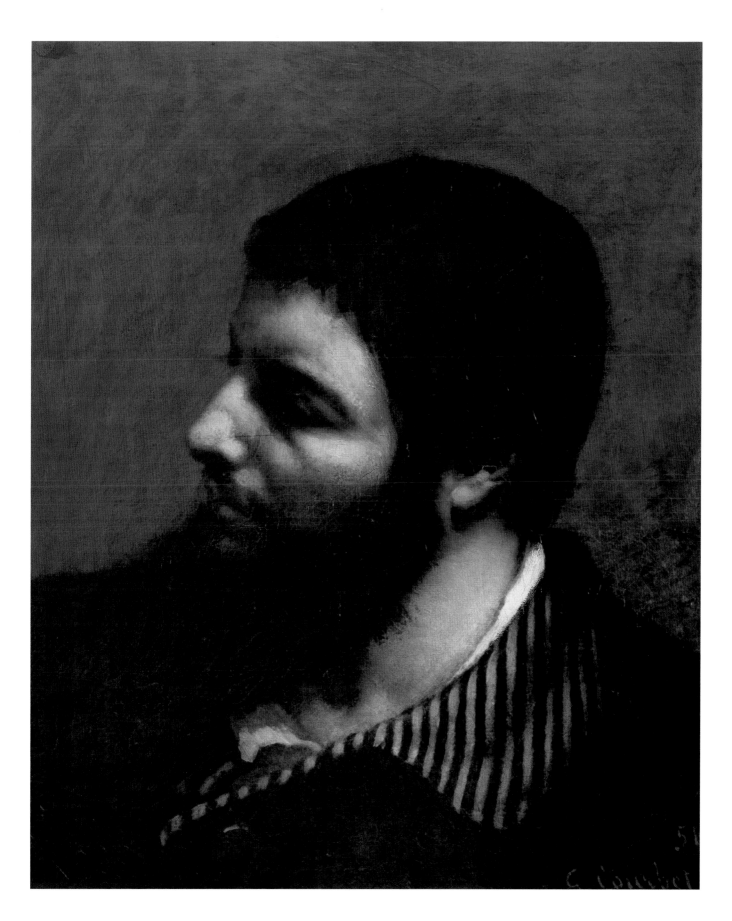

33. Solitude (The Covered Stream)

1866
Oil on canvas
37 x 53 1/8 in. (94 x 135 cm)
Signed and dated lower right: Gustave Courbet 66
Gift of Alfred Bruyas, 1868
868.1.26

Provenance

Alfred Bruyas, Montpellier (purchased from the artist, 1866).[1]

Selected Exhibitions

Paris 1939, no. 31, as *Solitude*; Montpellier 1985, pp. 62–63, no. 29, ill., and p. 100, no. 36; Trento 1993, no. 157, ill.; Montpellier 1996, no. 48, ill. p. 106.

Selected References

Bruyas 1876, pp. 190–91, no. 43, as *Solitude, cours de la Loue (Doubs)*; Fernier 1977, vol. 2, pp. 32–33, no. 583, ill., as *Solitude*.

Solitude is the only painting Bruyas purchased directly from Courbet after the double blow of the critical response to the 1855 Exposition Universelle and Champfleury's satirical article of 1857.[2] The first portrayed Bruyas as a naive and unwitting instrument of Courbet's irrepressible vanity; the second made the patron's own narcissism the object of ridicule. Given such bad blood, why did Bruyas's interest in Courbet reawaken after almost a decade of slumber?

It seems that the renewal of the friendship was driven by the entreaties of Courbet, who in January 1866 wrote Bruyas in hopes that he would help provide for the widow of his friend Pierre-Joseph Proudhon. In the same letter, the painter conveyed his enthusiasm upon hearing a report of Bruyas's possible interest in acquiring a landscape. In response to this news, Courbet wrote that he would gladly offer one of his own paintings in exchange for one of Bruyas's Troyons. A month later Courbet described this promised landscape as "the most beautiful one I have, and perhaps even that I have done in all my life."[3]

It is difficult to know for certain if Courbet truly believed *Solitude* to be his best landscape or rather was exaggerating in order to curry Bruyas's generous favor. This issue is complicated further by the fact that *Solitude* is a copy of a painting acquired for the imperial collection by the Superintendant of the Fine Arts, the Count de Nieuwerkerke, shortly before the renewal of the correspondence between Courbet and Bruyas. Whether the painter was referring to the original or the copy, or merely boasting, others certainly thought highly enough of the canvas to give it considerable praise. Besides the obvious attentions of Nieuwerkerke, it attracted those of Corot and the critic Théophile Silvestre.[4]

The latter's interest is particularly illuminating because, as Ting Chang has argued, Silvestre's initial support for Courbet in the 1850s had eroded considerably by the time of the 1876 publication of the Bruyas catalogue.[5] Despite his general condemnation in this catalogue of the Courbetian landscape as an unnecessarily dark "coal-man's Arcadia," Silvestre did not directly target *Solitude* as an example of this tendency. Whatever the reason for this lack of specificity, his comments nonetheless mark an about-face from his writing of the 1850s, where it was precisely the way in which forms emerged from darkness that made Courbet's painting so appealing. Quoting Courbet, Silvestre wrote: "we are enveloped by the morning fog; things are barely perceptible; the sun rises; forms draw themselves; the sun ascends; the forms illuminate themselves and announce themselves in full plenitude. I do in my paintings what the sun does in nature."[6] One could argue that this process of illuminating forms by means of touches of paint gradually accumulating on the dark brown ground of the canvas is exactly what one witnesses in front of *Solitude*. Contrary to Silvestre, it is not the blackness of coal dust but the darkness of nature's primordial origins that Courbet offers the viewer.

Besides the painting's singular pictorial qualities, Courbet's depiction of a scene from nature must have caught Bruyas's fancy, as the landscape genre was noticeably absent in his collection of Courbet's work (excepting the much smaller *Sea at Palavas* [cat. 31], which unlike *Solitude* does not represent the artist's native province). It was a lacuna that may have weighed heavily on the patron's mind as he was making plans at around the same time for the donation of his collection to the Musée Fabre, especially given Courbet's marked success in this genre during the 1860s. That *Solitude* was a replica of a painting bought by Nieuwerkerke no doubt added to its appeal, and its acquisition by Bruyas thus signals a remarkable change in the attitude of col-

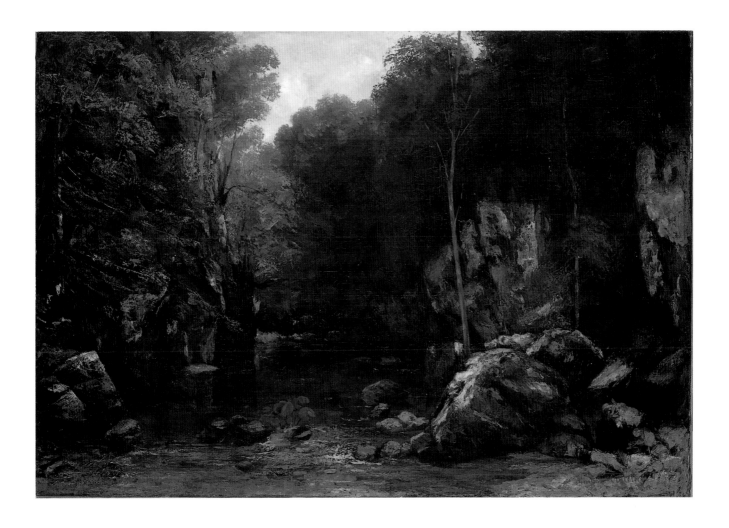

lectors over the course of the Second Empire. Whereas in the heyday of realism Bruyas was more or less a solitary pioneer in his acquisition of Courbet's work, by the time of the public opening of his gallery the list of Courbet's admirers had grown to include, for better or worse, the arbiters of official taste.　**PG**

1. See Courbet to Bruyas, Jan.–Feb. 1866, in Chu 1992, pp. 274–75, no. 66-5; and Courbet to Urbain Cuenot, 6 Apr. 1866, in Chu 1992, pp. 276–78, no. 66-7.
2. Champfleury, "Histoire de M.T.," *Revue des Deux Mondes*, 15 August 1857, pp. 863–85; reprinted in

Montpellier 1985, pp. 141–53.
3. Courbet to Bruyas, Jan.–Feb. 1866, in Chu 1992, pp. 272–75, nos. 66-3 and 66-5.
4. Silvestre in Bruyas 1876, p. 191, no. 43.
5. Chang 1998.
6. Silvestre 1856, p. 270.

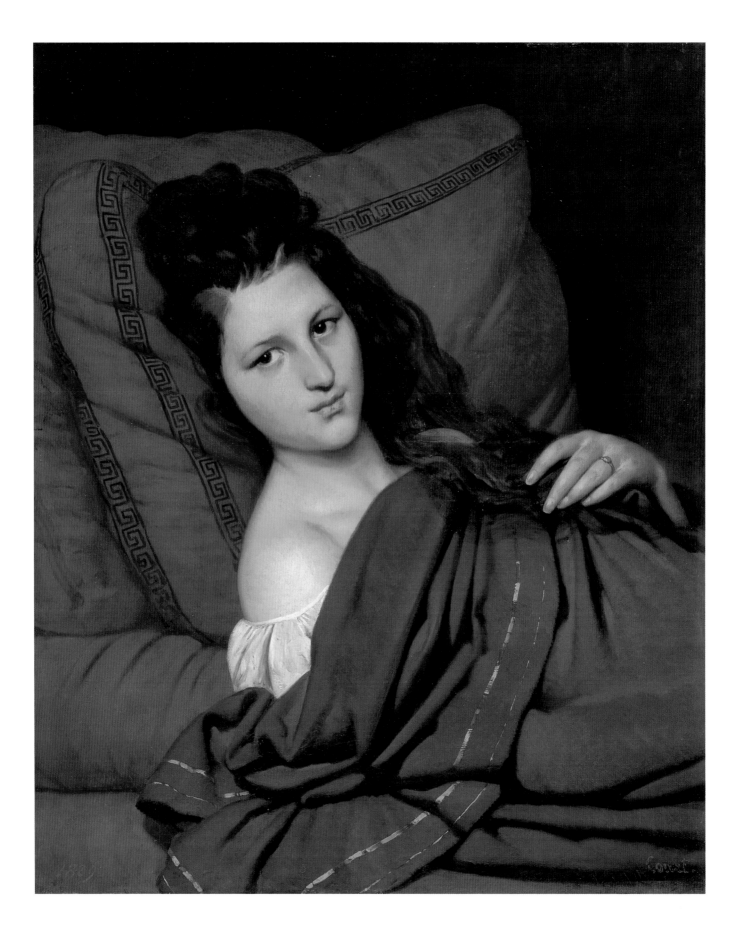

Joseph Désiré Court

Rouen 1797–Paris 1865

34. *Woman Reclining on a Divan*

1829
Oil on canvas
31 1/2 x 25 5/8 in. (80 x 65 cm)
Signed lower right: Court; dated lower left: 1829
Gift of Alfred Bruyas, 1868
868.1.16

Provenance
The artist (posthumous sale, Hôtel Drouot, Paris, 23–28 Feb. 1866, no. 71, as *Jeune femme sur un divan*, sold to Jules Laurens as agent for Bruyas);[1] Alfred Bruyas, Montpellier.

Selected References
Bruyas 1876, p. 199, no. 45; Montpellier 1985, p. 100, no. 38, ill. p. 111.

The model in *Woman Reclining on a Divan* appears in several paintings by Joseph-Désiré Court, including one in the Musée Magnin in Dijon that has been known since 1938 as *Portrait Presumed to Be the Artist's Wife*. As well as sharing identical features—dark brown hair, a long oval face, and a small mouth—the two figures are posed in similarly informal manners, wrapped in a blue-gray cloak or shawl with her chin in her hands in the Dijon painting, and propped against pillows with her drapery and chemise slipping from her shoulders in the present work. The intimacy of these depictions suggests that the model may well have been the artist's wife, a supposition perhaps supported by the presence of a ring on the woman's hand in the Montpellier canvas. Jules Laurens, who bought the painting for Bruyas, left the exact nature of their relationship open, commenting that this oft-depicted model "seems to have been the greatest affection of [Court's] heart and his art."[2] Whether or not the woman's identity is known, the painting emphasizes her sensuality—she is shown caressing her hair as she gazes outward with slightly heavy-lidded eyes—more than her individuality as a portrait subject.[3]

In 1817 Court enrolled at the École des Beaux-Arts, where he studied with Antoine-Jean Gros. In 1821 he won the Prix de Rome, and in 1827 he had his first major success at the Salon with *The Death of Caesar* (Musée du Louvre, Paris), which was bought by the French state. Court subsequently executed several commissions for King Louis Philippe at Versailles and began increasingly to paint portraits for the French aristocracy. Extensive study of classical antiquity was part of standard academic training, and while there is nothing especially classical about the informal composition of *Woman Reclining on a Divan*, the meander pattern that decorates the pillow hints at Court's knowledge of Greek and Roman art. In addition, the allusion to the French tricolor in this painting may reflect Court's status as an official painter, one whose professional identity was bound to his role as portraitist of the ruling class.

Bruyas owned two other paintings by Court, one of them an oil sketch for the celebrated *Death of Caesar*.[4] In the 1868 plan of his gallery, Bruyas placed this sketch next to Courbet's *Meeting* (cat. 30) at the center of the first room, presumably attesting to the esteem in which he held the artist. According to the numerous reviews and commentaries included in the 1876 catalogue of his collection, however, Bruyas valued these paintings as early works of an artist who later wasted his talents. "The best painting by Monsieur Court is the *Death of Caesar*," Bruyas wrote, "his best portrait is *Woman in Blue Drapery Reclining on a Divan*."[5] If these works combine a "virile memory of antiquity"[6] with a directness and naturalness of approach, Court's later work suffered, according to Bruyas, because he gave himself over to the demands of official patronage. Though only alluded to in this context, the collector, by means of his own patronage, hoped to provide to the artists of his day a means of avoiding just such a fate. **LS**

1. Sold for 300 francs. See undated letter from Laurens to Bruyas, Montpellier MS 405, no. 77. In the Montpellier Municipal Library, this letter has been placed between one dated Nov. 1865 and one dated 6 Mar. 1866; in it Laurens clearly refers to the sale of Feb. 1866. "Following all your directives, I went to Paris and I viewed with care the Court exhibition. . . . it is inconceivably below its real value that I was able to get for you, for 300 francs, a half-length painting of a woman lying on a red divan."
2. Bruyas 1876, p. 199.
3. Cabanel's *Albaydé* (cat. 17) has numerous formal parallels to Court's painting and suggests a similar, if more overtly erotic, atmosphere. Cabanel's sitter was identified only as "a model from the Trastevere neighborhood" of Rome, implying that she was Jewish and thereby heightening her exotic nature. Bruyas 1851, p. 7.
4. Musée Fabre (inv. no. 868.1.15). The other is a sketch of *Louis XVI, Marie Antoinette et le dauphin se réfugiant à l'Assemblée législative* (inv. no. 868.1.17).
5. Bruyas 1876, p. 202.
6. Théophile Gautier, in *L'Art moderne* (Paris, 1856), cited in Bruyas 1876, p. 203.

Thomas Couture
Senlis 1815–Villiers-le-Bel 1879

35. *Portrait of Alfred Bruyas*

1850
Oil on canvas
23 5/8 x 19 11/16 in. (60 x 50 cm) oval
Signed and dated lower left: T.C. 1850
Gift of Alfred Bruyas, 1868
868.1.11

Provenance
Alfred Bruyas, Montpellier
(commissioned from the artist, 1850).

Selected Exhibitions
Paris 1939, no. 32; Montpellier 1977, unnumbered.

Selected References
Bruyas 1851, p. 11, no. 21, as *Interprétation de tête, dans les données de Titien*; Bruyas 1852, p. 29, no. 27, as *Interprétation de tête, dans les données de Titien*; Bruyas 1854, p. 14, no. 10, as *Puissante interprétation dans les données du Titien*; Bruyas 1876, pp. 205–20, no. 47; Boime 1980, pp. 411–12, fig. X.12; Montpellier 1985, p. 87, no. 9, and p. 100, no. 40, ill. p. 91, as *Alfred Bruyas de profil*.

This is one of a pair of portraits Bruyas commissioned from Couture in 1850, when the artist was at the height of his popularity as a portraitist. Three years earlier, at the Salon of 1847, Couture had exhibited *The Romans of the Decadence* (Musée d'Orsay, Paris) to great acclaim. Thus when Bruyas, who had left Montpellier in December 1849 to make his first trip to Paris, undertook the search for an artist to paint his portrait, Couture would have been a logical, established choice. Several previous portraits by his fellow Montpellierains Cabanel and Glaize (see cats. 15, 63, 64) reveal not only the sitter's penchant for art collecting but also offer evidence of the friendship between collector and artist.[1] Couture's portrayal, painted under very different circumstances, provides none of this context. It shows Bruyas dressed in a simple dark jacket and white collar in near profile against a plain, nebulous background. Executed with thick brushstrokes visibly pulled across a fairly coarse-weave canvas, the painting seems to have been rapidly executed; the existence of an oil sketch of a nearly full-length standing male nude on the reverse indicates that Couture also reused a canvas he already had in his studio. The simplicity of the depiction might in part reflect the brief and purely professional contact between artist and patron. Nonetheless, the naturalism of Couture's portrait marks a distinct shift in Bruyas's taste away from academicism, and the work represented an element of Bruyas's "solution," his search for truth and freedom in art, that he was soon to find even more powerfully advanced by Gustave Courbet.[2]

In his 1851 catalogue, Bruyas described this portrait as an "interpretation of a head, in the style of Titian," while its pair was "in the style of Vandick" [*sic*]. Bruyas regularly likened paintings in his collection to earlier prototypes such as Titian, Velázquez, or Rembrandt. His judgments are based on certain stylistic qualities in each work, but they are also an effective means of providing his paintings with an art historical lineage. The reference to Titian in this instance draws attention to the painting's relatively light tone and, perhaps, the lack of strong contrast between the sitter's fair skin and the pale olive green background, but seems otherwise less than apt. The profile view, however, does recall earlier Italian portraiture and classical medals and coins, prototypes Bruyas clearly had more explicitly in mind while in Rome in 1848, when he commissioned a bronze medallion with a profile portrait from Eugène Guillaume.[3]

The first part of Bruyas's description is perhaps even more revealing. By calling the portrait "an interpretation of a head," Bruyas downplayed the importance of his own identity.[4] This strategy was part of his approach to contemporary art in general, and portraiture in particular, for he felt that his patronage allowed artists to express their own personality through their art. He made the point explicit in his catalogue of 1853, where he listed the names of the artists who had painted his portrait under the heading "Interpretations. Same Type [footnoted 'M. Alfred Bruyas']; which vary according to the nature of the artist." [5] This perspective in fact coincides with Couture's own opinions on por-

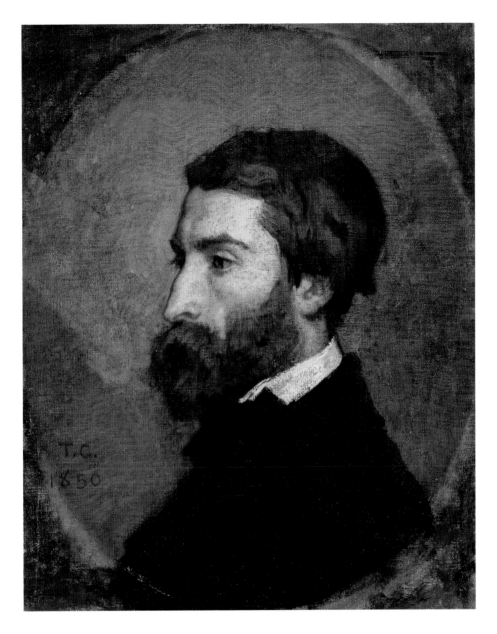

traiture. Speaking in 1853 to the same author, Théophile Silvestre, who would later write much of the 1876 catalogue of Bruyas's collection, Couture stated that "all my portraits bear the stamp of my own militant and aggressive personality. . . . I obey my own rules rather than those of my model."[6] Many later writers, including Silvestre himself, took Couture at his word and found that this portrait captured little of the sitter's personality. But the image, which does convey something of the delicate presence found in other portraits of Bruyas, seems to have pleased its owner at the time of its creation as an example of his role as a patron and collaborator with his chosen artists. **SL**

1. This relationship is made most explicit in the inscription on Glaize's 1849 portrait (cat. 64), dedicated to Bruyas as the "friend and instigator of the fine arts," from his "affectionate painter."

2. In his 1852 catalogue, Bruyas referred to Couture as an artist "frankly applied to nature," engaged in a "great, sublime battle." Bruyas 1852, pp. 12–13. See also Sylvain Amic's essay in the present volume.

3. Musée Fabre, inv. no. 876.3.90.

4. The title given to the other of the pair in 1854, *A Young so-called Bourgeois*, suggests Bruyas was distancing himself even more radically from the portrayal,

perhaps in an effort to underscore his solidarity with artists rather than the bourgeoisie. Since the description continues, "Portrait of M. B. Dedicated to Courbet," Bruyas may also have intended to hold it up as an example of artistic expression at a period when he was encouraging just such expression from another artist, Courbet.

5. Bruyas 1853, p. 40.

6. Bruyas 1876, p. 210. It is cited as coming from Silvestre's *Histoire des artistes vivants*, vol. 2, a volume that was never published but for which Silvestre had accumulated some material.

Alexandre-Gabriel Decamps
Paris 1803–Fontainebleau 1860

36. *The Road to Toulon*

c. 1839
Watercolor over graphite on paper
8 1/2 x 11 1/2 in. (21.7 x 29.3 cm)
Signed along lower edge: DECAMPS
Gift of Alfred Bruyas, 1868
868.1.29
Exhibited Dallas and San Francisco only

Provenance
Joseph Fau, Paris (sold, Hôtel des ventes
mobilières, Paris, 7–8 January 1850, no. 16);[1]
Alfred Bruyas, Montpellier.

Selected Exhibitions
Montpellier 1860, no. 502, as *Scène de singes
travestis*, lent by Bruyas.

Selected References
Bruyas 1851, p. 13, no. 30, as *Les singes travestis*;
Bruyas 1852, p. 32, no. 36, as *Les singes travestis*;
Bruyas 1854, p. 26, no. 45, as *Singes travestis*;
Laurens 1875, pl. 5 (lithograph after the drawing;
reversed); Bruyas 1876, pp. 244–69, no. 52, as
Le Chemin de Toulon; Claparède 1962, no. 51, ill.,
as *Le Chemin de Toulon; singes travestis*;
Mosby 1977, vol. 2, pp. 484–85, no. 188 (dates the
drawing to c. 1839), pl. 142a.

Alfred Bruyas's agent Théophile Silvestre was one of Alexandre-Gabriel Decamps's harshest critics. His occasionally blistering study of Decamps's appeared in the wake of the artist's retrospective exhibition alongside Ingres and Delacroix at the Exposition Universelle of 1855.[2] In the 1876 catalogue of the Bruyas collection, Silvestre somewhat moderated his view of this artist, perhaps in deference to his patron. He called this sheet "a little masterpiece, for the character and the simplicity of the materials as well as a great souvenir of the artist's first voyage in the midi of France."[3]

Bruyas considered Decamps "possibly the most individual and the most picturesque of the modern painters."[4] He bought this watercolor from the Fau collection in 1850, when the artist was at the height of his popularity and widely acknowledged as a leader of the French school. Five years earlier, Paul Huet marveled at the premium that collectors placed on Decamps's drawings: "I remember too well having exhibited my charcoal drawings, and the best ones naturally, at a dealer's on the rue Neuve-Vivienne, who had some sketches by Decamps in the same manner, but very incomplete and very far from the vigor that Decamps . . . wanted to obtain. I saw the amateurs of Decamps go into ecstasy in front of his drawings and not even glance at mine."[5]

Although Decamps worked successfully in a variety of genres, he was best known to his contemporaries as a painter of orientalist subjects and anthropomorphized animal pictures like *The Road to Toulon*. Here he contrives a scene of pathos—a bound captive marched to the prison at Toulon by a pair of mounted and armed gendarmes—and makes a travesty of the tragedy by casting the human roles with monkeys. **JAG**

1. Bruyas 1851 erroneously indicates that this drawing was purchased out of the collection of A. Mosselman in 1850. The latter collection was sold in Paris on 4–5 Dec. 1849; however, the present sheet cannot be identified with either the two paintings (nos. 52–53) or eight drawings (nos. 147–54) by Decamps in that sale. Claparède 1962, no. 51, cited an analogous work ("une aquarelle analogue") entitled *Gendarmes conduisant un condamné (scène de singes travesties)*, which was sold from the Fau collection on 7–8 Jan. 1850 for 355 francs; it is apparent that the Fau watercolor and the Bruyas watercolor are in fact one and the same.
2. "Decamps," in Silvestre, 1856, pp. 148–86.
3. Bruyas 1876, p. 245.
4. Ibid., p. 255.
5. R. Paul Huet quoted in Mosby 1977, vol. 1, p. 9.

Eugène Delacroix
Charenton 1798–Paris 1863

37. *Wolf and Fox Hunt*, after Peter Paul Rubens

c. 1820–24?
Watercolor and black chalk with traces of gouache, over graphite on paper
7 1/2 x 11 in. (19.2 x 27.9 cm)
Delacroix vente stamp in red ink, lower right (Lugt 838); inscribed in graphite, upper right corner: 26 Newman
Bruyas Bequest, 1876
876.3.105
Exhibited Dallas and San Francisco only

Provenance
The artist (posthumous sale, Hôtel Drouot, Paris, 22–27 Feb. 1864, under no. 635 [8 sheets]); Alfred Bruyas, Montpellier.

Selected Exhibitions
Paris 1963b, no. 43, as *Chasse au renards*; Frankfurt 1987, no. I3, ill.; Rouen 1998, cat. no. 108, list no. 182, ill. p. 124.

Selected References
Bruyas 1876, pp. 324–28, no. 64, as *Chasse aux loups, aquarelle d'après Rubens*; Robaut 1885, p. 475, no. 1957, as *Chasse aux loups*; Claparède 1962, no. 60, ill., as *La Chasse aux Loups et aux renards, d'après Rubens*.

Of the earlier masters with whom Delacroix imagined himself in an ongoing, vital dialogue, first and foremost was the Flemish painter Peter Paul Rubens (1577–1640). "That man Rubens is admirable," he wrote in his journal on 21 October 1860: "What an enchanter! I get annoyed with him at times: I argue with him because of his heavy forms, because of his lack of research and of elegance. How superior he is to all those little qualities which make up all the baggage of the others! He, at least, has the courage to be himself: he forces you to accept those so-called defects deriving from that force which sweeps him along himself. . . . Rubens does not chasten himself, and he is right. By permitting himself everything, he carries you beyond the limit scarcely attained by the greatest painters; he dominates you, he overpowers you with all his liberty and boldness."[1] Delacroix's adulation was demonstrated in the sheer number of copies and studies that he produced after Rubens during the course of his long career. The catalogue of the posthumous sale of Delacroix's studio in 1864 listed fourteen paintings and 105 drawings after the Flemish master, and many more

Fig. 1. Peter Paul Rubens and Workshop,
Wolf and Fox Hunt, c. 1615–21.
Oil on canvas, 8 ft. 5/8 in. x 12 ft. 4 1/8 in.
(245.4 x 376.2 cm). The Metropolitan Museum of Art,
New York. John Stewart Kennedy Fund, 1910

studies after Rubens are to be found in the artist's sketchbooks.[2]

In copying the paintings of Rubens and other artists in his personal pantheon, Delacroix made frequent recourse to reproductive engravings and etchings as intermediary *aides-mémoires*. A sketchbook dating from the late 1820s contains a number of drawings after prints by Rubens's great interpreter Pieter Claesz. Soutman (c. 1580–1657).[3] One of the sheets combines motifs from two of Soutman's etchings after Rubens: a head of a man from the *Wild Boar Hunt* (Musée de Marseille), and the heads of a wolf and fox from the *Wolf and Fox Hunt* (see fig. 1).[4] In these and other studies, Delacroix seems to have been unconcerned that the motifs he copied from Soutman's reproductive prints reversed the orientation of the original painting.

Delacroix's continuing fascination with Rubens's hunt subjects is revealed in several journal entries of the late 1840s, in which he refers to etchings by Soutman in his own collection.[5] At work on his painting *Lion Mauling an Arab* (1847; Nasjonalgalleriet, Oslo), he wrote on 23 January 1847, "Consider, for my paintings, the fine exaggerations of horses and of men in Rubens, especially in the *Hunt* by Soutman."[6] Two days later, he added, "I have before my eyes the *Hunts* by Rubens, among others, the *Lion Hunt* etched by Soutman."[7] Delacroix went on to praise Rubens's *Hippopotamus and Crocodile Hunt*, also available to him in the form of a reproductive etching by Soutman, and on 6 March 1847 wrote, "I made some sketches from the *Hunts* by Rubens; there is as much to be learned from his exaggerations and his swelling forms as from exact imitations."[8]

In none of his journal entries did Delacroix make specific mention of Rubens's monumental *Wolf and Fox Hunt* (fig. 1), and in the absence of his own annotations, the watercolor study in the Bruyas collection cannot be precisely dated. An essential question is whether Delacroix saw the painting at first hand, or based his copy solely on a reproductive print. Unlike the sketch of 1825–30, the watercolor preserves the orientation of Rubens's painting.[9] It excerpts the dramatic central portion of Rubens's composition, the pair of trapped wolves, contorted and snarling in the moment preceding the kill. Soutman's etched copy (fig. 2) and the three known reproductive prints based on it take

certain liberties that make it possible to confirm or refute Delacroix's dependence on a printed source.[10] The most notable and relevant disparity between the painting and Soutman's print is in the figure of the hunting dog, bounding toward the wolves from below the rearing horse at right. In the print, this dog appears as a spotted hound with dark, pendulous ears, in contrast to the pale greyhound with small, triangular ears depicted in the painting. Although Delacroix's copy is not fully worked in the figure of the hunting hound, it is clearly derived from the greyhound in the painting. Further, Delacroix's sensitive application of color is faithful to Rubens's palette, as is most clearly evidenced by the red-orange tunic on the charging huntsman at left, the red tassel on his pike, and the striking blue tonality of the distant undergrowth along the horizon.

When might Delacroix have had the opportunity to see the painting? Arnout Balis has traced its history in the *Corpus Rubenianum* as follows: it was in the collection of the Counts of Altamira in Madrid until 1814, when it was taken by the French and placed on exhibition at the Louvre.[11] The painting was restituted to the Altamiras in 1815, who sold it five years later in Paris. By 1824, it was in the hands of the London art dealer John Smith, who sold it to a private collector in Hampshire. Jean Claparède offered the plausible suggestion that Delacroix could have seen the original painting when it was shown at the Louvre in 1814–15, but the watercolor technique exhibited in the Bruyas sheet is certainly beyond the capacity of the young art student of the mid-1810s (it wasn't until 1816 that Delacroix received instruction in watercolor from Charles Soulier). It is also possible that Delacroix saw the picture when it was on the art market during the early 1820s, a date that is consistent with the Bruyas sheet's graphic intensity and richness in its mixing of watercolor, chalk, and gouache over pencil.

A painted copy of the *Wolf and Fox Hunt*, also in the proper direction and with Rubens's greyhound, is in the collection of the Ordrupgaard, Copenhagen.[12] It has been attributed, inconclusively, to two of Delacroix's acquaintances: Théodore Géricault (1791–1824) and Hippolyte Poterlet (1804–1835).[13] Further study of this canvas's authorship and dating may shed light on the circumstances surrounding the genesis of Delacroix's watercolor in the Bruyas collection. **JAG**

Fig. 2. Pieter Claesz. Soutman (Flemish, c. 1580–1657), *Wolf and Fox Hunt*. Etching, 18 1/2 x 25 1/4 in. (47.1 x 64.1 cm). Herzog Anton Ulrich-Museums Braunschweig–Kunstmuseum des Landes Niedersachsen

1. Delacroix 1960, vol. 3, pp. 307–8.
2. Hôtel Drouot, Paris, pp. 22–24, lots 161–74 (paintings), and p. 74, lots 635–37 (drawings).
3. Cabinet des dessins, Musée du Louvre, Paris, RF 9144; published in Sérullaz 1984, vol. 2, pp. 346–49, no. 1752.
4. Ibid., fol. 14 recto. For Soutman's prints, see Hollstein 1983, pp. 223–34; the head of the man is taken from p. 232, no. 19, the fox and wolf heads from p. 231, no. 18.
5. The 1864 sale of Delacroix's collection included a large number of unspecified Old Master prints; lot 845 consisted of one hundred prints of the Flemish and Dutch schools.
6. Delacroix 1960, vol. 1, p. 165.
7. Ibid., p. 168.
8. Ibid., p. 201.

9. This fact alone does not necessarily prove that it was made after the painting, since there were two later engravings that reversed Soutman's composition and therefore reflect the proper orientation of the painting.
10. The copies after Soutman's etching are cited by Balis 1986, p. 97, as follows: copy 12, by Willem van der Leeuw; 13, by Giovanni Termini; and 14, by Jan van Troyen. The latter print, misattributed to its publisher Cornelis Visscher, was put forth as the source for Delacroix's watercolor in Frankfurt 1987, p. 186.
11. Paris 1815, p. 85.
12. Balis 1986, p. 96, copy 4.
13. Bazin 1987, vol. 2, p. 446, no. 347.

38. Portrait of Aspasie

c. 1824
Oil on canvas
37 7/8 x 25 5/8 in. (81 x 65 cm)
Gift of Alfred Bruyas, 1868
868.1.36

Provenance
The artist (posthumous sale, Hôtel Drouot, Paris, 17–19 Feb. 1864, no. 192, as *Étude d'après une mulâtresse, figure à mi-corps*, sold to Andrieu); Pierre Andrieu, Paris; Alfred Bruyas, Montpellier (by 1864).

Selected Exhibitions
Paris 1864, no. 302, as *Étude d'après une mulâtresse, figure à mi-corps*, lent by Bruyas; Paris 1930, no. 7, as *La Mulâtresse*; Paris 1939, no. 36, as *Aline, la Mulâtresse*; Paris 1963a, no. 36, as *Aline la Mulâtresse*.

Selected References
Bruyas 1876, pp. 271–72, no. 54, as *La Mulâtresse, étude d'après nature*; Robaut 1885, pp. 17, 479, no. 47, as *La Mulâtresse*; Sérullaz 1963, pp. 26–27, no. 43, ill., as *Aline la Mulâtresse*; Johnson 1981–89, vol. 1, pp. 52–53, no. 79, as *Portrait of Aspasie*, and vol. 2, pl. 70; Montpellier 1985, p. 101, no. 45, ill. p. 112, as *Aline la Mulâtresse*; Honour 1989, pp. 36–38, fig. 20, as *Portrait of Aspasie*; Daguerre de Hureaux 1993, pp. 60, 66, ill. p. 63 as *Portrait d'Aspasie*.

Delacroix's interest in subjects based on real and fictional events in foreign lands predates his first trip outside France, as ambitious paintings derived from the Greek war of independence like his 1824 *Scenes from the Massacres at Chios* (Musée du Louvre, Paris) demonstrate. Numerous studies of figures in Greek or Turkish costume made in the early 1820s reveal the artist's interest in depicting such subjects accurately. He also sought out models in Paris who are identifiably non-European even before his 1832 trip to Morocco and Algeria, when he made extensive sketches of the people he encountered there (see cat. 39).[1] The *Portrait of Aspasie*, one of at least three canvases that probably depict the same woman, is a painting of such a model. It can be dated to about 1824 thanks to a preparatory drawing in a sketchbook (Musée du Louvre, Paris) whose other sheets are securely datable to 1823–24.[2] If Delacroix's contemporaneous studies of Greek and Turkish costumes suggest a certain scientific detachment, however, this work emphasizes the erotic content of his exotic imagery. The same model may also have posed for the reclining partially nude figure in the lower center of *The Death of Sardanapalus* (1827; Musée du Louvre, Paris), one of Delacroix's most highly charged Orientalist images of exotic sexual decadence.[3]

Although Théophile Silvestre first identified the sitter as "Aline the mulatto" in the 1876 catalogue of the Bruyas collection, the subject is almost certainly a woman named Aspasie, an identification based on two journal entries Delacroix made many years after completing the painting.[4] Two other portraits (both Collection of Mrs. Walter Feilchenfeldt, Zurich) depict a very similar-looking woman, posed in an equally casual manner; these are often labeled *Aspasie the Moorish Woman*. A fourth closely related painting, generally titled simply *Woman in a Blue Turban* (Private collection), depicts a more formally dressed and posed sitter and is probably the same work Delacroix exhibited in the Salon of 1827 as *Study Head of an Indian Woman*.[5] The variety of identifications underscores that each painting's erotic charge derives primarily from the sitter's nearly unadorned dark skin, rather than from external ornaments or a harem-like setting.

Delacroix seems to have executed *Portrait of Aspasie* rapidly, in an almost sketch-like manner, particularly in the striped dress. Radiographic examination has also recently revealed that the artist reused a canvas for this work, painting over an unidentifiable portrait and a profile head copied after Rubens.[6] Other aspects seem more carefully considered. The warm, muted colors highlight the sitter's skin, purposefully set off between the white of her chemise and the jet black of her necklace, earring, and hair. Further, the preparatory sketch for this painting demonstrates that Delacroix modified the pose slightly, rendering a coquettishly direct glance in the drawing more distant and mysterious in the painting. Johnson suggests that the artist and his model may have had a sexual relationship, a possibility that the visual evidence of the painting certainly supports; in any case, Delacroix kept this portrait until his death, perhaps due to both its informal facture and its intimate nature. **SL**

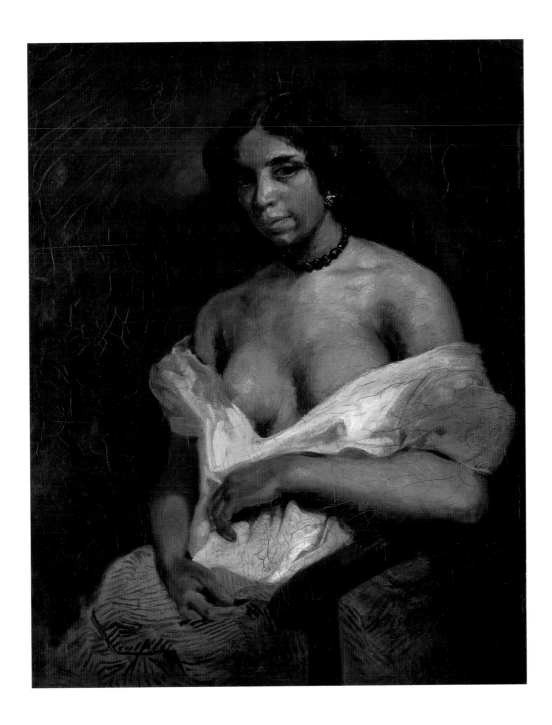

1. One of many examples is a pastel of the head of a black man wearing a turban (Musée du Louvre, Paris), which may relate to *Greece Expiring on the Ruins of Missolonghi* of 1826 (Musée des Beaux-Arts de Bordeaux). See Sérullaz 1984, vol. 1, no. 107.

2. Johnson 1981–89, vol. 1, p. 53. For the drawing, see Sérullaz 1984, vol.

2, pp. 330–31, no. 1749, fol. 35 recto (RF 23355).

3. Théophile Silvestre (in Bruyas 1876, p. 271) equates the two models, and Johnson 1981–89 (vol. 1, p. 61) states that the sitter for a related work, *Portrait of a Woman in a Blue Turban*, "bears a marked physical resemblance" to the figure in *Sardanapalus*.

4. See Delacroix 1960, vol. 3, p. 91, entry of 1 Apr. 1857 ("*Aspasie* life-size, knee-length," in a list that probably served as an inventory of his studio at the time) and p. 128, entry of 4 Oct. 1857 ("For *Aspasie* waist-length, life-size, see a good sketch in an album of the time"). This sketch is undoubtedly the one cited in note 2 above.

5. See Johnson 1981–89, vol. 1, pp. 60–61, no. 88.

6. The profile is that of Henri IV, from Rubens's series of paintings on the life of Marie de Medici (Musée du Louvre, Paris). This information was provided by Sylvain Amic, whom I also wish to thank for his help with this entry as a whole.

39. *Two Studies of Algerian Women*

1832
Graphite and watercolor on paper
4 1/4 x 5 1/4 in. (10.7 x 13.2 cm)
Delacroix vente stamp in red ink, lower right (Lugt 838); Inscribed by the artist, for the left figure: *jaune d'or, cerise, vert, fouta*; for the right figure: *noir, montre, chemise à fleurs exac[tement] les même*
Bruyas Bequest, 1876
876.3.99
Exhibited Richmond and Williamstown only

Provenance
The artist (posthumous sale, Hôtel Drouot, Paris, 17–29 Feb. 1864, possibly no. 552, as *Etudes ayant servie pour les Femmes d'Alger*, or under no. 571, *Scènes de la vie arabe* [about 250 sheets]); Pierre Andrieu, Paris (sold to Silvestre as agent for Bruyas, Mar. 1874);[1] Alfred Bruyas, Montpellier.

Selected Exhibitions
Paris 1939, no. 139.

Selected References
Bruyas 1876, p. 330, no. 67, as *Femme d'Alger*; Robaut 1885, no. 478, as *Femme d'Alger*; Claparède 1962, no. 52, ill., as *Deux etudes de femmes d'Alger; inconnue et Zohra Bensoltane*.

40. Study for "Women of Algiers in Their Apartment": Woman Seated à la Turque

c. 1834
Graphite and watercolor on paper
5 5/8 x 4 7/8 in. (14.4 x 12.5 cm) maximum
Bruyas Bequest, 1876
876.3.100
Exhibited Richmond and Williamstown only

Provenance
The artist (posthumous sale, Hôtel Drouot, Paris, 17–29 Feb. 1864, under no. 571, as *Scènes de la vie arabe* [about 250 sheets]); Alfred Robaut, Paris (sold to Silvestre as agent for Bruyas, Mar. 1874);[2] Alfred Bruyas, Montpellier.

Selected Exhibitions
Paris 1939, no. 140, as *Femme d'Alger*; Toulouse 1991, no. 7, ill., as *Étude d'atelier pour Les Femmes d'Alger*.

Selected References
Bruyas 1876, no. 68, as *Femme d'Alger*; Robaut 1885, under no. 1629, ill. (after a drawing by Robaut); Claparède 1962, no. 53, ill., as *Étude d'atelier pour les femmes d'Alger; femme assise à la turque*.

Orientalist subjects, drawn from or imagined about the cultures of North Africa and the Near East, had been a staple of Delacroix's oeuvre even before his trip to Morocco and Algeria in 1832. The direct experience of North Africa enriched and validated this aspect of his repertoire and continued to inspire him for the remainder of his career. Delacroix, "a young painter with wit, talent, worldliness, and an excellent character," had been asked to join the mission of Count Charles de Mornay, sent by King Louis Philippe to smooth relations between the new French colony of Algeria and its neighbor, Morocco.[3] The party left France in late January 1832, briefly visiting Spain before landing in Tangier. Delacroix and his companions spent the next five months in Morocco and Algeria, the artist recording his experiences in letters, journal entries, and sketchbooks. "The appearance of that country will always remain in my eyes; the men and women of that beautiful and strong race will excite my memory as long as I live. It was among them that I truly rediscovered antique beauty."[4]

These two watercolors, acquired near the end of Bruyas's life, exemplify the sorts of drawings Delacroix made during his North African sojourn and in the years after, as he sought to translate his personal experiences into a grand public art. Both relate directly to his most celebrated Orientalist painting, *Women of Algiers in Their Apartment* of 1834 (fig. 1). Théophile Silvestre wrote enthusiastically to Bruyas about their importance, describing *Two Studies of Algerian Women* as "the first and true key to the *Women of Algiers*" and noting their relevance to Bruyas's 1849 version of the painting (cat. 44): "When placed below or to the side of your painting: what a beautiful commentary!"[5]

Delacroix had been frustrated throughout his North African sojourn at the lack of opportunity to draw Muslim women in their domestic quarters. Only during his stay in Algiers from 25 to 28 June 1832 was he able to visit the house of a *chaouch*, a sergeant or corsair, probably of Turkish origin: "M. Poirel [a French official for the port of Algiers] arranged for Delacroix to be secretly shown into the house. The women, hav-

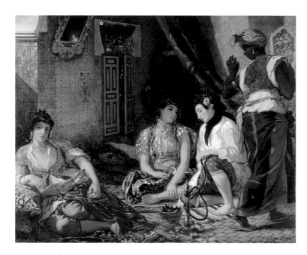

Fig. 1. Eugène Delacroix,
Women of Algiers in Their Apartment, 1834.
Oil on canvas, 70 7/8 x 90 1/8 in. (180 x 229 cm).
Musée du Louvre, Paris

made a quick second sketch of her head just to the side. The drawing would be used when the artist conceived his 1834 painting, the poses changed but the costuming essentially the same. The studies of Zohra formed the basis for the seated figure at the right.

The second drawing, *Study for "Women of Algiers in Their Apartment,"* is a preparatory study for the central seated figure in the painting, and was likely produced in the Paris studio in 1834, despite Bruyas's own belief that it was made in Morocco.[11] It is carefully rendered, the contours drawn and redrawn, the pose and expression—the tilt of her head and the placement of her hands as she sits "à la Turque"—having become the central focus. Elie Lambert questioned whether Delacroix used a model at all, suggesting that he relied instead on his memory and the Algerian sketches; the figure relates to one in a watercolor, now in the Louvre, in which Delacroix identified the model as Mouney Bensoltane, very likely Zohra's sister.[12] Lambert notes that another drawing, squared for transfer and without watercolor, shows a different model and may have been drawn from life in the Paris studio. The Bruyas drawing, in his view, was thus the bridge between Delacroix's personal experience in the harem in Algiers and the workings of his own studio.[13] **RR**

ing been forewarned, donned their most beautiful clothing, and Delacroix made watercolor sketches of them that he would later use to paint the *Women of Algiers.*"[6] Despite an element of stage-setting and play acting—the critic Philippe Burty reported that the *chaouch*'s wife served tea and prepared a *narghile* (water pipe) before reclining in full costume on the divan[7]—the uniqueness of the situation must not have been lost on either the artist or his models. Presented with the scene, Delacroix is said to have exclaimed, "How beautiful! It's like the time of Homer!"[8]

Some dozen drawings were made during what must have been a quick visit, all on sheets of similar size that probably formed a small sketchbook.[9] *Two Studies of Algerian Women* exhibits the quick, deft handling of the pencil and touches of watercolor—done "on the fly," to use Delacroix's phrase—that typifies the group, the poses loosely rendered and attention placed on the costuming. Delacroix noted the colors of the clothing—"golden yellow," "cherry," "green," etc.—as well as the patterning: "flowered shirt exactly like these." Yet he did not neglect his models, inscribing their names on several of the sheets. Based on notations on other drawings, the figure on the right, seated with her arms folded, is Zohra Bensoltane, probably one of the *chaouch*'s daughters.[10] The crouching figure on the left, drawing on the *narghile*, is unidentified; Delacroix

1. See letter from Silvestre to Bruyas of 14 Feb. 1874 (Montpellier MS 365, no. 3), in which he suggests Andrieu might accept 100 or 150 francs for the drawing. In a letter of 5 Mar. 1874 (Doucet MS 215, no. 84), Silvestre notes that Andrieu is about to send the drawing, as soon as he has made a tracing of it to remember it by.
2. Sold for 40 francs. See letters from Silvestre to Bruyas of 1 and 2 Apr. 1874. Doucet MS 215, nos. 102–3.
3. As characterized by Mlle Mars, de Mornay's lover; quoted in Jobert 1998, p. 140.
4. Silvestre 1926, p. 30.
5. "la première et vraie clef des *Femmes d'Alger*"; "Mis au dessous ou à coté de votre tableau; quel jolie commentaire!" Montpellier MS 365, no. 3, Paris, 14 Feb. 1874.
6. Charles Cournault, "La Galerie Poirel au musée de Nancy,"

Courrier de l'Art, 12 Oct. 1882, pp. 483–86, quoted in Lambert 1937, p. 11.
7. Burty 1883, pp. 76–79 and 94–98.
8. Attributed to Delacroix by Burty 1883, pp. 76–79 and 94–98; quoted in Lambert 1937, p. 11.
9. The fundamental study of the drawings is still Lambert 1937.
10. Lambert traced the name, as well as another mentioned by Delacroix, Touboudji, to prominent Muslim families in Algiers. Lambert 1937, p. 13.
11. Silvestre thought the work was painted in Morocco (Bruyas 1876, p. 331), although he probably used the designation "Morocco" to indicate the entire North African trip.
12. Lambert 1937, p. 30; for the Louvre drawing, see Sérullaz 1984, no. 1621.
13. Lambert 1937, p. 30.

41. *Moroccan Military Exercises*

1832
Oil on canvas
23 1/4 x 28 3/4 in. (59 x 73 cm)
Signed and dated lower center: Eug. Delacroix /
1832
Gift of Alfred Bruyas, 1868
868.1.37

Provenance

Count Charles de Mornay, Paris (until 1850; sale,
Hotel Drouot, Paris, 18–19 January 1850, no. 117,
sold to Collot for 600 francs, or no. 119, sold for
300 francs);[1] Collot; [Auguste Cornu, Paris, sold to
Bruyas, June 1850, for 400 francs];[2] Alfred Bruyas,
Montpellier.

Selected Exhibitions

Montpellier 1860, no. 77, as *Charge de cavaliers
arabes*, lent by Bruyas; Paris 1864, no. 300, as
Charge de cavaliers arabes, lent by Bruyas; Paris
1939, no. 38; London 1984, no. 13, ill.; Paris 1994a,
no. 58, ill.; Paris 2002, no. 209, ill.

Selected References

Bruyas 1851, p. 13, no. 32, as *Le Giaour, charge de
cavaliers Arabes (scène d'Algérie)*; Bruyas 1852,
p. 32, no. 38, as *Le Giaour, charge de cavaliers
Arabes (scène d'Algérie)*; Bruyas 1854, p. 22,
no. 22, as *Le Giaour, charge de cavaliers Arabes
(scène d'Algérie)*; Bruyas 1876, pp. 272–76, no. 55,
as *Marocains courant la poudre, fantasia*; Robaut
1885, p. 111, no. 408, ill. (after drawing by Robaut),
as *Fantasia ou exercices marocains*; Johnson
1981–89, vol. 3, pp. 161–62, no. 351, as *Arab Cavalry
Practising a Charge*; vol. 4, pl. 164; Montpellier
1985, p. 101, no. 46, ill. p. 112, as *Marocains courant
la poudre, fantasia*.

Moroccan Military Exercises was the first major oil
to emerge from Delacroix's 1832 North African
sojourn. It depicts an extraordinary custom witnessed
by Count Charles de Mornay's embassy on numerous
occasions as they traveled in Morocco and Algeria: the
so-called *course de poudre*, or *fantasia*, in which a group
of Arab cavalrymen charge forward in unison before
pulling up abruptly on their mounts and firing their
muskets. One particular incident witnessed by the
artist on 6 March at Souk el-Had el-Gharbia, south of
Tangier, might have inspired the present canvas:
"*Courses de poudre* in the plain before the river. . . . The
tribe follows us; disorder, dust; precedes the cavalry.
Courses de poudre: the horses in the dust, the sun
behind. The arms pulling back from the momentum."[3]
In a later commentary, Delacroix underscored the danger
of the exercise, noting that the unevenness of the
terrain and the impulsiveness of the horses frequently
resulted in injury.[4] The Count de Mornay recognized
that the exercise was "used for grand occasions or in
honor of important dignitaries," but, he went on, "the
Christians, for whom these marks of consideration are
performed, run a certain risk, as the Moors like to aim
at their faces to see if they panic."[5]

Like many of Delacroix's paintings inspired by the
trip to Africa, *Moroccan Military Exercises* was loosely
based on drawings made on site, although no single
example matches precisely. An elaborate watercolor
from one of de Mornay's albums—finished in Toulon
during the group's return to Paris—shows a similar
composition, although the horsemen charge from the
right and the ramparts of Meknès are visible in the
background (fig. 1).[6] Nevertheless it was through such
drawings, along with his remarkable visual memory,
that Delacroix was able to capture so vividly in his finished
painting a sense of the energy and excitement of
the event. The picture is remarkable for its dynamism,
Delacroix having dispensed with conventional compositional
strategy in which the main elements are balanced
around a central focal point. The cavalry has
seemingly rushed headlong into the pictorial field from
the left, their mounts caught in mid-gallop, creating a
strong horizontal axis. (The critic Théophile Thoré
answered complaints about the fact that none of the
horses touch the ground with the retort, "They're flying.")[7]
Only the heads of the horses, thrown back in

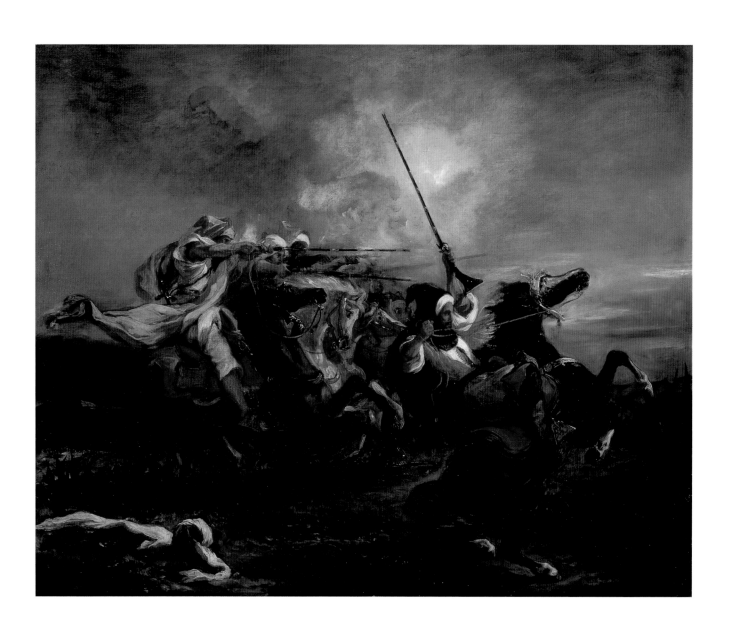

Fig. 1. Eugène Delacroix,
Arabian Charge Before a Gateway to Meknès.
Watercolor with traces of graphite on paper,
6 1/8 x 10 11/16 in. (15.6 x 27.2 cm).
Musée du Louvre, Paris

terror, eyes ablaze, and the emphatic vertical of the rearing horse and rider anchor the group, stop the forward momentum, and hold the viewer's attention at the right edge of the canvas. The fluidity of the paint, applied in thick brushstrokes, enlivens the surface of the canvas while heightening the sense of immediacy.

This painting is one of four depicting the *course de poudre* that Delacroix made over the course of fifteen years.[8] The provenances and exhibition histories of the various versions have sometimes been confused, but there is no question that the present canvas was the earliest and that its first owner was the Count de Mornay. The latter was forced to sell it, however, along with several other paintings by Delacroix, in 1850 when he was having financial difficulties. The artist is known to have objected to the sale and to be particularly upset over *Moroccan Military Exercises,* which he felt was worth 2,000 francs, but which ended up selling for 600. It was during this very time, as Ting Chang has noted, that Bruyas was in Paris meeting artists and dealers as he began to assemble his collection.[9] While he did not purchase the painting at De Mornay's auction, he acquired it six months later for 400 francs, far under the value established by Delacroix. Bruyas was initially confused about the subject of the picture, for he catalogued it in 1851 as *Le Giaour, charge de cavalier Arabes (scène d'Algérie), Le Giaour* being a reference to Lord Byron's poem of 1813 that had served as the inspiration for several earlier paintings by Delacroix.[10] But by 1876 he had corrected himself, having by that time assembled a large collection of paintings and drawings by the artist, as well as having developed a personal relationship with him.

RR

1. In the copy of the 1850 sale catalogue at the Frick Art Reference Library, no. 117 *(Combat du Giaour)* is annotated "vendu à l'amiable 600 à M. Collot." While the title of no. 119 *(1830. Cavaliers arabes)* seems a better description of the present picture, the letter from the dealer Cornu to Bruyas notes, "I told Monsieur Collot that he had let you have this picture for 400 francs although he paid more for it" (letter of 8 June 1850; Doucet MS 214, no. 2). Unless the annotation is incorrect, both the name and the price suggest that no. 117 was the work that passed from Collot through Cornu to Bruyas.
2. Cornu states in his letter to Bruyas, "I have the painting by Eug. Delacroix which I have cleaned since it was very dirty," surely referring to this picture. He gives the purchase price as 400 francs.
3. Delacroix 1960, vol. 1, p. 131.
4. Delacroix, in the catalogue of the Salon of 1847, pp. 53–54, in which he exhibited another version of the subject. See also Bruyas 1876, p. 18. For the version exhibited in 1847 (sometimes confused with the Bruyas version painted in 1832), see Johnson 1981–89, no. 376.
5. Cited in Paris 1994a, p. 188.
6. See Sérullaz 1984, vol. 2, pp. 17–38, no. 1571, in which the watercolor is rightly said to be closer to the composition of *Arab Cavalry Practicing a Charge* (Städelsches Kunstinstitut, Frankfurt, inv. 1466).
7. As reported by Théophile Silvestre in Bruyas 1876, p. 274.
8. For the other versions, see Johnson 1981–89, nos. 349, 353, and 376.
9. Chang 1996a, p. 197.
10. Bruyas's confusion may have been based on the fact that one of the paintings in the Count de Mornay's sale was catalogued as *Combat du Giaour.* For the possible confusion between paintings in that sale, see note 1 above.

42. Bouquet of Flowers

1843
Black crayon, watercolor, and gouache on blue paper
8 3/8 x 10 5/8 in. (21.3 x 27.1 cm)
Delacroix vente stamp in red ink, lower left (Lugt 838)
Bruyas Bequest, 1876
876.3.101
Exhibited Richmond and Williamstown only

Provenance

The artist (posthumous sale, Hôtel Drouot, Paris,
17–29 Feb. 1864, under no. 625, sold for 200 francs);
Constant Dutilleux (until d. 1865; posthumous sale,
26 Mar. 1874, no. 19, sold to Silvestre as agent for
Bruyas, for 410 francs); Alfred Bruyas, Montpellier.

Selected Exhibitions

Possibly Paris 1864, no. 200 or 207;[1] Paris 1939,
no. 141; Paris 1998b (Paris only), no. 25, ill.

Selected References

Bruyas 1876, pp. 315–19, no. 62, as *Fleurs*; Robaut
1885, no. 776, ill. (after a drawing by Robaut);
Claparède 1962, no. 55, ill., as *Bouquet de fleurs*.

Bouquet of Flowers was a late purchase made
through Théophile Silvestre along with the water-
color *The Porte d'Amont, Étretat* (cat. 43). After visiting
the presale exhibition of the collection of Constant
Dutilleux, Silvestre included both works in a short list
of sale items by Delacroix that he recommended to
Bruyas.[2] Part of Silvestre's initial attraction to *Bouquet
of Flowers* was the low price he thought the watercolor
would sell for, yet the day following the sale he justified
the ultimately high price by praising the watercolor for
its special refinement, charm, and freshness.[3]

In early fall 1848 Delacroix began to focus intently
upon a series of flower and fruit studies at his country
estate in Champrosay, near Fontainebleau, where he
had retreated from revolutionary turmoil in Paris.
These works represent a rare instance of Delacroix's
concern for objective reality rather than imagined sub-
jects or scenes filtered through memory and shaped by
aesthetic license. By the next year's Salon he was ready
to exhibit large-scale studio paintings based on his
studies. The artist's great admirer Alfred Robaut cata-
logued the present watercolor to 1843, along with a sim-
ilar watercolor bouquet in his own collection.[4]
Recently Arlette Sérullaz questioned Robaut's dating

and suggested the work belongs instead to the 1848–49
series, based on a comparison with a sheet of flower
studies in graphite dated 13 November 1848.[5] In an 1849
letter to Dutilleux, Delacroix specified his intent in his
flower paintings.[6] Rather than producing hackneyed
backdrops and finicky details, he wished to capture the
ensemble and to show nature as it presented itself, with
originality and as much variety as possible. As T. J.
Clark has described, the artist realized his ambitions
much better in his studies for the series than in the
final, carefully worked paintings.[7] Clark's words hold
true for the watercolor study in Montpellier, whether it
is part of the 1848–49 series or dates from several years
earlier. The heady flowers burst forth from a vase
whose neck is only suggested in silhouette against a
delicately washed ground.

It is clear that Silvestre, and through him Bruyas,
knew of Delacroix's intentions for his later flower
series. In the 1876 catalogue of his collection, Bruyas
highlighted the natural aspect of the watercolor
Bouquet of Flowers and warmly reiterated its naive,
primitive, and childlike qualities. He also related
Delacroix's passion for flowers of all sorts, which drove
him to cut himself on thorns in the Champrosay coun-
tryside as he searched for new wild plants.[8] These poet-
ic descriptions might recall the characterization made
earlier by Delacroix's passionate admirer Baudelaire,
who likened the artist to "a volcanic crater artistically
hidden by bouquets of flowers."[9] **PSC**

1. This work is listed in Bruyas 1876
as having been in the Paris 1864
exhibition. There are two watercol-
ors of flowers listed in the exhibi-
tion. No. 207 was lent by Alfred
Robaut; it is likely this is the same
work listed in Robaut 1885,
no. 775, as a watercolor of flowers
owned by Robaut, that is, a work
different from the present drawing.
No. 200 was lent in 1864 by Paul
Tesse; it seems unlikely that it can
be identified as the present work.
2. Letter from Silvestre to Bruyas of
25 Mar. 1874 (Doucet MS 215,
no. 98).
3. Letter from Silvestre to Bruyas of
27 Mar. 1874 (Montpellier MS 365,
no. 6).
4. Robaut 1885, no. 775.
5. Paris 1998, p. 124. The sheet of
graphite studies, now in the Prat
collection, is no. 26 in the cata-
logue.

6. Letter of 6 Feb. 1849, published
in Bruyas 1876, pp. 317–18.
7. Clark 1973, pp. 131–32. Clark
highlights Delacroix's Champrosay
flower series as a conscious retreat
from the events of revolution, and
he seems to suggest within his
larger discussion that the project
ultimately failed in part because of
the artist's high emotional invest-
ment and political anxieties.
8. Bruyas 1876, p. 316, where the
Delacroix letter cited above in note
6 is printed just after Bruyas's
entry. Although the passage is
attributed to Bruyas, the Silvestre
letter cited above in note 3 con-
tains similar wording, suggesting
that Silvestre was probably the
actual author of the entry.
9. Baudelaire 1927, p. 36 (originally
published as a letter to the editor
of *L'Opinion nationale* [Sept.–Nov.
1863]).

43. *The Porte d'Amont, Étretat*

1849?
Black chalk, graphite, watercolor, and gouache
on blue paper
6 1/8 x 8 1/8 in. (15.7 x 20.6 cm)
Delacroix vente stamp in red ink, lower right
(Lugt 838)
Bruyas Bequest, 1876
876.3.102
Exhibited Dallas and San Francisco only

Provenance
The artist (posthumous sale, Hôtel Drouot, Paris,
22–27 Feb. 1864, under no. 595, sold for 310 francs
to Alfred Robaut); Constant Dutilleux (until d. 1865;
posthumous sale, 26 Mar. 1874, no. 18, sold for 500
francs to Silvestre as agent for Bruyas); Alfred
Bruyas, Montpellier.

Selected Exhibitions
Paris 1963a, no. 396, as *Les falaises d'Étretat*;
Bordeaux 1974, no. 7, ill. (erroneously as no. 10),
as *Les Falaises d'Étretat*; Toulouse 1991, no. 8, ill.,
as *Les falaises d'Étretat*; Paris 1993a, no. 69, ill., as
Vue de la plage et des falaises d'Étretat; Montpellier
1996, no. 51, ill. p. 89, as *Vue de la plage et des
falaises d'Étretat*; Paris 1998 (Philadelphia only),
no. 48, ill., as *Cliffs of Étretat*.

Selected References
Bruyas 1876, pp. 314–15, no. 61, as *Falaise
d'Étretat*; Robaut 1885, p. 272, no. 1031, ill. (after a
drawing by Robaut), as *Falaises d'Étretat*; Claparède
1962, no. 56, ill., as *Les falaises d'Étretat*; Sérullaz
1963, pp. 306–7, no. 405, ill., as *Les falaises
d'Étretat*.

1. Delacroix 1960, vol. 1, p. 316.
2. See Herbert 1994, chap. 3,
"Étretat's History and Fame,"
pp. 61–69.
3. Paris 1993a, p. 9.
4. Sérullaz 1963, p. 307.
5. The analogous view of the porte
d'Amont is in a private collection; it
is illustrated in Paris 1993a, no. 70,
p. 47. Two other watercolors
showing the Porte d'Aval may have
been carried out at the same time:
one, in the Musée Marmottan,
Paris (inv. 5063), is on a sheet
measuring 150 by 200 mm; the
other, in the Museum Boijmans Van
Beuningen, Rotterdam (inv. F II
163), is on green-blue paper
measuring 145 by 240 mm. The
Marmottan watercolor is illustrated

in Paris 1993a, no. 71, p. 48; the
Boijmans watercolor is catalogued
and illustrated in Hoetink 1968,
p. 88, no. 112.
6. Doucet MS 215, no. 98, 25 Mar.
1874.
7. Montpellier MS 365, no. 6, 27
Mar. 1874. "C'est cher mais c'est
charmant et d'une délicatesse
infinie. . . . La Falaise d'Étretat, par
la matinee d'été la plus limpide,
est le portrait le plus aimable
possible du lieu fait sur place, avec
délices, par Delacroix un moment
en vacances, échappé à Paris et à
l'écrasante besogne de l'atelier: les
poumons ravivés par l'air vif, l'oeil
réjoui par la Lumière et le coeur
expansif, à la vue de la mer."

That great line of blue, green, pink, of that undefinable color which is that of the vast sea, always transports me. The intermittent sound which reaches one already from afar and the smell of the salt are truly intoxicating."[1] So wrote Delacroix in his journal on 9 October 1849 during a stay with his cousins at Valmont, near the coastal communities of Fécamp and Étretat. By the time of this visit, Étretat was well on its way to converting itself from a sleepy fishing village to a popular tourist resort. Not surprisingly, the discovery of Étretat by artists and writers preceded and, in many ways, precipitated its transformation into a destination for Parisian visitors.[2] Delacroix made at least fourteen trips to Valmont and Dieppe between 1813 and 1860.[3] Maurice Sérullaz suggested that the watercolor in the Bruyas collection dates from his autumn, 1849 excursion.[4] Delacroix selected a viewpoint on the beach at Étretat, facing north toward the eroded chalk cliff called the Porte d'Amont. What sets this composition apart from his other views of the Channel coast is the almost reticent depiction of the site's most extraordinary feature, the perforated cliff. While lavishing attention on the textures and colors of the cliffs, he seems to have been at least as interested in describing the graceful curve of the pebble beach and the mounds of seaweed and other marine detritus arrayed at regular intervals in the foreground. On the same occasion, he painted a second watercolor on paper of identical color and dimensions, showing a similar view at high tide.[5]

Théophile Silvestre advised Bruyas to buy this watercolor and the *Bouquet of Flowers* (cat. 42) at the sale of the Dutilleux collection on 26 March 1874. The day before the sale, Silvestre called it a "little marvel," noting that he had examined it in the company of Corot.[6] He was even more effusive in his praise after the sale, writing that "it is expensive [500 francs] but charming and of infinite delicacy. . . . *La Falaise d'Étretat*, on the clearest of summer mornings, is the most genial portrait possible of the spot, made by Delacroix with pleasure, during a vacation, escaped from Paris and the crushing labor of the studio: his lungs revived by the brisk air, his eye rejoicing in the light, and his heart bursting before the view of the sea."[7] **JAG**

44. *Women of Algiers in Their Apartment*

1849
Oil on canvas
33 1/8 x 43 3/4 in. (84 x 111 cm)
Signed lower left: Eug. Delacroix
Gift of Alfred Bruyas, 1868
868.1.38

Provenance
Possibly Count Charles de Mornay, Paris (sold, Hôtel Drouot, Paris, 18–19 Jan. 1850, no. 118);[1] (sale, before Feb. 1850; sold to Bruyas);[2] Alfred Bruyas, Montpellier.

Selected Exhibitions
Paris, *Salon*, 1849, no. 506; Montpellier 1860, no. 74, lent by Bruyas; Paris 1864, no. 297, lent by Bruyas; Paris 1900, no. 218; Paris 1939, no. 40; Zurich 1987, no. 67, ill.; Nantes 1995, no. 74, pl. 171; Paris 2003, no. 3, ill.

Selected References
Bruyas 1851, p. 13, no. 31, as *Les femmes d'Alger (scène d'intérieur)*; Bruyas 1852, p. 32, no. 37, as *Les femmes d'Alger (scène d'intérieur)*; Bruyas 1853, p. 28, as *Femmes d'Alger*; Bruyas 1854, p. 22, no. 21, as *Les femmes d'Alger (scène d'intérieur)*; Laurens 1875, pl. 1 (lithograph after the painting); Bruyas 1876, pp. 276–86, no. 56; Robaut 1885, no. 1077; Johnson 1981–89, vol. 3, pp. 191–93, no. 382, and vol. 4, pl. 171; Montpellier 1985, p. 101, no. 48, ill. p. 112; Yeazell 2000, pp. 26–27, 34–36, fig. 6.

This marvelous painting, one of the iconic works in the Bruyas collection, is a variation on the celebrated canvas Delacroix exhibited at the Salon of 1834. Like that painting, it evocatively conjures up a scene witnessed by the artist in June 1832 during his trip to the French colony of Algeria, when he was granted the privilege of visiting a Muslim household. The watercolor sketches the artist produced during that remarkable session, one of which was acquired by Bruyas (cat. 39), directly inspired both the Louvre painting and this variant. Nevertheless, the two pictures are significantly different in design and mood, so thoroughly did the artist rethink the composition, lighting, and specific details. Why Delacroix chose, some fifteen years later, to paint the second version is unknown, although he probably would have counted on selling it easily, given the fame of the first version, which had been acquired by the state for the Musée du Luxembourg. Around the same time he painted a third harem scene, smaller and vertical in format, now in Rouen.[3] As Elie Lambert pointed out, in the 1840s and 1850s Delacroix was painting smaller versions of many of his most famous paintings, such as *The Death of Sardanapalus* (Philadelphia Museum of Art and Musée du Louvre, Paris).[4] They seem to have been made for a variety of reasons—as gifts for friends, for the artist to keep when he sold the prime version, or to sell on the open market.

The present work is best described as a complete rethinking of the 1834 painting. Delacroix clearly saw it as an independent work, for he exhibited it at the Salon of 1849, shortly after finishing it. Compared to the Louvre painting, it is arguably even more alluring, exotic, and, to use the painter's term in reference to the setting that inspired it, "intoxicating."[5] The near obsessive focus on the details of costuming, furniture, and accoutrements that characterizes the Louvre version—what Bruyas dismissed as "that overabundance of accessories smelling a bit of those Algerian boutiques so common in Paris these days"[6]—is replaced by an exploration of mood, atmosphere, and subtle light effects. This is in part the result of Delacroix's evolving style, which incorporates a more fluid and richer brushwork enhanced by the application of varnish between the paint layers.[7] Bruyas saw the influence of the Italian Renaissance painter Correggio (1494–1534) in this work, as much in the rich tonalities as for the

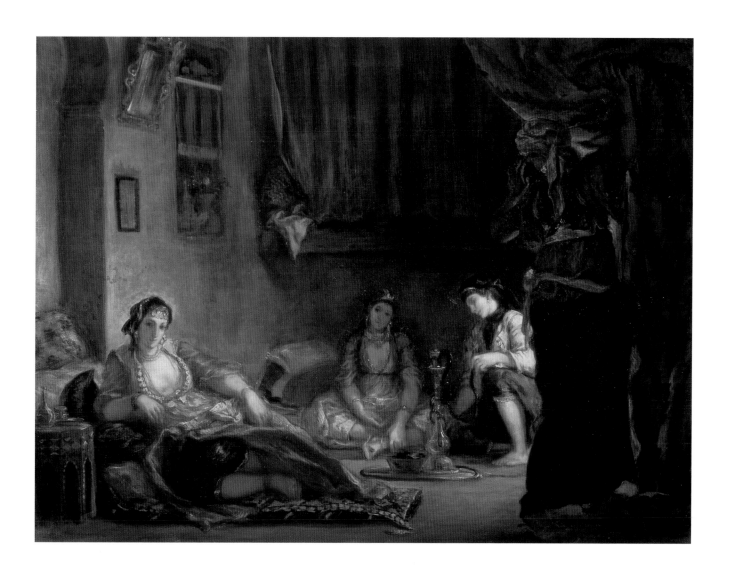

Fig. 1. Eugène Delacroix,
Arab Woman Seated on Cushions, 1832?
Watercolor and pencil on paper,
4 1/4 x 5 3/8 in. (10.7 x 13.8 cm).
Musée du Louvre, Paris

sensuality of the subject.[8] But it is primarily due to a more mysterious and evocative distribution of lights and darks: the bright, even illumination of the Louvre painting gives way to a deeply shadowed interior. The black servant at the right—whose action in the earlier picture is unclear—draws aside a curtain, revealing a room filled with a golden glow. The raking light flows through the composition, illuminating some figures and objects—refracting through the glass bowl of the *narghile* and shimmering across the embroidered costume of the reclining woman, for example—while throwing others in shadow. Only as the viewer's eyes adjust do other details emerge: the posture and action of the servant, the vase and pitcher in the alcove on the wall, the tabouret table at lower left. This delicate balance appealed to several of the critics at the Salon of 1849, one of whom admired the "warm and peaceful harmony, the flesh tones velvety and lively . . . the interior calm and true."[9]

Despite having been painted more than fifteen years after Delacroix's visit to a harem in Algiers, the Bruyas painting in many ways captures more precisely what he saw and experienced there than does the 1834 canvas. The poses of the figures and the details of the room itself, as Lee Johnson observed, are closer to the watercolor sketches, in particular a drawing for the reclining woman (fig. 1).[10] The accessories, such as the pitcher and basin in the alcove and the curtain in the background, the pillows propped at the woman's elbow, and her languorous pose, all correspond remarkably to the drawing. In the painting, Delacroix gave the reclining woman a more revealing bodice, no doubt an attempt to heighten the sensual appeal of the picture. The alluring effect—what Johnson called the "mood of lethargic reverie"—is exactly as described by Philippe Burty in his account of Delacroix's visit to the Algerian household in 1832: "Secrecy was promised on both sides. The woman, warned by her husband, dressed herself in her richest costumes and waited, seated on a divan. Algerian women are thought by the Orientals to be the most beautiful on the Barbary coast. They know how to bring out their beauty by rich fabrics of silk and velvet, embroidered in gold. . . . When, after traversing some dark corridor, one penetrates the part that is reserved for them, the eye is really blinded by the vivid light, the fresh faces of the women and children appearing suddenly amid this mass of silk and gold. For a painter, that is a moment of fascination and strange happiness."[11]

For Bruyas, there was no doubt that his painting was superior to the earlier version, a "new creation" by an artist who had matured in the intervening years. While it was unquestionably "all nature," it was nature that was "deeper, exalted, and simplified by the imagination." He was especially proud of his "small masterpiece," which he hoped would in turn "inspire other masterpieces from some future enthusiasts."[12] **RR**

1. Sold for 450 francs. Johnson 1981–89 questions whether this painting was indeed the version in the Mornay sale.
2. In the 1876 catalogue Bruyas wrote that Delacroix gave the painting to a "charity lottery" (*loterie de bienfaisance*), where he purchased it (Bruyas 1876, p. 280). Piron 1865, p. 109, also notes that this painting was "sold for a lottery for 1,500 fr." Further, in a letter to Bruyas of 8 Feb. 1850, Louis Tissié noted that he was sending a case that evening from Montpellier containing "the Women of Algiers by Delacroix," among other things, so that Bruyas could have it with him in Paris. Letter published in Bruyas 1854, pp. 176–77. This suggests either that the lottery and the Mornay sale are one and the same (and that Piron's sale price is incorrect), or that this painting was not in the Mornay sale, since it seems unlikely that it could have been sold twice and shipped from Paris to Montpellier and back again between 19 Jan. and 8 Feb.
3. Johnson 1981–89, vol. 3, no. 378.
4. Lambert 1937, pp. 38–39. For these variants, see Johnson 1981–89, nos. 286 and 302.
5. See the discussion under cat. 38.
6. Bruyas 1876, p. 279.
7. Delacroix 1960, vol. 1, p. 259.
8. Bruyas 1876, p. 280.
9. Alphonse de Cailleux, quoted in Johnson 1981–89, vol. 3, p. 193.
10. Sérullaz 1984, vol. 2, p. 152, no. 1623.
11. Quoted in Jobert 1997, p. 147; for the original, see Burty 1883, pp. 76–79 and 94–98; and Lambert 1937, p. 10.
12. Bruyas 1876, pp. 279–80.

45. Michelangelo in His Studio

c. 1850
Oil on canvas
15 3/4 x 12 5/8 in. (40 x 32 cm)
Signed lower left: E. Delacroix
Gift of Alfred Bruyas, 1868
868.1.40

Provenance
[Georges Thomas, Paris, bought from the artist, Mar. 1853;[1] sold to Bruyas, 1853]; Alfred Bruyas, Montpellier).

Selected Exhibitions
Montpellier 1860, no. 75, lent by Bruyas; Paris 1864, no. 299; Toulouse 1865, no. 207; Paris 1939, no. 42; Nantes 1995, no. 75, pl. 170.

Selected References
Bruyas 1853, pp. 24, 38, as *Découragement de Michel-Ange dans son atelier de sculpteur*; Bruyas 1854, no. 16, as *Le Découragement de Michel-Ange*; Bruyas 1876, pp. 296–306, no. 58; Robaut 1885, p. 316, no. 1184, ill. (after a drawing by Robaut); De Tolnay 1962, pp. 43–52; Johnson 1981–89, vol. 3, pp. 126–28, no. 305, and vol. 4, pl. 126; Montpellier 1985, p. 101, no. 49, ill. p. 112.

Delacroix represents the Renaissance master Michelangelo Buonarotti in his studio, deep in thought amid his sculptures. He sits—or half reclines—on a bench, wearing work clothes and leaning an elbow on a modeling stand, a chisel and several books dropped to the floor and a portfolio of drawings leaning against a pedestal. Prominent in the right background is the *Medici Madonna*, destined for the Medici chapel in San Lorenzo, Florence, in which the seated Virgin, the Christ Child on her lap, provides a visual parallel to the figure of Michelangelo; visible at the left edge is the left leg of the *Moses*, intended for the tomb of Pope Julius II. Delacroix applied the paint in rich, broad strokes, employing a muted palette, the burgundy of the artist's cloak the only note of strong color amid the range of grays, browns, and blacks. The studio is cluttered and shadowy, but a soft light falling from the upper right picks out the sculptures and illuminates the great man's face, revealing an intense expression characteristic of the artist's celebrated *terribilità*. The trope of the struggling genius fascinated Delacroix, and in an essay on Michelangelo published in 1830 he imagined a scene very much like the present

painting: "I see him at an advanced hour of the night, struck with fear at the spectacle of his creations, rejoicing in the secret terror that he wanted to awaken in men's souls. . . . It was then the expression of a profound melancholy, or perhaps his agitation, his dread, in thinking of the future life: the regrets of mature age, the fear of the obscure and frightening future."[2]

Théophile Silvestre dated the picture to 1853, the year Delacroix sold it to the dealer Georges Thomas, but it was probably completed several years earlier. Delacroix started it in September 1849 and continued work on 18 May 1850.[3] Given the picture's modest dimensions, Lee Johnson reasonably suggested that it was more or less complete by the end of May. Yet Delacroix labored over the concept: a preliminary drawing depicts the artist facing left, head bowed, slumped at the base of one of his massive statues, tools still in hand (fig. 1).[4] In this drawing, Delacroix noted several of the items— "book," "paintbrush," "architectural plans / boxes"— intended to underscore Michelangelo's learning and creative diversity. The inscriptions at the top—"Le penseroso [*sic*]" and "gigantic marble statues–the figure / of Michelangelo relatively / small"—suggest that Delacroix wished to emphasize Michelangelo's brooding personality, but also his discouragement.[5] The exhausted artist in the drawing would be replaced in the painting by a robust, energized personality, but the suggestion of inner torment became, if anything, even more compelling. Bruyas had no doubt that Michelangelo was portrayed at a moment of self-doubt: "This subject . . . is treated by the author with great truthfulness. The great Michelangelo discouraged! Amid his colossal statues that he has left nearly all unfinished!"[6]

Michelangelo in His Studio has always been understood as a visual manifestation of Delacroix's lifelong fascination for the artist rather than an accurate recreation of Michelangelo's studio. (As Charles de Tolnay noted, the sculptures shown in the painting were never in the studio together, since the *Moses* was made in Rome in 1515–16 and the *Medici Madonna* in Florence between 1521 and 1532.)[7] Like many of Delacroix's small paintings of creative personalities he admired, from the musician Niccolò Paganini to the poet Torquato Tasso, the picture is a rumination on the artist's life and work: "it's Eugène Delacroix's meditative and fervent identi-

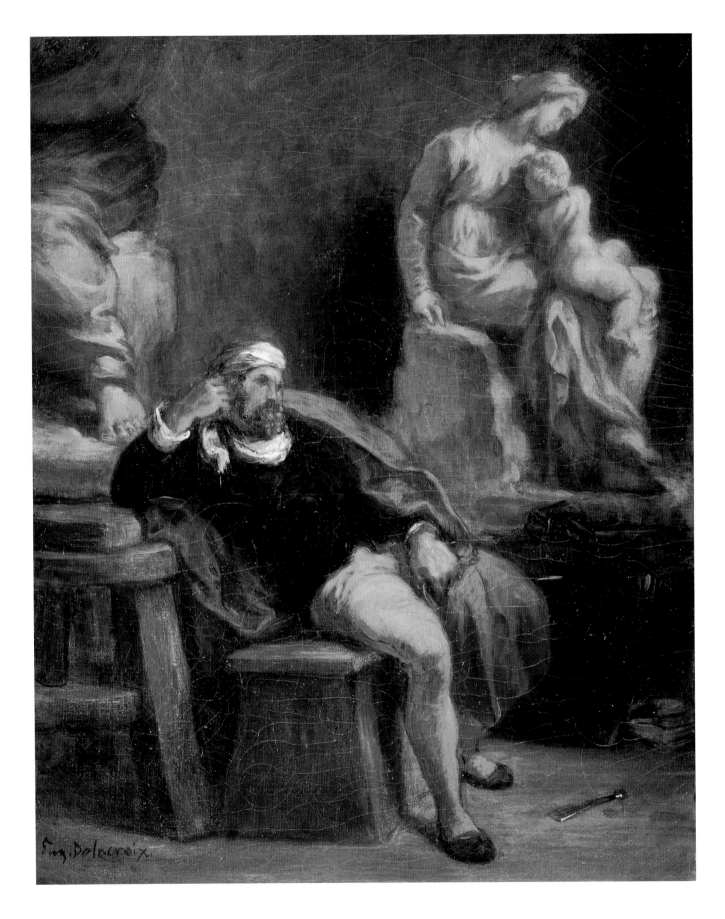

fication with the great Florentine," as Silvestre put it.[8] Delacroix wrote extensively about Michelangelo, and Michelangesque motifs abound in his art, but this painting—and a pastel in the Bruyas collection showing the *Apotheosis of Michelangelo*—are rare examples where he depicts the Renaissance master himself.[9] For Silvestre the painting was a virtual self-portrait. Everything from the books to the white scarf—"That famous neckerchief of Delacroix has been placed on Michelangelo's neck as if it were his own"—underscored the personal rapport Delacroix felt for Michelangelo.[10] This line of interpretation held firm for much of the next century, culminating in Jack Spector's 1984 psychoanalytic reading, which claimed that Delacroix's feelings of artistic impotency are symbolized in the placement of Michelangelo between the sculptures of Moses and the Virgin Mary: "The crux of [Delacroix's] problems is projected in the tension between Michelangelo's potency in displacing the father (Moses) and having the mother to himself, and his impotence and frustration as an artist owing to his failure to integrate the mother and achieve independence."[11]

Johnson brought a needed note of skepticism, arguing against making too literal a connection between Delacroix and Michelangelo. He suggests that Delacroix's picture may have been inspired less by his personal identification with the artist than by a very similar painting by his friend Joseph Nicolas Robert-Fleury, a lithograph of which was published in 1850. He reminds us that Delacroix admired many artists, especially Raphael—the great hero of French classicism

Fig. 1. Eugène Delacroix,
Study for "Michelangelo in His Studio," 1864.
Graphite on paper,
14 7/8 x 9 5/8 in. (37.8 x 24.4 cm).
Fitzwilliam Museum, Cambridge

(and of Delacroix's stylistic rival Ingres)—devoting a long article to him and in 1831 exhibiting a painting, now lost, showing Raphael meditating in his studio.[12] Regardless of how completely Delacroix may have identified with the myth of Michelangelo, his extraordinary painting—unique in his oeuvre, as Silvestre was at pains to point out—epitomizes Romanticism's thrall to the cult of genius. **RR**

1. At the end of his journal for 1852, Delacroix noted that he had sold this painting to Thomas for 500 francs. See Delacroix 1960, vol. 1, p. 502. Delacroix wrote to Thomas on 14 Mar. 1853, stating that Thomas could pick up the painting the following day. See Joubin 1936–38, vol. 3, pp. 144–45.
2. "Michel-Ange," *Revue de Paris* 15–16 (1830), as quoted in Jobert 1998, p. 46. See also Spector 1984, pp. 19–28.
3. Johnson 1986, vol. 3, no. 305, p. 127.
4. A second drawing, also in

Cambridge, shows the composition closer to that of the painting and includes a separate study for the modeling stand that became a key element in the final concept.
5. As is often pointed out, "Il Pensieroso" (the Thinker) here refers to Michelangelo, but it was also the popular name for the statue of Lorenzo de' Medici in the Medici chapel in San Lorenzo, Florence.
6. Bruyas 1854, no. 16.
7. De Tolnay 1962, pp. 43–52.
8. Bruyas 1876, p. 298.
9. The pastel, dating from the

1850s, is also in the Museé Fabre (inv. no. 876.3.98). As Bruyas himself pointed out, it repeats a composition depicting Socrates that was part of the ceiling decoration of the Deputies's Library at the Palais Bourbon finished in 1847 (Johnson 1989, vol. 5, no. 549). A smaller version of the oil painting, in the National Gallery of Art, Washington, D.C., is now considered a copy, probably by Delacroix's assistant Pierre Andrieu. See Eitner 2000, pp. 236–38.
10. Bruyas 1876, pp. 297–98. Silvestre even divined physical

similarities between the artists: "Michelangelo's legs are really those of Delacroix: slender legs. . . that bothered him as did his short little nose, just as Michelangelo was himself bothered by his small size and his nose, broken when Torreggiano punched him."
11. Spector 1984, pp. 19–28.
12. Johnson 1986, vol. 1, pp. 208–9, no. L105. See also Paris 1998, p. 28. For a full analysis of Delacroix and Raphael, see Lichtenstein 1979.

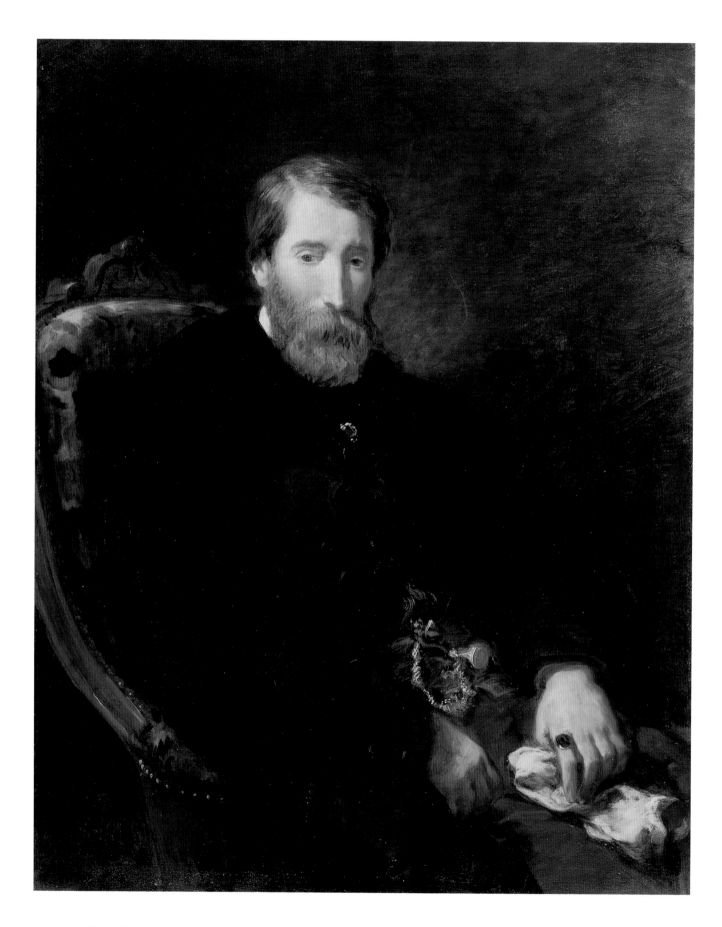

46. Portrait of Alfred Bruyas

1853
Oil on canvas
36 5/8 x 29 1/8 in. (93 x 74 cm)
Signed and dated lower left: E. Delacroix / 1853
Gift of Alfred Bruyas, 1868
868.1.41

Provenance
Alfred Bruyas, Montpellier
(commissioned from the artist, 1853).[1]

Selected Exhibitions
Paris 1864, no. 301, as *Portrait de M. A. B.*, lent by
Bruyas; Toulouse 1865, no. 206; Paris 1939, no. 43,
ill.; Zurich 1987, no. 91, ill.; Toulouse 1991, no. 3, ill.;
Amsterdam 2003, unnumbered, ill.

Selected References
Bruyas 1853, p. 40; Bruyas 1854, p. 16, no. 14;
Laurens 1875, pl. 2 (lithograph after the painting);
Bruyas 1876, pp. 334–52, no. 69; Robaut 1885,
p. 324, no. 1209, ill. (after a drawing by Robaut);
Johnson 1981–89, vol. 3, pp. 57–59, no. 239 and
vol. 4, pl. 59; Montpellier 1985, p. 88, no. 17,
and p. 101, no. 50, ill. p. 91; Floetemeyer 1998,
pp. 94–118, fig. 24; Chicago 2001, pp. 254–55, 257,
291, 324, fig. 135.

Delacroix and Bruyas may have met in 1845 at Eaux-Bonnes, a spa in the Pyrenees, and they probably renewed their acquaintance in early 1853 while the collector was in Paris. Delacroix had already started this portrait by 9 March of that year, when he wrote to Bruyas apologizing for an interruption in his work and requesting a sitting the next day; he finished it shortly after 4 May. Just as Bruyas's contact with Thomas Couture, another prominent, well-established artist, had been brief, his contact with Delacroix was limited to these few months. For his part, Delacroix rarely portrayed sitters outside his circle of friends and relatives. Yet the clearly sympathetic depiction of Bruyas suggests a certain rapport between the artist and his subject. If many of Delacroix's earlier portraits are marked by his admiration for the refinement and elegance of English portraiture, his painting of Bruyas follows few such stylistic precedents; it seems rather to be the product of direct observation and engagement. He commented on the work in his journal shortly before its

completion, invoking Rembrandt (1606–1669) and Veronese (1528–1588), only to note that he could find no models among the Old Masters for the artful creation of directness and naturalness that he sought. "I would like . . . for the artifice not to be felt at all, but that the interest be indicated as necessary; this, once again, can only be obtained by sacrifices, but they must be infinitely more delicate than those in Rembrandt's manner to suit my desire."[3]

"The interest" of this image, it can be inferred, is the sitter's state of mind. This evocative portrait of Bruyas, showing him ensconced in an armchair with a short overcoat draped around his shoulders, indeed seems to portray the collector as a melancholy Romantic. Bruyas's slightly slumped posture even suggests a degree of infirmity, perhaps reflecting the demeanor of a man with tuberculosis who often wrote to friends of his poor health. The composition reinforces a sense of inwardness, as the bulk of the sitter's body is completely enclosed within a single outline formed by the arm

of the chair at the left and by the edge of his coat at the right; only his head rises above this enveloping shape. Bruyas's handkerchief might also contribute to the suggestion of frailty. Another portrait of the collector seated in a chair, by Courbet, is often explicitly titled *Bruyas malade* (Bruyas sick), although in that work as in the Delacroix, the interpretation of illness owes as much to the sitter's reputation as to the evidence present in the painting.[4] Nonetheless, the compositional emphasis Delacroix gives to the head, heightened by the oblique light that makes the face and right hand glow against the darkness of the clothing and background, evokes the sitter's interior life. This focus in turn invites interpretation.[5]

Indeed, critics tended to concentrate on the idea that the portrait depicts its subject as physically and spiritually suffering. When it was exhibited in Toulouse in 1865, Jules Buisson characterized the sitter as a "spent body, a sad and dragging soul, always faced with Hamlet's question . . . to be or not to be . . . a man who's been dying since the day he was born."[6] This is probably the initial source for Théophile Silvestre's far more extensive commentary, in the 1876 catalogue of the Bruyas collection, linking the portrait not only to Delacroix's numerous depictions of Hamlet but to the artist himself as another embodiment of the tragic hero.[7] In the network of associations that Silvestre created, Delacroix saw Bruyas as the incarnation of Hamlet and was so taken with this idea that he himself asked Bruyas whether he might paint his portrait. In depicting the collector, however, the artist attributed his own spirit to his subject: "Delacroix could not help but exaggerate this background of suffering and sadness, so much did he feel it in himself."[8] As he did in his comments on nearly all the collector's portraits, Silvestre felt that this work betrayed too much of the artist's personality and captured too little of the sitter's, that it portrayed Bruyas's physical weakness without conveying his moral strength.[9] In fact, it is Silvestre who exaggerated the degree of suffering Delacroix's portrait conveys, in order to advance his argument that no artist, not even the most skilled, could capture a true likeness of Bruyas.[10] But Silvestre was surely right to praise Delacroix's perceptive and empathetic portrayal of Bruyas's introspective nature.

47. *Alfred Bruyas*

1853
Graphite on paper
11 1/8 x 8 3/4 in. (28.4 x 22.3 cm)
Signed lower left: Eug Delacroix
Bruyas Bequest, 1876
876.3.103
Exhibited Dallas and San Francisco only

Provenance
Alfred Bruyas, Montpellier
(gift from the artist, 1853).

Selected Exhibitions
Paris 1939, no. 143; Frankfurt 1987, no. C5, ill.

Selected References
Bruyas 1854, no. 24;[2] Bruyas 1876, p. 352, no. 71; Robaut 1885, p. 324, no. 1208, ill. (after a drawing by Robaut); Claparède 1962, no. 58, ill.

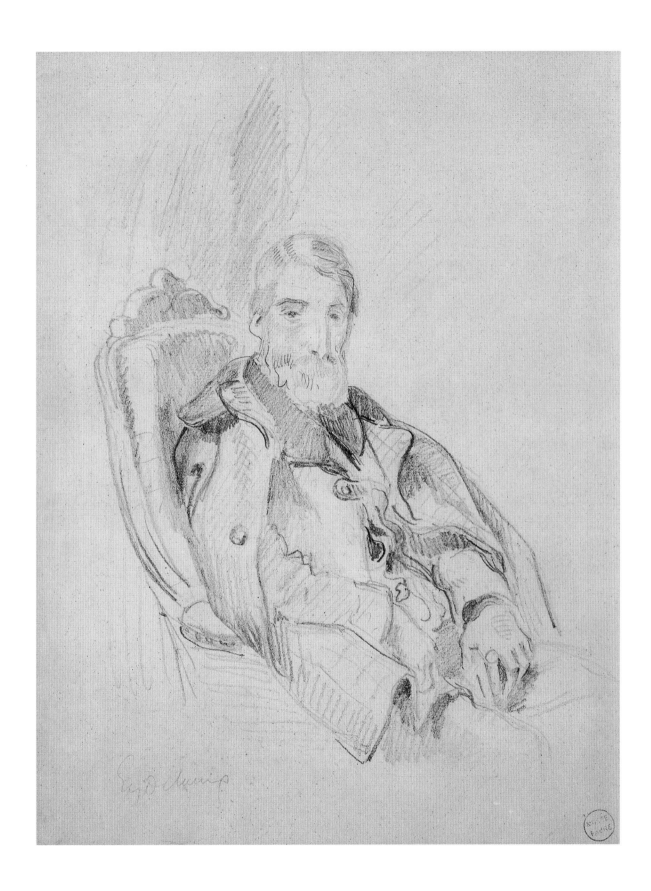

The drawing is a preparatory study for the painting. Delacroix noted in his letter of 9 March that, "thanks to the drawing I made of you, I've come a long way with your portrait."[11] Many elements are already present in this initial sketch, from the diagonal orientation of the sitter, to his pensive yet penetrating gaze, to the patterned lining of his coat. The painting includes such additional details as the watch chain, rings, and tiepin, and the flowered fabric of the chair, all of which reinforce the contrast of red and green that appears throughout the image.[12] More importantly, the figure in the painting is turned slightly further toward the viewer, so that the body is at once more firmly enclosed within a single, continuous line, and rendered more solid and substantial, filling more of the pictorial space. In addition, the handkerchief is barely indicated in the drawing, while it appears prominently in the painting.

These modifications might suggest that the artist sought to give the sitter a more forceful presence in the final work, and that the handkerchief was not integral to Delacroix's initial conception but was emphasized in the painting as a visual accent more than as a key to the significance of the image.

Bruyas clearly valued his portrait by Delacroix, one of the most eminent artists of the day. In his 1854 catalogue Bruyas called the 1,000-franc price "infinitely modest," and he placed the painting at the entrance to the first room of the Galerie Bruyas in his 1868 plan.[13] While he did not develop the type of relationship with Delacroix that he did with Cabanel, Tassaert, or Courbet, all of whose self-portraits he owned, he did engage another artist to make a copy of Delacroix's most celebrated self-portrait so that he could have at least a facsimile in his collection.[14] **SL**

1. At the end of his journal for 1852, Delacroix lists this portrait, presumably as having been commissioned for 1,000 francs. See Delacroix 1960, vol. 1, p. 503. He wrote three letters to Bruyas requesting sittings; they are dated 9 Mar., 16 Apr., and 4 May 1853; see Joubin 1936–38, vol. 3, pp. 144, 148, and 151.
2. Described as "Sketch (original) of the aforementioned portrait [by Delacroix] of M. Alfred Bruyas, signed and given to him by the artist (Paris 1853)."
3. Delacroix, journal entry of 28 Apr. 1853; reprinted in Delacroix 1960, vol. 2, p. 28.
4. Courbet, *Alfred Bruyas*, known as *Bruyas malade* (Musée Fabre, inv. no. 868.1.25).
5. Vincent van Gogh was one viewer who identified with the portrait. In

1889, after visiting the Musée Fabre with Paul Gauguin, he wrote to his brother of Bruyas's strong resemblance to the brothers themselves, citing the collector's melancholy temperament as well as his red hair. See Gogh 1958, vol. 3, p. 108, letter no. 564.
6. Jules Buisson, *Salon de 1865*, pp. 10–11, cited in Toulouse 1991, p. 11.
7. For a discussion of Delacroix's treatment of Hamlet, see, among others, Sérullaz and Bonnefoy 1993, and Jobert 1998, pp. 278–83.
8. Bruyas 1876, p. 340.
9. Silvestre criticized all of Delacroix's portraits, in part to play down their significance within the collection. See Chang 1996a, pp. 319–28, for a discussion of this point. The portraits had already come under attack by Champfleury in his satirical article "L'histoire de M. T.,"

Revue de Deux Mondes, 15 Aug. 1857 (reprinted in Montpellier 1985, pp. 141–53).
10. Silvestre was probably with Delacroix when the agreement to paint this portrait was made. But his claim that Delacroix asked Bruyas to sit for him seems improbable. Since Silvestre himself is the only source for the account of Delacroix's perception of Bruyas's illness and his difficulty in painting portraits because he "suffered for his model," these comments cannot be traced in the published editions of Delacroix's journals or letters that relate to this painting.
11. Letter of 9 Mar. 1853, Joubin 1936–38, vol. 3, p. 144.
12. Johnson 1981–89 and Floetemeyer 1998 both discuss the repeated red-green color harmonies.

13. Bruyas 1854, p. 49. The plan is reproduced in Chang 1996b, fig. 13. This portrait is the first painting at the top of the left-hand wall.
14. *Self-Portrait of Delacroix*, c. 1837 (Musée du Louvre, Paris). The copy (Musée Fabre, inv. no. 876.3.29) is by Pierre Andrieu, a collaborator of Delacroix's from whom Bruyas also bought one of the preparatory drawings for the *Women of Algiers* (cat. 39). The painting is first mentioned in a letter to Bruyas of 14 Feb. 1874 (Montpellier MS 365, no. 3), in which Silvestre noted that Bruyas had requested the copy from Andrieu. Bruyas seems to have paid 500 francs and received the copy by early April 1874. See letter of 27 Mar. 1874, Montpellier MS 365, no. 6.

48. *Écorché Study of a Horse's Leg*

1855
Graphite, and gray, black, and red washes on paper
13 1/2 x 9 1/4 in. (34.2 x 23.6 cm)
Dated in gray wash, lower right: 28 avril 55;
inscribed in graphite, upper right: A; annotated in
graphite, to the left of the motif: grand dorsal /
adducteur du bras / gros extenseur de l'avant bras
/ long extenseur de l'avant bras / Court extenseur
de l'avant bras / fléchisseur oblique du métacarpe /
fléchisseur interne du métacarpe; annotated in
graphite, to the right of the motif: petit pectoral /
sous scapulaire / sous épineux / grand pectoral /
omo brachial / long fléchisseur de l'avant bras /
extenseur antérieur de métacarpe / tendon de
l'extenseur oblique du / métacarpe; Delacroix vente
stamp in red ink, lower left (Lugt 838)
Bruyas Bequest, 1876
876.3.104
Exhibited Dallas and San Francisco only

Provenance
The artist (posthumous sale, Hôtel Drouot, Paris,
22–27 Feb. 1864, probably under no. 507
[16 sheets], sold for 25 francs to Robaut); Alfred
Robaut; Théophile Silvestre; Alfred Bruyas,
Montpellier (gift from Silvestre, Apr. 1876).

Selected References
Robaut 1885, p. 462, no. 1876; Claparède 1962,
no. 59, ill., as *Étude de jambe de cheval; écorché.*

This stark anatomical study of a horse's leg was one of a group of sixteen drawings acquired by Alfred Robaut in the Delacroix atelier sale of February 1864. Eleven of the sheets were eventually acquired by Étienne Moreau-Nélaton and are now in the Cabinet de dessins of the Louvre.[1] Several of the sheets bear dates between 28 April and 2 May, 1855; one of the undated studies[2] is inscribed "C^dt de Paiva," a reference to a certain Madame Paiva who entertained Delacroix and a group of his acquaintances just prior to the opening of the Exposition Universelle on the evening of 2 May 1855. Like another of the Louvre drawings (fig. 1), the Montpellier study includes extensive pencil annotations in the artist's hand specifying the clinical terms for the musculature of a horse's leg.

Silvestre sent this drawing to Bruyas on 20 April 1876, along with a note indicating, "You will find in the small crate an anatomical fragment of a horse by Eugène Delacroix and annotated by him, that I offer you with great pleasure. It is deserving of interest."[3] **JAG**

Fig. 1. Eugène Delacroix,
*Muscle Studies
of Horses' Legs*, 1855.
Black crayon and red
chalk on tracing paper
adhered to paper,
16 5/8 x 11 1/2 in.
(42.3 x 29.1 cm).
Musée du Louvre, Paris
(RF 10695)

1. Sérullaz 1984, vol. 1, pp. 358–61,
nos. 967–77, inv. nos. RF
10695–705.
2. Inv. no. RF 10699.
3. Montpellier MS 365, no. 37:
"Vous trouverez dans la petite
caisse un fragment anatomique de
cheval par Eugène Delacroix et
annoté par lui-même, que je vous
offre avec un vif plaisir. Cela est
digne d'intérêt."

Paul Delaroche

Paris 1797–1856

49. *Assassination of the Duc de Guise*

1830
Graphite, watercolor, and gouache on paper, scored (later) for transfer
8 5/16 x 12 7/16 in. (21.1 x 31.6 cm); a vertical strip 1/2 in. (1.3 cm) wide has been added to the sheet along the left edge
Signed in blue watercolor, lower right: P.D. 1830
Bruyas Bequest, 1876
876.3.107
Exhibited Richmond and Williamstown only

Provenance
Jules Claye, Paris (sold for 200 francs to Silvestre as agent for Bruyas, Jan. 1875);[1] Alfred Bruyas, Montpellier.

Selected Exhibitions
Nantes 1999, no. 21a, ill. p. 38.

Selected References
Bruyas 1876, pp. 416–18, no. 74, as *Assassinat du duc de Guise*; Claparède 1962, no. 63, ill., as *Assassinat du duc de Guise*; Ziff 1977, p. 146; Bann 1997, pp. 190, 289 n. 84; London 1997, pp. 59–63, fig. 23; Chang 1998, p. 114.

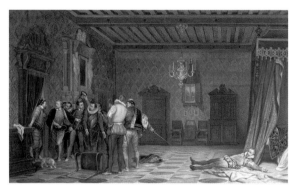

Fig. 1. Paul Delaroche,
Assassination of the Duc de Guise at the Château de Blois in 1588, 1834.
Oil on canvas, 22 7/16 x 38 9/16 in. (57 x 98 cm).
Musée Condé, Chantilly

After entering the École des Beaux-Arts in 1816, Paul Delaroche eventually settled in the studio of Antoine-Jean Gros (1771–1835). Professional recognition followed, including membership in the Académie des Beaux-Arts in 1832, a professorship at the École the following year, and many notable commissions and honors. Concurrently Delaroche won the devotion of the middle class, becoming one of the most celebrated artists of his time.[2] Aspiring to the highest rank among his peers, Delaroche utilized classic academic procedures and treated serious religious and historical subjects. However, he specialized in a hybrid form of history painting, termed "historical genre," which emphasized historically accurate but anecdotal details of place, costume, and emotion. Some in the academic establishment criticized this trivialization of subject matter.[3] The public, on the other hand, responded enthusiastically to Delaroche's narrative approach and attractive glossy finish. Stylistically, he was acknowledged as an artist of the *juste milieu*, that compromise between Ingres's neoclassical emphasis on line and the supremacy of color as championed by Delacroix and the Romantics.

By the middle of Delaroche's career, critics such as Théophile Gautier (1811–1872) were already belittling his technical skill and artistic accomplishments. And Théophile Silvestre, who guided Bruyas's acquisitions during the 1870s, continued in this vein. Writing to Bruyas on 17 January 1875, Silvestre maintained that "[Delaroche] can make his effect on the public and on all those more impressed by fame than genius. With the head of *Saint Cecilia* [sic], this *Assassination of the Duc de Guise* will serve as two sheets of consolation for the *prud'hommesque* [pompous] *bourgeois* who adore Delaroche and calligraphy as much as they detest Delacroix and expression."[4] Delaroche's detractors were forced to acknowledge his popularity with the philistines.

Delaroche had attained wide acclaim in the 1820s and 1830s, following a series of successes, including the *Execution of Lady Jane Grey* (1833; The National Gallery, London), which was shown in the 1834 Salon and remains today his best-known work. From this moment comes his *Assassination of the Duc de Guise*, known in three painted variations—the Montpellier watercolor of 1830; a watercolor dated 1832 in the

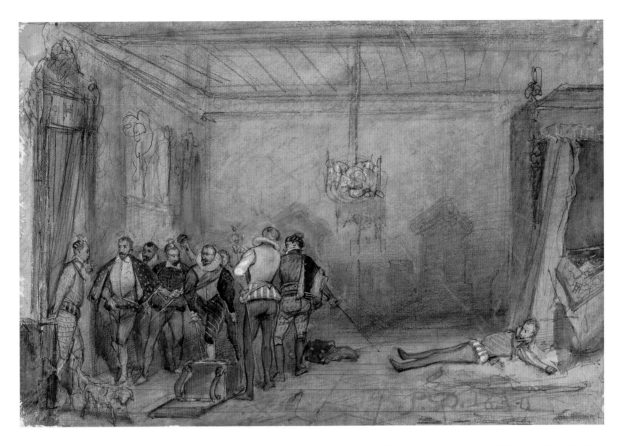

Wallace Collection; and a small oil painting (fig. 1) executed on commission for the Duc d'Orleans and exhibited at the 1835 Salon, after which a handsome print was made by the Goupil firm.[5] The compositional elements laid out in the Montpellier sketch survived almost unchanged through the subsequent renderings.

Delaroche depicts the assassination of the powerful Henri de Lorraine, third Duc de Guise (1550–1588). The Guise family played major roles in the sixteenth-century political struggles between France, England, and Scotland and between French Catholic and Protestant factions. By 1588, the charismatic and ambitious Duc de Guise had garnered the support of the French people. As leader of the Catholic League he was favored by the Spanish king Phillip II and Pope Gregory XIII and posed a continuing threat to the throne of the French king Henri III. Thus, during the 1588 gathering of the Estates General at the Château de Blois, a group of King Henri's courtiers lured the Duc de Guise into the king's bedchamber and murdered him.

The purchase of this watercolor allowed Bruyas to represent Delaroche with the earliest version of one of his most celebrated compositions. Even Gautier, when

reviewing the retrospective exhibition held after Delaroche's death, had picked out the *Duc de Guise* for special mention as "very likely his masterpiece."[6] In the Bruyas/Silvestre quest for a collection characterized by an "unbiased comprehensiveness," this acquisition filled the stylistic middle ground between the triangulation of Neoclassicism, Romanticism, and Realism. **LFO**

1. See letter from Claye to Silvestre of 28 [Jan.?] 1875, in which he discusses the price of this drawing. Doucet MS 214, no. 61.
2. Excellent recent monographs on Delaroche include Bann 1997 and Nantes 1999; see also Bann 2000.
3. For example, the German art critic Heinrich Heine complained in his review of the Salon of 1831 that Delaroche "has no great predilection for the past itself, but for its representation." Cited in Bann 2000, pp. 3–4.
4. Montpellier MS 365, no. 14, 17 Jan. 1875: "Il [Delaroche] peut faire son effet sur le public et sur toutes les personnes que la renommée frappe infiniment plus que le génie. Avec la tête de *Ste-Cécile*, cet *Assassinat du Duc de Guise*

servaient deux fiches de consolation pour les bourgeois Prud'hommesques, qui adorent Delaroche et la calligraphie autant qu'ils détestent Delacroix et l'expression." See also Doucet MS 215, no. 174, 19 Dec. 1874; quoted in Haedeke 1980, p. 213.
5. On the evolution of the composition and the various versions and studies, see Bann 1997, pp. 190–96.
6. Gautier 1858, p. 78: "la *Mort de duc de Guise*, son chef-d'oeuvre peut-être." Translated in its entirety in Gould 1975. On Delaroche's memorial exhibition and its unique catalogue illustrated with photographs of his works, see Bann 1997, pp. 16–17.

154 Delaroche

50. *Head of an Angel*

c. 1836
Black crayon and stumping, with touches of white
gouache and traces of red chalk on paper
16 1/8 x 11 11/16 in. (40.9 x 29.7 cm)
Initialed in graphite, lower right: *P.D.*; inscribed in
graphite, below neckline: no 3773.
Bruyas Bequest, 1876
876.3.108
Exhibited Richmond and Williamstown only

Provenance
[Pierre-Firmin Martin, Paris, sold for 50 francs to
Silvestre as agent for Bruyas, May 1874];[1]
Alfred Bruyas, Montpellier.

Selected Exhibitions
Nantes 1999, no. 35c, ill. p. 134, as *L'Ange du 2e plan*.

Selected References
Bruyas 1876, pp. 418–22, no. 75, as *Sainte Cécile*;
Claparède 1962, no. 64, ill., as *Tête d'ange*; Chang
1998, p. 114.

Fig. 1. Paul Delaroche,
Saint Cecilia, 1836.
Oil on canvas, 79 1/2 x 63 3/4 in.
(202 x 162 cm).
Victoria and Albert Museum, London

I n the 1868 plan for his galleries within the Musée
Fabre, Bruyas had listed Delaroche among those
artists to be added to the collection.[2] Subsequently,
Bruyas and Silvestre discussed the acquisition of spe-
cific works by that renowned artist of the *juste-milieu*,
and the *Head of an Angel* was purchased in 1874.

This refined drawing details a figure in Delaroche's
monumental *Saint Cecilia*, depicting the patron saint
of music with two attendant angels (fig. 1). Presented at
the 1837 Salon, the painting marked Delaroche's new
interest in religious subject matter, which would dom-
inate his later career.[3] The composition of the *Saint
Cecilia*, worked out in Italy,[4] reflects the assimilation of
early Italian elements, both figurative and decorative,
including architectural details and intricate mosaics.
Contemporary critics noted the stylistic influence of
the Renaissance masters Perugino (c. 1450–1523) and
Raphael (1483–1520), as well as the more contemporary
influence of Ingres. Beyond the novelty of the religious
theme, a pronounced simplification of the composi-
tional elements was also new within the context of
Delaroche's output. Overall the critical reception to
this change of direction was negative.[5] To paraphrase
Paul Mantz, one of many detractors: "The *Saint Cecilia*
is one of the artist's complete failures; the painting is
cold, dead, flat, and I do not believe that even one of
the master's students would have agreed to sign it

today."[6] Delaroche never exhibited at the Salon again.

On the Bruyas sheet, the angel's face is beautifully
idealized and delicately rendered in three-quarter pro-
file. Against the full curvilinear contours of the pri-
mary face, another angel's features are seen in sharp,
strict profile, suggested in reserve in the drawing.
Louise Vernet (1814–1845), Delaroche's wife, is recog-
nized as the model for both angels and Cecilia.[7] The
highly finished Bruyas study formed the basis for Elie-
Philippe-Joseph Duriez's lithograph dated 1841 and
published by Goupil.[8] **LFO**

1. See letter from Silvestre to
Bruyas, of 5 May 1874 (Doucet MS
215, no. 122), in which he says he
is sending this drawing.
2. Archives municipales,
Montpellier; reprinted in Chang
1996a, fig. 20.
3. On the religious revival in nine-
teenth-century French society and
art, see Foucart 1987.
4. In preparation for his first reli-
gious commission—the decoration
of the nave of the Madeleine in
Paris—Delaroche made the first of
three trips to Italy in 1834–35. He
studied Italian art and techniques,
in particular the great fresco cycles
of Florence and Rome.
5. On the response to Delaroche's
1837 Salon offerings, see Ziff 1977,
pp. 160–66.

6. *Revue parisienne*, 1857, p. 71;
quoted in Nantes 1999, p. 296.
7. In December 1834, Delaroche
married the daughter of Horace
Vernet, director of the French
Academy in Rome, in the church of
San Luigi dei Francesi, with its
famous Domenichino frescoes
depicting scenes from the life of
Saint Cecilia. See Ziff 1977, p. 162;
Nantes 1999, p. 29; portraits of
Louise are reproduced in Rome
2003, nos. 47, 47a, 48.
8. Nantes 1999, pp. 180, 206, 296,
no. 35d, ill. p. 181. As Gautier
observed, Goupil's extensive repro-
duction of Delaroche's oeuvre
helped to promote and solidify
the artist's position in the popular
market.

Achille Devéria

Paris 1800–1857

51. *Crucifixion*

Brush and brown wash over graphite on paper
4 7/16 x 3 1/8 in. (11.3 x 8 cm)
Signed in pen and brown ink at lower right: A.D.
Bruyas Bequest, 1876
876.3.109
Exhibited Dallas and San Francisco only

Provenance
Alfred Bruyas, Montpellier.

Selected References
Bruyas 1876, pp. 433–34, no. 76, as *Le Christ en croix*; Claparède 1962, no. 65, ill., as *Le Christ sur la croix*.

Achille Devéria, along with his younger brother Eugène, was a prominent artist of the Romantic era. In the 1820s and 1830s, after studying at the École des Beaux-Arts in the studio of Anne-Louis Girodet (1767–1824), he became a member of a literary and artistic circle that included Victor Hugo, Alexandre Dumas *père*, and Franz Liszt, all of whose portraits he recorded in lithographs. In keeping with the renewed interest in religious art in the period,[1] both brothers produced large-scale works on religious themes for the Salon and for various churches and chapels. Achille is perhaps best known, however, for his lithographic illustrations, such as a series of eighteen prints called *The Hours of the Day*. These depict a young, wealthy Parisienne engaged in various quotidian pursuits, just the sorts of images that Baudelaire was referring to when he characterized Devéria's lithographs as "faithful representatives of that elegant and perfumed society of the Restoration."[2]

Devéria's *Crucifixion* combines the religious aspect of his work with his generally secular illustrational style. It depicts three robed angels floating on clouds, surrounding the figure of Christ. The figures are small and almost doll-like in scale, the angels resembling elegant Parisian women more than traditional biblical figures. In his 1876 catalogue, Bruyas compared Devéria's angels to those in Delacroix's *Christ in the Garden of Olives* (church of Saint Paul-Saint Louis, Paris), shown in the Salon of 1827.[3] The resemblance to Delacroix's three angels is fairly superficial, and the comparison was surely intended to give this small drawing greater art historical importance.[4] But Devéria certainly knew Delacroix's work and even seems to have taken a more elaborate crucifixion scene by Delacroix as the basis for one of his own lithographs.[5] **SL**

1. On religious art in the early nineteenth century, see Foucart 1987 and Nantes 1995.
2. Charles Baudelaire, "Salon de 1845," translated in Baudelaire 1965, p. 12.
3. Bruyas 1876, p. 433.
4. In a letter to Bruyas of 22 Mar. 1876, Théophile Silvestre commented that he feared the drawing might be insufficient to sustain an entry on Achille Devéria in the collection catalogue. Montpellier MS 365, no. 34.
5. Lithograph illustrated in Gauthier 1925, p. 111. According to Gauthier (p. 169), Devéria noticed a watercolor sketch in Delacroix's studio; the latter then completed the sketch and gave it to Devéria, who presumably copied it for his lithograph. The location of the watercolor is unknown.

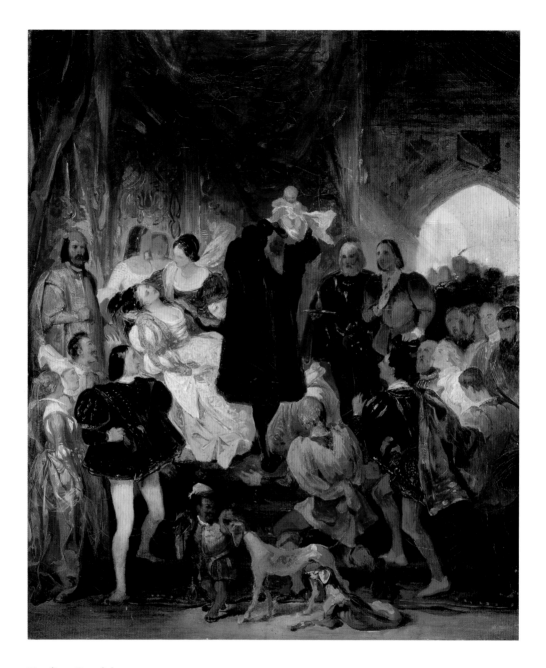

Eugène Devéria

Paris 1805–Pau 1865

52. *Sketch for "The Birth of Henri IV"*

c. 1826
Oil on canvas
25 1/4 x 21 1/4 in. (64 x 54 cm)
Gift of Alfred Bruyas, 1868
868.1.27

Provenance
[Cachardy, Paris; sold, Hôtel Drouot, Paris, 8–10
Dec. 1862, no. 15, as *La naissance d'Henri IV,
esquisse du tableau du musée du Luxembourg*,
sold for 100 francs to Cadart]; Alfred Cadart, Paris
(1862–63; sold Dec. 1863 for 350 francs to Jules
Laurens as agent for Bruyas);[1] Alfred Bruyas,
Montpellier.

Selected Exhibitions
Paris 1889, no. 291; Paris 1939, no. 45; London
1959, no. 126, as *The Birth of Henri IV*.

Selected References
Bruyas 1876, pp. 443–50, no. 77, as *La Naissance
de Henri IV*; Comte 1981, pp. 137–41, fig. 4;
Montpellier 1985, p. 101, no. 52, ill. p. 113.

Eugène Devéria and Alfred Bruyas met in 1842 at Eaux-Bonnes, a spa in the Pyrenees. By September of that year, Bruyas had already commissioned drawings from the artist,[2] and he continued to do so in 1847 and 1850, when he proposed that Devéria depict the peasants from the region around the spa in their characteristic costumes (see cat. 53). The two men had thus been friends for many years when Alfred Bruyas bought this large oil sketch in 1863, just two years before the painter's death. A traditional history painting depicting the birth of the French king who reigned from 1589 to 1610, it was an interesting purchase for the collector. Its acquisition by Bruyas would seem to indicate that he was stepping back from his adventurous purchases of the early 1850s, when he turned to Courbet and realist art. The sketch itself was made as part of the thoroughly academic process of preparation for the painting of the same subject exhibited by Devéria at the Salon of 1827 (fig. 1). This painting was the artist's public debut and, even in his lifetime, was considered to be his masterpiece. Although Devéria

was, like his brother Achille, a pupil of Girodet, his own aesthetic was less decidedly classical than that of his teacher. Devéria's later paintings of religious and historical subjects failed to attract the same admiration as this painting, two preparatory oil studies for which are also in French museums—the present work and another in the Musée des Beaux-Arts, Angers.

The painting has a fascinating combination of the two conflicting trends in French painting—Poussinism and Rubenism. It relates in the proportions of it format and its chromatic brilliance to the Rubens cycle of paintings commissioned by Marie de Medici, Henri IV's wife, to depict events from her life, including the birth of her first son, the future Louis XIII (Musée du Louvre, Paris). And there is little doubt that Devéria conceived of this painting of Louis XIII's father as a kind of pictorial "prequel" to the Rubens cycle. Yet, if Rubens painted on a vast scale with scores of assistants, Devéria worked on a much smaller scale, on a single canvas, carefully blocking out each figure's position. Like a number of artists who worked during the July monarchy, Devéria wanted it both ways—applying to the representation of French history lessons learned from classical art as well as the tradition of Flemish color painting. Despite the renown of the full-scale version of this painting, Devéria's work had fallen out of favor by the 1860s; as Jules Laurens commented on purchasing the sketch for Bruyas, it could be obtained for a modest price because such painting was no longer in fashion. **RB**

Fig. 1. Eugène Devéria,
The Birth of Henri IV, 1827.
Oil on canvas, 16 ft. 1 1/2 in. x 13 ft. 1 in.
(484 x 392 cm).
Musée du Louvre, Paris

1. See letter from Laurens to Bruyas of 31 Dec. 1863, in which he mentions purchasing this painting from Cadart and comments that it is an "advantageous price that can only be explained because the painting is not in fashion." (ce prix est trouvé avantageux et ne s'explique que par le non-à-la-

mode de ladite peinture.) Montpellier MS 405, no. 61.
2. In a letter dated 27 Sept. 1842, another spa visitor, A. E. Cuniac, asked Bruyas whether Devéria had finished the "(drawing) subjects commissioned" by the collector. Reprinted in Bruyas 1854, pp. 70–71.

53. *Harvesters*

1850
Watercolor, gouache, and graphite on paper
19 x 15 3/16 in. (48.2 x 38.6 cm)
Signed and dated in graphite, lower right: Eug.
Deveria / Edinburgh 1850; Musée Fabre stamp in
blue ink, lower right (Lugt 1867)
Bruyas Bequest, 1876
876.3.159
Exhibited Richmond and Williamstown only

Provenance
Alfred Bruyas, Montpellier (commissioned from the
artist, 1850).[1]

Selected Exhibitions
Paris 1980, no. 213, ill.

Selected References
Bruyas 1851, p. 12, no. 25, as *Famille de paysans
de la vallée d'Ossau, souvenir des Eaux-Bonnes*;
Bruyas 1852, p. 31, no. 31, as *Famille de paysans
de la vallée d'Ossau, souvenir des Eaux-Bonnes*;
Bruyas 1854, pp. 29–30, no. 62, as *Famille de
paysans de la vallée d'Ossau, souvenir des Eaux-
Bonnes*; Bruyas 1876, p. 453, no. 79, as *Les
Faucheurs*; Claparède 1962, no. 68, ill., as *Les
Faucheurs*.

Fig. 1. Eugène Devéria,
Two Young Peasants of the Ossau Valley. c. 1847.
Graphite and gouache on paper,
17 11/16 x 14 3/16 in. (44.9 x 36 cm).
Musée Fabre, Montpellier

This fascinating sheet was made by the French *juste-milieu* master in Scotland in 1850. Bruyas seems to have commissioned it as a pendant to an earlier drawing of 1847 entitled *Two Young Peasants of the Ossau Valley* (fig. 1). It represents a rural subject which, although uncommon in Devéria's paintings, played a larger role in his graphic oeuvre. This is, in itself, an anomaly for nineteenth-century French artists, who tended not to mix high and low genres within a career. Most artists specialized in one type of imagery, for which they were known by the art-loving public. Devéria, it seems, managed to combine a career as a painter of historical and religious subjects with that of a draftsman who was attracted to landscape and rural motifs. A painting of a family of peasants from Brittany is in the Musée des Beaux-Arts in Avignon, but this is an oddity.

It is fascinating to contrast Devéria's view of rural life with that of the artist most associated with this type of subject at mid-century, Jean-François Millet. Whereas Millet's peasants are treated as almost mythic humans engaged in a struggle to survive, Devéria preferred to represent peasant figures in the manner familiar to students of Italian rural imagery of the first half of the nineteenth century—that is, as costumed figures who seem completely content with their lot in life and who allow themselves to be represented by one of their "betters." As a picturesque souvenir of a region Bruyas visited often and clearly enjoyed, the drawing also recalls the works the collector commissioned during his Roman sojourns, particularly Cabanel's *La Chiaruccia* (cat. 18), a painting of a pleasingly costumed Italian peasant. For his part, Théophile Silvestre found *Harvesters* and its companion drawing mannered and false and marred by a desire to please.[2] **RB**

1. In a letter dated 18 Feb. 1850, Aglée Devéria wrote to Bruyas on behalf of her husband, stating that Bruyas's "desire for a pendant to [his] first drawing will be satisfied." The drawing referred to is probably *Two Young Peasants of the Ossau Valley* (fig. 1), which Devéria made in July 1847. A second letter from Aglée Devéria, dated 8 May 1850, notes that the latest drawing "had been sent directly from Edinburgh," surely a reference to the present work. See Doucet MS 216, nos. 144 and 143.
2. Silvestre, in Bruyas 1876, p. 453.

Narcisse Virgile Diaz de la Peña
Bordeaux 1808–Menton 1876

54. *Love's Meeting*
(*Les rendez-vous d'amour*)

1849
Oil on canvas
10 5/8 x 7 1/2 in. (27 x 19 cm)
Signed and dated lower left: N. Diaz / 1849
Gift of Alfred Bruyas, 1868
868.1.30

Provenance
Alfred Bruyas, Montpellier (acquired c. 1849–50).[1]

Selected Exhibitions
Montpellier 1860, no. 78, as *La Saison des amours*, lent by Bruyas; Toulouse 1865, no. 230, as *La Saison des amours*.

Selected References
Bruyas 1851, p. 12, no. 26, as *La Reine des Amours (Allégorie)*; Bruyas 1852, p. 31, no. 32, as *La Reine des Amours (Allégorie)*; Bruyas 1854, p. 42, no. 92, as *La Reine des Amours (Allégorie)*; Laurens 1875, pl. 10, as *La Saison des Amours* (lithograph after the painting; reversed); Bruyas 1876, pp. 458–61, no. 80; Montpellier 1985, p. 101, no. 53, ill. p. 113.

This tiny canvas was purchased by Bruyas shortly after his first trip to Paris in December of 1849. Diaz painted scores of works like this one for middle-class collectors, which, because they are generally small, also seem to have appealed to amateurs who collected prints and drawings. The work itself is rare in Diaz's oeuvre for being dated, and its 1849 date proves that it was completed by the artist shortly before being acquired by Bruyas. Its small size relates it to other canvases he purchased at the same time, including two Corot landscapes (cats. 23, 24), perhaps with the idea of decorating a room with small-scale "cabinet pictures." None of the works do anything to prepare us for the boldness and suddenness of Bruyas's move to buy large, roughly painted, and combative paintings by Courbet in 1853. Indeed, everything in this small canvas is the opposite of Courbet. Its soft-focus facture alludes to late Titian, Veronese, and Tintoretto. Its imagery, with representations of various types of love, is both allegorical and actual, including men and women as well as putti, and its composition is at once internally balanced and utterly self-contained. Everything about the painting is calculated to charm the viewer, and even if a classicist might be put off by its somewhat messy paint handling, the painting is so delightfully tiny that no one could be very angry with its maker's lapses in rigor. **RB**

1. In Bruyas 1851 this painting is annotated "Paris, 1849"; in Bruyas 1854 it is annotated "Paris, 1850." Bruyas made his first trip to Paris in December 1849 and probably purchased at least two works before the end of the year from the dealer Cornu.

Jules Didier

Paris 1831–1892

55. *A Pine Forest at Castel Fusano*

1869
Oil on canvas
29 1/2 x 45 3/8 in. (75 x 115 cm)
Signed and dated lower right: Jules Didier / 1869
Bruyas Bequest, 1876
876.3.31

Provenance
Alfred Bruyas, Montpellier.

Selected Exhibitions
Montpellier 1996, no. 64, ill. p. 104.

Selected References
Bruyas 1876, p. 478, no. 85; Montpellier 1985,
p. 102, no. 59, ill. p. 113.

Jules Didier was at the height of his career when he painted this imposing Italianate landscape. He had won the Prix de Rome in 1857, and, following on that success, he exhibited at every major Salon, winning prizes in 1866 and 1869, the year in which he completed *A Pine Forest at Castel Fusano*. Although the scale of this canvas might suggest that it was submitted to the Salon of that year, it bears no relationship to the titles of the two exhibited works listed in the catalogue, and it is more likely a work painted for private sale. Unfortunately, we have no record of Bruyas's purchase of the painting, and it is not mentioned until the year it was given to the museum in 1876. Again, this very traditional landscape demonstrates how far Bruyas had retreated from the kind of bold painting he had championed in the 1850s.

This work represents the Campagna di Roma, the countryside around Rome, a site favored by French landscape painters since the seventeenth century, when Claude Lorrain and Nicolas Poussin painted there. Yet, where these earlier artists had stressed the classical origins of the landscape by painting ruins and picturesque inhabitants of the region, Didier emptied his pictorial

world of any reference to human history or even agriculture. The immense black cattle drinking in the pond are untended and seem to move as if in a world before men, and birds swoop lazily over the water as they had for millennia. Nothing disrupts the peace and serenity of the view, and, as viewers, we encounter no herdsman, no hut, and no crumbled wall to refer to the Romans, ancient or modern, who inhabited this pristine landscape.

It is salutary for us to remember that, in the summer of 1869, when this large landscape was dated, Renoir, Monet, and Pissarro were all painting together in the modern Parisian suburbs of Bougival and Louveciennes, while Didier took the well-trod path to Italy. While his painting shows a considerable power of invention, it fits comfortably into the classical landscape genre started in the seventeenth century and invigorated around 1800 by Pierre Henri de Valenciennes (1750–1819). It is a pity that Bruyas was now too timid and too grand to buy anything by the young Parisians. One almost suspects that Bruyas bought this painting to balance another similarly sized work as he contemplated the hanging of his gallery at the Musée Fabre. **RB**

Gustave Doré
Strasbourg 1832–Paris 1883

56. *Evening on the Banks of the Rhine*

1853–55
Oil on canvas
47 1/4 x 76 3/4 in. (122.6 x 194.4 cm)
Signed lower right: Gv. Doré
Gift of Alfred Bruyas, 1868
868.1.45

Provenance
Alfred Bruyas, Montpellier (bought from the artist, Nov. 1857).[1]

Selected Exhibitions
Paris 1855b, no. 2983, as *Le Soir*; Montpellier 1860, no. 85, as *Le Soir—paysage pris dans les îles du Rhin, près de Strasbourg, par un effet de soleil couchant*, lent by Bruyas; Strasbourg 1983, no. 20, ill.; Montpellier 1996, no. 66, ill. p. 101.

Selected References
Bruyas 1876, p. 480, no. 86; Valmy-Baysse 1930, vol. 2, p. 118, no. 2983; Montpellier 1985, p. 102, no. 62, ill. p. 113.

Gustave Doré's reputation rests chiefly on his skill and prolific output as a literary illustrator, in part because few of his paintings entered public collections, and many have subsequently been lost.[2] Nonetheless, he painted a wide range of subjects throughout his career. *Evening on the Banks of the Rhine* is one of the earliest of his major landscape paintings. Made when Doré was in his early twenties, its view of the Rhine River at sunset is surely a form of pictorial homage to his happy childhood spent in Strasbourg. Doré left his native town in 1841, but he returned to the region numerous times between 1853 and 1870, and he probably based this work on sketches made during such a visit. The artist often depicted dramatic views of mountain ranges, waterfalls, or panoramic vistas on very large canvases, their heightened reality linking in certain ways with his work as an illustrator and caricaturist. While the present image seems more straightforwardly descriptive of the stillness at nightfall, the low horizon line creates a slightly exaggerated perspective, so that the trees, their tops still illuminated by sunlight, appear particularly narrow and elongated. This lends a sense of drama to an otherwise calm and unremarkable site.

Doré submitted *Evening on the Banks of the Rhine* to the Exposition Universelle of 1855 along with another landscape called *The Prairie* (location unknown) and an immense canvas representing the recent battle at

Alma during the Crimean War (destroyed). His selection of large-scale paintings in the established genres of history and landscape probably reflects his desire to raise his profile as a painter. The work's inclusion in this important exhibition seems to have influenced Doré in choosing this painting for Bruyas's collection, since he makes particular note of the fact in a letter to the collector.[3] Bruyas's second purchase from Doré,

made at the urging of Jules Laurens, was also a large landscape, *Souvenir of the Alps*.[4] As Laurens commented in a letter to Bruyas, the acquisition would save the canvas from neglect and possible destruction in Doré's studio storage, a state of affairs that very clearly illustrates not only the lack of demand for Doré's paintings, but also Bruyas's interest in a less popular aspect of a famous artist's work.[5]

SL and RB

1. In a letter to Bruyas of 29 Oct. 1857 (Doucet MS 216, no. 147), Doré stated that he would shortly send a painting, as Bruyas had requested; in another letter dated 12 Nov. 1857 (reprinted in Borel 1922, p. 30), Doré described this painting, "a landscape taken among the islands of the Rhine," and stated that he was sending it to Bruyas. According to a letter from Jules Laurens to Bruyas, the collector had requested a painting from Doré by July of that year; Laurens also noted that "Doré intends to ask 1,000 fr. for the canvas he is planning to

send you." Letter of 16 July 1857, Montpellier MS 405, no. 11.
2. See Nadine Lehni, "Gustave Doré peintre," in Strasbourg 1983, pp. 51–57.
3. Letter of 12 Nov. 1857 cited in note 1. "This painting figured in the Exposition Universelle of 1855 under the title 'Evening.'"
4. Musée Fabre, inv. no. 868.1.46. Although there has been some confusion over the dates of purchase of the two paintings by Doré, Laurens's letter to Bruyas of 22 Jan. 1859, in which he describes *Souvenir of the Alps* and includes a

small sketch of the painting, makes clear that this was the second acquisition. See Montpellier MS 405, no. 22.
5. Letter of 4 June 1859, Montpellier MS 405, no. 24. "I wanted especially to get Doré's second painting to you, one that the artist himself had wanted to return to storage in his studio, from which it will leave sometime soon, along with four others for your compatriots. . . . I am tremendously happy to save them from [certain destruction?]. They have already suffered a great deal. I removed them from a verita-

ble charnel house or ossuary, and there are still too many that remain there." (Je voulais surtout vous faire tenir le second tableau de M. Doré, que l'auteur lui-même a bien voulu faire rentrer en dépôt dans son atelier, d'où il va enfin partir, un de ces moments, avec quatre autres pour de vos compatriotes. . . . Je suis profondément heureux de les sauver d'une [immanquable destruction?] Elles ont déjà beaucoup souffert. Je l'ai retiré d'un véritable charnier ou ossuaire; et il n'en reste toujours que trop.)

Hippolyte Flandrin

Lyon 1809–Rome 1864

57. A Saint

1852
Graphite on paper, lightly squared
12 x 5 5/8 in. (30.4 x 14.2 cm); a vertical strip
7/8 in. (2.1 cm) wide has been added to the sheet
along the left edge
Signed in black ink, upper right: Hte Flandrin;
dated at lower left: X[illeg.] 1852
Bruyas Bequest, 1876
876.3.111
Exhibited Dallas and San Francisco only

Provenance
Mme Hippolyte Flandrin, the artist's widow
(given to Bruyas);[1] Alfred Bruyas, Montpellier.

Selected References
Bruyas 1876, p. 496, no. 91, as *Un Saint,
dessin pour vitrail*; Claparède 1962, no. 104, ill.,
as *Un Saint*.

Born in Lyon in 1809, two years before his brother Paul, Hippolyte Flandrin showed early promise and moved to Paris, where he entered the studio of J. A. D. Ingres at the age of twenty. He won the Prix de Rome in 1832, and in Italy he was particularly inspired by the painting of Raphael (1483–1520) and the sculpture of Phidias (c. 490–c. 430 B.C.). Flandrin, the first of Ingres's students to win the Prix de Rome, was close to his master, and applied his teacher's devotion to academic principles of draftsmanship and neoclassicism particularly to the realm of church mural painting, a revitalized art in the mid-nineteenth century and one that Flandrin dominated. His work suffered criticism and neglect in the later years of the century and particularly in the century following, partly due to his extremely methodical commitment to tradition, which made his work less original than his master's, and partly due to changing aesthetic tastes.

The present study can be identified as Saint Adrian, one of the figures in the double processional frieze of saints that Flandrin created between 1849 and 1853 for the nave of the contemporary Byzantine-style church of Saint-Vincent-de-Paul in Paris. Basing his figures and their order on the litanies of the saints, the artist placed choruses of male apostles, martyrs, doctors, bishops, and confessors on the right side of the nave,

and choruses of female martyrs, virgins, mothers, and penitents on the left.[2] The last group on the left toward the entrance, in which Saint Adrian appears second in line with his wife Saint Natalia, consists of saintly couples and families.[3] Flandrin had included two short processional friezes in his recently completed decoration of the neo-Byzantine church of Saint-Paul de Nîmes, but the Paris church offered space for extended processions, presenting on either side over 125 feet of nave wall bands between lower and upper entablatured colonnades.[4] The numerous figures, which stand rigidly erect against a gold-ornamented ochre ground and follow a consistent rhythmic spacing, prompted critic Théophile Gautier to compare them to the masterpieces of Flandrin's antique hero Phidias by christening them "Christian Panathenaeans."[5]

A Saint represents an intermediate step in Flandrin's process, exemplifying the careful study of a model in his studio after he had developed an initial overall sketch of the chorus. He then transferred the drawing to the wall by means of squaring, sketched in the complete chorus in paint, and then worked up the image to achieve the final painting.[6] In the frieze Saint Adrian adopts the same pose and attitude as the study figure, with head bent forward and eyes peering upward, but the painted version shows him beardless, with greater detail added to his drapery and his proper right foot turned out directly toward the viewer. Additionally, Adrian's hands are fastened by a looping chain and they clasp between them the hand of his wife, Natalia.

The Bruyas catalogue of 1876 listed Flandrin's Saint as a gift of the artist's widow, Aimée Flandrin. Probably some time after her husband's death in 1864, she assembled an album containing his studies for Saint-Vincent-de-Paul and for his previous commission at Saint-Paul de Nîmes.[7] It may have been while reviewing and compiling her husband's related works that Aimée thought to offer the present drawing to Bruyas.[8] Perhaps the gift was in acknowledgment of Bruyas's collecting landscapes by Flandrin's brother Paul. Besides the Valley of Hyères purchased and donated to the Musée Fabre in 1868 (cat. 58), Bruyas seems to have acquired Souvenir of the Yerres at Brunoy when it appeared in the Salon of 1865.[9]

PSC

1. As noted in Bruyas 1876.
2. For assistance the artist consulted with Father Cahier, a Jesuit priest. See Flandrin 1909, pp. 234–36. See also Daniel Imbert, "Les Peintures murales de l'église Saint-Vincent-de-Paul à Paris (1848–1853)," and the contrasting discussion in Bruno Horaist, "Saint-Germain-des-Prés," both in Paris 1984, pp. 111 and 125–26, respectively.
3. Adrian, a Roman officer at the court of Nicomedia, is said to have converted after witnessing the strength of persecuted Christians. His wife, Natalia, tended him and fellow prisoners until they were executed.
4. Paris 1984, p. 110, mentions a sketch that suggests Flandrin considered including very similar figures of Adrian and Natalia in his frieze decoration at Nîmes, though in a different distribution with fellow figures.
5. Théophile Gautier, Les Beaux-arts en Europe (Paris, 1855), cited in Paris 1984, p. 111.
6. The foregoing is based upon the description of the artist's practice at Saint-Vincent-de-Paul offered by his nephew in Flandrin 1909, p. 232.
7. Another possibility is that Aimée's daughter Cécile made the album, as related in Paris 1984, p. 216.
8. Possibly she gave the drawing in 1872, for a letter from Silvestre to Bruyas of 4 Dec. 1872 mentions Bruyas's receiving a drawing by Flandrin (Doucet MS 215, no. 39). Claparède 1962 erroneously connects this letter with Paul Flandrin's portrait drawing of Hippolyte (cat. 59), purchased in 1875.
9. The acquisition of the 1865 Salon painting is mentioned in the chronology of Paul Flandrin compiled by Olivier Jouvenet, in Paris 1984, p. 294, though the painting is not currently in the Musée Fabre collection.

Paul Flandrin

Lyon 1811–Paris 1902

58. *Valley of Hyères*

1868
Oil on canvas
10 1/4 x 14 1/4 in. (26 x 36 cm)
Signed lower left: Paul Flandrin
Gift of Alfred Bruyas, 1868
868.1.49

Provenance
Alfred Bruyas, Montpellier.

Selected References
Bruyas 1876, pp. 507–8, no. 91; Montpellier 1985,
p. 102, no. 66, ill. p. 114.

Through the vagaries of fate Paul Flandrin never attained the fame achieved by his older brother Hippolyte, yet he became quite a successful landscape painter. The brothers experienced the same training together and shared a studio, and Paul frequently assisted Hippolyte on his projects, including the decoration of Saint-Vincent-de-Paul (see cat. 57). In 1832, the year Hippolyte won the Prix de Rome, Paul won a prize for a historical landscape sketch. Failing the Prix de Rome competition the next year, Paul nonetheless decided to join his brother in Italy, where their teacher J. A. D. Ingres became director of the French Academy in 1835. Paul established his vocation as a historical landscapist in Rome, encouraged by Ingres and taking Nicolas Poussin (1594–1665) as his model. He debuted at the Salon of 1839 with two landscapes, winning a second-class medal, and in 1852 he was named chevalier of the Legion of Honor. Just as his brother was celebrated for expressing the purity of religion by means of the formal purity he learned from Ingres, Paul was known for transmitting Ingres's ideals to landscape, as sum-

marized in Baudelaire's oft-repeated jibe that he "Ingres-ized" the countryside.[1]

Each summer for many years Paul Flandrin left Paris to explore painting motifs in different regions—early on in the region of his native Lyon, and subsequently in the valley of the Rhône, in the area around Nîmes in 1849, and in Marseille in 1857 and 1859. In the 1860s he spent several summers at the home of his friend the sculptor Eugène André Oudiné (1810–1887) in Étretat, where, like Delacroix (cat. 43), he painted the famous ocean cliffs. Flandrin likely painted the 1868 *Valley of Hyères*, a picturesque view of a rural spot in the nearby region of Brittany, during that year's visit to the Oudiné family.

In addition to the lasting commitment to the classical tradition of Poussin and Claude Lorrain (1600–1682), by this time the artist's works showed some influence from Camille Corot, with whom he worked frequently outdoors. His manner was now suppler, and he had begun to use a fragmented touch to represent foliage. Many of Flandrin's paintings, in particular the large canvases he exhibited at the Salon, contain staffage figures in antique dress, such as classical shepherds, nymphs, or archers. With its contemporary-looking shepherd and dozing dog in the foreground, *Valley of Hyères* presents a more up-to-date and rustic scene. The artist took care to describe dappled light on the ground, the trunks and foliage of individual willows, poplars, and other trees both near and far, and colorful spots of flowers in the foreground—a vision of the verdant lushness and variety of a specific location in the French countryside.

Nevertheless, the painting remains true to Flandrin's classical bent. The trees lining the brook provide a convenient opening at center, where the head of the silhouetted, meditative shepherd breaks above the bank line. Tall trees at left and a boulder at right serve as standard repoussoirs, and the landscape gently, rhythmically, and subtly unfolds in a series of five successive parallel planes—flower-scattered foreground, lower sunlight-streaked meadow, grassland beyond the stream, tree-covered hills in the distance, and, finally, a Poussinesque sky. Although the figures are not dressed *all'antica*, Théophile Gautier's comment about the painting still rings true: "one feels that the shepherds of the *Eclogues* competed under the branches, in alternating strophes."[2] **PSC**

1. Baudelaire 1962, p. 67.

2. As cited in Bruyas 1876, p. 511.

59. *Portrait of Hippolyte Flandrin*

1873
Graphite and black chalk with touches of white chalk on paper
12 7/8 x 10 in. (32.8 x 25.5 cm)
Signed and dated in graphite at lower left:
Paul Flandrin / 1873
Bruyas Bequest, 1876
876.3.112
Exhibited Dallas and San Francisco only

Provenance
Alfred Bruyas, Montpellier (bought from the artist, June 1875).[1]

Selected References
Bruyas 1876, pp. 508–9, no. 92; Claparède 1962, no. 107, ill.

Paul and Hippolyte Flandrin had a close relationship, both personally and professionally. Testifying to the brothers' bond are the many images they made of each other, including double portraits in which each one represented the other. The present drawing by Paul, while recalling Ingres's well-known graphite portraits, provides several contrasts with the master's style. Paul depicted his brother Hippolyte with a pensive gaze that just misses contact with the viewer, expressing a particular individuality different from that of Ingres's sitters, who typically gaze out directly with assurance and sangfroid. The portrait is also darkly shaded in the face, with extensive modeling in the body, creating a somewhat dry, even labored, appearance. Paul's graphite portraits are usually lighter and

more fluidly contoured, like those by Ingres, with shaded modeling limited more exclusively to the face.

The unusual characteristics of this portrait drawing, along with the inscribed date of 1873, nine years after the sitter's death, suggest the artist may have based it on a photograph. Although no photograph showing Hippolyte in a similar pose is currently known, there exists a photograph of Hippolyte seated rather than standing, in which he appears approximately the same age, looking out with a similar off-center regard. As in the drawing, light comes from the upper left and highlights the face within the dark, framing hair, several threads of gray appear in the beard, and distinct shadows describe the grooves between the sitter's eyes and next to his nose, suggesting the faithfulness of the drawing to the sitter's appearance.[2]

In the enthusiastic 1875 letter to Bruyas in which he settled the price for the work, Paul expressed his feelings of gratitude that one of his drawings would join a collection containing works by his good friends Jules Laurens (see cats. 71–74) and Jean Joseph Bonaventure Laurens (1801–1890). He also declared his happiness that the likeness of his dear brother would remain in the city of Montpellier, which had welcomed Hippolyte so warmly.[3]

PSC

1. See letter from Flandrin to Bruyas, dated 4 June 1875, in which he requests 300 francs payment for this work. Doucet MS 216, no. 149.
2. The photo is reproduced in Paris 1984, p. 216, no. 136b.
3. Likely Paul was referring to the period in 1848–49, when he assisted Hippolyte with the decoration of Saint-Paul de Nîmes, near Montpellier. Hippolyte left the region in May 1849, but Paul stayed behind to paint the countryside, meeting Jules Laurens in Montpellier.

Eugène Fromentin

La Rochelle 1820–Saint Maurice 1876

60. *Tents of the Smalah of Si-Hamed-Bel-Hadj, Sahara*

1850
Oil on canvas
17 3/8 x 32 3/4 in. (44.3 x 85.2 cm)
Signed and dated lower right: Eug. Fromentin /
1850
Gift of Alfred Bruyas, 1868
868.1.47

Provenance
Alfred Bruyas, Montpellier (by 1860).

Selected Exhibitions
Montpellier 1860, no. 276, as *Paysage d'Orient*,
lent by Bruyas; Paris 1939, no. 51; Seville 1992,
unnumbered, ill. p. 188; Montpellier 1996, no. 85,
ill. p. 97; Paris 1997, no. 147, ill.

Selected References
Bruyas 1876, pp. 515–17, no. 94, as *La Smala
de Si-Hamed-ben-Hadj*; Montpellier 1985, p. 103,
no. 68, ill. p. 114; Thompson and Wright 1987,
pp. 84, 88; Peltre 1995, p. 69, fig. 27.

Throughout the nineteenth century, Europeans were fascinated with the Middle East and North Africa. Algeria had been part of France's colonial empire since 1830, and its exotic and ancient civilization only enhanced the excitement and the curiosity of the French Orientalists. Eugène Fromentin was one of the earliest pictorial interpreters of Algeria. He strove to become a history painter and emulated the work of Eugène Delacroix. During a six-week journey in 1846 to Algeria, the young Fromentin discovered a new world of sensations and colors. Within two days of his arrival he wrote: "Everything here interests me. The more I study nature here, the more convinced I am that the Orient is still waiting to be painted. To speak only of the people, those that have been given us in the past are merely bourgeois. The real Arabs, clothed in tatters and swarming with vermin, with their wretched donkeys, their ragged, sun-ravaged camels, silhouetted darkly against those splendid horizons; the stateliness of their attitudes, the antique beauty of the draping of all those rags—that is the side which has remained unknown."[1]

Fromentin returned to Algeria the next year and stayed for eight months, during which time he produced the sketches that were the origin of *Tents of the Smalah of Si-Hamed-Bel-Hadj, Sahara*. It was an extraordinary odyssey. Fromentin was the first European painter to venture to the far southern regions of Algeria, an especially dangerous area that still resisted the colonial power of France. He stayed in Constantine in the northeast from February to early May of 1848 and then spent seven weeks in the oasis town of Biskra. He took a three-day expedition from Biskra, accompanied by a local named Si-Hamed-Bel-Hadj. Fromentin described the trip as "the real pearl of our remembrances."[2] It was this visit that gave him the richest opportunity to be immersed in the picturesque and characteristic details of North African life.

Of special interest to him was the nomadic existence of the area's inhabitants, dictated by seasonal changes. Fromentin portrayed tribal life, nomads on the move or setting up camp, seen against sweeping plains and wide skies. In this work, the apparent immobility of the Sahara desert contrasts with the constant movement of the tents and figures. Fromentin aspired to document this remote place for those who could not travel there, becoming both the narrator and the interpreter. He

remarked, "to penetrate further into Arab life than is permitted seems to me ill-considered curiosity. One must observe this people from the distance at which they choose to show themselves."[3] This attitude determined Fromentin's approach to his subjects: scenes depicted from afar, actions unfolding in a frozen moment, and landscapes traced in broad, abstract strokes within which he attempted to present, in carefully calibrated light, a generalized view of his Orient. Fromentin's distance from his subject, indeed, seems vital to his work's appeal.

Fromentin based his depiction of the tents of Si-Hamed-bel-Hadj's tribe on his own experience of the desert, emphasizing the emptiness, the heat, and above all, the effects of the sun. He painted the light as pure and almost blinding, its intensity made palpable by the contrasting shadows. Fromentin stresses the aridity of the implacable desert, its burned atmosphere, and color. The painting not only captures an instant under the luminous vault of the African sky, but also reflects the silent oppressiveness of daytime. Although Fromentin valued accuracy, he eschewed purely docu-

mentary painting. His painting instead reflects the delicate imprint left on the painter's sensibility by his direct experience of the subject.

The early history of *Tents of the Smala of Si-Hamed-Bel-Hadj* is problematic. Certain sources[4] state that the canvas is signed and dated 1849 and identify it as one of five Algerian paintings Fromentin showed at the Salon of 1849. The work is clearly dated 1850, and this date is also assigned to it in current cataloguing at the Musée Fabre. Further, several descriptions of the work that appeared in the 1849 Salon mention details, such as aloes in the landscape and women or children visible within the tents, that seem difficult to link to the present work. Fromentin painted and exhibited numerous images based on his Algerian travels including eleven paintings in the Salon of 1850. The initial identification in Bruyas's 1876 catalogue of the present painting as one shown in 1849 may simply be erroneous. **LS**

1. Fromentin 1909, p. 172.
2. Thompson and Wright 1987, p. 84.
3. Fromentin 1984, p. 176.
4. Montpellier 1996 and Peltre 1995.

Théodore Géricault

Rouen 1791–Paris 1824

61. *Study of a Severed Arm and Legs*

1818–19
Oil on canvas
21 3/8 x 25 1/4 in. (54 x 64 cm)
Bruyas Bequest, 1876
876.3.38

Provenance
The artist (posthumous sale, Hôtel de Bullion, Paris, 2–3 Nov. 1824, under no. 17, one of *Dix études de diverses parties du corps humaine*); Jules Claye, Paris (by 1867; sold to Silvestre as agent for Bruyas, 11 Dec. 1874);[1] Alfred Bruyas, Montpellier.

Selected Exhibitions
Paris 1889, no. 383, as *Étude*; Paris 1939, no. 54; Rouen 1963, no. 9, as *Fragments anatomiques*; Paris 1991a, no. 175, ill. no. 224, as *Étude d'un bras et de deux jambes*; London 2003, no. 25, ill., as *Study of Truncated Limbs*.

Selected References
Bruyas 1876, p. 577, no. 96; Clément 1879, pp. 131, 305, no. 107, as *Étude d'après le nature morte pour La Méduse*; Eitner 1972, pp. 36–37, 168–69, no. 92, pl. 92; Eitner 1983, pp. 183, 345 n. 133, fig. 172; Montpellier 1985, p. 103, no. 71, ill. p. 114; Bazin 1987–97, vol. 6, pp. 30, 40, 150–51, no. 2048, ill. as *Étude de bras et de jambes coupés*; Athanassoglou-Kallmyer 1992, pp. 599, 602–3, fig. 3; Nochlin 1994, pp. 19–23, fig. 13.

This remarkable image depicts two severed legs and an arm arranged in an almost balletically graceful configuration on a dark surface. The subtle gradations of color and dramatic chiaroscuro lighting enhance the painting's impact. As Delacroix commented in his journal, "this fragment by Géricault is truly sublime. . . . It is the best argument in favor of beauty as it should be understood."[2] Indeed, the painting evokes both horror and pleasure, a combination that distinguishes the stronger emotional response produced by the sublime from that arising from the merely beautiful. In addition, Delacroix's description of the painting as a fragment, while not entirely accurate, points to the ambiguous status of the work, a completed, independent painting of the fragmented body that Géricault produced during the same period he was working on *The Raft of the Medusa* (Musée du Louvre, Paris).

Géricault devoted nearly a year and a half in 1818–19 to the creation of that canvas. He made pencil, charcoal, and ink sketches of every aspect of the work, from overall compositional outlines to individual figure studies, and painted portraits of several of his models.[3] The body parts that appear in the present work and in several related paintings, including an image of severed heads, however, were never incorporated into the final work and thus are not, properly speaking, sketches for it.[4] Instead Géricault seems to have made these paintings in parallel with the full-scale canvas as exercises in capturing not only the appearance of the body in death (truly *nature morte*, the French term for still life or, literally, dead nature), but also precisely the sublime, horrifying atmosphere he was attempting to represent in the *Raft*. Géricault is reputed to have worked on such studies for several months in the winter of 1818, obtaining body parts, presumably discarded after dissection or autopsy, from a nearby hospital and keeping them in his studio until they reached advanced states of decay.[5]

Géricault painted the same legs and arm in another study (Musée du Louvre, Paris), but gave greater emphasis to the horrific nature of the image by arranging the limbs in a less organized, less unified manner and by placing the cut ends of the body parts, rather than the hands and feet, directly in the foreground. The painting of severed heads, one with a gaping mouth and unseeing eyes (Nationalmuseum, Stockholm), representing as it does the locus of human consciousness

in an unequivocally inanimate state, only heightens the terrifying aspect of these works.[6] In contrast, just as the final painting shows heroic, unblemished figures rather than the ravaged survivors Géricault knew had been found after the shipwreck of the *Medusa*, the Montpellier painting shows little evidence of decay. It is composed so harmoniously, in a symmetrical arrangement with the cut ends of the limbs obscured by shadow and the rest of the forms bathed in a warm, glowing light, that the painting takes on an uncanny, almost living, presence. **SL**

1. See letter of 3 Dec. 1874 from Silvestre to Bruyas, in which he states that he had "a painted study by Géricault for the [*Raft of the*] *Medusa* which is admirable. I could send it to you if you'd like for fifteen days." (J'ai ici une étude peinte de Gericault pour la *Méduse*, qui est admirable. Je puis vous l'envoyer si vous voulez pour quinze jours.) Doucet MS 215, no. 171. In a letter of 12 Dec. 1874, Silvestre noted that he had bought the painting the previous day from Jules Claye for 1,500 francs, although Bruyas had been willing to offer 2,000. Doucet MS 215, no. 172.

2. Delacroix 1960, vol. 3, p. 71.

3. Eitner 1972, p. 35.

4. The inventory of Géricault's studio and the posthumous sale of his collection both list ten paintings of body parts. See Bazin 1987–97, vol. 1, pp. 88–89, 96. Only some of these are currently known; Eitner 1972 (pp. 167–69) catalogues six, while Bazin 1987–97 (vol. 6, pp. 148–52) attributes only four to Géricault.

5. See Clément 1879, pp. 131–32; this and other accounts are repeated in most of the subsequent literature.

6. See Athanassoglou-Kallmyer 1992 on allusions to the politics of capital punishment, and Nochlin 1994 on the abject nature of this group of paintings.

Jean-Léon Gérôme
Vesoul 1824–Paris 1904

62. Decorative Project for the Library at the Conservatoire des Arts et Métiers, Paris

1852
Oil on canvas
21 5/8 x 17 3/4 in. (55 x 45 cm)
Signed and dated lower left: J. L. Gérôme / 1852
Bruyas Bequest, 1876
876.3.41

Provenance
Alfred Bruyas, Montpellier (purchased from the artist, with Silvestre as agent, Jan. 1876).[1]

Selected Exhibitions
Vesoul 1981, no. 119, ill., as *Décoration pour les Arts et Métiers*; Paris 1991b, no. 143, as *Art et Science. Esquisse pour le décor de la nouvelle bibliothèque du Conservatoire des Arts et Métiers.*

Selected References
Ackerman 1986, pp. 40–41, 192–93, no. 42B, ill.; Ackerman 2000, pp. 38–39, 222–23, no. 42.2, ill., as *Allegorical Figures of the Arts and Sciences*; Montpellier 1985, p. 103, no. 76, ill. p. 114; Chang 1998, pp. 114–15.

Even after the opening of the Bruyas galleries in the Musée Fabre in 1868, the quest to broaden the scope of the collection continued. In January 1876, Théophile Silvestre proposed the acquisition of this painting representing a decorative project for the library at the Conservatoire des Arts et Métiers (Conservatory of Arts and Trades) by the academic artist Jean-Léon Gérôme.[2] In that same year, Gérôme became a member of the *conseil supérieur des Beaux-Arts*, having already been named one of the three professors at the reorganized École des Beaux-Arts (1863) and a member of the Institut de France (1864). Gérôme's paintings commanded enormous prices in France and America, which explains Silvestre's remark about the exorbitant price that Bruyas would likely have to pay.[3] The artist catered to a clientele that included wealthy industrialists as well as the wider public, who purchased inexpensive reproductions of his work published by the Goupil firm. Today, as in the nineteenth century, Gérôme's art and his aesthetic philosophy engender strong reactions—both positive and negative.[4]

A figure of controversy, Gérôme additionally personified the entrenched officialdom of the École des Beaux-Arts and the French Academy, profiting from their hierarchal organization and adhering to their conservative style. Writing in 1862, Émile Zola cast Gérôme as one of the institutionalized reactionaries who consistently opposed advancement of the avant-garde, which subsequently resulted in attacks on the Impressionists.[5] To this generalized criticism, Silvestre added his own reservations about Gérôme and the painting under consideration for purchase by Alfred Bruyas: "I send it to you only because of the celebrity of the artist. . . . as for myself, I need only tell you that I am not infatuated. I see no more than an overrated name and a date in Modern Art."[6]

Shrewdly skirting controversial material, Silvestre selected a work that represents one of Gérôme's public commissions. Founded in 1794, the Conservatoire des Arts et Métiers (now part of the Conservatoire national des arts et métiers) had since 1800 been housed in the former monastery of Saint Martin-in-the-Fields, Paris.[7] A pet project of Louis-Philippe's July Monarchy, which came to power with the 1830 revolution, the revitalization of the conservatory called for the renovation of the monastery facility, creating a proper museum and library within the technical school. However, the institution was to serve two functions: one educational, the other political. The conservatory would celebrate French technology, industry, and design, while simultaneously providing the government a presence in a restless district of Paris that had spawned a series of armed civil uprisings.[8] In 1838 the architect Léon Vaudoyer (1803–1872) received the contract for renovating the monastery, which presented significant design challenges. Expanded over several centuries, the monastery complex included structures built in various styles, including medieval and Renaissance. Instead of imposing a nineteenth-century classicizing veneer on the entire complex, Vaudoyer planned to maintain the historic sections. His vision was to capitalize on the visual richness, allowing the architecture to illustrate the monastery's organic growth, but also the evolution of French architecture styles.[9]

The transformation of the spacious gothic refectory into the library reading room is chronicled in both contemporary prints and documents (fig. 1).[10] On the

Fig. 1. Reading room of the Conservatoire
des Arts et Métiers

own conception to the architect's overarching vision. His figures are manifestly neoclassical, with the pointed arches of the figural niches providing the only medieval detail. Vaudoyer asked the interior ministry to compel Gérôme to make the stylistic adjustments necessary to harmonize the paintings with the architecture. The painter refused, requesting instead that a panel of three artists adjudicate the issue. Evidently the matter was settled privately, as shortly thereafter, Gérôme received the outstanding balance of his fee of 5,000 francs.

The reading room's iconographic program, which restated the message that welcomed visitors at the conservatory's exterior portal, promoted a typically mid-nineteenth-century concept: art and science inform and advance industry.[12] Separated into two bays by the engaged colonnettes of the room's vaulting system, Gérôme's pictorial elements echo the form and rhythm of the actual lancet and rose windows in the hall. Figures of "Metalwork" (personifying form) and "Ceramics" (personifying color) represent the foundation of "Art," just as "Chemistry" and "Physics" support "Science." Gérôme's fully developed conception of the individual figures is evident in a beautiful pencil drawing, recently on the art market.[13] The pleasing symmetry of the design enhances the quiet dignity of the Dantesque figure of "Science." However, these classical forms have little in common with the attenuated gothic vocabulary of the medieval hall's original design. Unfortunately, Gérôme's murals were destroyed when the hall was modernized in 1965. The Bruyas painting remains the most complete and elegant document of the artist's intentions and color scheme. **LFO**

basis of a now lost sketch, Gérôme won the commission for the hall's primary decorative element: monumental paintings representing personifications of the arts and sciences to cover one end wall of the room. Vaudoyer believed the young Gérôme was well suited to the task and, importantly, able to work in a style consistent with the hall's gothic surroundings.[11] Unfortunately, Gérôme proved unwilling to subject his

1. See letter from Silvestre to Bruyas, 7 Jan. 1876, in which he states he is sending this painting to Bruyas. "They are asking 1,000 francs for it," he writes, "and if we have to buy it from Gérôme or from his father-in-law Goupil, I don't know what kind of exorbitant price they will want for it." Montpellier MS 365, no. 19.
2. Gerald Ackerman, the acknowledged expert on Gérôme, very kindly shared with me the documents regarding this commission collected over many years of research. I wish to thank him for his kindness. The standard catalogue raisonné is

Ackerman 1986; a revised French edition was published in 2000.
3. See note 1.
4. Gérôme's technical mastery and powers of observation must be acknowledged; but some believe the artist squandered these talents on sensational subject matter. Supporters, such as Théophile Gautier, noted that he had gained his skill as an "ethnographer" through personal experience on numerous trips to the Middle East. Nonetheless, Gérôme's accurately detailed and exquisitely painted interpretations of North African society also proved to be the flash

point for many issues, including race, gender, and the politics of empire.
5. Zola 1862.
6. Montpellier MS 365, no. 19: "Je vous l'envoie surtout au point de vue de la célébrité de l'auteur. . . . Moi je n'ai qu'à vous dire que je n'en suis pas engoué. Je ne vois là qu'un grand nom surfait et une date de l'art moderne."
7. For a history of the Conservatoire des Arts et Métiers, see Le Moël 1994.
8. The infamous 1834 massacre at 12 rue Transnonain, chronicled in Daumier's print, took place nearby.

9. Bergdoll in Le Moël 1994, p. 90.
10. For reproductions of numerous contemporary prints, see Le Moël 1994.
11. Correspondence from early 1850 and fall 1851, relating to the work at Saint Martin-in-the-Fields, is in the Archives Nationale (F21-32ANP), Paris.
12. On the decorative program of the library reading room, see Bergdoll in Le Moël 1994.
13. Sotheby's, New York, 3 May 2000, lot 56.

Auguste Barthélémy Glaize

Montpellier 1807–Paris 1893

63. *Interior of Bruyas's Study*

1848
Oil on canvas
19 3/8 x 23 5/8 in. (49 x 60 cm)
Signed and dated lower left: A. Glaize / 1848
Bruyas Bequest, 1876
876.3.43

Provenance
Alfred Bruyas, Montpellier (commissioned from the artist, 1848).

Selected Exhibitions
Montpellier 1849, no. 46, as *Mr. A. B., dans son cabinet, au milieu de quelques amis*; Paris 1939, no. 57.

Selected References
Bruyas 1851, p. 16, no. 42, as *Intérieur du cabinet de M. Alfred Bruyas*; Bruyas 1852, p. 36, no. 52, as *Intérieur du cabinet de M. Alfred Bruyas*; Bruyas 1854, [p. 10], unnumbered, as *Le Cabinet Bruyas (intérieur)*; Bruyas 1876, p. 580, no. 102, as *Intérieur de M. Bruyas*; Marie 1984; Montpellier 1985, p. 87, no. 7, and p. 103, no. 78, ill. p. 90.

Auguste Barthélémy Glaize, a native of Montpellier, studied painting in Paris with brothers Eugène and Achille Devéria.[1] Although active as a painter of allegorical, historical, and religious scenes, Glaize supplemented his income throughout his career by painting portraits. Bruyas sat for Glaize at least five times during his life, and he also owned at least one history painting by the artist. He listed Glaize as an important contemporary history painter in his catalogue of 1851.[2]

Glaize painted Bruyas in his study shortly after the collector's return from his second trip to Italy. Glaize's painting shows a curtained room in which a number of paintings, drawings, and relief sculptures are displayed in a dense hanging on the walls. A number of these works are portrayed in enough detail to be recognizable; the triptych painted for Bruyas by Cabanel in 1847–48 hangs high on the rear wall (see cats. 17–19), below which are paintings by Alexandre Longhet, Eugène Devéria, and Glaize himself, as well as a drawing by Cabanel (cat. 20).[3] The Italianate landscape on the easel is not one that passed into the collection of the Musée Fabre, but may represent one of several landscapes by Louis Français (1814–1897) that Bruyas owned at the time.[4]

Bruyas is positioned prominently among a small group of friends and supporters. At far left is Auguste Bimar, a Montpellier native who worked in Paris as a lawyer. Next to him, Bruyas stands as gracious host in a pose of elegant informality; he looks out at the viewer while resting one hand on the shoulder of his dear friend Louis Tissié.[5] Between Bruyas and Tissié stand Henri Bricogne wearing a red cravat, a good friend who helped Bruyas acquire paintings in Paris,[6] and Jacques Bruyas, the wealthy father of Alfred and sometimes reluctant financier of his son's expensive lifestyle. Tissié leans forward and studies the painting displayed on the easel. Bruyas *père* also looks toward the painting, but without the implication of rapt attention and admiration displayed by Tissié.

To the right of the easel, the character of Bruyas's study changes. On a pedestal is a sculptural group of three nude female figures related to a fountain in Montpellier,[7] and before it on the floor are two paintings propped up on a thick book and a cascade of exotic items—a leopard skin, a North African slipper, various vases in different styles, an ostrich egg, jumbled

colorful fabrics. Nearly hidden in this corner is a young boy peering out from behind the sculpture pedestal. Finally, the right wall of Bruyas's study opens in a large window, through which we see Italianate architecture bathed in sunlight under a blue sky.

In the center of the painting is a woman, seated on a chair before the easel, her back to the viewer, her head turned toward Bruyas. She has been speculatively identified as the wife of Tissié,[8] but the deliberately anonymous way she is presented suggests that she is intended primarily as a compositional device in the painting. Her position and pose provide a link between the group of identifiable men standing at left and the imaginative clutter at right, as her upper body relates her to the men, but her lower body faces the far side of the room, and one foot rests on a tasseled cushion that overlaps the leopard skin. Several other portraits of Bruyas include anonymous female figures that act as compositional or symbolic elements, most notably *The Burnoose* (cat. 64), also by Glaize.[9] It seems likely that the figures of the woman and child are not intended as portraits of specific people as but figural types that add nuance to both the composition and the content of the painting.

The right side of Glaize's painting may refer to the scope and character of Bruyas's interest in the arts. Different locations are implied: Italy (the scene through the window), Montpellier (the sculptural group), and the Near East (the objects on the floor). The juxtapositions might also refer to different types of art collected by Bruyas—landscape, figural, genre—and even different styles: realist, classicizing, romantic.

By commissioning a painting of his collection at this

early date, Bruyas gives an indication of what was to become increasingly clear—collecting for him was not a hobby but a career with serious intent. His later attempts to characterize his collection were done through publications and the installations at the Musée Fabre. Bruyas retained ownership of the Glaize painting until his death. Looking back on it, he must have taken pleasure in reflecting on how far his collection had come. Indeed, within a few years of the completion of this painting, the character and profile of Bruyas's

collection would change dramatically. The comments Bruyas wrote about his collection in these early years express his sense of providing leadership for a shared vision with a group of likeminded people; he dedicated this painting in his 1854 catalogue to "M. Bruyas *père*, L. Tissié, R. Adhémar, E. Mey, etc." Two of those men are portrayed in the painting, but two are not. The implication, that the formation of Bruyas's collection was of interest to many, must have been one of the main motives in commissioning such a painting. **KMM**

1. Marie 1984, p. 132. For a detailed biography and listing of Glaize's oeuvre, see Marie 1984, appendix 1–3.
2. Bruyas 1851, p. 31. In a document titled "Diverses Phases de la Galerie Bruyas (Art Moderne)," written on his monogrammed letterhead, Bruyas listed Glaize as one of the artists related to his gallery in the period 1848–49. Doucet MS 214, no. 1.
3. For a detailed discussion of the works of art in the painting, see Marie 1984, pp. 30–44.
4. Ibid., pp. 38–41.
5. In his many portraits, Bruyas nearly always wore a large black

ring on his left index finger; that it does not appear in this painting is curious. Tissié is portrayed as wearing a red signet ring on his left index finger; he must have given this ring to Bruyas at some point, as both rings are now in the collection of the Musée Fabre. Indeed, it may be Tissié's ring that appears as the gold and coral ornament on Bruyas's watch chain in both Courbet's and Delacroix's 1853 portraits (cats. 29 and 46). Bruyas's ring is carved with the figure of Hercules and the Nemean lion; Tissié's is carved with the Virgin and Child.
6. Marie 1984, p. 49.

7. The sculpture has been identified by Marie as a variant of the marble group atop an eighteenth-century fountain by Étienne d'Antoine in the Place de la Comédie in Montpellier; Marie 1984, p. 44. It is unknown whether Bruyas actually owned such a sculpture. Marie suggests that the sculpture may be an allusion to the collector's city and the location of his gallery.
8. See ibid., p. 53, and Chang 1996a, p. 170.
9. Also, in 1856 Jules Laurens created a lithograph entitled *The Dream in Life* (see cat. 90, fig. 1) that is a montage of images of Bruyas encircling the head and shoulders of a

dark-haired woman who gazes dreamily at the viewer. Bruyas's likeness appears a number of times in this print; at top he is shown in somber poses derived from three photographs, and at the sides and bottom are details from various paintings in his collection in which his likeness appears (see cat. 90 for a further examination of this print). The Laurens lithograph demonstrates the extent to which Bruyas's self-identity was entwined with his collection, and how the female muse, always a pretty, dark-haired woman, might personify the imaginative and creative force behind such an accomplishment.

64. *Portrait of Alfred Bruyas (The Burnoose)*

1849
Oil on canvas
57 1/8 x 45 5/8 in. (145 x 116 cm)
Signed, dated, and inscribed lower right: ALL' SIGR. A / BRVYAS / AMICO ED INSTIGATOR / DELLE BELLE / ARTI. / IL SVO / PITTORE ED / AFFEZIONAT / AGlaize [AG in monogram] / 1849
Gift of Frédéric Bazille, Mme André Bazille, Mme Meynier de Salinelles, 1952
52.11.1

Provenance
Alfred Bruyas, Montpellier (given to Tissié); Louis Tissié, Montpellier (before 1876); Suzanne Tissié (Mme Marc Bazille), his daughter, Montpellier (d. 1911); Frédéric, André, and Laure (Mme Meynier de Salinelles) Bazille, her children; given to the Musée Fabre, 1952.

Selected Exhibitions
Montpellier 1977, unnumbered cat.

Selected References
Bruyas 1851, p. 17, no. 43, as *Le Burnous*; Bruyas 1852, p. 36, no. 53, as *Le Burnous*; Bruyas 1854, p. 11, no. 5, as *Le Burnous*; Montpellier 1985, p. 87, no. 8, ill. p. 90, and p. 104, no. 79.

Bruyas commissioned this portrait from Glaize in the fall of 1848, shortly after returning from his second trip to Italy.[1] Although the painting was executed in France, Bruyas appears to be standing before ruins in the Roman countryside. He wears a type of shawl known as a *burnoose* that had been given to him by Jules Laurens following a trip to the Near East.[2] A broad-brimmed traveler's hat casts a deep shadow over his eyes, and he himself casts a shadow over the woman who appears to his right.

The female figure, with dark hair and eyes, a loose-fitting white blouse, and a laurel wreath, may be intended to personify Italy. A similar characterization of Italy can be found in other paintings of the period, such as the allegorical representation by Friedrich Overbeck (1789–1869) of *Italica and Germanica* (1811–28; Bayerische Staatsgemäldegalerie, Munich).[3] Bruyas stands slightly in front of the woman, casting a shadow on her face. The tulip she holds, a luxurious, hybrid type, its white petals tipped with red, has a

wealth of allusions. Besides associations with beauty and luxury, such a flower carries connotations of the transience and fragility of life.[4] This could be a reference to the brevity of Bruyas's stay in Italy, or perhaps even to his fragile health, as could the deep shadow over his eyes. In addition, tulips are native to Turkey, so the flower might hold another allusion to the travels of Laurens, who had just given his friend the richly ornamented shawl. In 1851 Bruyas described *The Burnoose* as an "homage to J. Laurent [*sic* for Laurens] on his return from Egypt. Painting motif executed after documents collected from various countries."[5] The "various countries" must be Italy, represented by the setting and the female figure, and the Near East, manifested in the burnoose and the tulip.

In his 1854 catalogue, Bruyas dedicated the painting "to his comrades" and included the following line: "Let us never be afraid to appear too naive or too simple, when truth is our goal."[6] Such a comment has little apparent relation to the painting, but reads as personal aside directed at those who understood Bruyas's aims. Glaize, for his part, included an inscription on the column base at right, written in Italian to match the theme of the painting. In it Glaize called Bruyas the "friend and instigator" of the fine arts; the column above the inscription may allude to the structure or support Bruyas provided that allowed art, represented by the ivy that clings to and grows along the side of the column, to flourish. Bruyas made a point of commenting on this type of collaboration, stating in relation to another portrait that "among the subjects or pieces of painting that make up the cabinet of M. A. B., most, commissioned by him, were the object of a sustained study and combination with the Artist."[7] Painted in a period when Bruyas commissioned numerous portraits, Glaize's portrait represents the collector as a worldly dandy, secure in his role among his artist friends, painted by one of them and standing in an Italianate landscape reminiscent of the place where they spent time together.

At some point Bruyas gave this portrait to his close friend Louis Tissié, through whose family it descended until it joined the collection of the Musée Fabre in 1952. For Bruyas, clearly, this painting had rich associations with his friends and his travels at an early point in his collecting career. **KMM**

1. Léotoing 1979, p. 6.
2. Bruyas had spent time in Florence and Rome with Laurens in 1846, just before Laurens left on an official mission to Greece, Turkey, Armenia, Egypt, and Persia, for which he served as draftsman and from which he brought back the shawl as a gift for Bruyas. Montpellier 1985, p. 26.
3. The representation of *La Chiaruccia* by Alexandre Cabanel in Bruyas's collection (cat. 18) also follows this basic type.

4. Tulips carry these associations as well as a connection to the life of the mind in the famous quadruple portrait by Peter Paul Rubens known as *The Four Philosophers* in the Pitti Palace and probably known to Bruyas from his visits to Florence.
5. Bruyas 1851, p. 17.
6. Bruyas 1854, p. 11.
7. Ibid., pp. 18–19, in an entry on a portrait of Bruyas by Octave Tassaert (Musée Fabre, inv. no. 876.3.64).

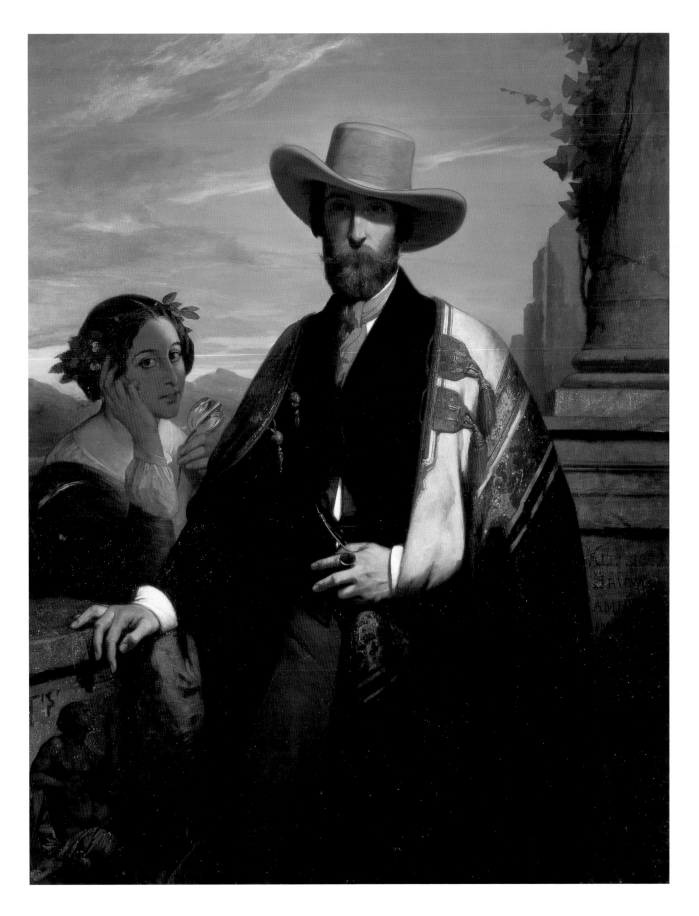

Paul Huet

Paris 1803–1869

65. *Mountain Landscape*

1833
Watercolor over graphite on paper
8 5/8 x 11 1/2 in. (21.9 x 29.2 cm)
Huet vente stamp in red ink, lower right (Lugt 1268)
Bruyas Bequest, 1876
876.3.115
Exhibited Richmond and Williamstown only

Provenance
The artist (d. 1869); René Paul Huet, his son
(1869–72; sold to Jules Laurens as agent for Bruyas,
1872);[1] Alfred Bruyas, Montpellier.

Selected Exhibitions
Montpellier 1996, p. 157, no. 118, ill. p. 95, as
Paysage de montagne.

Selected References
Bruyas 1876, no. 117, as *Paysage*; Claparède 1962,
no. 121, ill., as *Paysage de montagne*; Miquel 1962,
p. 88, ill. p. 85, as *Vallée d'Auvergne—Murols*.

ike beautiful melodies," observed the Romantic painter Paul Huet, "nature in effect transports the imagination into the infinite."[2] Théophile Gautier discerned synaesthetic qualities in Huet's paintings, noting "every touch of his brush is a stanza from the colored ode that he sings."[3] In their broad and frequently temperamental conception of nature, his landscapes also suggest the grand English tradition; Gautier found in them evocations of Gainsborough, Constable, and Turner. "The sites have their melancholy and cheerfulness, their sorrows and joys, their hours of wild gaiety and of mournful despondency, that must be translated in their general sense," he wrote. "M. Paul Huet always seeks this broad sensation, and finds it often."[4] To Huet, capturing the unique personality and "feeling" of a site was more important than the mere transcription of its topographical features.

As a young student in Paris during the late 1810s, Huet enrolled in the studios of Pierre-Narcisse Guérin (1774–1833) and Antoine-Jean Gros (1771–1835), and

66. Riverbank, Saint-Thomas near Bort-les-Orgues

1833
Pen and brown ink, brush and brown wash, and watercolor over graphite on paper
11 3/8 x 18 5/16 in. (28.9 x 46.5 cm); a vertical strip 1 9/16 in. (3.9 cm) wide has been added to the sheet along the left edge
Huet vente stamp in red ink, lower right (Lugt 1268)
Bruyas Bequest, 1876
876.3.114
Exhibited Richmond and Williamstown only

Provenance
The artist (d. 1869); René Paul Huet, his son (1869–72; sold to Jules Laurens as agent for Bruyas, 1872); Alfred Bruyas, Montpellier.

Selected Exhibitions
Montpellier 1996, p. 157, no. 119, ill., as *Les Eaux de Saint-Thomas près de Bort-les-Orgues (Corrèze)*.

Selected References
Bruyas 1876, no. 116, as *Paysage*; Claparède 1962, no. 122, ill., as *Les Eaux de Saint-Thomas près de Bort-les-Orgues (Corrèze)*; Miquel 1962, p. 88, as *Les Eaux de Saint-Thomas*.

made the acquaintance of Eugène Delacroix and the gifted watercolor painter Richard Parkes Bonington (1802–1828). In the Salon of 1824 he discovered the work of the English painter John Constable (1776–1837), and this encounter had a profound impact on his subsequent development as a landscape painter. His first submissions to the Salon of 1827 marked the beginning of a long and successful public career as a painter, lithographer, and etcher.

Mountain Landscape and *Riverbank, Saint-Thomas near Bort-les-Orgues* have both been dated to the early 1830s, when Huet began to make a name for himself as a leader of the French Romantic movement.[5] His summer travels at first took him to diverse and picturesque sites in Normandy, and in 1833 he ventured southward into the Auvergne. Both watercolors display his fluency in the medium and his desire to capture vistas of great sweep and drama. As a freely executed watercolor painted over a light underdrawing, *Mountain Landscape* preserves the feeling of a plein air sketch.

Riverbank is handled in a more labored technique, in which the dense washes of color are combined with linear contours and areas of cross-hatching in pen and brown ink. A recumbent figure provides a measure of scale and also reflects Huet's anglophilic sensibility, while giving the composition a greater sense of finish.

Much of Huet's work remained with his family after his death. In 1872, Bruyas purchased several drawings from Huet's son, through the intermediary of the artist Jules Laurens. The presence of Huet's red vente stamp on the three drawings in the Bruyas collection (cats. 65–67) indicates that they were purchased after the artist's death in 1869; the sale of his studio inventory did not take place until 1878, two years after Bruyas's bequest to the Musée Fabre. **JAG**

1. In a letter of 11 Dec. 1872, Laurens wrote to Bruyas of several drawings and a painted sketch he had just acquired from Huet's son. Montpellier MS 405, no. 128. Laurens was considering which additional drawings to select from among those offered, including one which he described as depicting "a very southern subject: wide open space, rocks, mountains, with a river in a channel in the earth," probably *Riverbank, Saint Thomas* (Laurens to Bruyas, 20 Dec. 1872,

ibid., no. 129). Although Laurens's descriptions do not clearly match *Mountain Landscape*, it must have been among the drawings purchased at this time.
2. Huet 1911, p. 73.
3. From an article in *Ariel*, 2 Apr. 1836, quoted in Gautier 1994, p. 255.
4. From *La Presse*, 10 May 1848, quoted in ibid., pp. 255–56.
5. Miquel dated both of the watercolors to 1833; see Miquel, 1962, p. 88, and Montpellier 1996, p. 157.

67. *Seascape*

1850
Black and white chalks with stumping on paper
11 x 17 1/4 in. (28 x 43.8 cm)
Huet vente stamp in red ink, lower left (Lugt 1268)
Bruyas Bequest, 1876
876.3.113
Exhibited Richmond and Williamstown only

Provenance
The artist (d. 1869); René Paul Huet, his son (1869–72; sold to Jules Laurens as agent for Bruyas, 1872);[1] Alfred Bruyas, Montpellier.

Selected Exhibitions
Montpellier 1996, p. 157, no. 120, ill.

Selected References
Bruyas 1876, no. 115; Claparède 1962, no. 124, ill.; Miquel 1962, ill. p. 161, as *Marine entre Villers et Trouville*.

At the edge of the sea, a solitary figure stands resolute in the face of turbulent nature. Huet's construction of this scene reflects his deeply Romantic conception of the landscape. The setting of this melancholic drawing is the Channel coast between Villers and Trouville, where the artist spent part of the summer of 1850.[2] Perspective is subtly created by a series of parallel lines concentrated at the low horizon, lines broken only by a cliff at left and a silhouette—perhaps of a fisherman—in the stiff wind. There is a formal economy to Huet's black chalk lines across the lower register of the sheet. The real subject of this drawing is neither the shore nor the sea, but the sky, heavy with dense clouds. This is also the primary site of Huet's graphic performance, with the meteorological drama evoked by freely drawn and locally smudged patches of black and white chalk used in concert with the reserve of the paper.

Huet's privileging of the sky over the land in this sheet and a number of his other landscapes reflects a fascination with cloud forms shared among both scientists and artists during the first half of the nineteenth century. It was John Constable (1776–1837), a painter held in the highest esteem by Huet, who wrote in a frequently cited letter of 1821, "That Landscape painter who does not make his skies a very material part of his composition—neglects to avail himself of one of his greatest aids. . . . It will be difficult to name a class of Landscape—in which the sky is not the 'key note'—the 'standard of scale'—and the chief 'Organ of sentiment.'"[3] In France, Eugène Boudin and Gustave Courbet were particularly noted for their cloudscapes.

Although Alfred Bruyas is silent on the subject, one can imagine that he recognized a formal as well as a psychological kinship between Huet's composition and Courbet's *Sea at Palavas* (cat. 31), which he acquired from the artist in 1854. The arc of the man's body and his placement on Courbet's canvas recall the fisherman's pose in Huet's sheet. Huet revisited this subject in an almost monochromatic painting, *Study of the Sea in the English Channel* (location unknown), which he exhibited in the Salon of 1861.[4]

JAG

1. In a letter of 11 Dec. 1872, Laurens wrote to Bruyas of several drawings and a painted sketch he had just acquired from Huet's son. This drawing is described as "a simple line of the sea at low tide, [under?] a great cloudy sky. . . . With the least material [effort?] possible, the [effect?] is as fine as it is grandiose and powerful, as inspired as it is true." Montpellier MS 405, no. 128.
2. Pierre Miquel dated the sheet to Huet's Normandy excursion of 1850; Miquel 1962, p. 161.
3. This quote is taken from the letter written by Constable to John Fisher on 23 Oct. 1821, quoted in Edinburgh 2000, p. 156.
4. Illustrated in Miquel 1962, p. 203. In his commentary on the 1861 Salon, Théophile Thoré described the painting as made of "only two tones: a monotone band of yellowish gray for the sea, a band of iron gray for the sky." Reprinted in Huet 1911, pp. 515–16.

68. Landscape—Hunter in the Forest of Fontainebleau

c. 1865
Oil on panel
14 5/8 x 20 7/8 in. (37 x 53 cm)
Signed lower left: Paul Huet
Bruyas Bequest, 1876
876.3.46

Provenance

The artist (d. 1869); René Paul Huet, his son (1869–72; sold to Jules Laurens as agent for Bruyas, 1872);[1] Alfred Bruyas, Montpellier.

Selected References

Burty 1869, p. 104; Bruyas 1876, p. 587, no. 113, as *Paysage*; Montpellier 1985, p. 104, no. 89.

Fig. 1. Paul Huet,
Forest of Fontainebleau—The Hunters, 1868.
Oil on canvas, 34 1/4 x 49 1/4 in. (87 x 125 cm).
Musée du Louvre, Paris

Huet traveled widely in France as well as in other European countries, but he did not visit the forest of Fontainebleau until 1849, well after the site had become the favorite subject of artists such as Théodore Rousseau and Jean-François Millet. His approach to painting the landscape, emphasizing dramatic compositions and weather conditions, remained closer to Romanticism than to Rousseau's more naturalistic style. This panel, painted with short, thick brushstrokes, effectively conveys the sense of air moving through the tree branches, the appearance of sunlight sporadically penetrating the thick cloud cover, and the motion of the huntsman in the foreground as he strides up the hill with his two dogs playing at his feet. Huet's summary execution allows the warm beige of the ground layer to show through in numerous areas.

As this fluid handling suggests, the painting is a sketch for a larger canvas, *Forest of Fontainebleau—The Hunters* (fig. 1), a work that Huet exhibited at the Salon of 1868.[2] There is also a pen and ink sketch of the same motif (location unknown) that shows another stage in the evolution of the composition.[3] The primary group of trees and the figures of hunters on horseback at the left appear little changed from the drawing to the panel, but in the ink sketch the foreground hunter and his dogs climb a path sloping upward to the left, rather than to the right as in the painted sketch. Huet also placed the trees more centrally in the painted sketch and presented them as a more unified mass than the varied group that appears in the ink drawing. The artist introduced far fewer modifications in working from the painted sketch to the final canvas. Aside from the greater sense of depth, more finished brushwork, and more clearly defined forms in the final painting, particularly in the two secondary mounted hunters, the most notable difference is the introduction of a small stand of birch trees at the right, replacing the two thin trees in both the ink and the painted sketches. This change gives the composition both greater balance and greater contrast, as the slim, pale birches, seemingly huddled together for support, offset the sturdy, dark mass of oak trees. In his review of the Salon of 1868, Ernest Chesneau used just this contrast to emphasize the drama and harshness of the setting. "In a desolate landscape, drowned in rain all the way to the horizon, a few spindly birches bend lamentably, fastening their

shaken roots to rough blocks of volcanic rock; alone, a group of great, firmly rooted oaks effortlessly resist the torment."[4]

Both Huet and Bruyas were at Eaux-Bonnes, a spa in the Pyrenees frequented by artists, in 1845. While they may have met at the time, Bruyas did not purchase any work by Huet until many years later.[5] In the 1868 plans for the Galerie Bruyas, in fact, Bruyas listed Huet along with several other artists under the heading "to come," presumably indicating his intention to buy work by these artists. It was not until 1872 that the collector entered into negotiations with the artist's son, through the intermediary of Jules Laurens, to buy a group of works by Huet. **SL**

1. In a letter of 11 Dec. 1872, Laurens wrote to Bruyas of a painted sketch he had just acquired from Huet's son, referring to the present work, along with several drawings. Laurens paid 1,500 francs for the group of works. Montpellier MS 405, no. 128.
2. The painting appeared in the Salon with the title *Fontainebleau*. Burty 1869, p. 104, describes it as a "*tableau composé* after a motif in the forest of Fontainebleau," and lists a sketch of 36 x 53 cm, which must refer to the present work.
3. Illustrated in Huet 1911, pl. XV, as *Fontainebleau. Les Chasseurs*.
4. Ernest Chesneau, in *Le Constitutionnel*, 1 July 1868; reprinted in Huet 1911, p. 524.
5. Miquel 1962, p. 135, states incorrectly that Bruyas bought "a series of watercolors and drawings" from Huet during the visit to Eaux-Bonnes.

Jean Auguste Dominique Ingres

Montauban 1780–Paris 1867

69. Studies for "Jesus among the Doctors"

c. 1842–51 (assembled, touched up, and signed by Ingres in 1866)
Oil on multiple pieces of canvas mounted on panel
13 3/8 x 18 1/2 in. (34 x 47 cm)
Signed lower right: Ingres
Bruyas Bequest, 1876
876.3.48

Provenance
[Étienne-François Haro, Paris, purchased from the artist 13 Oct. 1866];[1] Ingres's posthumous sale, Hôtel Drouot, Paris, 6–7 May 1867, no. 5, sold back to Haro for 990 francs; [Étienne-François Haro, Paris, 1867–74; sold to Silvestre as agent for Bruyas, July 1874, for 2,000 francs];[2] Alfred Bruyas, Montpellier.

Selected Exhibitions
Paris 1867a, no. 4; Paris 1939, no. 67.

Selected References
Bruyas 1876, p. 589, no. 119; Wildenstein 1954, pp. 228–29, no. 304, fig. 187; Montpellier 1985, p. 105, no. 91, ill. p. 115; Vigne 1995a, p. 338, fig. 259; Montauban 2000, pp. 4, 12, ill. p. 13.

This is one of eight recorded oil sketches for Ingres's large painting *Jesus among the Doctors* (fig. 1), a project on which the artist labored intermittently for twenty years. Ingres received the commission in 1842 from Queen Marie-Amélie for the chapel of the Château de Bizy, but by the revolution of 1848 it was still incomplete. The picture remained in his studio and in 1851 was well enough advanced that Ingres had it engraved by Achille Reveil (1800–1851); he finished it only in 1862, when he was eighty-two years old. It is one of Ingres's most monumental, if still little appreciated, historical pictures. Its overall design is indebted to Raphael's frescoes in the Stanza della Segnatura in the Vatican, and the artist's difficulties in bringing the work to resolution suggest that he found it hard to engage fully with its potential. The picture received mixed reviews when Ingres exhibited it in 1862; the Goncourt brothers complained that "There is not a morsel of paint on that big canvas," but Théophile Gautier admired its religious feeling—he likened Ingres's easel to an altar—and the beauty of the draperies.[3] An attempt to acquire it for the nation failed; in the end, the picture remained in Ingres's possession and was included in the artist's bequest to his native town of Montauban.

As part of standard academic procedure, Ingres habitually employed oil sketches and drawings of all types in preparing for his monumental figure paintings. The intent was to synthesize a careful observation of nature with a grand conception that idealized and universalized the subject. In addition to the oil studies, over a hundred drawings survive for *Jesus among the Doctors*, many of them nude studies of a woman who, remarkably, posed for most of the figures of the doctors, along with numerous sketches of heads, hands, draperies, and several drawings for the overall design.[4] The exact relationship of the oil sketches to these drawings is uncertain, but they were likely made after Ingres had blocked out the composition on the large canvas and drawn the figures. In the Bruyas oil sketch, Ingres focused on the heads of several of the "doctors," or Jewish scribes, with whom the young Jesus debates, as well as those of Joseph and the Virgin Mary. He studied the models from life, observing with acuity their physiognomies and capturing their amazement and astonishment as described in the Gospel of Saint Luke

(2:47–48). They are close in appearance to the figures in the final painting, notwithstanding the minor adjustments one would expect: Mary's mouth is closed in the oil study but slightly open in the painting; the staff held by Joseph is shorter in the study; his raised hand is in front of Mary's head in the study and behind it in the painting. The doctor in the lower center is bareheaded in the study and turbaned in the painting; what is his hand in the study becomes the hand of the companion to his right in the painting. These adjustments had already been introduced into the large canvas when Réveil engraved it in 1851, leading one to conclude that the oil studies had been completed by that date, if not earlier.

The technique of grouping several head studies was an accepted part of French artistic practice, one that Ingres would have learned in the studio of his teacher Jacques-Louis David (1748–1825). Ingres's touch is fluid, beautifully colored, and startlingly descriptive—particularly in the striking face and raised hand of Joseph at the right edge—qualities that did not entirely translate to the purified, marmoreal figures in the final painting. Even so, one critic in 1861 commented on the vivid characterization of the figures in the large canvas: "People living today have been transported by the painter's genius to another time and place."[5] This engaging naturalism was the product of Ingres's familiarity with his models, several of whom have been identified as the artist's friends, including the landscape painter Alexandre Desgoffe (1805–1882), who posed for the figure of Joseph, and Gautier, who sat for the figure of the bearded doctor in the lower center.[6] Late in life Ingres recognized the appeal of his oil studies to collectors, and he is known to have cut them up, reassembling them onto panels to make small pictures; these "visual concoctions" were likely all made in 1866.[7] The satisfying *mise-en-page* of the Bruyas painting, with the disparate heads interlocked as in a jigsaw puzzle, was made from at least six small pieces of canvas, corresponding to the individual heads and the hand of the bearded man at the lower center. Ingres bridged the gaps with additional paint: this is most apparent in the young man at left, whose proper left forearm and red drapery extend past the edge of the original piece of canvas; and in the Virgin, whose blue headdress was largely painted after the assemblage was complete. As a

Fig. 1. J. A. D. Ingres,
Jesus among the Doctors, 1842–62.
Oil on canvas, 8 ft. 6 3/8 in. x 10 ft. 6 in. (265 x 320 cm).
Musée Ingres, Montauban

final act of completion, Ingres appended his signature.

Studies for "Jesus among the Doctors" was a late addition to the Bruyas collection, acquired only in 1874. In June of that year Théophile Silvestre lamented the absence of a work by Ingres and wrote to Bruyas about several examples he had examined in the possession of Étienne-François Haro (1827–1897).[8] Haro, a painter, dealer, and restorer, had acquired a large group of works from Ingres in 1866, shortly before the artist's death; he lent many of them—including the present study—to the posthumous retrospective exhibition in April 1867.[9] Silvestre wrote enthusiastically to Bruyas about the oil studies, noting that Gautier and other friends of Ingres had served as models for the figures, although he balked at Haro's asking price of 3,000 francs. He eventually paid that amount for both the present work and a second study of heads, for *The Apotheosis of Homer*, one of twenty assembled oil sketches for that project owned by Haro. The choice of these works suggests that Silvestre recognized that Ingres had conceived of *Jesus among the Doctors* as a kind of Christian counterpart to his celebrated *Homer*. While the oil studies can hardly be considered major

examples of Ingres's work, Haro described them as "in some ways the confession and testament of his genius."[10] They undoubtedly appealed to Bruyas for their relatively informal naturalism—qualities that would have made them at home with the great suites of Realist and Romantic pictures that had always defined the collection.

RR

1. This painting is not listed among those sold to Haro in order to be put up for public sale, but it may have been added to the group at the last minute. See Montauban 2000, pp. 4–5.
2. In an undated letter of early July 1874, Haro wrote to Bruyas that Silvestre had just purchased this painting from him for 2,000 francs. On 17 July 1874 he wrote again to Bruyas, noting that he had received Bruyas's statement of payment, to be made in three installments. See Doucet MS 214, nos. 47 and 48. Silvestre wrote to Bruyas on 4 July 1874, stating that he had just concluded affairs with Haro, having bargained with the dealer to obtain this work for 2,000 francs, and chosen another study, for *The Apotheosis of Homer*, for the remaining 1,000 francs that Bruyas

was willing to spend. See Montpellier MS 365, no. 9.
3. For the Goncourts, see New York 1999, p. 372; for Gautier see Snell 1982, pp. 91 and 101.
4. See Vigne 1995b, nos. 702–816.
5. Quoted in Blanc 1870, p. 202.
6. Paris 1939, p. 61; Vigne 1995b, p. 304.
7. The phrase is Georges Vigne's, see Vigne 1995a, p. 192. For a full discussion of Ingres's "patchwork" studies, see Montauban 2000. Several were dated 1866 as well as signed by Ingres.
8. Letter to Bruyas of 9 June 1874. Montpellier MS 365, no. 8.
9. For Haro's relationship with Ingres, see Montauban 2000, pp. 3–4.
10. "en quelque sorte la confession et le testament de son genie." Letter to Bruyas, July (?) 1874; Doucet MS 214, no. 47.

Eugène Isabey

Paris 1803–Lagny 1886

70. *The Storm (Shipwreck)*

1845
Oil on canvas
25 5/8 x 31 1/2 in. (65 x 80 cm)
Signed and dated lower right: E. Isabey / 1835 or
1845
Gift of Alfred Bruyas, 1868
868.1.50

Provenance
[F. Moreaux, Paris; sold for 500 francs to Jules
Laurens as agent for Bruyas, Mar. 1868];[1] Alfred
Bruyas, Montpellier.

Selected Exhibitions
Dieppe 1966, no. 25, as *La Tempête*; Montpellier
1996, p. 159, no. 124, ill. p. 92.

Selected References
Laurens 1875, pl. 8, as *La Tempête* (lithograph after
the painting; reversed); Bruyas 1876, p. 590, no.
122; Miquel 1980, vol. 2, p. 206, no. 1141, ill.;
Montpellier 1985, p. 105, no. 92, ill. p. 115.

Fig. 1. Théodore Gericault,
*Drowned Woman and Child
on a Beach (L'Epave)*, c. 1822.
Oil on canvas 19 3/4 x 23 3/4 in. (50.2 x 60.3 cm).
Musée des Beaux-Arts, Brussels

Eugène Isabey's reputation as a marine painter rests primarily on his stormy coastal scenes, but rarely did he achieve the sense of gloomy foreboding—of "profound distress"—that characterizes the Bruyas *Storm*.[2] The scene is a treacherous cove or bay, its rocky shore pounded by a crashing sea, the peak of a towering cliff starkly silhouetted against a tempestuous sky. An unremitting palette of slate grays, acidic greens, black-brown and white combines with Isabey's characteristic rigorous brushwork to create a maelstrom of driving wind and chaotic waves; only the barest indication of a beach at the lower left provides secure ground. Brilliant moonlight reflects off the roaring surf, throwing the murky cliffs into near impenetrable obscurity and drawing the eye to a smashed ship's mast and torn sail in the left foreground. The mood of dread is made complete by the detail of a human limb extending from the folds of the sail.

Stormy seas and shipwrecks had long been popular themes in European art, both for their obvious appeal as spectacle and for their potential as a statement on the human condition. For Isabey's contemporaries, such scenes might have called to mind the biblical flood—*Winter, or The Deluge* by Nicolas Poussin (1594–1665), one of the famed depictions of the Four Seasons painted in 1660–64 for the Duc de Richelieu (Musée du Louvre, Paris), is the paradigmatic example—although by the nineteenth century the subject had been secularized into a general expression of humanity's struggle with natural forces.[3] Isabey's picture follows in the tradition of Claude-Joseph Vernet (1714–1789) and Philippe-Jacques de Loutherbourg (1740–1812), whose marine paintings were immensely popular with collectors and exhibition visitors in the second half of the eighteenth century. Michel Hilaire has pointed out that Isabey's motif of a leg emerging from flotsam was anticipated in de Loutherbourg's celebrated *Shipwreck* of 1769 (Château-musée de Dieppe), which the critic Denis Diderot had singled out for admiration.[4] De Loutherbourg's and Vernet's marines were imaginary—although the latter's sometimes loosely resembled the Italian coast around Naples—and were admired for both their dramatic compositions and their inclusion of lively figures battling the elements. Isabey's rocky coastal scenes were also in all likelihood invented, even if their features, too, were

drawn from the landscape most familiar to its author, in the case of the Bruyas *Storm* the beaches of Normandy that were so frequently the subject of his paintings.[5]

Like those of his eighteenth-century predecessors, Isabey's marines invariably include generic narrative elements—fishermen attempting to launch boats in heavy seas, sailing ships driven precariously toward rocks, or, more innovatively, smugglers disembarking on lonely beaches under the cover of night. These anecdotes heightened the drama and helped to fire the spectator's imagination. Eighteenth-century critics believed that Vernet's paintings could inspire in the sensitive spectator both awe and terror at nature's power—what would have been referred to as the Sublime—and virtuous fellow feeling at the sight of his figures, often survivors of shipwrecks depicted in heroic struggle to save themselves. Occasionally such scenes were based on historical or literary accounts, such as Bernardin de Saint-Pierre's 1787 novella *Paul et Virginie*. This tale of tragic lovers ends with Virginie washed up on a beach in the Ile-de-France (now Mauritius) following a shipwreck. The subject was popular with artists, including Vernet, at the end of the eighteenth century, and Isabey himself painted at least two versions of it.[6] Whether the Bruyas painting is based on the novella, as Miquel suggests, is, however, doubtful.[7] The general topography of the stormy cove is indeed similar to that represented in Isabey's *Paul et Virginie* paintings, but the all-important presence of the dead Virginie, forever beautiful in death and mourned over by Paul, is replaced by a grimly anonymous—and very likely male—leg. Moreover, the emotive *sensibilité* demanded of the reader of Saint-Pierre's melodrama is ill served by Isabey's lugubrious realism, in which an edifying message has been abandoned for mere shock and horror. In this regard Isabey's closest expressive and—given the rough application of paint and jarring harmonies of light and color—aesthetic

inspiration is not Vernet or de Loutherbourg, but Théodore Géricault, whose remarkable group of small stormy coastal views with drowned figures anticipate Isabey's canvas (fig. 1).[8]

Nothing is known of Bruyas's thoughts on Isabey's *Storm*. It was acquired in 1868 for 500 francs and installed that year in the first room of the Galerie Bruyas, on the same wall as *The Meeting* (cat. 30), suggesting that he felt it was an important addition to the collection. Even its date of execution has remained somewhat controversial, as the third and fourth numbers of Isabey's date are difficult to decipher. Bruyas himself read it as 1832, although the supplement to the 1876 catalogue put it at 1835, and recent scholars have read it as 1845. Based on the picture's style, it could have been painted anytime during that period. Three other versions of the composition are known, one in watercolor and two in oil, one of which, in the museum in Carpentras, France, is smaller and more freely handled, suggesting that it might be a preliminary oil sketch for the more finished Bruyas painting.[9] **RR**

1. See the receipt from Moureaux to Laurens, dated 5 Mar. 1868, listing "une peinture Isabey (marine)." Doucet MS 214, no. 25.
2. Michel Hilaire, in Montpellier 1996, p. 159.
3. Eitner 1955, pp. 281–90. See also Rouen 1999.
4. Montpellier 1996, p. 159.
5. The topography of the Bruyas painting is similar to the Normandy scenes illustrated in Miquel 1980, nos. 826 and 1302 bis.
6. Miquel 1980, nos. 1089 and

1302, both traditionally titled *La mort de Virginie*.
7. Miquel actually catalogues the Bruyas painting under the title *La Tempête; etude pour le tableau La mort de Virginie*, but the painting and its variants seems only tangentially related to Isabey's two versions of the subject.
8. See Tinterow 1992.
9. Miquel 1980, nos. 406 and 805. The watercolor, in a private collection in Montpellier, is noted in Montpellier 1996, p. 159.

souvenir à Alfred Bruyas
J. Laurens

ROME 1846

71

Jules Laurens
Carpentras 1825–Saint-Didier 1901

71. *Portrait of a Young Woman*

1846
Black, white, and red chalks with stumping and
traces of yellow chalk on paper
14 1/4 x 10 1/2 in. (36.3 x 26.8 cm)
Inscribed and dated in black chalk, lower right: ROME
1846; inscribed and signed in black chalk, lower
left: souvenir à Alfred Bruyas / J. Laurens
Bruyas Bequest, 1876
876.3.151
Exhibited Richmond and Williamstown only

Provenance
Alfred Bruyas, Montpellier.

Selected References
Bruyas 1876, p. 597, no. 141, as *Tête femme de
profil*; Claparède 1962, no. 144, ill., as *Portrait d'une
jeune femme*.

Jules Laurens and Alfred Bruyas were particularly close friends. While we do not know the circumstances of their initial meeting, it is likely that they met in Montpellier when Laurens, who was born in the nearby village of Carpentras, was a student there from 1837 to 1842.[1] They were certainly close by the time Laurens embarked in 1846 for a three-year journey through Greece, Turkey, Armenia, Egypt, and Persia as the official draftsman on a research expedition financed by the French ministry of education (Ministère de l'Instruction Publique) led by the husband-and-wife team of Xavier and Adèle Hommaire de Hell.[2] We know, for example, that the artist and Bruyas spent time together in Rome at the outset of Laurens's eastward trek, for it was during this Roman encounter that Laurens drew *Portrait of a Young Woman* and dedicated it to Bruyas, inscribing the sheet "*souvenir à Alfred Bruyas, J. Laurens. Rome 1846.*"

The identity of the woman remains a mystery. Laurens, however, appears to have used the same model for another drawing in the Bruyas collection.[3] Catalogued under the title *Italienne*, the signed but undated oval drawing in black crayon and watercolor portrays an Italianate peasant woman in folk dress sitting by a rural wayside. The figure in both drawings shares similarly strong facial features presented in left profile and the same slightly pensive, downcast gaze.

Portrait of a Young Woman, drawn primarily in black chalk, is heightened with touches of color that are added with a degree of delicacy that may come as something of a surprise given the strong sense of presence and immediacy of the woman depicted. The traces of color, especially the red used around the eye, lips, and nose, the touch of yellow on the earring, and the white highlights sketched in behind the figure's head are so lightly applied as to be in places almost imperceptible. **CCW**

1. As suggested by Haedeke 1980, p. 95.
2. Between 1854 and 1860 a selection of one hundred drawings and watercolors Laurens completed on this journey were published, along with a chronicle of the expedition written by Mme Hommaire de Hell (whose husband had died in 1848 while on the journey), in a four-volume set, *Voyage en Turquie et en Perse*.
3. Musée Fabre, Montpellier, inv. 868.1.63. See Claparède 1962, no. 145.

72. *The Chemin des Sables at Fontainebleau, Storm Effect*

c. 1869
Oil on canvas
37 1/2 x 57 1/8 in. (96 x 147.3 cm)
Signed lower right: J. Laurens
Bruyas Bequest, 1876
876.3.54

Provenance
Alfred Bruyas, Montpellier.

Selected Exhibitions
Paris, *Salon*, 1869, no. 1392; London 1995, pp.
106–7, no. 21, ill.; Montpellier 1996, p. 161, no. 129,
ill. p. 105; Narbonne 1999, no. 47, ill.; Treviso 2000,
no. 11, ill.

Selected References
Bruyas 1876, p. 594, no. 131, as *Paysage, Chemin
des Sables à Fontainebleau*; Montpellier 1985,
p. 105, no. 100.

Jules Laurens spent several months during the winter of 1849–50 in Marlotte, a small village in the forest of Fontainebleau. The area by then had been attracting artists interested in a naturalistic approach to painting landscapes and scenes of humble peasant life. During his stay, Laurens befriended many of the painters who congregated there who are associated with the so-called Barbizon School, including Narcisse Diaz de la Peña, Théodore Rousseau, Jean-François Millet, and Charles Jacque (1813–1894).[1] It is conceivable as well that Alfred Bruyas, who spent that winter in Paris, visited Marlotte during this same time.

The Chemin des Sables at Fontainebleau, along with a painted seascape also from the Bruyas collection,[2] reveals Laurens's affinity with the artists who gathered in and around Barbizon, and shows him approaching most closely the Barbizon "mode" of landscape painting. The painting also evokes certain works by Georges Michel (1763–1843), whose approach to landscape was an important model for the generation of Barbizon artists, particularly on account of his preference for painting relatively naturalistic views of the local French countryside that are often imbued with a dramatic storminess, as well as his custom of utilizing sketches made outdoors directly from nature, a practice which became a defining characteristic of the Barbizon school.[3]

Laurens's painting presents a scene of storm clouds darkening the sky as transient shafts of late-day sunlight rake across boulders and rock outcroppings that form a path through the sand. A sense of scale and a feeling for the immanence of the approaching tempest are provided by the solitary figure who steadies himself against the rocks, and a dog racing up the path toward him, away from the breaking storm. Laurens reinforced the tension of the scene by accentuating the heaviness of the skies and contrasts of light and dark, while at the same time enlivening the picture with small, deftly applied points of local color. The features of the landscape are not defined with sharp, descriptive clarity; the artist applied thin paint in varied touches of great economy to suggest the differing textures and surfaces of the rocks and sand. The effects of rain are evoked by thin washes of paint through which Laurens dragged a coarse brush to mimic a sudden torrent from the clouds, while the man's windswept cloak suggests the intensity of the storm.

Laurens presented a vision of the Fontainebleau forest that was very different from that of most artists who worked there. Whereas most painters generally focused on the stillness of the forest interior, using the enveloping trees to create images of solitary refuge, Laurens chose instead to focus on the treeless, barren, rocky zones of the forest, areas of remarkable rock outcroppings and sandy pathways that artists rarely depicted. Equally unusual for Barbizon painters is Laurens's use of the drama of the storm as a vehicle for conveying an underlying sense of foreboding. The mood is one of subtle unrest; the figure leaning headlong into the wind represents less an image of sanctuary in the unspoiled wilds than a meditation on Man confronted by the immensity of Nature. **CCW**

1. Laurens previously met several of these (and other) artists in an earlier visit to Fontainebleau, which he made in 1842. He would return to Marlotte in 1855, and at the Salon of 1857 he exhibited a painting titled *Près Marlotte (Seine-et-Marne)*.

2. *Seascape* (Musée Fabre, inv. no. 876.3.52).
3. Although considerably dramatized, the principal source of information on Georges Michel's life remains Sensier 1873. An insightful discussion of Sensier's biography was presented by Parsons and McWilliam 1983.

73. *Auvergne Interior*

1859
Watercolor, gouache, and black crayon on paper
17 7/8 x 14 1/8 in. (45.4 x 35.9 cm)
Signed and dated in gouache, lower right: JULES LAURENS. Auvergne. 1859; Musée Fabre stamp in blue ink, lower right (Lugt 1867)
Gift of Alfred Bruyas, 1868
868.1.61

Provenance
Alfred Bruyas, Montpellier.

Selected References
Bruyas 1876, p. 597, no. 142, as *Intérieur pris en Auvergne*; Claparède 1962, no. 146, ill., as *Intérieur auvergnat*.

Jules Laurens was an inveterate traveler. Following his three-year (1846–49) journey to the Near East he toured Europe extensively, but it was his native Auvergne that inspired him most as an artist.[1] His surviving sketchbooks and drawings show he was a keen and dedicated observer of the particulars of rural lifestyles, customs, and landscapes.[2] These two drawings typify the nearly ethnographic care and sheer delight with which he portrayed the specifics of rural life in the Auvergne.

The highly finished *Washerwomen* is a final preparatory study for *Laveuses de Tauves*, an oil Laurens exhibited at the Salon of 1864.[3] The figures, who present complementary front-and-back views in order to display details of dress, are wearing a type of folk costume typical of the region around Tauves. The edge of a linen bonnet is twice rolled to frame the face, and on one of the women this is then covered by a straw bonnet tied with two black velvet ribbons wrapped around the bonnet's top. A petticoat of striped wool is covered by an apron that is rolled up and tied behind the back. The blouse is long sleeved and tightly fitted to the body; the woman facing us, who has stopped to roll up her sleeves, wears a fringed shawl over the blouse, tucked into the petticoat.

Auvergne Interior dates from Laurens's second trip through the province, in 1859. In the dirt-floored room of a peasant dwelling, a woman is preparing to pour cream into a large pot to churn into butter, while a small child behind her tips a large basket toward the viewer to display heads of cabbage. The furnishings in the room are depicted with care. They include a lift-top chest that doubles as a table, called a *maie*, in the lower left; a gathered bunch of onions and a large flour sieve hanging from a tall wooden wall cupboard; and a box bed with curtains in the right-hand corner, near which a covered plate used for storing cooking grease hangs from the ceiling. The real focus of the picture, however, is the woman's costume. She wears a long red dress pleated horizontally just below the knee and a brown apron that has been rolled back to reveal the bottom edge of an exquisite, fringed shawl draped over her shoulders and across her chest. The most characteristic element of her attire is the striking headdress. A type particular to the Latour region of Auvergne and already becoming rare when Laurens drew the picture, it is

74. *Washerwomen*

c. 1864
Watercolor and black crayon on paper
18 1/2 x 14 3/8 in. (47.1 x 36.5 cm)
Signed in gouache, lower left:
JULES LAURENS.
Gift of Alfred Bruyas, 1868
868.1.62

Provenance
Alfred Bruyas, Montpellier.

Selected References
Bruyas 1876, p. 597, no. 144, as *Femmes au lavoir*; Claparède 1962, no. 147, ill., as *Femmes au lavoir*.

known as a *serre-malice*, consisting of a wide, decorative brass hoop that fits tightly to the head in order to hold the black veil in place, even in strong wind.

Both of these very beautiful watercolors focus especially carefully on the specifics of costume and setting that typify particular regions of the Auvergne. The peasant subject matter may recall certain works by Jean-François Millet or Gustave Courbet. It would be a mistake, however, to assume that Laurens was attempting to explore the types of social concerns one associates with those artists. His are not peasants suffering the dehumanizing hardship and boredom of repetitive manual labor. On the contrary, the rich outfits and comfortable, if humble, interior accoutrements indicate a level of comfort well above privation. Laurens's intent was not to extend a radical political doctrine of social reform; rather he approached his subject like an anthropologist documenting the folkways of his native province. **CCW**

1. Laurens made at least four tours through the province (in 1856, 1859, 1860, and 1877) and in 1858 published an article, "En Haute-Auvergne," in *L'Illustration*.
2. See, for example, the selection of his works in Clermont-Ferrand 1975.
3. Paris, *Salon*, 1864, no. 1123.

Prosper Marilhat
Vertaizon 1811–Paris 1847

75. Ruins of the Mosque of al-Hākem, Cairo

c. 1832
Graphite on paper
12 x 18 1/4 in. (30.4 x 46.5 cm) maximum
(arched sheet)
Inscribed lower left: Djami el Hakim / Caire
Bruyas Bequest, 1876
876.3.120
Exhibited Dallas and San Francisco only

Provenance
Alfred Bruyas, Montpellier (by 1851).

Selected Exhibitions
Montpellier 1860, no. 543, as *Mosquée Djame de Hakim (Caire)*; Clermont-Ferrand 1973, no. 33; Marseille 1975, no. 111.

Selected References
Bruyas 1851, p. 22, no. 59, as *Mosquée Djame de Hakim (Caire)*; Bruyas 1852, p. 41, no. 69, as *Mosquée Djame de Hakim (Caire)*; Bruyas 1876, no. 150, as *Une Mosquée*; Claparède 1962, no. 163, ill., as *Ruines de la mosquée du Calife Hakem*.

Fig. 1. Prosper Marilhat,
The Ruins of the Mosque of al-Hākem, Cairo, c. 1846.
Oil on canvas, 33 1/4 x 51 1/2 in. (84.5 x 130.7 cm).
Musée du Louvre, Paris

Born in the Auvergne, Prosper Marilhat studied painting with Camille Roqueplan (1803–1855) during the late 1820s before embarking on a voyage to the Middle East that would alter the course of his career. In 1831 he set sail from Toulon on an artistic and botanical expedition led by the Austrian naturalist Karl von Hügel (1795–1870). After passing through Greece, Syria, Lebanon, and Jerusalem, the traveling party reached Egypt, and there Marilhat spent three months drawing the ancient monuments. He parted from Hügel's team and returned to France in 1832 aboard the steamship *le Sphinx*, in the company of the Obelisk of Luxor. Marilhat spent the next fifteen years painting subjects inspired principally by his Egyptian sojourn, for which he gained both popular and critical acclaim, especially from the pen of his great champion Théophile Gautier.[1]

Marilhat's inscription in the lower left corner of this large sheet identifies the site as the al-Hākem Mosque, one of the great monuments of medieval architecture in Islamic Cairo. Built between A.D. 990 and 1013, the mosque took its name from al-Hākem bi-Amr Allāh ("Ruler by God's Command"), Egypt's third Fatimid-period caliph, who financed its completion. At the end of the eighteenth century, Napoleon's army occupied the site, and contributed to the state of disrepair apparent in Marilhat's drawing. The artist selected a low viewpoint into the ruined arcades at the western quadrant of the site looking up at the massive, stucco-covered brick piers that once supported wooden roofs. Rising in the center of the view is one of the mosque's most peculiar features: a minaret partially enclosed in a trapezoidal stone structure, standing at the northern corner of the main facade.

The drawing in the Bruyas collection is a study for Marilhat's undated painting in the Louvre (fig. 1). The painting differs from the drawing in several significant respects: Marilhat eliminated the structure in the background to the right of the tower, as seen through the two arches, as well as the horizontal struts between the arches, thereby clarifying their silhouettes and emphasizing their monumentality. He also reversed the viewing angle of the two arches at the right, causing the vanishing point to be shifted away from the center of the composition. Finally, in the painting Marilhat dramatically increased the number of figures, creating an

orientalist *halte* narrative within the otherwise topographical scene. Writing to his sister from Alexandria, the artist expressed a fascination for Egyptian culture that rivaled his interest in architecture: "The ruins here are less important [than in Greece], but the inhabitants are the most extraordinary thing that I have ever seen. There are figures among them that are absolutely identical to those which the ancient Egyptians sought to imitate in their sculptures."[2] A second drawing by Marilhat in the Bruyas collection entitled *Rest of the Meharistes* depicts several Egyptian figures and camels of the kind inserted in the Louvre painting.[3]　　**JAG**

1. Gautier's 1856 book *l'Art Moderne* contains a thirty-three page essay on Marilhat. See Frans 1982, pp. 1–10.
2. Quoted in Gautier 1856, p. 109.
3. Musée Fabre, inv. no. 876.3.173, also part of Bruyas's 1876 bequest. Illustrated in Claparède 1962, no. 164.

Edouard-Antoine Marsal
Montpellier 1845–1929

76. Alfred Bruyas in His Study

1876
Oil on canvas
24 1/4 x 19 1/8 in. (61.5 x 48.5 cm)
Signed and dated lower right: E. Marsal 1876
Gift of Colette Alicot, 1998
98.6.10

Provenance
Alfred Bruyas, Montpellier (d. 1877; bequeathed to
Alicot); Louise Clarisse Bruyas (Mme Alicot), his sister
(from 1877); by descent to Colette Alicot, her
granddaughter-in-law, Montpellier.

Selected References
"Chronique" 1999, p. 25, ill. p. 97.

In one of the last portraits of Bruyas, Montpellier artist Edouard-Antoine Marsal portrays the benefactor in his study, surrounded by the trappings of his life as a wealthy collector—handsome furnishings, an opened portfolio of drawings or prints, and two of Antoine-Louis Barye's most famous bronzes arranged as counterparts on either end of his desk.

Marsal, who studied first with Charles Matet (1791–1870), a successful local artist whose students included Alexandre Cabanel, Ernest Michel (1833–1902), and Alfred Bruyas himself,[1] and then with Cabanel, exhibited at the Salon from 1868 to 1888. Marsal received particular recognition for his portraits, though he also painted historical and genre subjects, so it is not surprising that Bruyas would have commissioned a portrait from him. The collector might have heard of the young Marsal while he was studying in Montpellier, or while he was a pupil of Cabanel, one of Bruyas's friends. Also, as Bruyas and Marsal were fellow Montpellierains, and given Bruyas's penchant for having his portrait painted, such a commission was nearly inevitable.

Bruyas sat for Marsal in the final year of his life and appears frail and partly stooped in the painting. He is shown in his private study, holding a pen and glancing up from his work, surrounded by three Barye sculptures. The portrait reveals the taste for Barye that led Bruyas to acquire at least twenty-two works by the artist. Barye consciously made his sculptures on a domestic scale, and they found their way into many a late-nineteenth-century den or gentleman's office; he once boasted that he had a sculpture to fit any mantelpiece or any pocketbook.[2] The three Barye sculptures shown in this painting, the *Seated Lion*, the *Lion with a Serpent*, and the *Inkstand with an Owl* (see entry for cats. 4–8), provide a link between Bruyas's personal surroundings and the gallery that he had created for public display.

We know that Bruyas purchased two versions of both the *Seated Lion* and *Lion with a Serpent* from Barye,[3] and it seems likely that he purchased one set for his gallery and one for his personal use, as shown here. The inkwell was probably not intended for public display, as Bruyas's active use of it in this portrait suggests.[4] Both the Marsal portrait and the Barye inkwell entered the Musée Fabre collection in 1998 by gift of a descendent of his family. It is likely that the versions of the *Seated Lion* and *Lion with a Serpent* seen in this painting were never part of the museum's collections but remained in his family or were dispersed with his other personal property after his death. **KMM**

1. Montpellier 1985, p. 78.
2. After Barye's death, Henry James wrote for the 25 Dec. 1875 issue of the *New York Herald Tribune*, "To have on one's mantle-shelf or one's library table one of Barye's business-like little lions diving into the entrails of a jackal, or one of his consummate leopards licking his fangs over a lacerated kid has long been considered the mark, I will not say of a refined, but at least of an enterprising taste." Cited in Louisville 1971, p. 40.
3. They were acquired in Apr. 1872 and Feb. 1875, Doucet MS 216, no. 33 and 43. See entries 4–8 in this catalogue for a full discussion of the purchase of two versions of each of these sculptures.
4. He acquired this in Oct. 1874. Doucet MS 216, no. 42.

Jean-François Millet

Gruchy 1814–Barbizon 1875

77. *Offering to Pan*

1845
Oil on canvas
20 1/2 x 11 1/2 in. (52 x 29 cm)
Signed lower right: J. F. Millet
Gift of Alfred Bruyas, 1868
868.1.65

Provenance
Alfred Bruyas, Montpellier
(acquired 1850).

Selected Exhibitions
Paris 1939, no. 77; Tokyo 1982a, no. 15,
ill.; Nagano 2001, no. 26, ill.

Selected References
Bruyas 1851, p. 21, no. 57, as *Offrande à
Priape*;[1] Bruyas 1852, p. 41, no. 67, as
Offrande à Priape; Laurens 1875, pl. 21,
as *L'Offrande* (lithograph after the
painting); Bruyas 1876, p. 602, no. 154;
Sensier 1881, p. 86, ill. p. 85 (print after
the painting); Montpellier 1985, p. 106,
no. 112, ill. p. 116.

Millet first studied painting at the age of nineteen, when he was sent to work with a portrait painter in the town of Cherbourg. In 1837 he moved to Paris and entered the École des Beaux-Arts, in the studio of the history painter Paul Delaroche. Although he continued his studies for two years, he failed to win the Prix de Rome in the competition of 1839. He left the École soon thereafter and began trying to make a living as an artist, painting primarily portraits and subjects inspired by classical mythology and Italian Renaissance and eighteenth-century French painting.

Offering to Pan belongs to this early period. It depicts a young woman, perhaps a nymph, in a shady wood, reaching up to place a garland on a statue. At her feet is a basket holding a red container shaped like a Greek pottery vessel, while in the background are two companions, one of them half-draped like the main figure, holding another Greek vase and wearing a laurel wreath. Although the statue consists only of a male head and shoulders and lacks Pan's characteristic attributes of horns and goat legs, the title supplies the figure's identity and helps to clarify the painting's purpose as a celebration of leisure and playful sensuality. Bruyas initially titled the painting *Offering to Priapus*, referring to another Greek god who represented fertility more specifically than Pan, who was a god of sensual pleasure.[2]

The painting's execution, consisting of visible small touches of paint that create soft-edged forms and delicate effects of light and color, echoes the art of Venetian colorists and resembles many works by Narcisse Diaz de la Peña (see cat. 54). By the early 1840s Diaz had achieved great success, particularly among collectors, with his small-scale paintings of charming pastoral subjects, and Millet was surely conscious of emulating his style. The two artists probably met at about the time *Offering to Pan* was painted;[3] Millet returned to Paris from a stay in Normandy in December 1845, and the following year Diaz helped Millet place some of his work with several Parisian art dealers. Perhaps even before their meeting, however, Diaz was aware of Millet's work. On seeing Millet's two submissions to the Salon of 1844, the older artist is said to have commented, "here at last is a newcomer who has the science that I would like to have, and who has movement, color, and expression. Here is a painter."[4]

Offering to Pan is one of Bruyas's earlier purchases, probably acquired during his first trip to Paris. He also bought several paintings by Diaz in the same period; clearly the prettily pastoral subject matter of both artists' work in this manner appealed to him.[5] But Millet, who had moved to the town of Barbizon in 1849, had already begun to paint with a more somber palette and to draw his subjects from the landscape and the people around him. His painting *The Sower* (Museum of Fine Arts, Boston), exhibited to both acclaim and criticism in the Salon that opened in December 1850, cemented his reputation as a painter of peasant life. Despite his interest in the emerging principles of Realism, Bruyas seems not to have followed the development of Millet's turn to new subjects painted in an unconventional style in the 1850s (or, for that matter, of Diaz's naturalistic depictions of the forest of Fontainebleau) in the same way that he became an avid collector of Courbet's challenging Realism. In the late 1860s, Bruyas requested another painting from Millet, and although the artist seems to have worked on a large-scale landscape for him until about 1872, the commission was never fulfilled.[6] The four Millet drawings that Bruyas later purchased all downplay the focus on rural labor and hardship that characterize many of the artist's mature works. **SL**

1. Bruyas 1851 annotates this painting "Paris 1850," presumably indicating the date of purchase.
2. Perhaps Bruyas was aware of another painting Millet seems to have made entitled *Sacrifice to Priapus*, presumably now lost. See Sensier 1881, p. 87, and Paris 1975, p. 49. There is a drawing in the Fogg Art Museum, Harvard University (681.1927), that may relate to *A Sacrifice to Priapus*. In a letter of 13 Jan. 1875, written as he was working on the 1876 catalogue of Bruyas's collection, Théophile Silvestre noted that according to Alfred Sensier, Millet's biographer, the proper title of the present work was *Offering to Pan*. Doucet MS 215, no. 181.
3. Sensier 1881 dates the painting to Millet's 1845 stay in Le Havre.
4. Diaz as quoted in Sensier 1881, p. 78.
5. Of the five Diaz paintings in Bruyas's collection, at least four were acquired by 1851. Bruyas specifically recalled purchasing one of them in 1849, during one of his first visits to the Parisian dealer Auguste Cornu. Letter from Bruyas to Théophile Silvestre of 20 Jan. 1875, quoted by Silvestre in a letter of 22 Mar. 1876. Montpellier MS 365, no. 34.
6. The commission was given through the intermediary of Silvestre, who informed Bruyas on 24 Dec. 1868 that he had just written to Millet of Bruyas's desire for a painting. Doucet MS 215, no. 9. Millet began work in 1871 on a painting that was to be the same size as Delacroix's *Women of Algiers in Their Apartment* (cat. 44), depicting what Silvestre described as "earth, sky, and sea." This suggests an image related to the 1870–71 *Cliffs at Gruchy* (Museum of Fine Arts, Boston). Letters of 29 May and 18 July 1871, Doucet MS 215, nos. 17 and 19. I wish to thank Sylvain Amic for his insights into this issue.

78. Well House at Gruchy

1863–65
Black conté crayon and pastel with white
heightening on paper
Signed lower right: J. F. Millet
14 3/4 x 18 1/8 in. (37.5 x 46 cm)
Bruyas Bequest, 1876
876.3.124
Exhibited Dallas and San Francisco only

Provenance
Théodore Rousseau (posthumous sale, Hôtel
Drouot, Paris, 27 Apr.–2 May 1868, no. 556, as *Cour
intérieure d'une maison rustique*, sold to Silvestre);
Théophile Silvestre, Paris (1868–72; given to
Bruyas, Jan. 1872);[1] Alfred Bruyas, Montpellier.

Selected Exhibitions
Paris 1939, no. 150, as *Bâtiment faisant face à la
maison natale de Millet à Gruchy*; Paris 1975, no.
194, ill.; Seoul 2002, no. 57, ill.

Selected References
Bruyas 1876, no. 158, as *Maison de Millet*;
Claparède 1962, no. 174, ill.

The hamlet of Gruchy, Millet's birthplace, was a small group of houses along a single street on the coast of Normandy, near Cherbourg. As Millet himself described it, "the village stands on rocky cliffs in a hollow of land opening northward toward the sea. . . . The view in the village is of course obstructed by houses, but going down toward the sea, one suddenly faces the great marine view and the boundless horizon."[2] This drawing depicts one of the structures within the village, the stable and well house, with its conical roof, that lay across a small pathway from the house in which Millet was born. The sturdy farm buildings, their stone walls overgrown with grasses and brush, and the woman bending to feed geese and chickens in the yard effectively convey the bucolic nature of the scene.

Millet recorded sites in Gruchy a number of times, in both paintings and drawings, the present pastel being one of two very similar depictions of the same building. The version in Boston (fig. 1) has been dated to

1863, and this pastel is probably a later replica, perhaps intended by Millet specifically for his friend and Barbizon neighbor Théodore Rousseau. In both sheets, Millet worked up the composition in black conté crayon, adding shades of green and yellow pastel and touches of white to complete the image. The two drawings match in almost every detail, from the groupings of chickens and geese to the red and blue of the woman's clothing; the white shapes of linen on a clothesline behind the well house roof are virtually the only feature that differentiates the slightly larger Montpellier drawing from the Boston work.

This drawing is probably based on sketches Millet made during a summer-long return visit in 1854, though he did not complete the drawing until about nine years later. After a brief stay in 1866, Millet again returned to his native region in 1870–71, during a period when the Franco-Prussian War and the Paris Commune forced many to leave the capital and its surrounding towns. At one point during that visit, Millet made a trip accompanied by Alfred Sensier (1815–1877) to see his old house, which he no longer owned. Théophile Silvestre was himself staying in Cherbourg because of the unrest in Paris, and may have joined Millet and Sensier on the same trip.[3] In two letters to Bruyas regarding the purchase of this drawing, Silvestre wrote, "I have been there; I entered the house, now inhabited by customs agents, with Millet himself, who began to cry on seeing it again." He then gave a long description of the village and the house, noting that the sea was just behind the buildings depicted, and commenting, "you cannot imagine the effect that the

Fig. 1. Jean-François Millet, *House with a Well at Gruchy*, c. 1863. Pastel over black conté crayon heightened with pen and ink on beige wove paper, 12 1/2 x 17 in. (31.8 x 43.2 cm). Museum of Fine Arts, Boston. Gift of Quincy Adams Shaw, Jr., and Mrs. Marian Shaw Haughton

sight of this poor paternal house, left behind thirty-five years before, produced on Millet when he found himself in the street, before the door, to show it to me. It was a flood of memories, intercut with sobs."[4] As Robert Herbert has noted, the scale of the woman in the drawing is considerably reduced, perhaps to emphasize the height of the buildings, and perhaps also hinting at Millet's childhood memories of the site as larger and more imposing that it actually was.[5] **SL**

1. In a letter of 5 Mar. 1870, Silvestre asked for a loan from Bruyas of 3,500 francs, and proposed a group of works as a guarantee against the loan. This work was initially described as "a beautiful drawing by Millet (interior courtyard of a rustic house)." After numerous letters in the following years, Silvestre finally sent these works to Bruyas in Jan. 1872. In the

letter of 11 Jan. 1872 informing Bruyas that they had been sent, Silvestre added that the house was located at Gruchy. Doucet MS 215, nos. 11 and 29.
2. Letter to Théophile Silvestre, 18 Apr. 1868, translated and reprinted in Boston 1984, p. 242.
3. Moreau-Nelaton 1921, vol. 3, pp. 75–76, describes Millet's visit with Sensier, from 3 to 20 Oct. 1871. He

also notes (p. 61) that Silvestre had been in Cherbourg along with Millet since fall 1870. Silvestre's letters between Oct. 1870 and Jan. 1872 in Doucet MS 215 were all sent from Cherbourg.
4. "J'ai été sur les lieux; je suis entré dans la maison, maintenant habitée par les douaniers, avec Millet lui-même, qui se mit à pleurer en la revoyant." Letter of 15 Dec.

1872, Doucet MS 215, no. 40. "Vous ne pouvez vous figurer l'effet que produisit sur Millet la vue de cette pauvre maison paternelle, quittée depuis 35 ans, lorsqu'il se trouva dans la rue, devant la porte, pour me la montrer. C'était un flot de souvenirs, coupé par des sanglots." Letter of 17 Dec. 1872, Doucet MS 215, no. 41.
5. Herbert in Paris 1975, p. 240.

79. Peasant Woman Feeding Her Child (La Bouillie)

1864–66
Black conté crayon heightened with white chalk on paper
Signed lower right: J. F. Millet
14 9/16 x 12 in. (37.0 x 30.5 cm)
Bruyas Bequest, 1876
876.3.121
Exhibited Richmond and Williamstown only

Provenance
H. Atger, Paris (sold, Hôtel Drouot, Paris, 12 Mar. 1874, no. 79, as *Intérieur*, for 450 francs);[1] Alfred Robaut, Paris (sold to Bruyas for 1,500 francs, Oct. 1876);[2] Alfred Bruyas, Montpellier.

Selected Exhibitions
Paris 1975, no. 173, as *La bouillie de l'enfant*, ill.; Seoul 2002, no. 49, ill.

Selected References
Bruyas 1876, no. 155, as *Une Femme et son Enfant*; Claparède 1962, no. 175, ill., as *La Bouillie*.

After his 1849 move to Barbizon, Millet concentrated in his paintings and drawings on the surrounding landscape and its inhabitants, as well as on his own growing family. His second wife, Catherine Lemaire, and their nine children probably inspired many of the scenes of figures in softly lit, modest interiors that Millet produced in the 1850s and 1860s. At the same time, Millet, who was already well-versed in classical and biblical literature, studied the work of earlier masters such as Jean-Siméon Chardin (1699–1779) and the seventeenth-century Dutch artists from whom Chardin often drew.[3] Millet's interior scenes of women working at various tasks therefore frequently combine the very simple, unadorned clothing, rooms, and furniture of his contemporary experience with allusions to the art of the past.

The present drawing depicts a woman wearing a plain dress, a headscarf, and large shapeless shoes, blowing on a spoonful of hot soup to feed to the infant on her lap, whose swaddling has been loosened so he can warm his feet at the fire. The cat, similarly basking in the fire's heat, adds to the sense of contentment sug-

gested by the scene. While the image likely derives from Millet's own life, the figures are subsumed into an artistic tradition that extends back to images of the Virgin and Child, a connotation the artist surely intended to exist simultaneously with the evidence of a more specific time and place.

There are a number of related works. Perhaps the first appearance of this composition is in two tiny sketches of a woman holding a child on her lap and blowing on a spoon, one of them dated to about 1857.[4] Along the upper left side of that sketch is a diagonal crisscross pattern that seems to indicate a window, thereby linking the initial conception both to Dutch prototypes and to other works by Millet that depict figures seated by windows, such as *The Knitting Lesson* (c. 1858–60; Sterling and Francine Clark Art Institute, Williamstown, Massachusetts). Millet referred to these rough sketches for at least two groups of works. One is a painting of *A Woman Feeding Her Child* (1861; Musée des Beaux-Arts, Marseille) that the artist exhibited in the 1861 Salon and subsequently repeated in a drawing and an etching. These focus closely on the two figures, showing the woman at three-quarters length with little indication of the setting. The other group consists of the present work and a very closely related drawing in the Fogg Art Museum.[5] Both these drawings retain the relative proportions of the initial sketch, though they substitute a hearth and cauldron for the window at the left.

The general outlines of the figures and the room are almost identical in the two versions, and only a few of the details differ. Millet executed the Fogg drawing only in black conté crayon and included several objects that do not appear in the Montpellier work, which in turn has white chalk highlights in the faces and clothing of the figures absent from the Fogg version. Robert Herbert has dated the Montpellier drawing to 1864–66 and stated that it is a later replica of the Fogg work.[6] This later reworking of a composition is not unusual in Millet's oeuvre. The artist often used his rough sketches as source material for images made several years afterwards, while his practice of making more than one version of his paintings and drawings, with slight variations each time—as he did with *The Well-House at Gruchy* (cat. 78)—might be understood in the context of standard academic practice.[7]

Bruyas purchased *Peasant Woman Feeding Her Child* just a few months before his death, on the strong recommendation of Théophile Silvestre. Its homespun domesticity, so different from Millet's more controversial depictions of peasant life, seems to have appealed to the collector and his advisor. Indeed, Silvestre valued the drawing primarily for the moral and artistic purity he perceived in it, commenting in a letter to Bruyas that "this type of rustic familial salubriouness is a principle and a lesson to hold against present and future corruption in life and in art. It is the antidote to the poison of mannerists and makers of pretty infections."[8] This is the sort of assessment that helped characterize Millet, however inaccurately, as a simple peasant artist who celebrated the traditional values of rural life, a reputation that has only more recently been reconsidered. **SL**

1. Paris 1975 gives the seller's name as H. Atger; the cover of the sale catalogue in the Frick Art Reference Library is annotated with the name Hatger.
2. See receipt dated 26 Oct. 1876 from Robaut for a drawing by Millet. Doucet MS 214, no. 81.
3. Millet knew the work of these artists in the Louvre and, as Alexandra Murphy notes, he collected prints by them and reproductions after their work. Boston 1984, p. 91.
4. Both Musée du Louvre, Paris, RF 5665 verso, and RF 5680. Cited in Claparède 1962, under no. 175.
5. *Peasant Mother Feeding Her Child*, date unknown. Black conté crayon on paper, 15 x 12 1/8 in. (38.1 x 30.8 cm). Fogg Art Museum, Harvard University Art Museums, Cambridge, Mass. (1943.879).
6. Herbert in Paris 1975, p. 215. This chronology may be supported by the presence in one of the Louvre sketches cited in note 4 of two curving lines at the top of the composition; these might correspond to the jug on the mantel that appears in the Fogg version, but not in the Montpellier one.
7. As Patricia Mainardi notes, the first definition of the word "copy" in the *Dictionnaire de l'académie des beaux arts* (1884) described such works as "simple repetitions, recognizable often through some variation that the master himself has intentionally put there." Mainardi 1999, p. 130.
8. "Ce type de la salubrité familiale rustique est un principe et une leçon a conserver contre la corruption present et future de la vie et de l'art. C'est l'antidote contre le poison des maniéristes et des faiseurs de jolies infections." Letter of 25 May 1876, Montpellier MS 365, no. 49.

80. *Landscape in Allier*

c. 1866–67
Pen and brown ink, brown wash, and watercolor
over graphite on paper
7 3/16 x 9 5/8 in. (18.2 x 24.4 cm)
Millet vente stamps in black ink, lower right (Lugt
1460) and lower right, verso (Lugt suppl. 1816a);
inscribed in black ink, lower left, verso: no 18; in
brown ink, upper left, verso: 386
Bruyas Bequest, 1876
876.3.123
Exhibited Dallas and San Francisco only

Provenance
The artist (d. 1875; posthumous sale, Hôtel Drouot,
10–11 May 1875, no. 70, as *Chemin montant à un
hameau*, sold to Théophile Silvestre as agent for
Bruyas);[1] Alfred Bruyas, Montpellier.

Selected Exhibitions
Paris 1939, no. 152; Paris 1975, no. 202, as *Paysage
de l'Allier (Chemin montant à un hameau, aux
environs de Cusset)*; Montpellier 1996, no. 140, ill.
p. 107; Clermont-Ferrand 2002, no. 71, ill., as
Paysage de l'Allier, Chemin montant à un hameau.

Selected Reference
Bruyas 1876, no. 157, as *Paysage*; Claparède 1962,
no. 177, ill., as *Paysage de l'Allier; environs de
Cusset.*

In the summers of 1866, 1867, and 1868, Millet traveled to Vichy in central France, where his ailing wife visited the spas for which the town was known. While there, he explored the countryside, finding in it elements reminiscent of his native Normandy coast or the environs of Paris. Millet made nearly two hundred sketches of the region, the two present drawings among them, in small, sometimes tiny, sketchbooks to serve as notes to help him remember the topography and colors of the landscape. He probably began most of the drawings in graphite in front of the motif, then strengthened them with ink, and finally added color to some, accomplishing the later steps either in his lodgings in Vichy or in his studio in Barbizon after returning from his month long visits.

He wrote of the sketches to his friend and biographer Alfred Sensier, commenting, "I believe I have made them with a certain precision, for I want them to be of a sort that I can use, and that I don't forget due to the vague state in which I left them. I have colored some little ones with watercolor so that I can better recall the aspect of the general tone of the country, which in sum

81. *Landscape near Vichy*

c. 1866–67
Graphite, pen and brown ink, watercolor, and
gouache on paper
4 3/8 x 6 7/16 in. (11.1 x 16.3 cm)
Millet vente stamp in black ink, lower right, verso
(Lugt suppl. 1816a); inscribed in brown ink, lower
right: Vichy; in graphite, center-right: jaune; in
graphite, upper-center: vert; in black ink, lower left,
verso: n 78
Bruyas Bequest, 1876
876.3.122
Exhibited Richmond and Williamstown only

Provenance
The artist (d. 1875; posthumous sale, Hôtel Drouot,
10–11 May 1875, no. 74, as *Coteaux aux environs de
Vichy*, sold to Théophile Silvestre as agent for
Bruyas);[2] Alfred Bruyas, Montpellier.

Selected Exhibitions
Paris 1939, no. 151; Montpellier 1996, no. 139, ill.;
Clermont-Ferrand 2002, no. 7, ill., as *Coteau aux
environs de Vichy auprès de l'Allier,* dated 1866–68.

Selected References
Bruyas 1876, no. 156, as *Paysage*; Claparède 1962,
no. 176, ill., as *Paysage des environs de Vichy.*

is fresh and which . . . bears some resemblance to many
places in Normandy."[3] Many of the sketches, like
Landscape near Vichy, bear notations about colors and
features of the landscape, implying that Millet added
the watercolor at a later point, and many are labeled
with the name of the nearest town, to remind the artist
of the general location of the site. Millet then used a
number of these sketches as the basis for more finished
pastels and paintings.[4]

The mid-1860s were a period when Millet turned
increasingly to depictions of landscape. Indeed, the
drawings from Allier (the *département* in which the
town of Vichy is located), while often including hous-
es, fences, and roadways, are mostly empty of human
figures. They are also characterized by inventive spatial
compositions, perhaps inspired in part by the tech-
niques of Japanese prints, as though Millet were exper-
imenting with ways of viewing and depicting the land-
scape. The winding road in *Landscape in Allier* leads
the eye up a small hillside topped by a house that fits
perfectly into the slope. Millet used a low vantage point
to emphasize the height of the terrain, and drew the

closest trees in silhouette to enhance the depth of the space. In *Landscape near Vichy* the foreground is nearly empty, drawing the viewer partway in, while the middle distance is filled with a line of trees against a hillside that extends across the entire composition. It has been suggested that the trees border or lie between two branches of the Allier river, the touches of blue along the bases of the trees and the edge of the field perhaps representing the river or its reflection.[5] Both drawings display the bright, clear washes of watercolor characteristic of the Vichy series, tones distinctly different from the generally subdued palette of much of Millet's work.

Théophile Silvestre purchased both of these drawings for Bruyas at the sale of the artist's collection. He commented of *Landscape in Allier* that it was "a marvel . . . it was the most beautiful in the sale" and "the most beautiful that Millet ever made in his life. The more you see it the more you will love it."[6] This enthusiasm

perhaps reflects Silvestre's fairly recent appreciation of Millet's work.[7] Silvestre's reassessment may in turn have influenced Bruyas, for apart from his early purchase of the oil painting *Offering to Pan* (cat. 77) and an unsuccessful attempt to commission another painting, Bruyas acquired works by Millet, all of them drawings, only in the last few years of his life. **SL**

1. On 15 May Silvestre noted that he had received 1,200 francs as payment from Bruyas. Doucet MS 215, no. 211. The receipt from Pillet, dated 29 May 1875, states that Silvestre paid 1,165.75 francs for his purchases at the sale (cats. 80 and 81). See Doucet MS 214, no. 65.
2. See note 1.
3. Reprinted in Clermont-Ferrand 2002, p. 136.
4. Alexandra R. Murphy states that "perhaps as many as fifty" of these sketches were used as preparatory studies. See Boston 1984, p. 177.
5. Clermont-Ferrand 2002, p. 111.
6. "Le no. 70 est une merveille . . . C'était la plus belle de la vente . . . Quant au no. 70 c'est la plus belle que Millet aie fait de sa vie. Plus vous le verrez plus vous l'aimerez." Letter of 15 May 1875, Doucet MS 215, no. 211.
7. In Boston 1984, p. 240, Silvestre is described as changing his opinion of Millet's work after seeing his paintings at the Exposition Universelle of 1867.

Dominique-Louis Papety

Marseille 1815–1849

82. *Temptation*

c. 1836–41?
Graphite, watercolor, and gouache on paper
2 3/4 x 4 3/4 in. (7 x 12.1 cm)
Bruyas Bequest, 1876
876.3.127
Exhibited Dallas and San Francisco only

Provenance
Alfred Bruyas, Montpellier.

Selected References
Bruyas 1876, p. 607, under no. 165, as *La Tentation* (one of three watercolors framed together); Claparède 1962, no. 204, ill., as *La Tentation*.

Contrary to his desires, Dominique-Louis Papety was never a pupil of Ingres. Yet the master greatly admired his talent and strongly influenced him. Along with close friends Hippolyte and Paul Flandrin (see cats. 57–59), Papety became one of the most significant members of Ingres's neoclassical orbit, until a cholera epidemic in his native Marseille cut his life short at the age of thirty-four.

Papety's parents had hoped he would take over the family soap manufactory in Marseille, but he continued his artistic studies by moving to Paris at age twenty, where he entered the studio of Léon Cogniet (1794–1880). He rapidly succeeded in winning the Prix de Rome the following year, which allowed him to study at the French Academy in Rome, then under the directorship of Ingres. During his years as a pensioner Papety made copies after Raphael, and he visited Florence, Naples, Venice, and Padua. Later he made return trips to Italy, and also visited Greece and the Middle East. His oeuvre spanned history paintings, religious compositions, orientalist and genre scenes, as well as images based on the ideas of the social theorist

82

Charles Fourier. Today he is best known for a work from the last category, *Dream of Happiness* (Musée Antoine Vivenel, Compiègne), completed in 1843, the paradigmatic example of the translation of Fourier's socialist ideals into the realm of contemporaneous painting.

No doubt Bruyas knew and appreciated Papety's Fourierist leanings. He owned two watercolor and chalk sketches for *Dream of Happiness*, both of which were included in his bequest to the Musée Fabre. He probably became acquainted with the artist through Papety's most important patron, François Sabatier (1818–1891), who met Papety in Italy in 1839 and helped convert him to Fourierism.[1] Like Bruyas, Sabatier was a native son of Montpellier and provided significant support to both artists and art institutions.[2]

Despite his allegiance to the ideals espoused by Ingres, Papety developed a somewhat eclectic manner. This aspect of his work relates in part to his diverse range of subject matter. An early instance of the connection between subject and style is documented in a letter the artist wrote from Rome to his friend and first teacher in Marseille, Augustin Aubert (1781–1857). Distinguishing the creation of sacred art from secular art, he listed Raphael, Perugino, and Fra Bartolommeo among his models for the former, while for the latter he included the Venetians Titian, Veronese, and Giovanni Bellini.[3]

The aquatic allegory of passion *Love Conquers All* looks back to Venetian Renaissance art through its loosely brushed water, smoky modeling, and robust naiads (which also recall the female figures of Rubens). Floating above the swirling water, Cupid leads two couples of naiads and tritons, who gaze up rapturously at the god holding their leashes of ribbons and flowers. Executed in the last year of the artist's life, the study may have been made specifically for Bruyas, particularly as it illustrates love as a guiding principle, a concept often cited by the collector.[4] The subject also follows the advice given to artists by Fourierist critic Desiré Laverdant in the same year he wrote extensively on *Dream of Happiness*: "to our luxury-delighted eyes offer smiles, glorious fêtes, ecstasies and happiness."[5]

Temptation presents another sensual scene, even

83. *Love Conquers All*

1849
Gouache and black chalk on paper
14 5/8 x 11 in. (37.1 x 28 cm)
Signed and dated in red gouache, lower left:
DOM. PAPETY. 1849
Gift of Alfred Bruyas, 1868
868.1.68
Exhibited Dallas and San Francisco only

Provenance
Alfred Bruyas, Montpellier (by 1851).

Selected Exhibitions
Montpellier 1860, no. 563, lent by Bruyas;
Montpellier 1980, no. 75.

Selected References
Bruyas 1851, p. 22, no. 62, as *Triomphe de l'Amour*;
Bruyas 1852, p. 42, no. 72, as *Triomphe de l'Amour*;
Bruyas 1854, p. 34, no. 70, as *Triomphe de l'Amour*;
Laurens 1875, pl. 22, as *Troupeau de l'Amour*
(lithograph after the drawing; reversed); Bruyas
1876, p. 606, no. 164, as *Troupeau de l'Amour*;
Claparède 1962, no. 220, ill., as *Omnia Vincit Amor*;
Montpellier 1985, pp. 123–24, ill.

more broadly brushed. The last aspect can be explained by the fact that the drawing is a diminutive watercolor sketch, similar to the numerous studies for *Dream of Happiness*. The woman's body curves up directly from the groin of the prostrate man, whose hands and feet appear to be bound, and she makes an ambiguous gesture with her upraised arms. Such features recall the turbulent sexuality found in works by Delacroix or even Henry Fuseli (1747–1825).

The composition provides a telling inversion of the artist's early watercolor *The Death and Burial of Saint Mary of Egypt*, a vignette in a series illustrating episodes from the life of the saint, a former prostitute who repented and subsequently lived as an ascetic in the desert.[6] For *Temptation* Papety used the same rocky grotto that appears in *Saint Mary*. There Mary's half-clothed body extends across the image beginning with her head at the left, and Father Zosima kneels above her toward the right. *Temptation* reverses the genders of the horizontal and vertical figures, and orients them in the opposite direction. Whereas Mary is blessed by a straight-backed monk dressed in a heavy robe with flutelike folds, her male counterpart in *Temptation* is tormented by a fleshy nude female whose body is dappled with fleeting lights and shadows. Both drawings, like *Love Conquers All*, illustrate Papety's interest in the theme of sensuality and its complex, even problematic, nature, whether in secular or spiritual terms, an interest that Bruyas also shared. **PSC**

1. While Papety was an Academy pensioner Sabatier commissioned him to contribute to a Fourierist décor for his Florentine palace. For more on the Sabatier commission and Papety's relationship with him and other Fourierists, see Amprimoz 1980, pp. 57–67.
2. Sabatier bequeathed many works by Papety to the Musée Fabre in 1892.
3. Letter of 25 Sept. 1839, published in Amprimoz 1986, p. 253.
4. In an 1854 letter to Courbet, Bruyas sent a photograph of this work with the annotation "magnificent drawing made for the Cabinet Bruyas." Letter reprinted in Montpellier 1985, p. 123. Bruyas's

collection catalogues, however, do not mention that Papety made the drawing for Bruyas.
5. Desiré Laverdant, "Salon de 1842," *La Phalange*, 3rd ser., vol. 5, no. 43 (10 Apr. 1842), pp. 699–700, as quoted in Finlay 1979, p. 328. Laverdant believed such images of "l'amour du beau" would lead to supreme beauty.
6. Made while Papety was a student in Rome, the series of four watercolors is illustrated in Columbia 1989, pp. 286–87, pl. 25. The series was part of Sabatier's 1892 bequest to the Musée Fabre. *The Death and Burial of Saint Mary of Egypt* (Musée Fabre, inv. no. 892.4.38) measures 4 3/4 x 6 1/4 in. (12 x 16 cm).

Joseph Nicolas Robert-Fleury

Cologne 1797–Paris 1890

84. *Young Woman at Her Toilette*

Before 1852
Oil on canvas
21 7/16 x 18 5/16 in. (54,5 x 46,5 cm)
Signed lower left: Robert-Fleury
Gift of Alfred Bruyas, 1868
868.1.70

Provenance
Alfred Bruyas, Montpellier (by 1852).

Selected Exhibitions
Montpellier 1860, no. 239, as *La Toilette*.

Selected References
Possibly Bruyas 1852, p. 44, no. 84, as *Étude*;
Bruyas 1854, p. 25, no. 34, as *Le Lever, modèle
de femme*;[1] Laurens 1875, pl. 7, as *La Toilette*
(lithograph after the painting; reversed); Bruyas
1876, p. 611, no. 177, as *La Toilette*; Montpellier
1985, p. 106, no. 115, ill. p. 116.

Joseph Nicolas Robert-Fleury studied painting with Horace Vernet (1789–1863), Anne-Louis Girodet (1767–1824), and Antoine-Jean Gros (1771–1835) before traveling for several years through Europe, including Holland and Italy, as drawing master to an English family. He specialized in dramatic historical scenes, such as *Galileo before the Inquisition, 1632* (1847; Musée du Louvre, Paris), painted with highly detailed crispness and stagelike settings. He was particularly interested in scenes of religious fanaticism and depictions of the perceived abuses of the Catholic Church.[2] He also painted biblical themes and events from the lives of great artists, such as *The Death of Titian* (1861; Koninklijk Museum voor Schone Kunsten, Antwerp). By contrast, the Bruyas painting is a figure study of a nude woman sitting on a bed.

In pose, composition, and lighting, in which luminous flesh and white linens stand out against a velvety dark background of draperies, the painting appears to be inspired by Rembrandt's great *Bathsheba* of 1654 (Musée du Louvre, Paris), where the central figure also sits on the edge of a bed with rumpled linens, one hand resting on the bed behind her, one hand before her (in her case holding the fateful letter), and with one foot advanced. Robert-Fleury's nude is without the implication of any specific story, and in contrast to the downturned glance of Bathsheba, she looks out at the viewer with challenging indifference. The Rembrandt had been in Parisian collections since around 1840 and may have entered the collection of Louis La Caze in 1843.[3]

Bruyas listed Robert-Fleury in his 1851 catalogue as one of eight artists representing history painting under the heading *La peinture en 1851*. The interest that Bruyas must have had in Robert-Fleury at that time is indicated by his inclusion in this short list, which also names Ingres, Delacroix, Couture, Cabanel, Glaize, Ary Scheffer (1795–1858), and Jean Adrien Guignet (1816–1854).[4] While the painting Bruyas acquired by Robert-Fleury is not of an overtly historicizing theme, it corresponds to his interest in figure studies as seen in other paintings and drawings in his collection and is an example of a traditional subject by an established artist. As a further indication of his admiration of the painting, Bruyas selected the Robert-Fleury as one of thirty items for publication in the Laurens lithograph portfolio in 1875.[5] **KMM**

1. Annotated "Paris 1852," presumably indicating the date of Bruyas's purchase.
2. For a discussion of Robert-Fleury's religious painting, see Driskell 1986, pp. 80–89.
3. The painting was part of the Paul

Périer sale in Paris in 1843, after which La Caze is the next known owner. The provenance of the painting is published in Brown, Kelch, and van Thiel 1991, p. 242.
4. Bruyas 1851, p. 31.
5. Laurens 1875, plate 7.

Théodore Rousseau
Paris 1812–Barbizon 1867

85. *The Pond*

c. 1840
Oil on canvas
20 7/8 x 25 1/4 in. (53 x 64 cm)
Signed lower left: Th. Rousseau
Gift of Alfred Bruyas, 1868
868.1.71

Provenance
The artist (sold, Hôtel des Ventes Mobilières, Paris,
2 Mar. 1850, no. 1 or no. 37);[1] [Auguste Cornu, Paris,
probably sold to Bruyas, June 1850];[2] Alfred Bruyas,
Montpellier.

Selected Exhibitions
Montpellier 1860, no. 278, as *Clairière dans la forêt
de Fontainebleau, au printemps*, lent by Bruyas;
Paris 1939, no. 86; Trento 1993, no. 148, ill.;
Montpellier 1996, pp. 178–79, no. 177, ill. p. 94;
Lyon 2002, no. 99, ill. p. 189.

Selected References
Bruyas 1851, p. 24, no. 71, as *Mare et clairière au
printemps*; Bruyas 1852, p. 44, no. 85, as *Mare et
clairière au printemps*; Laurens 1875, pl. 18, as *La
Mare* (lithograph after the painting; reversed);
Bruyas 1876, p. 612, no. 178, as *La Mare, forêt de
Fontainebleau*; Montpellier 1985, p. 106, no. 116, ill.
p. 116; Schulman 1999, p. 276, no. 515, ill.

Théodore Rousseau is generally recognized as the
leading artist of a group of realist or naturalist
landscape painters who were drawn to the village of
Barbizon near the Forest of Fontainebleau toward the
middle of the nineteenth century. In the 1830s
Rousseau's paintings were purchased by the Duc
d'Orléans and other important government figures,
and he was boldly championed by the critic Théophile
Thoré. In 1836, however, his submission to the Salon,
Descent of the Cattle from the Meadows (Rijksmuseum
Mesdag, the Hague), was soundly rejected, the first of a
series of rejections from 1836 to 1841 that led him final-
ly to withdraw from the official competition entirely,
from 1842 until the conservative Salon climate
"thawed" with the revolution of 1848. He was part of a
committee of artists who reorganized the Salon in 1848,
the same year in which the new Republican govern-
ment commissioned *View of the Forest of Fontaine-
bleau, Sunset* (Musée du Louvre, Paris). In 1849 he
showed in the Salon for the first time in fourteen years,
winning a first-class medal. This positive critical and
personal financial situation endured into the mid-
1850s, when various aspects of his life deteriorated dra-
matically.

The Pond, dated about 1840, may be taken as a para-
digm of the artist's landscapes inspired by his lifelong
familiarity with the Forest of Fontainebleau. This work
has aptly been described as "suffocating" in atmos-
phere.[3] Cattle pause to drink at a watering hole deep
within the forest. Their roughly defined forms almost
blend into the brown and russet landscape around
them. The indications of agrarian culture are slight: the
cattle, a human figure near the base of the tall oak (dis-
cernable largely due to a patch of white headgear) and
the suggestion of a tiny human silhouette in the far dis-
tance, visible through the parting of the trees only
because of the daubs of red and white that denote its
costume. The silvery gray clouds that dominate the sky
imbue the painting with a sense of a breathing atmos-
phere. Otherwise, the foreground and middle ground
are dominated by a dense, almost indecipherable land-
scape. It is extremely difficult to distinguish the details
of tree foliage and branches, shrubbery, grassy bank,
and water. The brushstrokes and colors seem to move
in every direction, blending into one another. Only a
few passages are easily distinguishable, describing a

gnarled branch, a fan of foliage, seeming to float on the surface of the dense massing of paint. Nature is depicted as a tangled mass of vegetation without lofty vistas or picturesque marks of civilization. The scene is remarkable in its mundaneness. By embracing the unruly irregularity of the non-site of the western European forest, Rousseau transforms the traditional model of landscape defined by seventeenth-century Dutch artists and by Claude Lorrain (1604–1682). It is almost as if Rousseau has captured the secret impulses or language of nature, an interior world that defies rational description: "No one can make sap run in the trunks like he does . . . the air and humidity, this life of the forest penetrating all his paintings . . . The execu-

tion is sometimes soft, sometimes violent, untidy like a sketch or brutally overloaded, but this supreme quality of vegetal life absorbs everything. . . . These trees are very poorly leafed but they grow."[4]

The mighty oak is nearly ubiquitous in Rousseau's compositions and had great symbolic meaning for him. Rousseau described his romantic rapture and pantheistic euphoria before a tree: "One winter day I saw [this tree] covered in snow, white as one of Ossian's warriors. He spread his great arms like an old bard. A branch fell at my feet and nearly killed me; it would have been a beautiful death, in the heart of the forest, killed by an oak and perhaps forgotten there. . . . See all those beautiful trees, I drew them all thirty years ago,

I made all their portraits. Look at that birch over there; the sun lights it and makes of it a column of marble, a column which has muscles, limbs, hands, and a beautiful skin, white and pallid, like a skin of dryads."[5] His is a complete immersion, a total spiritual and physical identification with the life cycle of nature.

Rousseau's pain must have been acute when he witnessed the destruction of the sacred corners of his beloved forest. His paintings of wetlands filled with ancient gnarled roots and decaying trees exemplify an attitude about the preservation of the landscape that could not help but have political overtones. The Barbizon artists opposed the plans of Napoléon III's government to trim and manage the chaotic ecology of the forest.[6] *The Pond*, in its celebration of the old, untouched, and tangled landscape, carries a latent ecological-political message that Rousseau would later make explicit in his participation in a petition to protest the government's drainage and forest control. An 1839 article in the journal *L'Artiste* proclaims the symbolic and real value of the Fontainebleau forest to the Barbizon artists: "As all artists attest, the forest of Fontainebleau is Europe's most beautiful; it is the only one in France where one can see some vestiges of the virgin forest, traversed in addition by convenient picturesque roads." Fontainebleau was their "sacred oasis" and "magnificent studio."[7] **DK**

1. The sale catalogue gives no information other than titles. No. 1 is titled *Clairière dans la forêt de Fontainebleau*; no. 37 is titled *Clairière au printemps*.
2. See letter from Cornu to Bruyas of 8 June 1850 in which he discusses "what remains due" from Bruyas for a painting by Rousseau, and lists the amount of 400 francs. Doucet MS 214, no. 2.
3. Trento 1993, p. 246.
4. Théophile Gautier, cited in Michel Hilaire, "Le Paysage romantique," in Montpellier 1996, p. 35.
5. As quoted in San Francisco 1962, p. 68.
6. Thomas 2000, p. 166.
7. "La forêt de Fontainebleau: Dévastations," *L'Artiste*, 2nd ser., 3 (1839), p. 290, as quoted in Thomas 2000, p. 165.

86. *Marsh at Villebussière, Berri*

1842
Black chalk on paper
Rousseau vente stamp in black ink at lower left
(Lugt 2436)
13 5/8 x 21 7/8 in. (34.5 x 55.7 cm)
Bruyas Bequest, 1876
876.3.136
Exhibited Richmond and Williamstown only

Provenance
The artist (posthumous sale, Hôtel Drouot, Paris, 27 Apr.–2 May 1868, no. 166, sold to Silvestre); Théophile Silvestre (1868–72; given to Bruyas, Jan. 1872);[1] Alfred Bruyas, Montpellier.

Selected Exhibitions
Paris 1939, no. 194, as *Marécage*; Paris 1967, no. 68, ill.; Montpellier 1996, no. 174, ill.

Selected References
Bruyas 1876, no. 182, as *Paysage*; Claparède 1962, no. 240, ill., as *Marais à Villebussière; Berry*; Schulman 1997, no. 274, ill., as *Marais à Villebussière en Berri*, dated 1842.

This black-chalk drawing is remarkable in its radical spareness. Nearly the entire upper two thirds of the paper is left untouched—a vast expanse of undifferentiated sky. Moreover, the lowest register of the page is also essentially a void, denoting an ambiguous expanse of marshland. The drawing is built with admirable economy: tufts of marsh grass and scrubby plants emerge out of the watery landscape in the middle ground. The horizon is defined by a line of trees, a scrim that diminishes dramatically at left and right to a thin graphite trace.

In 1842 Rousseau made a trip to Berry, encouraged by his painter friend Jules Dupré (1811–1889), who had frequently visited and painted in the Berry region. Rousseau stayed in the tiny village of Le Fay but wandered throughout the countryside including Villebussière, perhaps a mile to the northwest. In the middle of the nineteenth century Berry was a remote and fairly barren landscape of scrubby woods and fields dotted with ponds and marshes. Nevertheless, Rousseau made over forty drawings and numerous sketches of the area. Its dramatic emptiness was an

important catalyst in releasing Rousseau from culturally determined notions of the picturesque, allowing him to embrace instead what might be called a *lower* level of meaning embedded in the ordinary, unembellished landscape itself. Greg Thomas has rather ingeniously termed this new tack in Rousseau's work his discovery of "ecological" meaning. Faced with a landscape of "minimal cultural meaning," Rousseau accesses a more elemental relationship to the land, where "the uncontrollable narrative of natural processes displaces those of rural life."[2]

Théophile Silvestre, Rousseau's friend and Bruyas's advisor, focused on the subtle emptiness of this drawing in a descriptive letter to the collector: "Another drawing done in black chalk is of the fine grassy growth of a swamp in Berry. One sees, farther on, the silhouette of a little wood getting smaller and smaller, bordering the plain. It's not much but it's everything for the intelligent eye of a spectator initiated into painting, not by painting but by nature; because someone who does not know nature to begin with can hardly come to understand painting."[3] **DK**

1. In a letter of 5 Mar. 1870, Silvestre asked for a loan from Bruyas of 3,500 francs and proposed a group of works, including this drawing, as a guarantee against the loan. After numerous letters in the following years, Silvestre finally sent these works to Bruyas on 11 Jan. 1872. Doucet MS 215, nos. 11 and 29.
2. Thomas 2000, pp. 132–35.
3. "Un autre dessin fait au crayon noir est la chevelure herbue et fine d'un marécage de Berry. On voit, plus loin, la silhouette décroissante d'un petit bois, bornant la plaine. C'est peu de chose, mais c'est tout pour l'oeil intelligent du spectateur initié à la peinture, non par la peinture mais par la nature; car celui qui n'a pas connu la nature tout d'abord n'arrive guère à comprendre la peinture." Letter from Théophile Silvestre to Alfred Bruyas, 30 Nov. 1872, Doucet MS 215, no. 37.

87. Path in the Forest, Autumn

1848–50
Graphite with touches of watercolor on paper
5 1/4 x 8 1/4 in. (13.4 x 21.1 cm) maximum (irregular sheet)
Rousseau vente stamp in black ink, lower left (Lugt 2436); Musée Fabre stamp in blue ink, lower right (Lugt 1867)
Bruyas Bequest, 1876
876.3.138
Exhibited Dallas and San Francisco only

Provenance
The artist (posthumous sale, Hôtel Drouot, Paris, 27 Apr.–2 May 1868, possibly no. 342, as *Bouleaux et rochers de Jean-de-Paris*,[1] probably sold to Silvestre); probably Théophile Silvestre, Paris (1868–72; probably given to Bruyas, July 1872);[2] Alfred Bruyas, Montpellier.

Selected Exhibitions
Paris 1939, no. 193, as *Un sentier*; Montpellier 1996, no. 183, ill.

Selected References
Bruyas 1876, p. 613, no. 184, as *Paysage*; Claparède 1962, no. 248, ill., as *Un Sentier dans la forêt à l'automne*; Schulman 1997, no. 346, ill., as *Sentier de forêt en automne*, dated 1848–50.

Rousseau visited the village of Barbizon often between 1837 and 1840 and maintained a home there on a permanent basis from 1847. This pencil drawing of a trail in the Forest of Fontainebleau creates a powerful impression of physical vigor. The perspective is low, creating the sense that one is surrounded by the boulders at left and right. The trail meanders upward, past trees already shedding their leaves, and along the edge of the forest into the distance. The trees in the background are articulated with tightly spaced back-and-forth pencil strokes; the foliage seems to sway in the wind. The brush hanging over the rock at right is a complex tangle of intersecting and interweaving lines. A thicker pencil defines the outlines and edges of the large outcropping of rock with an emphatic heavy and continuous line. Typical for the artist's quick sketches in nature, there is no grandiose subject matter, no picturesque vista that defines the scene. Rather this is a study before the motif, the result of astute attention to details, capturing this quiet scene within the forest interior.

It is with superlatives that Silvestre described the entire group of drawings that he had dispatched to Bruyas in 1872: "Certainly some of these drawings have the lovely character of the natural impression, of energy and delicacy. The least of these sketches is the egg of a rare bird. These are little views of the plain of Barbizon, done on the spot in the countryside around the rustic house in Barbizon itself that Rousseau lived in and where he died. Two were done in the empty communal spaces behind the village, two others in the fields neighboring the route to Chailly, where he is buried, and before arriving in Barbizon from the direction of Chailly. The four very little works are almost pendants; these are little notes drawn on the knee while out walking, but they are fine notes, firm, correct, and suggestive. Barye saw them once at my house and was extremely moved. He found these little pieces admirable and more striking than paintings. One feels the distance and the color of the weather. The little drawings talk."[3] **DK**

1. This is described as a "drawing heightened with a few touches of watercolor," 13 x 20.5 cm, dated 1865–66, and listed with a group of drawings under the heading "Forest of Fontainebleau."
2. Given the provenances of Bruyas's other drawings by Rousseau, and the presence of this drawing in the Rousseau sale of 1868, it seems likely that this one was also owned by Silvestre. In a letter of 5 Mar. 1870, Silvestre asked for a loan from Bruyas of 3,500 francs, and proposed a group of works as a guarantee against the loan. Among these were "more than a dozen other drawings by Théodore Rousseau, smaller in size, given to me by his father." Despite this last comment, Silvestre may have purchased this drawing in 1868. After numerous letters in the following years, Silvestre finally sent a group of nine small drawings to Bruyas on 8 July 1872. Doucet MS 215, no. 11 and 33.
3. "Il est certain que quelques-uns de ces dessins ont un beau cachet d'impression naturelle, d'énergie et de finesse. Le moindre de ces croquis est l'oeuf d'un oiseau rare. Ce sont de petites vues de la plaine de Barbizon, faites sur place, dans les alentours de la maison rustique que Rousseau habitait, à Barbizon même, et òu il est mort. Deux sont pris sur les vacant communaux, derrière le village, deux autres, dans les champs avoisinant le chemin de Chailly, òu il est enterré; et avant d'arriver de Chailly à Barbizon. Les quatres petits sujets, tous petits, se font à peu près pendants; ce sont de petites notes, fait sur le genou en promenade, mais quelles notes fines, fermes, justes et suggestives! Barye les ayant vues un soir, chez moi, en était extrêmement ému. Il trouvait ces quatre petits morceaux admirables, et plus frappants que des tableaux. On y sent la distance et la couleur du temps. Les petits crayons parlent." Letter from Théophile Silvestre to Alfred Bruyas, 30 Nov. 1872, Doucet MS 215, no. 37.

88. *Oak Tree in a Marshy Landscape*

c. 1860
Pen and brown ink over graphite, with traces of black chalk on paper
11 5/8 x 14 in. (29.5 x 35.5 cm) framing line; 13 1/4 x 15 1/4 in. (33.7 x 38.8 cm) sheet
Bruyas Bequest, 1876
876.3.141
Exhibited Dallas and San Francisco only

Provenance
The artist (given to Silvestre); Théophile Silvestre (until 1872; given to Bruyas, Jan. 1872);[1] Alfred Bruyas, Montpellier.

Selected Exhibitions
Paris 1939, no. 192, as *Paysage*; Montpellier 1996, no. 175, ill.

Selected References
Bruyas 1876, p. 614, no. 187, as *Paysage*; Claparède 1962, no. 241, ill., as *Paysage d'étangs au chêne détaché*; Schulman 1997, no. 621, ill., as *Chêne solitaire au milieu des marais*, dated c. 1860.

In the 1840s Rousseau traveled extensively throughout France, often accompanied by his painter friend Jules Dupré. He visited the Sologne in the Berry region and Gascogne in the department of Landes, as well. Most striking about these destinations is their remoteness and almost total absence of grand picturesque views. These were hardly typical tourist destinations and represent a desire on Rousseau's part to immerse himself in fairly inhospitable, even desolate, landscapes. Landes, the name literally meaning "wasteland," is an area wedged between the glorious Pyrenees and the beautiful cultivated terrain of Bordeaux to the north. It is noteworthy that Rousseau discovered this rustic, uncultivated area of "heather, woods, marshes, ponds, and vast plains of sand," just as it was about to be transformed by a government sponsored campaign of forestation with maritime pines and the implementation of a major drainage project.[2] This extraordinary effort did succeed in fundamentally transforming the area, with the forestation leading inevitably to industrialization and therefore changing not merely terrain

but society as well. The same modernization was to befall the wild expanses of the Sologne, when under Napoléon III swampy, disease-ridden marshes were obliterated with the construction of canals and the planting of forests of scotch pine and birch trees.[3]

In March 1870, Silvestre included these two pen-and-ink drawings to Bruyas as part of a group of works intended as collateral for a loan he was requesting: "two superb pen drawings by Théodore Rousseau of a superb effect and sureness. They are sites in the Landes and the Sologne."[4] In his 30 November 1872 letter, with its long descriptions of the drawings that he had dispatched earlier that year, Silvestre wrote: "The two pendant drawings in ink are of a river bank and an oak in the sun in the swampy land of the Sologne. The oak is, in my opinion, the more beautiful, seen under a brilliant effusion of sunlight. It has a more lively and vibrant quality than the other. It is the drawing of an artist in his strength, his willpower, and his maturity. It is rough and virile."[5] Clearly he is describing the drawing of the single tree, boldly isolated in the watery landscape, a robust form that greets the rays of sun that emerge from behind light clouds. Michel Schulman, on the other hand, in his 1997 catalogue raisonné of the

graphic work, reserved his words of praise for the other drawing, titled *Pêcheur relevant ses nasses* in his entry: "There is no doubt that this drawing is one of the most beautiful by Théodore Rousseau."[6]

The praise for these pen drawings is understandable, as both are highly animated, delicate yet imbued with unmistakable energy. Rousseau creates a sense of atmosphere, a fullness of light, air, and movement. With quick, sure strokes of his pen he defines the cloud-studded sky. In both drawings the reflections of the tall trees on the surface of the water become a focus. In the work with the fisherman drawing up his net (a particularly fetching motif), the profile of the shore is an especially compelling element of the composition: The line begins at the lower-right corner, meanders diagonally toward the far left, and then returns to the right once again, only to disappear left behind the bank of trees and finally reemerge to define the distinct shore at upper right.

There is apparently a discrepancy about the dating of these works. Michel Hilaire describes them as youthful drawings contemporary to Rousseau's visits to Berry and Landes in 1842 and 1844, respectively. Schulman, on the other hand, ascribes them to about 1860.[7] **DK**

89. *Wooded Riverbank with a Large Isolated Tree*

c. 1860
Pen and brown ink over graphite, with traces of black chalk on paper
11 3/4 x 13 1/2 in. (29.9 x 34.4 cm) framing line; 13 1/8 x 15 1/4 in. (33.3 x 38.7 cm) sheet
Bruyas Bequest, 1876
876.3.142
Exhibited Richmond and Williamstown only

Provenance
The artist (given to Silvestre); Théophile Silvestre (until 1872; given to Bruyas, Jan. 1872); Alfred Bruyas, Montpellier.

Selected Exhibitions
Paris 1939, no. 167, as *Paysage au bord d'une rivière*; Montpellier 1996, no. 176, ill.

Selected References
Bruyas 1876, no. 189, as *Paysage*; Claparède 1962, no. 242, ill., as *Rivière et berge boisée avec un grand arbre détaché*; Schulman 1997, no. 620, ill., as *Pêcheur relevant ses nasses*, dated c. 1860.

1. In a letter of 5 Mar. 1870, Silvestre asked for a loan from Bruyas of 3,500 francs and proposed a group of works, including these two drawings, as a guarantee against the loan. After numerous letters in the following years, Silvestre finally sent these works to Bruyas in Jan. 1872. In the letter of 11 Jan. 1872 informing Bruyas that they had been sent, Silvestre noted that the two drawings had been given to him by the artist. See Doucet MS 215, nos. 11 and 29.
2. Girault de Saint-Fargeau, "Landes (département des)," in *Dictionnaire géographique*, vol. 2, p. 292, as quoted in Thomas 2000, p. 141 n. 88 and p. 144.
3. Thomas 2000, p. 144.
4. See Doucet MS 215, no. 11.
5. "Les deux pendants à la plume sont un bord de rivière et un chêne au soleil, dans une lande marécageuse de la Sologne. Le chêne est à mon avis, le plus beau, vu sous une brillante effusion de soleil. Il est d'un caractère plus vivant et plus vibrant que l'autre. C'est un dessin de l'artiste dans sa force, sa volonté et sa maturité. C'est âpre et mâle." Letter from Théophile Silvestre to Bruyas, 30 Nov. 1872, in Doucet MS 215, no. 37.
6. Schulman 1997, p. 296.
7. Montpellier 1996, p. 178. Schulman 1997, p. 296.

Octave Tassaert

Paris 1800–1874

90. *Heaven and Hell*

1850
Oil on canvas
83 1/2 x 55 7/8 in. (212 x 142 cm)
Signed and dated lower left: Oct. Tassaert / 1850
Gift of Alfred Bruyas, 1868
868.1.76

Provenance
Alfred Bruyas, Montpellier (by 1853).

Selected Exhibitions
Paris, *Salon*, 1850, no. 2877; Montpellier 1860,
no. 279; Paris 1900, no. 625.

Selected References
Bruyas 1853, pp. 9, 24, 27, 51; Bruyas 1854, p. 28,
no. 55, as *La France agitée entre les bons et les
mauvais instincts, ou Ciel et Enfer*; Bruyas 1876,
p. 617, no. 194; Prost 1886, pp. 16–24, no. 75, ill.
(print after the painting); Haedeke 1980, pp. 81–87;
Montpellier 1985, p. 87, no. 12, and p. 107, no. 124,
ill. p. 91 (detail); Le Guen 1993, vol. 2, pp. 92–94,
no. 281, ill.

Octave Tassaert received a standard academic train-
ing at the École des Beaux-Arts in Paris, and while
he is perhaps better known for his genre paintings of
sentimental or moralizing subjects, several official
commissions indicate that he also achieved a degree of
success with his more ambitious historical and mytho-
logical scenes. *Heaven and Hell* clearly stems from
Tassaert's study of past masters, its iconography deriv-
ing primarily from depictions of the Last Judgment.
The image features a group of naked figures, almost all
of them women, grappling with the tails of a three-
headed monster in order to avoid the glowing pit of
Hell at the bottom right, as several other figures are
selected by angels to rise toward the heavens.[1]
Although Tassaert followed no specific model for his
painting, the inclusion of a hybrid animal-monster and
the representation of Hell as a fiery underworld recall
Netherlandish examples of the theme, such as those by
Hieronymus Bosch (c. 1450–1516), while the strongly
sensual aspect of the twisting, piled-up figures suggests
the style of Rubens (1577–1640). At the apex of the pri-
mary group is a clothed woman who glances outward
at the viewer as a demon-like figure reaches toward her

and one of the women below holds up a mirror, pre-
sumably forcing her to confront her sinful nature. Two
additional scenes at the center right and upper left
complete the composition. The vignette at the right,
separated from the main scene by stormy celestial
clouds, seems to show a group in an earthly realm, the
man struggling to raise a woman, who holds a child in
her arms, toward redemption. This gesture is echoed in
the upper section, where a man supports a woman and
child, and faces the scales of judgment held by the
angel above them.

The painting earned numerous, though mixed, com-
ments when it was exhibited in 1850–51. Théophile
Gautier found some "charming groups and very pretty
passages" in the work though he disliked the pale col-
ors, and Frédéric Henriet called it an "original work"
filled with "spiritual painting," while Louis Peisse,
along with several other writers, criticized the "lineup
of tumbling forms and of human flesh, twisting and
tangled with a passion more apparent than real."[2]

Given the scale and ambition of *Heaven and Hell*, it
is perhaps surprising that the date and circumstances
of Bruyas's acquisition remain uncertain. Bruyas most
likely met Tassaert during his first visit to Paris,
between December 1849 and May 1850, particularly as
Tassaert's growing renown at this period would have
attracted the collector's attention. Many authors have
stated that Bruyas commissioned *Heaven and Hell* at
this time and perhaps even devised its composition. Its
complicated allegorical content certainly parallels
Bruyas's own often abstruse writing on such subjects as
morality, sin, and redemption. Moreover, several
authors have identified the woman in the upper center
as Bruyas's mistress.[3] Marion Haedeke noted that a
similar brown-haired woman appears in several other
works that Bruyas commissioned, most notably a com-
posite lithograph executed by Jules Laurens that com-
bines photographs of Bruyas, a painting by Marcel
Antoine Verdier known as Bruyas's presumed mistress,
and several details from *Heaven and Hell* (fig. 1).[4]
Finally, Philippe Bordes stated in 1985 that the bearded
man at the top who faces the angel of justice is Bruyas
himself, an identification that has since been generally
accepted.[5]

This small but important figure, significantly placed
as the first among the elect at the threshold of Heaven,

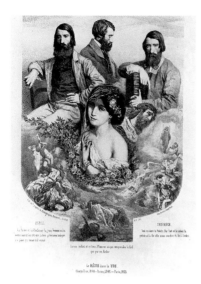

Fig. 1. Jules Laurens,
The Dream in Life, 1856.
Lithograph, 14 3/16 x 9 13/16 in.
(36 x 25 cm). Musée Fabre, Montpellier

does indeed resemble the collector. But several points make it difficult to state with certainty that Bruyas asked Tassaert either to paint this work for him or to include him in it. The first is that there is no indication in the 1850 Salon catalogue or the contemporary criticism that the painting belonged to Bruyas. Further, *Heaven and Hell* appears only in the 1853 catalogue of Bruyas's collection, not in the 1851 or 1852 publications. Then, in his 1854 catalogue, Bruyas not only implied that most of his collection was the result of his collaborative efforts with artists, but stated explicitly that two of Tassaert's paintings were based on sketches he himself had made. Surely if Bruyas had played a role in creating such a major work as *Heaven and Hell* he would have noted the fact.

Nonetheless, there is no question that once he did take possession of the painting, Bruyas quickly gave *Heaven and Hell* a very personal interpretation. The 1853 catalogue, which consists of a series of commentaries and quotations rather than a numbered list, includes a full page description of this work. Although it is attributed to Tassaert, Bruyas very likely wrote the text himself.[6] The interpretation focuses on the female figure at the upper center, who is described as "a soul in the guise of a young woman, tormented by the evil passions of the earth." Most of the other figures are also identified, including Pride, "who holds a mirror up to

[the young woman], which says 'see how beautiful you are,'" and the five women beside her, Envy, Anger, Luxury, Debauchery, and Hypocrisy. The idiosyncrasies of many of these identifications, such as labeling the woman with the mirror Pride rather than the more standard Truth, and calling the other women not sinners but embodiments of sin, is in keeping with Bruyas's habit of supplying alternate readings and titles to the works in his collection. Indeed, at the end of this description is the sentence "or it is France, torn between good and evil instincts," the primary title he gave to the painting in his catalogue of the following year. The reference, although it is difficult to pin down, appears to be to Louis-Napoléon's successful effort to become emperor of France and his subsequent support of the arts, for several earlier pages in the 1853 catalogue are headed "Document in support of the truth of 2 December 1851 [the date of Louis-Napoléon's coup d'état].... Splendor and riches devoted to art," and "Love of God, or the true power of Louis-Napoléon over France in 1852," with a photographic reproduction of Tassaert's painting on the following page. The perception of a single work of art as both intensely personal and universal is again characteristic of Bruyas's approach. That the collector devoted such an exegesis to *Heaven and Hell*, excerpted details for the related lithograph to illustrate the travails of his own life, and placed the painting in the center of the second room of his 1868 gallery plan, all indicate the importance Tassaert's painting held for Bruyas. **SL**

1. There is a small-scale replica of the painting in the Cleveland Museum of Art (1980.287) that follows the composition of the large canvas almost exactly, and is thus likely to be a repetition after the Montpellier painting, rather than a preparatory study. See Argencourt 1999, pp. 595–97.
2. Gautier, in *La Presse*, 22 Mar. 1851; Henriet, in *Le Théâtre*, 12 Mar. 1851; Peisse, in *Le Constitutionnel*, 21 Jan. 1851; all cited in Prost 1886, pp. 17, 19, 20.
3. Joubin 1926a, pp. 232–33 seems to have been the first to make this identification.
4. Haedeke 1980, p. 85. Laurens made the lithograph at Bruyas's request, in 1856. The Verdier painting entered the Musée Fabre collection as a gift from Bruyas's

great-grandniece Mme Alicot (inv. no. 98.6.11).
5. Bordes in Montpellier 1985, p. 27.
6. Bruyas 1853, p. 51. In a letter dated 9 Jan. 1854, Tassaert wrote to Bruyas that he "was quite surprised to find framed in gold and printed *le succinct* of *Heaven and Hell*." He went on to note somewhat cryptically that if he were to pass into posterity, it would be through the richness of the typography of this statement. Letter reprinted in Bruyas 1854, p. 51 (though this has "topography" rather than "typography"). It seems possible that "le succinct" refers precisely to the description Bruyas published in his catalogue the previous year.

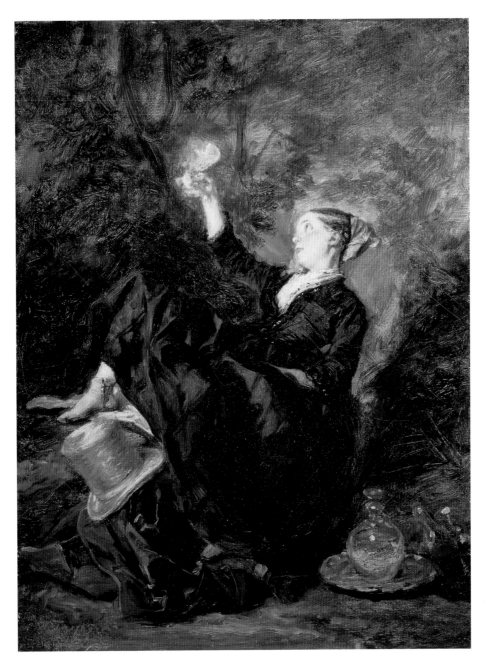

91. *Young Woman with a Wine Glass*

1850
Oil on canvas
13 3/8 x 10 1/4 in. (34 x 26 cm)
Signed and dated lower left: O. Tassaert / 1850
Gift of Alfred Bruyas, 1868
868.1.86

Provenance
Alfred Bruyas, Montpellier (purchased from the artist for 500 francs, 1852).[1]

Selected Exhibitions
Paris 1900, no. 626; Paris 1939, no. 89.

Selected References
Bruyas 1853, p. 27, as *Femme qui sourit à un verre de vin*; Bruyas 1854, p. 24, no. 29 as *Femme qui sourit à un verre de vin*; Laurens 1875, pl. 15, as *Le Vin* (lithograph after the painting; reversed); Bruyas 1876, p. 618, no. 197, as *La jeune Femme au verre de vin*; Prost 1886, p. 23, no. 84, ill. (print after the painting; reversed); Montpellier 1985, p. 107, no. 126, ill. p. 117; Le Guen 1993, pp. 194–95, no. 629, ill.; Le Guen 1998, p. 280, fig. 11.

92. *Reading the Bible*

1851
Black chalk with stumping on paper
8 11/16 x 10 1/16 in. (22 x 25.6 cm)
Signed and dated in black chalk, lower left:
O Tassaert 1851
Musée Fabre stamp in blue ink, lower right
(Lugt 1867)
Gift of Alfred Bruyas, 1868
868.1.84
Exhibited Richmond and Williamstown only

Provenance
Alfred Bruyas, Montpellier (by 1852).

Selected Exhibitions
Montpellier 1860, no. 582; Cleveland 1980, no. 63,
ill.

Selected References
Bruyas 1852, p. 46, no. 89; Bruyas 1853, pp. 27, 29;
Bruyas 1854, pp. 21–22, no. 20; Bruyas 1876, p.
622, no. 209; Prost 1886, p. 56, no. 402; Claparède
1962, no. 257, ill.; Le Guen 1993, p. 249, no. 874, ill.

Octave Tassaert was best known for small-scale paintings that appealed either to the viewer's sense of pity, through depictions of the lower classes of Paris, or to his appreciation of pleasure, through images incorporating varying degrees of eroticism. This group of works illustrates the range of themes with which Tassaert established his reputation; he was, as Murielle Le Guen has characterized him, "the painter of tears and good fortune."[2] In fact, *An Unfortunate Family* is a version of what is perhaps Tassaert's best-known work. In May 1849, the artist received a commission from the French state for *An Unfortunate Family* (Musée d'Orsay, Paris), which he exhibited to much acclaim in the Salon of 1850. Tassaert made numerous replicas of the composition, one of them the present work.[3] Bruyas presumably requested this version in 1852, a period of sustained relations with Tassaert,[4] and as he often did when the primary version of a work he admired was unavailable, Bruyas also purchased the earliest sketch for the painting (Musée Fabre, inv. no. 868.1.81), perhaps the very sketch with which Tassaert obtained the official commission.

An Unfortunate Family is based on an 1834 story by Félicité de Lamennais, *Les paroles d'un croyant* (The Words of a Believer). It depicts two women in an attic room where, as the excerpt published in the 1850 Salon catalogue described it, "snow covered the roofs, and a glacial wind whipped at the window of this narrow, cold residence." Tassaert suffused the scene with a chilly, blue-green light; only the fire in the brazier adds a note of contrasting color and highlights details of the figures' clothing and features, leaving the more roughly painted background in shadows. As the narrative explains, the older woman is gazing in supplication at an image of the Virgin and Child while the younger woman clings to her in tears; "a short time later, two forms, as luminous as souls, were seen rising toward the sky." While both the text and the image remain ambiguous about the cause of the women's death,

many of the Salon critics agreed with Paul Mantz that "the painting would be much better titled *Suicide*."[5] The women, according to this reading, are in the process of suffocating from the coal fire they have lit, rather than dying simply of cold and hunger. Since Tassaert himself committed suicide in just this manner in 1874, the artist may well have intended to allude to this possibility in a narrative that otherwise illustrates the power of religious faith over earthly concerns.[6]

Reading the Bible similarly depicts a scene of religious morality, though in a lighter, gently satirical vein.[7] The drawing depicts a group of simply dressed figures in a very plain interior, implying their lower-class status. The woman, intent on her reading, fails to notice that her young listeners are displaying a marked lack of interest, from the boy in the center who raises his arms in an ostentatious yawn, to the youngest child, who has fallen asleep in her sister's lap. This anecdotal genre scene, similar in content to the work of François Bonvin and others (see cat. 13), uses charm and humor to underscore the piety of the lower classes in a way that was eminently palatable for consumers of such images. If both this drawing and *An Unfortunate Family* can be understood as realist subjects, depicting lower-class life in good and bad times, they also demonstrate Tassaert's interest in literary sources and in religious themes, an interest probably strengthened by his work as a printmaker and illustrator. In this way the artist serves as a link between the earlier romanticism of Delacroix, who frequently drew on such sources, and the realism of Courbet, the most prominent of the emerging Realists and an artist Tassaert certainly knew.[8]

Young Woman with a Wine Glass exemplifies the other type of appeal Tassaert's paintings often presented. It depicts a scene of unequivocal pleasure, showing an elegantly dressed woman reclining on cushions in a wooded setting, gazing in enjoyment at a mostly emptied glass. A gray top hat resting atop a dark coat at her

93. *An Unfortunate Family (Suicide)*

1852
Oil on canvas
17 3/4 x 14 5/8 in. (45 x 37 cm)
Signed and dated lower right: O. Tassaert / 1852
Gift of Alfred Bruyas, 1868
868.1.80

Provenance
Alfred Bruyas, Montpellier (by 1852).

Selected Exhibitions
Montpellier 1860, no. 283, as *Une famille
malheureuse*; Cleveland 1980, no. 5, ill.

Selected References
Bruyas 1852, p. 45, no. 87, as *Une Famille
malheureuse*; Bruyas 1853, pp. 6, 27, as *Une famille
malheureuse*; Bruyas 1854, p. 14, no. 12, as *Famille
malheureuse*; Bruyas 1876, p. 620, no. 201, as
Suicide; Prost 1886, p. 28, no. 112, as *Suicide*;
Sheon 1981b, pp. 142–51, fig. 1; Montpellier 1985,
p. 107, no. 127, ill. p. 117; Le Guen 1993, pp. 165–66,
no. 561, ill., as *Le Suicide*.

feet implies a male presence. Like this discreet indicator, the painting itself is only mildly suggestive, particularly in contrast to other images by Tassaert that are more overtly erotic.[9] Further, while the top hat and the very sketchy facture of the landscape background introduce a note of modernity, the delicacy of the woman's more finished figure aligns the work with traditional depictions of the *fête champêtre* rather than with the confrontational realism of Courbet's paintings of women in outdoor settings. Although it clearly depicts a woman of questionable moral character, this type of image was intended to charm more than to instruct, and generally found favor with critics including Baudelaire, who commented of Tassaert's paintings in the Salon of 1846 that "Monsieur Tassaert . . . is a painter of the greatest merit whose talent would be best applied to amorous subjects."[10] Bruyas—who corresponded with Tassaert extensively, invited him to Montpellier in 1865, and acquired sixteen paintings from him—clearly appreciated the artist's talents. His collection demonstrates what almost every writer who commented on Tassaert points out, that the artist was equally skilled at religious subjects, themes of pleasure, and sentimental or melodramatic contemporary narratives.

SL

1. In a letter to Bruyas, Tassaert mentioned that he was owed 500 francs for "the smiling young woman with a glass of wine." Doucet MS 216, no. 174, undated; reprinted in Bruyas 1854, p. 94, dated 1852.
2. Le Guen 1998, p. 273. I wish to thank Ms. Le Guen and Ting Chang for their help with these entries.
3. Another version, dated 184[9?], is in the Musée de Grenoble. Prost 1886, pp. 15–16, lists several other replicas.
4. All three of Tassaert's portraits of Bruyas are dated 1852.
5. Mantz, "Salon de 1850–51," *L'Événement* (15 Feb. 1851), reprinted in Prost 1886, p. 18.
6. Chevillot 1995, p. 276, comments on Lamennais's story as an illustration of religious faith, and on the critics' interpretation of Tassaert's painting.
7. The drawing may be a preliminary study for a painting listed in Prost 1886, p. 29, no. 122, *Reading the Bible* (location unknown).

8. For an evaluation of Tassaert emphasizing his realism, see Cleveland 1980, p. 44 and Sheon 1981b; for an analysis of his transitional status see Le Guen 1998, p. 284. Le Guen 1993, p. 11, notes that from 1843 to 1849 Tassaert listed his address in the Salon catalogues as that of the studio of Monsieur Suisse. Since Courbet studied at the Académie Suisse during the same period, the two artists probably became acquainted at that time.
9. *Ariadne Abandoned*, also in Bruyas's collection (Musée Fabre, inv. no. 868.1.83) is one example. In fact, although *Woman with a Glass of Wine* is often catalogued as having been exhibited in the Montpellier Salon of 1860 under the title *A Bacchante*, it seems more likely that *Ariadne Abandoned*, with its reclining, naked figure, was the work shown.
10. Baudelaire, "Salon of 1846," quoted in Prost 1886, p. 10.

94. *The Painter's Studio*

1853
Oil on canvas
18 7/8 x 22 in. (48 x 56 cm)
Signed and dated lower left: Oct. Tassaert / 1853
Gift of Alfred Bruyas, 1868
868.1.91

Provenance
Alfred Bruyas, Montpellier (commissioned from
the artist, 1853).

Selected Exhibitions
Montpellier 1977, unnumbered, ill.; Dijon 1982,
no. 114, fig. 292.

Selected References
Bruyas 1853, p. 50, as *L'humble atelier*; Bruyas
1854, no. 13, as *Intérieur de l'atelier de M. Oct.
Tassaert*, sujet esquisse de M. Alfred Bruyas,
exécuté de commande par M. Oct. Tassaert; Bruyas
1876, p. 619, no. 200, as *L'Atelier du Peintre*; Prost
1886, p. 29, no. 127, ill. (print after the painting;
reversed), as *L'atelier de l'auteur*; Montpellier 1985,
p. 88, no. 20, and p. 108, no.133, ill. p. 92, as *Alfred
Bruyas dans l'atelier de Tassaert*; Le Guen 1993,
vol. 2, pp. 34–35, no. 93, ill.; Chang 1996b,
pp. 588–89, fig. 11; Le Guen 1998, pp. 274, 276, fig. 2.

One of Alfred Bruyas's primary goals as a collector was to render the formation of his collection as important an act of creation as that of painting itself. To this end, he repeatedly sought out artists with whom he could collaborate, supporting them financially and engaging them creatively. He even offered ideas for their compositions, proposals that frequently included presenting himself as a portrait subject. Tassaert's *The Painter's Studio* is perhaps the most complete embodiment of Bruyas's ideals in this regard. Executed in a detailed yet relatively freely painted manner, it represents the collector seated before an easel in Tassaert's studio in Paris, while the artist is relegated to the left corner of the image, turning to face Bruyas as he prepares his palette.[1] Around them are several of Tassaert's paintings: at the right is *Heaven and Hell* (cat. 90), which Bruyas purchased, a version of *An Unfortunate Family* (cat. 93) appears on the wall along with a portrait, and *The Angel and the Child* (Private collection, Paris) sits on the easel.[2] Joseph Fontaigne, a servant of Bruyas who was known as "petit Joseph," is seated on a couch in the background, waiting with evident lack of interest for the session to end.

As Ting Chang has discussed, this painting is nearly unprecedented in its literalization of the patron's central role and the artist's secondary one. Bruyas's prominent position between the artist and his canvas, his relaxed and confident pose, and his gesture of indicating some point about the work, clearly reveal his commanding involvement with the artistic process. Tassaert, for his part, represented himself in *profil perdu*, his features barely visible as he twists rather awkwardly away from his work to focus his full attention on the words of his patron. Judging by many of the letters from Tassaert to Bruyas, this relationship existed in fact as well as on canvas, although since Bruyas seems to have spent some time working on his own artistic efforts under the guidance of Tassaert, he might have been expected to accord the painter some greater degree of deference.[3] Bruyas evidently discussed his efforts to promote contemporary art with Tassaert, just as he spoke to Courbet approximately a year later, for Tassaert wrote in a letter of 28 August 1852, "you are taking great strides toward your solution! It is a noble effort from which you should emerge victorious."[4] Perhaps as a result of listening to the collector's high-

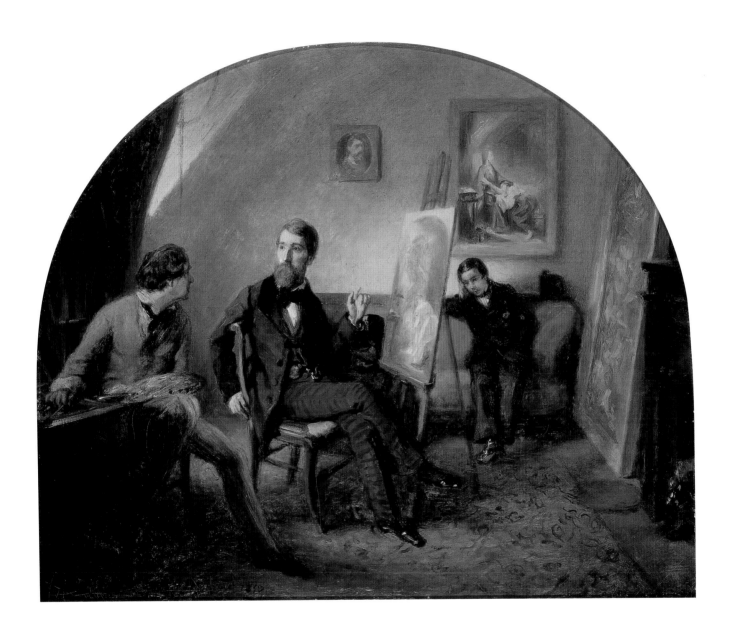

flown rhetoric, Tassaert tended to praise his patron almost to excess, commenting, for example, that "Medici is immortal thanks to the same fire that animates you."[5] This is just the sort of sentiment represented in *The Painter's Studio*.

Bruyas's involvement with Tassaert's paintings extended even further, in some instances, than simple discussions and encouragement. In the 1854 catalogue of his collection, Bruyas described this painting as a "subject sketch [*sic*, perhaps for sketched] by M. Alfred Bruyas, executed on commission by M. Oct. Tassaert." The idea that Bruyas may have initially composed this image and then requested that Tassaert paint it is supported by a comment the artist made in thanking the collector for sending some photographs of works in his collection. "I saw once again with infinite joy your pen and ink sketch of my smoky room, with you painting your little Joseph."[6] While this description does not match the painting precisely, it corresponds closely to the setting and the respective positions of the figures in it.[7] In addition, another painting listed in the 1854 catalogue seems to have had its genesis in the same practice. Number nineteen is entitled "A Souvenir of Florence (interpretation), by O. Tassaert," and further described as "after a sketch made and given to the artist by M. Alfred Bruyas." Since Bruyas often labeled portraits of himself "interpretations," this work is probably one of Tassaert's three depictions of him, showing the collector full-face wearing a loose white shirt, with a green, fur-collared coat thrown over one shoulder, and a blurry suggestion of a landscape and building in the distant background.[8] Here again, a comment by Tassaert probably corroborates the existence of such a drawing: "did you know," he wrote in 1852, "that at one point you were my master, when you traced your portrait in charcoal in my studio?"[9] As such comments make clear, Bruyas found in Tassaert an artist willing, even eager, to collaborate to a remarkable extent.

Although Bruyas maintained his relationship with Tassaert throughout the artist's life, even providing him with a studio in Montpellier for a brief period in 1865, he continued to search for other artists who might play a similar role. This was surely his intent in sending Courbet a photograph of Tassaert's *The Painter's Studio* in 1854, along with a note suggesting that the artist might provide his own version of such an image. As Courbet's *The Meeting* (cat. 30) demonstrates, however, the painter from Ornans had no intention of deferring to his patron in his artistic practice. Certainly in his own *Painter's Studio* of 1855 (Musée d'Orsay, Paris), Courbet situated himself squarely in the center of the composition, busily working on the painting before him, while Bruyas appears dimly in the right background among a large group of other figures who formed the artist's entourage of friends and supporters.[10] Although Courbet may have designed both of these works on some level as responses to Tassaert's painting, their representations of the relation between patron and artist made very clear that the situation depicted in Tassaert's *Painter's Studio* would not occur again, despite Bruyas's best efforts. **SL**

1. Théophile Silvestre sometimes referred to this painting as "the studio on the rue Notre-Dame-des-Champs," which was Tassaert's address at the time. See, for example, Silvestre 1874 (1 July), p. 2.
2. Bruyas owned a version of *An Unfortunate Family* (see cat. 93); this may be the painting represented, although Le Guen 1998, p. 276, suggests instead the sketch in the Musée de Grenoble. Le Guen also provides the identification of *The Angel and the Child*, and proposes that the portrait may be the *Self-Portrait in a Red Cap* in the collection of Gérald Schürr.
3. The evidence of Bruyas having studied in some way with Tassaert is limited, but it includes Silvestre's comment that Bruyas "had spent two years working at Tassaert's, and had frequented Delacroix, Troyon, Courbet, etc." Letter of 22 Feb. 1874, Montpellier MS 365, no. 5. Further, Bruyas seems on at least one occasion to have sent some drawings to Tassaert to solicit his opinion—which was that "your two compositions in pen and ink are two charming drawings; I say this not because you suggest I had a hand in it, but because they are most original in effect, and clear and striking in composition"—perhaps suggesting the continuation of a previous instructor-pupil relationship. Letter of 5 Aug. 1852, Doucet MS 216, no. 165.
4. "Vous marchez à grand pas dans votre solution! C'est un beau travail dont vous devez sortir victorieux." Doucet MS 216, no. 166. For a discussion of the importance of the word "solution" in Bruyas's vocabulary, see cat. 29.
5. Letter of 9 Jan. 1854; reprinted in Bruyas 1854, p. 51.
6. Ibid.
7. A note in the Musée Fabre files, dated 1946, states that there existed an annotated preparatory drawing for this work in a private collection in Montpellier, a provenance that might suggest the drawing was indeed made by Bruyas and kept until his death.
8. Musée Fabre, inv. no. 868.1.88.
9. Doucet MS 216, no. 173, undated; reprinted in Bruyas 1854, p. 57, dated 1852.
10. Bowness 1972, pp. 19–20, discusses the relation between Tassaert's and Courbet's paintings of their studios.

Chronology

1821	15 August: Birth of Jacques Louis Alfred Bruyas, son of the banker Jacques Bruyas, in Montpellier, France.
1835	First portrait of Bruyas, a drawing made by a school friend named Doumenjou (Musée Fabre, inv. no. 876.3.145).
1840	Bruyas studies painting in the studio of the Montpellier artist Charles Matet, a professor at the city's École des Beaux-Arts and curator of the Musée Fabre.
1843–45	First acquisitions of work by local artists, including his teacher Matet.
1843–48	Bruyas spends several weeks each year at Eaux-Bonnes, a spa in the Pyrenees, as treatment for his poor health. Bruyas meets numerous artists, including Eugène Devéria, Paul Huet, and Eugène Delacroix, during this period.
1846	Summer: Travels in Italy. Befriends fellow Montpellierain Alexandre Cabanel and other artists resident in the French Academy in Rome. Commissions a portrait from Cabanel (cat. 15).
1848	Second trip to Rome. Bruyas commissions a group of paintings from Cabanel on the themes of "work, love, and religion," for which Cabanel paints *La Chiaruccia, Albaydé*, and *A Thinker—Young Roman Monk* (cats. 17–19).
1849	December: Bruyas makes his first trip to Paris and soon buys several paintings from the dealer Auguste Cornu.
1850	Commissions two portraits from Thomas Couture (see cat. 35). Purchases Delacroix's *Moroccan Military Exercises* (cat. 41) and *Women of Algiers* (cat. 44), as well as Millet's *Offering to Pan* (cat. 77).
1851	Bruyas publishes the first catalogue of his collection.
1852	Second collection catalogue published. Studies painting with Octave Tassaert, from whom he commissions three portraits in the same year.
1853	Buys Delacroix's *Michelangelo in His Studio* (cat. 45) and commissions a portrait from him (cat. 46). May: sees Courbet's *Bathers* (cat. 28) and *Sleeping Spinner* (cat. 27) in the Salon and soon purchases both. Begins a collaborative relationship with Courbet, as he had done with Cabanel and Tassaert, by commissioning a portrait (cat. 29). Publishes a third collection catalogue in the form of a group of essays, quotations, and poems.
1854	May–September: Courbet visits Bruyas in Montpellier. Courbet paints *The Meeting* (cat. 30), as well as two other portraits of the collector and the *Self-Portrait with a Striped Collar* (cat. 32). Bruyas publishes another catalogue of his collection, in which he includes numerous letters he had received from friends and artists.
1855	Bruyas lends two paintings to Courbet's Pavillon du Réalisme, a private exhibition organized by the artist, and two paintings, including *The Meeting*, to the Exposition Universelle. *The Meeting*, mockingly called *"Bonjour, Monsieur Courbet!"*, attracts strong criticism, and Bruyas never travels to Paris to see either exhibition. The number of Bruyas's acquisitions begins to diminish considerably, only picking up again in the early 1870s.
1857	May–June: Courbet makes a second visit to Montpellier in the company of the writer Champfleury. Bruyas is deeply offended by the subsequent publication of Champfleury's satirical article mocking his collecting habits.
1859	Cabanel visits Bruyas in Montpellier.
1860	Bruyas helps organize a Salon for the town of Montpellier and lends many of the works in his own collection.
1861	9 October: Birth of Bruyas's daughter, Marie Eugénie Gabrielle (1861–1958), to Berthe Anthon.
1865	September: Bruyas arranges for a studio for Tassaert in Montpellier, though Tassaert quickly returns to Paris.
1868	12 November: Bruyas's first gift to the Musée Fabre, consisting of ninety-one paintings and works on paper. Creation of a series of three galleries within the museum, called the Galerie Bruyas, in which the collector arranges the works and becomes their curator.
1869	Renews his acquaintance with Théophile Silvestre, who becomes a collecting advisor and coauthor of the final catalogue of the Bruyas collection. Begins to adjust his collecting practices with the aim of creating a more comprehensive representation of nineteenth-century art.
1872	Acquisition of Géricault's *Study of a Severed Arm and Legs* (cat. 61) and of numerous works by Barye (see cats. 4, 5, 9).
1874	Purchases Courbet's *Portrait of Baudelaire* (cat. 25), as well as two small paintings by Ingres (see cat. 69).
1875	Publication of the *Album de la Galerie Bruyas*, a group of thirty lithographs by Jules Laurens after works in the collection.
1876	Bequest to the town of Montpellier of sixty paintings, seventy-eight drawings, and eighteen bronzes. Last portrait of the collector painted by Auguste Glaize (Musée Fabre, inv. no. 876.3.42). Publication of the *Galerie Bruyas*, the first part of a projected comprehensive catalogue, coauthored with Théophile Silvestre (d. 1875).
1877	1 January: Death of Alfred Bruyas, at the age of fifty-five.

Bibliography

Note: Exhibition catalogues are listed under the city of the organizing institution. Catalogues of the Paris Salon are not listed in the bibliography.

About 1855
About, Edmond. *Voyage à travers l'Exposition des beaux-arts.* Paris: L. Hachette, 1855.

Ackerman 1986
Ackerman, Gerald M. *The Life and Work of Jean-Léon Gérôme: With a Catalogue Raisonné.* London and New York: Sotheby's Publications; Harper and Row, 1986.

Ackerman 2000
Ackerman, Gerald M. *Jean-Léon Gérôme: Monographie révisée, catalogue raisonné mis à jour.* Rev. ed. Courbevoie: ACR, 2000.

Alexander 1965
Alexander, Robert L. "Courbet and Assyrian Sculpture." *The Art Bulletin* 67 (1965): 447–52.

Amprimoz 1980
Amprimoz, François-Xavier. "Un décor 'fouriériste' à Florence." *Revue de l'art*, no. 48 (1980): 57–67.

Amprimoz 1986
Amprimoz, François-Xavier. "Lettres de Dominique Papety à ses parents et à ses amis, Rome 1837–1842." *Archives de l'art français*, n.s., 28 (1986): 201–67.

Amsterdam 2003
Rijksmuseum Vincent van Gogh, Amsterdam. *Le choix de Vincent: Le musée imaginaire de Van Gogh.* Exh. cat. Amsterdam: Rijksmuseum Vincent van Gogh, 2003.

Andrews 1964
Andrews, Keith. *The Nazarenes: A Brotherhood of German Painters in Rome.* Oxford: Clarendon Press, 1964.

Argencourt 1999
Argencourt, Louise d', et al. *Cleveland Museum of Art: European Paintings of the Nineteenth Century.* 2 vols. Cleveland: Cleveland Museum of Art, 1999.

Athanassoglou-Kallmyer 1992
Athanassoglou-Kallmyer, Nina. "Géricault's Severed Heads and Limbs: The Politics and Aesthetics of the Scaffold." *Art Bulletin* 74 (Dec. 1992): 599–618.

Aubrun 1981
Aubrun, Marie-Madeleine. *Léon Benouville, 1821–1859: Catalogue raisonné de l'oeuvre.* Nantes: Les Presses de Sylvain Chiffoleau pour l'Association des Amis de Léon Benouville, 1981.

Babinski 1974
Babinski, Hubert F. *The Mazeppa Legend in European Romanticism.* New York: Columbia University Press, 1974.

Bachleitner 1976
Bachleitner, Rudolf. *Die Nazarener.* Munich: Heyne, 1976.

Bajou 1993
Bajou, Valérie. *Frédéric Bazille, 1841–1870.* Aix-en-Provence: Edisud, 1993.

Balis 1986
Balis, Arnout. *Rubens Hunting Scenes.* Trans. P. S. Falla. Corpus Rubenianum Ludwig Burchard, vol. 18, part 2. New York: Oxford University Press, 1986.

Bann 1997
Bann, Stephen. *Paul Delaroche: History Painted.* Princeton: Princeton University Press, 1997.

Bann 2000
Bann, Stephen. "The Image of History: Editorial." *Word & Image* 16, no. 1 (Jan.–Mar. 2000): 1–6.

Baudelaire 1927
Baudelaire, Charles. *Eugène Delacroix.* Paris: G. Crès, 1927.

Baudelaire 1962
Baudelaire, Charles. *Le Salon de 1845.* Paris: H. Lemaître, 1962.

Baudelaire 1965
Art in Paris, 1845–1862: Salons and Other Exhibitions Reviewed by Charles Baudelaire. Trans. and ed. by Jonathan Mayne. New York: Phaidon, 1965.

Bazin 1987–97
Bazin, Germain. *Théodore Géricault: Étude critique, documents et catalogue raisonné.* 7 vols. Paris: Bibliothèque des arts; Paris: Wildenstein Institute, 1987–97.

Besançon 2000
Musée des Beaux-Arts et d'Archéologie de Besançon. *Gustave Courbet et la Franche-Comté.* Exh. cat. Paris: Somogy; Besançon: Musée des Beaux-Arts et d'Archéologie, 2000.

Blanc 1870
Blanc, Charles. *Ingres: Sa vie et ses ouvrages.* Paris: Vve. J. Renouard, 1870.

Blanc 1876
Blanc, Charles. *Les artistes de mon temps.* Paris: Firmin-Didot, 1876.

Bordeaux 1974
Galerie des Beaux-Arts, Bordeaux. *Naissance de l'impressionnisme, 1874.* Exh. cat. Bordeaux: Galerie des Beaux-Arts, 1974.

Borel 1922
Borel, Pierre. *Le Roman de Gustave Courbet.* 2nd ed. Paris: E. Sansot, 1922.

Borel 1942
Borel, Pierre. "Un mécène romantique au XIXe siècle: Alfred Bruyas." *Pro Arte*, no. 6 (Oct. 1942): 9–12.

Borel 1951
Borel, Pierre, ed. *Lettres de Gustave Courbet à Alfred Bruyas.* Geneva: Pierre Cailler, 1951.

Boston 1984
Murphy, Alexandra R. *Jean-François Millet.* Exh. cat. Boston: Museum of Fine Arts, 1984.

Boston 1989
Tucker, Paul. *Monet in the 90s: The Series Paintings.* Exh. cat. Boston: Museum of Fine Arts, 1989.

Bowness 1972
Bowness, Alan. *Courbet's "L'atelier du peintre"*. Newcastle: University of Newcastle upon Tyne, 1972.

Bowness 1977
Bowness, Alan. "Baudelaire and Courbet." *Gazette des beaux-arts* 90 (December 1977): 189–99.

Brooklyn 1988
Faunce, Sarah, and Linda Nochlin. *Courbet Reconsidered*. Exh. cat. Brooklyn, N.Y.: The Brooklyn Museum; New Haven: Yale University Press, 1988.

Brown, Kelch, and van Thiel 1991
Brown, Christopher, Jan Kelch, and Pieter van Thiel. *Rembrandt: The Master and His Workshop*. New Haven and London: Yale University Press, 1991.

Bruyas 1851
Catalogue des tableaux, portraits, dessins, esquisses, études, peints d'après nature, par les principaux artistes modernes, composant le salon de peinture de M. Alfred Bruyas, de Montpellier. Montpellier: Imprimerie Boehm, 1851.

Bruyas 1852
Bruyas, Alfred. *Salons de peinture de M. Alfred Bruyas*. Montpellier: Imprimerie Boehm, 1852.

Bruyas 1853
Bruyas, Alfred. *Salons de peinture de M. Alfred Bruyas*. Paris: Plon Frères, 1853.

Bruyas 1854
Bruyas, Alfred. *Explication des ouvrages de peinture du cabinet de M. Alfred Bruyas*. Paris: Plon Frères, 1854.

Bruyas 1876
Bruyas, Alfred. *La galerie Bruyas*. Intro. by Théophile Silvestre. Paris: J. Claye, 1876.

Burty 1869
Burty, Philippe. *Paul Huet: Notice biographique et critique*. Paris: J. Claye, 1869.

Burty 1883
Burty, Philippe. "Eugène Delacroix à Alger." *L'Art* 32 (1883): 76–79, 94–98.

Büttner 1980
Büttner, Frank. *Peter Cornelius: Fresken und Freskenprojekte*. Wiesbaden: Steiner, 1980.

Büttner 1993
Büttner, Frank. "Unzeitgemässe Grosse: Die Fresken von Peter Cornelius in der Münchner Ludwigskirche und zeitgenössische Kritik." *Das Münster* 46 (1993): 293–304.

Cachin 2000
Cachin, Françoise. *Signac: Catalogue raisonné de l'oeuvre peint*. Paris: Gallimard, 2000.

Callen 1980
Callen, Anthea. *Courbet*. London: Jupiter Books, 1980.

Champion 1998
Champion, Jean-Loup, ed. *Mille sculptures des musées de France*. Paris: Gallimard, 1998.

Chang 1996a
Chang, Ting. "Alfred Bruyas: The Mythology and Practice of Art Collecting and Patronage in Nineteenth-Century France." D. Phil. thesis, University of Sussex, 1996.

Chang 1996b
Chang, Ting. "*The Meeting*: Gustave Courbet and Alfred Bruyas." *Burlington Magazine* 138 (1996): 586–91.

Chang 1998
Chang, Ting. "Rewriting Courbet: Silvestre, Courbet, and the Bruyas Collection after the Paris Commune." *Oxford Art Journal* 21, no. 1 (1998): 105–20.

Chevillot 1995
Chevillot, Catherine, ed. *Peintures et sculptures du XIXe siècle: La collection du musée de Grenoble*. Paris: Réunion des Musées Nationaux, 1995.

Chicago 2001
Druick, Douglas W., and Peter Kort Zegers. *Van Gogh and Gauguin: The Studio of the South*. Exh. cat. Chicago: Art Institute of Chicago, 2001.

"Chronique" 1999
"La Chronique des arts: Principales acquisitions des musées en 1998, France." *Gazette des beaux-arts* 133 (Mar. 1999): 25.

Chu 1992
Chu, Petra ten-Doesschate, ed. and trans. *Letters of Gustave Courbet*. Chicago: University of Chicago Press, 1992.

Claparède 1962
Claparède, Jean. *Dessins de la collection Alfred Bruyas et autres dessins des XIXe et XXe siècles*. Paris: Éditions des Musées Nationaux, 1962.

Clark 1973a
Clark, T. J. *Image of the People: Gustave Courbet and the Second French Republic, 1848–1851*. Greenwich, Conn.: New York Graphic Society, 1973.

Clark 1973b
Clark, T. J. *The Absolute Bourgeois: Artists and Politics in France 1848–51*. London: Thames and Hudson, 1973.

Clément 1879
Clément, Charles. *Géricault: Étude biographique et critique, avec le catalogue raisonné de l'oeuvre du maître*. 3rd ed. Paris: Didier et Cie., 1879.

Clermont-Ferrand 1975
Musée Bargoin, Clermont-Ferrand. *Jules Laurens en Auvergne*. Exh. cat. Clermont-Ferrand: Musée Bargoin, 1975.

Clermont-Ferrand 2002
Musée d'art Roger-Quilliot, Clermont-Ferrand. *Jean-François Millet: Voyages en Auvergne et Bourbonnais, 1866–1868*. Exh. cat. Milan: Skira; Paris: Seuil, 2002.

Cleveland 1980
Weisberg, Gabriel P. *The Realist Tradition: French Painting and Drawing 1830–1900*. Exh. cat. Cleveland: Cleveland Museum of Art, in cooperation with Indiana University Press, 1980.

Columbia 1989
Museum of Art and Archaeology, University of Missouri-Columbia. *The Art of the July Monarchy: France 1830 to 1848*. Exh. cat. Columbia: University of Missouri Press, 1989.

Comte 1981
Philippe Comte. "*La naissance d'Henri IV* de Devéria." *Revue du Louvre* 31, no. 2 (1981): 137–41.

Courthion 1948–50
Courthion, Pierre, ed. *Courbet raconté par lui-même et par ses amis: Sa vie et ses oeuvres*. 2 vols. Geneva: P. Cailler, 1948–50.

Daguerre de Hureaux 1993
Daguerre de Hureaux, Alain. *Delacroix*. Paris: Hazan, 1993.

Delacroix 1960
Delacroix, Eugène. *Journal de Eugène Delacroix*. Foreword by Jean-Louis Vaudoyer, introduction and notes by André Joubin. 3 vols. Paris, 1932. Reprint, Paris: Plon, 1960.

De Tolnay 1962
De Tolnay, Charles. "Michel-Ange dans son atelier par Delacroix." *Gazette des beaux-arts* 59 (1962): 43–52.

Dieppe 1966
Château Musée de Dieppe. *Eugène Isabey, 1803–1886*. Exh. cat. Dieppe: Le Musée, 1966.

Dijon 1970
Musée des Beaux-Arts de Dijon. *Louis Boulanger: Peintre-graveur de l'époque romantique, 1806–1867*. Exh. cat. Dijon: Musée des Beaux-Arts, 1970.

Dijon 1982
Musée des Beaux-Arts de Dijon. *La peinture dans la peinture*. Exh. cat. Dijon: Musée des Beaux-Arts de Dijon, [1982].

Dorival 1946
Dorival, Bernard. "A propos de Courbet, Delacroix et Géricault." *Les nouvelles littéraires* (21 Nov. 1946): 8.

Doucet MS 214
Institut national d'histoire de l'art, Bibliothèque d'art et d'archéologie Jacques Doucet, Paris. MS 214, Galérie Bruyas, acquisitions et catalogue, 1850–76.

Doucet MS 215
Institut national d'histoire de l'art, Bibliothèque d'art et d'archéologie Jacques Doucet, Paris. MS 215, Théophile Silvestre, correspondance avec A. Bruyas, 1854–75.

Doucet MS 216
Institut national d'histoire de l'art, Bibliothèque d'art et d'archéologie Jacques Doucet, Paris. MS 216, Correspondance d'artistes avec Alfred Bruyas, 1847–75.

Driskell 1986
Driskell, Michael Paul. "'To be of one's own time': Modernization, Secularism, and the Art of Two Embattled Academicians." *Arts Magazine* 61 (Dec. 1986): 80–89.

Edinburgh 1986
National Galleries of Scotland, Edinburgh. *Lighting Up the Landscape: French Impressionism and Its Origins*. Exh. cat. Edinburgh: National Galleries of Scotland, 1986.

Edinburgh 2000
Morris, Edward, ed. *Constable's Clouds: Paintings and Cloud Studies by John Constable*. Exh. cat. Edinburgh: National Galleries of Scotland, 2000.

Eitner 1955
Eitner, Lorenz. "The Open Window and the Storm-Tossed Boat: An Essay in the Iconography of Romanticism." *Art Bulletin* 37, no. 4 (1955): 281–90.

Eitner 1972
Eitner, Lorenz. *Géricault's "Raft of the Medusa."* London: Phaidon, 1972.

Eitner 1983
Eitner, Lorenz. *Géricault: His Life and Work*. London: Orbis, 1983.

Eitner 2000
Eitner, Lorenz. *French Paintings of the Nineteenth Century, Part I: Before Impressionism*. Washington, D.C.: National Gallery of Art, 2000.

Espezel 1939
Espezel, Pierre d'. "Le mouvement artistique." *Revue de Paris*, 15 Apr. 1939.

Farwell 1972
Farwell, Beatrice. "Courbet's *Baigneuses* and the Rhetorical Feminine Image." In *Woman as Sex Object: Studies in Erotic Art, 1730–1970*, ed. Thomas Hess and Linda Nochlin. New York: Newsweek, 1972.

Fernier 1977
Fernier, Robert. *La vie et l'oeuvre de Gustave Courbet: Catalogue raisonné*. 2 vols. Geneva: Fondation Wildenstein; Lausanne: Bibliothèque des arts, 1977–78.

Finlay 1979
Finlay, Nancy A. "Fourierist Art Criticism and the *Rêve de Bonheur* of Dominique Papety." *Art History* 2, no. 3 (Sept. 1979): 327–38.

Flandrin 1909
Flandrin, Louis. *Un peintre chrétien au XIXᵉ siècle: Hippolyte Flandrin*. Paris: Perrin et Cie., 1909.

Floetemeyer 1998
Floetemeyer, Robert. *Delacroix' Bild des Menschen: Erkundungen vor dem Hintergrund der Kunst des Rubens*. Mainz am Rhein: P. von Zabern, 1998.

Foucart 1987
Foucart, Bruno. *Le renouveau de la peinture religieuse en France (1800–1860)*. Paris: Arthéna, 1987.

Frankfurt 1987
Städtische Galerie im Städelschen Kunstinstitut Frankfurt am Main. *Eugène Delacroix: Themen und Variationen: Arbeiten auf Papier*. Exh. cat. Stuttgart: Verlag Gerd Hatje, 1992.

Frans 1982
Frans, Amelinckx. "Théophile Gautier et Marilhat." In *Théophile Gautier, l'art et l'artiste*. Actes du colloque international, Montpellier, vol. 1. Montpellier: Société Théophile Gautier, 1982.

Fried 1990
Fried, Michael. *Courbet's Realism*. Chicago and London: University of Chicago Press, 1990.

Fromentin 1909
Fromentin, Eugène. *Lettres de jeunesse, biographie et notes par Pierre Blanchon*. Paris: Plon-Nourrit, 1909.

Fromentin 1984
Fromentin, Eugène. *Un été dans le Sahara*. In *Oeuvres complètes*, ed. Guy Sagnes. Paris: Gallimard, 1984.

Gauguin 1923
Gauguin, Paul. *Avant et après*. Paris: G. Crès, 1923.

Gauguin 1950
Gauguin, Paul. *Lettres à Daniel de Monfried, précédées d'un hommage à Gauguin par Victor Segalen*. Ed. Mme Joly-Segalen. Paris: G. Falaize, 1950.

Gauthier 1925
Gauthier, Maximilien. *Achille et Eugène Devéria*. Paris: H. Floury, 1925.

Gautier 1856
Gautier, Théophile. *L'art moderne*. Paris: M. Lévy Frères, 1856.

Gautier 1994
Gautier, Théophile. *Critique d'art: Extraits des Salons (1833–1872)*. Ed. Marie-Hélène Girard. Paris: Séguier, 1994.

Gogh 1958
Gogh, Vincent van. *The Complete Letters of Vincent van Gogh*. 3 vols. London: Thames and Hudson, 1958.

Gould 1975
Gould, Cecil Hilton Monk. *Delaroche and Gautier: Gautier's Views on "The Execution of Lady Jane Grey" and on Other Compositions by Delaroche*. London: The National Gallery, 1975.

Grunchec 1983
Grunchec, Philippe. *Le Grand Prix de Peinture: Les concours des Prix de Rome de 1797 à 1863*. Paris: École nationale supérieure des beaux-arts, 1983.

Grunewald 1986
Grunewald, Marie-Antoinette. "Paul Chenavard et la donation Dufournet." *Revue du Louvre* 36, no. 1 (1986): 80–86.

Haddad 2000
Haddad, Michèle. "Baudelaire et Courbet, quelques précisions." *Bulletin des amis de Gustave Courbet*, no. 100 (2000): 19–35.

Haedeke 1980
Haedeke, Marion. *Alfred Bruyas: Kunstgeschichtliche Studie zum Maezenatentum im 19. Jahrhundert*. Frankfurt: Peter D. Lang, 1980.

Hamburg 1978
Hamburger Kunsthalle. *Courbet und Deutschland*. Exh. cat. Cologne: Du Mont, 1978.

Hauptman 1978
Hauptman, William. "Allusions and Illusions in Gleyre's *Le Soir*." *Art Bulletin* 60 (June 1978): 321–30.

Hempstead 1974
Emily Lowe Gallery. *Art Pompier, Anti-Impressionism: Nineteenth-Century Salon Painting*. Hempstead, N.Y.: The Gallery, 1974.

Herbert 1994
Herbert, Robert L. *Monet on the Normandy Coast: Tourism and Painting, 1867–1886*. New Haven: Yale University Press, 1994.

Herding 1991
Herding, Klaus. *Courbet: To Venture Independence*. Trans. John William Gabriel. New Haven: Yale University Press, 1991.

Hilaire 1995
Hilaire, Michel. *Le Musée Fabre*. Montpellier: Fondation Paribas, Réunion des Musées Nationaux, 1995.

Hilaire 1997
Hilaire, Michel. "Alfred Bruyas et Gustave Courbet: Le pacte d'un mécène et d'un artiste." *Dossier de l'art*, no. 39 (July 1997): 18–33.

Hoetink 1968
Hoetink, Hendrik Richard, comp. *Franse tekeningen uit de 19e eeuw. Catalogus van de verzameling in het Museum Boymans-van Beuningen*. Rotterdam: Het Museum, 1968.

Hofmann 1978
Hofmann, Werner. "Über die 'Schlafende Spinnerin.'" In *Realismus als Widerspruch: Die Wirklichkeit in Courbets Malerei*, ed. Klaus Herding. Frankfurt: Suhrkamp, 1978.

Hollstein 1983
[Hollstein, F. W. H.] *Hollstein's Dutch and Flemish Etchings, Engravings and Woodcuts, ca. 1450–1700*. Vol. 27, *Christoffel van Sichem I to Herman Specht*. Comp. Dieuwke de Hoop Scheffer and George S. Keys, ed. K. G. Boon. Amsterdam: Van Gendt, 1983.

Honour 1989
Honour, Hugh. *The Image of the Black in Western Art*. Vol. 4, *From the American Revolution to World War I*, part 2, *Black Models and White Myths*. Cambridge: Harvard University Press, 1989.

Huet 1911
Huet, René Paul, ed. *Paul Huet (1803–1869), d'après ses notes, sa correspondance, ses contemporains*. Paris: H. Laurens, 1911.

Hugo 1966
Hugo, Victor. *Les Orientales. Les Feuilles d'automne*. Ed. Pierre Albouy. Paris: Livre de Poche, 1966.

Isnard 1848
Isnard, Charles. "Les concours et les envois de Rome à l'École de Beaux-Arts." *L'Artiste* 44 (15 Oct. 1848): 60–61.

Jobert 1998
Jobert, Barthélémy. *Delacroix*. Princeton: Princeton University Press, 1998.

Johnson 1981–89
Johnson, Lee. *The Paintings of Eugène Delacroix: A Critical Catalogue*. 6 vols. Oxford: Clarendon Press, 1981–89.

Joubin 1926a
Joubin, André. *Catalogue des peintures et sculptures exposées dans les galeries du Musée Fabre*. Paris: Blondel la Rougerie, 1926.

Joubin 1926b
Joubin, André. "Les dix-sept portraits d'Alfred Bruyas, ou 'Chacun sa verité.'" *La Renaissance* 9 (Oct. 1926): 547–57.

Joubin 1936–38
Joubin, André, ed. *Correspondance générale d'Eugène Delacroix*. 5 vols. Paris: Plon, 1936–38.

Kühnholtz 1830
Kühnholtz, Henri. *Notice des dessins sous verre, tableaux, esquisses, recueils de dessins et d'estampes, réunis à la bibliothèque de la faculté de médecine de Montpellier*. Montpellier, 1830.

Lafont-Couturier 1998
Lafont-Couturier, Hélène. *Gérôme*. Paris: Herscher, 1998.

Lambert 1937
Lambert, Elie. *Delacroix et les Femmes d'Alger*. Paris: H. Laurens, 1937.

Laurens 1875
Laurens, Jules. *Album de la Galerie Bruyas (Musée de Montpellier), trente sujets choisis, lithographiés par Jules Laurens*. Paris, 1875.

Laurens 1901
Laurens, Jules. *La légende des ateliers: Fragments et notes d'un artiste-peintre (de 1842 à 1900)*. Carpentras: J. Brun, 1901.

Lausanne 1998
Musée Cantonal des Beaux-Arts, Lausanne. *Courbet: Artiste et promoteur de son oeuvre*. Exh. cat. Paris: Flammarion, 1998.

Lausanne 1999
Musée Cantonal des Beaux-Arts, Lausanne. *Le Sommeil, ou quand la raison s'absente*. Exh. cat. Lausanne: Musée Cantonal des Beaux-Arts, 1999.

Le Guen 1993
Le Guen, Murielle. "Octave Tassaert (1800–1874), peintre-lithographe: Biographie et catalogue raisonné de ses oeuvres." Doctoral thesis, Université Paris IV–Sorbonne, 1993.

Le Guen 1998
Le Guen, Murielle. "Octave Tassaert (1800–1874), peintre des larmes et de la bonne fortune." *Bulletin de la Société de l'Histoire de l'Art français* (1998): 273–86.

Le Moël 1994
Le Moël, Michel, and Raymond Saint-Paul, eds. *Le Conservatoire national des arts et métiers au coeur de Paris, 1794–1994*. Paris: Conservatoire national des arts et métiers: Délégation à l'action artistique de la ville de Paris, 1994.

Léotoing 1979
Léotoing, Gérard de. "La collection Bruyas au Musée de Montpellier." Thesis, École du Louvre, 1979.

Lichtenstein 1979
Lichtenstein, Sara. *Delacroix and Raphael*. New York: Garland, 1979.

London 1959
Tate Gallery and Arts Council Gallery, London. *The Romantic Movement*. Exh. cat. London: Arts Council of Great Britain, 1959.

London 1984
Royal Academy of Arts, London. *The Orientalists, Delacroix to Matisse: European Painters in North Africa and the Near East*. Exh. cat. London: Royal Academy of Arts, in association with Weidenfeld and Nicolson, 1984.

London 1995
Hayward Gallery, London. *Landscapes of France: Impressionism and Its Rivals*. Exh. cat. London: Hayward Gallery, 1995.

London 1997
Duffy, Stephen. *Paul Delaroche, 1797–1856: Paintings in the Wallace Collection*. Exh. cat. London: Trustees of the Wallace Collection, 1997.

London 2003
Tate Modern, London. *Crossing the Channel: British and French Painting in the Age of Romanticism*. Exh. cat. London: Tate Publishing, 2003.

Louisville 1971
J. B. Speed Art Museum, Louisville, Ky. *Nineteenth Century French Sculpture: Monuments for the Middle Class*. Exh. cat. Louisville, Ky.: The Museum, 1971.

Lugt
Lugt, Frits. *Les marques de collections de dessins et d'estampes. . .* Amsterdam: Vereeinigde Drukkerijen, 1921.

Lutterotti 1985
Lutterotti, Otto R. von. *Joseph Anton Koch, 1768–1839: Leben und Werk, mit einem vollständigen Werkverzeichnis*. Vienna: Herold, 1985.

Lyon 2000
Musée des Beaux-Arts, Lyon. *Paul Chenavard, 1807–1895: Le peintre et le prophète*. Exh. cat. Paris: Réunion des Musées Nationaux, 2000.

Lyon 2002
Musée des Beaux-Arts, Lyon. *L'école de Barbizon: Peindre en plein air avant l'impressionnisme*. Exh. cat. Lyon: Musée des Beaux-Arts, 2002.

Mainardi 1999
Mainardi, Patricia. "Copies, Variations, Replicas: Nineteenth Century Studio Practice." *Visual Resources* 15, no. 2 (1999): 123–47.

Mainardi 2000
Mainardi, Patricia. "Mazeppa." *Word and Image* 16, no. 4 (Oct.–Dec. 2000): 335–51.

Marie 1925
Marie, Aristide. *Le peintre poete Louis Boulanger*. Paris: H. Floury, 1925.

Marie 1984
Marie, Isabelle. "Intérieur du Cabinet de M. Bruyas, August Glaize, 1848." Mémoire de maîtrise, Université Paul Valéry, Montpellier III, 1984.

McPherson 1996
McPherson, Heather. "Courbet and Baudelaire: Portraiture Against the Grain of Photography." *Gazette des beaux-arts* 128 (Nov. 1996): 223–36.

McPherson 2001
McPherson, Heather. *The Modern Portrait in Nineteenth-Century France*. Cambridge: Cambridge University Press, 2001.

Merlhès 1984
Merlhès, Victor. *Correspondance de Paul Gauguin*. Paris: Fondation Singer-Polignac, 1984.

Michel 1879
Michel, Ernest. *Catalogue des peintures et sculptures exposées dans les galéries du Musée Fabre de la ville de Montpellier*. 8th ed. Montpellier: Imprimerie typographique de Jean Martel aîné, 1879.

Miquel 1962
Miquel, Pierre. *Paul Huet: De l'aube romantique à l'aube impressionniste*. Sceaux: Éditions de la Martinelle, 1962.

Miquel 1980
Miquel, Pierre. *Eugène Isabey, 1803–1886: La marine au XIXe siècle*. 2 vols. Maurs-la-Jolie: Martinelle, 1980.

Montauban 2000
Georges Vigne. *Le peintre aux ciseaux d'acier*. Exh. cat. Montauban: Musée Ingres, 2000.

Montpellier 1849
Société des amis des arts, Montpellier. *Ouvrages de peinture, sculpture, dessin et lithographie*. Exh. cat. Montpellier: Société des amis des arts, 1849.

Montpellier 1860
Notice des ouvrages de peinture, de dessin, d'architecture, de sculpture et des autres objets d'art anciens et modernes exposés au salon de Montpellier. Exh. cat. Montpellier, 1860.

Montpellier 1977
Musée Fabre, Montpellier. *Le roman d'un collectionneur: Alfred Bruyas, 1821–1877*. Exh. cat. Montpellier: Le Musée, 1977.

Montpellier 1979
Musée Fabre, Montpellier. *Le portrait à travers les collections du Musée Fabre, XVII, XVIII, XIX siècles*. Exh. cat. Montpellier: Le Musée, 1979.

Montpellier 1980
Musée Fabre, Montpellier. *De Raphael à Matisse: 100 dessins du Musée Fabre*. Exh. cat. Montpellier: Le Musée, 1980.

Montpellier 1985
Musée Fabre, Montpellier. *Courbet à Montpellier.*
Exh. cat. Montpellier: Le Musée, 1985.

Montpellier 1989
Musée Fabre, Montpellier. *Dessins d'Alexandre Cabanel, 1823–1889.* Exh. cat. Montpellier: Le Musée, 1989.

Montpellier 1996
Musée Fabre, Montpellier. *De la nature: Paysages de Poussin à Courbet dans les collections du Musée Fabre.* Exh. cat. Montpellier: Le Musée; Paris, Réunion des Musées Nationaux, 1996.

Montpellier MS 365
Bibliothèque municipale, Montpellier. MS 365, Lettres de Théophile Silvestre et de sa veuve Céline Silvestre à Alfred Bruyas.

Montpellier MS 405
Bibliothèque municipale, Montpellier. MS 405, Lettres de Jules Laurens à Bruyas, de 1849 à 1876.

Mosby 1977
Mosby, Dewey F. *Alexandre Gabriel Decamps, 1803–1860.* New York: Garland, 1977.

Munich 1996
Haus der Kunst, Munich. *Corot, Courbet, und die Maler von Barbizon.* Munich: Haus der Kunst München, 1996.

Nagano 2001
Mercian Karuizawa Art Museum, Nagano, Japan. *Le chemin de Millet: Autour des collections du Musée Thomas Henry, Cherbourg.* Exh. cat. Tokyo: RMN Japon, 2001.

Nantes 1995
Musée des Beaux-Arts, Nantes. *Les années romantiques: La peinture française de 1815 à 1850.* Exh. cat. Paris: Réunion des Musées Nationaux, 1995.

Nantes 1999
Musée des Beaux-Arts, Nantes. *Paul Delaroche: Un peintre dans l'histoire.* Exh. cat. Paris: Réunion des Musées Nationaux, 1999.

Narbonne 1999
Lepage, Jean. *Le bon vent et le vent mauvais: Les souffles d'Éole dans les collections publiques françaises.* Exh. cat. Narbonne: Musée d'art et d'histoire, 1999.

New York 1999
Tinterow, Gary, and Philip Conisbee, eds. *Portraits by Ingres: Image of an Epoch.* Exh. cat. New York: Metropolitan Museum of Art, 1999.

Nochlin 1966
Nochlin, Linda. *Realism and Tradition in Art, 1848–1900: Sources and Documents.* Englewood Cliffs, N.J.: Prentice-Hall, 1966.

Nochlin 1967
Nochlin, Linda. "Gustave Courbet's *Meeting*: A Portrait of the Artist as a Wandering Jew." *Art Bulletin* 49 (Sept. 1967): 209–22.

Nochlin 1982
Nochlin, Linda. "The Depoliticization of Gustave Courbet: Transformation and Rehabilitation Under the Third Republic." *October*, no. 22 (Fall 1982): 65–78.

Nochlin 1994
Nochlin, Linda. *The Body in Pieces: The Fragment as a Metaphor of Modernity.* New York: Thames and Hudson, 1994.

Nogaret 1860
Nogaret, Xavier. "Exposition de Montpellier." *Gazette des beaux-arts*, no. 6 (June 1860): 302–9.

Ockman 1991
Ockman, Carol. "'Two Large Eyebrows à l'orientale': Ethnic Stereotyping in Ingres's *Baronne de Rothschild*." *Art History* 14 (Dec. 1991): 521–39.

Olivier 1852
Olivier, Georges. "Le Salon de Montpellier II." Series of articles in *Le messager du midi*, 26 Apr.–10 May 1852.

Ornans 2002
Musée Courbet, Ornans. *Courbet/Hugo: Les peintres et les littérateurs.* Exh. cat. Ornans: Musée Courbet, 2002.

Panofka 1834
Panofka, Theodor. *Antiques du cabinet de M. le comte de Pourtalès-Gorgier.* Paris: F. Didot, 1834.

Paris 1815
Notice des tableaux des écoles primitives de l'Italie, de l'Allemagne, et de plusiers autres tableaux de différents écoles, exposés dans le grand Salon du Musée Royal. Paris: Dubray, 1815.

Paris 1855a
Avenue Montaigne, Paris. *Exhibition et vente de 40 tableaux et 4 dessins de M. Gustave Courbet.* Paris: Impr. S. Raçon, 1855.

Paris 1855b
Palais des Beaux-Arts, Paris. *Exposition universelle.* Paris, 1855.

Paris 1864
Société nationale des beaux-arts, Paris. *Exposition des oeuvres d'Eugène Delacroix.* Paris: Impr. de J. Claye, 1864.

Paris 1867a
École nationale supérieure des beaux-arts, Paris. *Catalogue des tableaux, études peintes, dessins et croquis de J. A. D. Ingres.* Paris, 1867.

Paris 1867b:
Exposition des oeuvres de M. G. Courbet: Rond-Point du Pont de l'Alma. Paris: Lebigre-Duquesne Frères, 1867.

Paris 1889
Exposition universelle de 1889: Exposition centennale. Paris, 1889.

Paris 1900
Exposition universelle internationale de 1900: Exposition centennale de l'art français de 1800 à 1889. Paris, 1900.

Paris 1930
Musée du Louvre, Paris. *Exposition Eugène Delacroix: Peintures, aquarelles, pastels, dessins, gravures, documents.* Exh cat. Paris: Musées Nationaux, 1930.

Paris 1939
Musée de l'Orangerie, Paris. *Les Chefs-d'oeuvre du Musée de Montpellier.* Exh. cat. Paris: Musée de l'Orangerie, 1939.

Paris 1956
Musée du Louvre, Paris. *Barye: Sculptures, peintures et aquarelles des collections publiques françaises.* Exh. cat. Paris: Éditions des Musées Nationaux, 1956.

Paris 1963a
Musée du Louvre, Paris. *Centenaire d'Eugène Delacroix, 1798–1863.* Exh. cat. Paris: Ministère d'État, Affaires culturelles, 1963.

Paris 1963b
Ministère des affaires culturelles. *Le rôle du dessin dans l'oeuvre de Delacroix.* Exh. cat. Paris: Éditions des Musées Nationaux, Ministère des affaires culturelles, 1963.

Paris 1967
Musée du Louvre, Paris. *Théodore Rousseau, 1812–1867.* Exh. cat. Paris: Réunion des Musées Nationaux, Ministère d'État, Affaires culturelles, 1967.

Paris 1973
Musée du Louvre, Paris. *Les autoportraits de Courbet.* Exh. cat. Paris: Éditions des Musées Nationaux, 1973.

Paris 1974–75
Galeries Nationales du Grand Palais, Paris. *De David à Delacroix: La peinture française de 1774 à 1830.* Exh. cat. Paris: Secrétariat d'État à la culture, Éditions des Musées Nationaux, 1974.

Paris 1975
Galeries Nationales du Grand Palais, Paris. *Jean-François Millet.* Exh. cat. Paris: Éditions des Musées Nationaux, 1975.

Paris 1977
Galeries Nationales du Grand Palais, Paris. *Gustave Courbet, 1819–1877.* Exh. cat. Paris: Éditions des Musées Nationaux, 1977.

Paris 1980
Galeries Nationales du Grand Palais, Paris. *Hier pour demain: Arts, traditions et patrimoine.* Exh. cat. Paris: Éditions de Réunion des Musées Nationaux, 1980.

Paris 1984
Foucart, Jacques, et al. *Hippolyte, Auguste et Paul Flandrin: Une fraternité picturale au XIXe siècle.* Exh. cat. Paris: Éditions de la Réunion des Musées Nationaux, 1984.

Paris 1991a
Galeries Nationales du Grand Palais, Paris. *Géricault.* Exh. cat. Paris: Réunion des Musées Nationaux, 1991.

Paris 1991b
Musée d'Orsay, Paris. *Les Vaudoyer: Une dynastie d'architectes.* Exh. cat. Paris: Réunion des Musées Nationaux, 1991.

Paris 1993a
Sérullaz, Arlette. *Delacroix et la Normandie.* Paris: Musée national Eugène Delacroix, 1993.

Paris 1993b:
Pichois, Claude, and Jean-Paul Avice. *Baudelaire-Paris.* Paris: Éditions Paris-Musées, 1993.

Paris 1994a
Institut du Monde Arabe, Paris. *Delacroix in Morocco.* Trans. Tamara Blondel. Exh. cat. Paris: Flammarion, 1994.

Paris 1994b
Musée d'Orsay, Paris. *La jeunesse des musées: Le Musée en France au XIXe siècle.* Exh. cat. Paris: Éditions de la Réunion des Musées Nationaux, 1994.

Paris 1996a
Galeries Nationales du Grand Palais, Paris. *Corot.* Exh. cat. Paris: Réunion des Musées Nationaux, 1996.

Paris 1996b
Musée du Louvre, Paris. *La Griffe et la dent: Antoine Louis Barye (1795–1875), sculpteur animalier.* Paris: Réunion des Musées Nationaux, 1996.

Paris 1997
Musée d'Orsay, Paris. *Théophile Gautier, la critique en liberté.* Exh. cat. Paris: Réunion des Musées Nationaux, 1997.

Paris 1998
Galeries Nationales du Grand Palais, Paris. *Delacroix: Les dernières années.* Exh. cat. Paris: Réunion des Musées Nationaux, 1998.

Paris 2000a
Musée d'Orsay, Paris. *Courbet et la Commune.* Exh. cat. Paris: Réunion des Musées Nationaux, 2000.

Paris 2000b
Galeries Nationales du Grand Palais, Paris. *Méditerranée, de Courbet à Matisse.* Exh. cat. Paris: Réunion des Musées Nationaux, 2000.

Paris 2002
Institut du Monde Arabe, Paris. *Chevaux et cavaliers arabes dans les arts d'Orient et d'Occident.* Exh. cat. Paris: Institut du Monde Arabe; Gallimard, 2002.

Paris 2003
Institut du Monde Arabe, Paris. *De Delacroix à Renoir: L'Algérie des peintres.* Exh. cat. Paris: Hazan; Institut du Monde Arabe, 2003.

Parsons and McWilliam 1983
Parsons, Christopher, and Neil McWilliam. "'Le Paysan de Paris': Alfred Sensier and the Myth of Rural France." *Oxford Art Journal* 2 (1983): 38–58.

Peltre 1995
Peltre, Christine. *L'atelier du voyage: Les peintres en Orient au XIXe siècle.* Paris: Le Promeneur, 1995.

Piron 1865
Piron, E. A. *Eugène Delacroix, sa vie et ses oeuvres.* Paris: J. Claye, 1865.

Poletti and Richarme 2000
Poletti, Michel, and Alain Richarme. *Barye: Catalogue raisonné des sculptures.* Paris: Gallimard, 2000.

Pommier 1986
Pommier, Edouard. "Naissance des musées de province." In *Les lieux de mémoire,* ed. Pierre Nora. Vol. 2. Paris: Gallimard 1986.

Prost 1886
Prost, Bernard. *Octave Tassaert: Notice sur sa vie et catalogue de son oeuvre.* Paris: L. Baschet, 1886.

Prouté and Bidon 1977
Prouté, Paul, and Colette E. Bidon. "Louis Hector Allemand, peintre-graveur lyonnais (1809–1886)." *Nouvelle de l'estampe,* no. 33 (May–June 1977): 5–22.

Reiset and Villot 1859
Reiset, F., and F. Villot. *Collection des dessins originaux de grands maîtres, gravé en fac-simile par Alphonse Leroy.* Paris: A. Leroy, 1859.

Robaut 1885
Robaut, Alfred. *L'oeuvre complet de Eugène Delacroix: Peintures, dessins, gravures, lithographies.* Paris: Charavay, 1885.

Robaut 1905
Robaut, Alfred. *L'oeuvre de Corot: Catalogue raisonné et illustré.* Paris: H. Floury, 1905; reprinted Paris: L. Laget, 1965–66.

Robinson and Nygren 1988
Robinson, Lilien F., and Edward J. Nygren. *Antoine-Louis Barye: The Corcoran Collection.* Washington, D.C.: The Corcoran, 1988.

Rome 2003
Accademia di Francia, Rome. *Maestà di Roma, da Napoleone all'unità d'Italia: d'Ingres à Degas, les artistes français à Rome*. Rome: Electa, 2003.

Rouen 1963
Musée des Beaux-Arts, Rouen. *Géricault, un réaliste romantique.* Exh. cat. Rouen: Musée des Beaux-Arts, 1963.

Rouen 1978
Musée des Beaux-Arts, Rouen. *Mazeppa.* Exh. cat. Rouen: Le Musée, 1978.

Rouen 1998
Musée des Beaux-Arts, Rouen. *Delacroix: La naissance d'un nouveau romantisme.* Exh. cat. Rouen: Musée des Beaux-Arts; Paris: Réunion des Musées Nationaux, 1998.

Rouen 1999
Musée des Beaux-Arts, Rouen. *Autour de Claude-Joseph Vernet: La marine à voile de 1650 à 1890.* Exh. cat. Arcueil: Anthèse; Rouen: Musée des Beaux-Arts, 1999.

Rubin 1980
Rubin, James Henry. *Realism and Social Vision in Courbet and Proudhon.* Princeton: Princeton University Press, 1980.

San Francisco 1962
Herbert, Robert L. *Barbizon Revisited.* Exh. cat. [San Francisco: California Palace of the Legion of Honor]; New York: Clarke and Way, 1962.

Schulman 1997
Schulman, Michel. *Théodore Rousseau, 1812–1867: Catalogue raisonné de l'oeuvre graphique.* Paris: Éditions de l'amateur, 1997.

Schulman 1999
Schulman, Michel. *Théodore Rousseau, 1812–1867: Catalogue raisonné de l'oeuvre peint.* Paris: Éditions de l'amateur, 1999.

Sensier 1873
Sensier, Alfred. *Étude sur Georges Michel.* Paris: A. Lemerre, 1873.

Sensier 1881
Sensier, Alfred. *La vie et l'oeuvre de J.-F. Millet.* Paris: A. Quantin, 1881.

Seoul 2002
Seoul Museum of Art. *Le chemin de Millet, 1814–1875.* Exh. cat. Seoul: Seoul Museum of Art, 2002.

Sérullaz 1963
Sérullaz, Maurice, ed. *Mémorial de l'exposition Eugène Delacroix organisée au Musée du Louvre à l'occasion du centenaire de la mort de l'artiste.* Paris: Éditions des Musées Nationaux, 1963.

Sérullaz 1984
Sérullaz, Maurice. *Dessins d'Eugène Delacroix, 1798–1863.* 2 vols. Musée du Louvre, Cabinet des dessins, Inventaire général des dessins, École française. Paris: Ministère de la culture, Éditions de la Réunion des Musées Nationaux, 1984.

Sérullaz and Bonnefoy 1993
Sérullaz, Arlette, and Yves Bonnefoy. *Delacroix & Hamlet.* Paris: Éditions de la Réunion des Musées Nationaux, 1993.

Seville 1992
Cartuja de Santa Maria de las Cuevas, Seville. *Paisaje mediterraneo.* Exh. cat. Milan: Electa, 1992.

Sheon 1981a
Sheon, Aaron. "Courbet, French Realism, and the Discovery of the Unconscious." *Arts Magazine* 55, no. 5 (Feb. 1981): 114–28.

Sheon 1981b
Sheon, Aaron. "Octave Tassaert's 'Le Suicide': Early Realism and the Plight of Women." *Arts Magazine* 55, no. 9 (May 1981): 142–51.

Sherman 1989
Sherman, Daniel. *Worthy Monuments: Art Museums and the Politics of Culture in Nineteenth-Century France.* Cambridge: Harvard University Press, 1989.

Silvestre 1856
Silvestre, Théophile. *Histoire des artistes vivants, français et étrangers: Études d'après nature.* Paris: E. Blanchard, 1856.

Silvestre 1874
Silvestre, Théophile. "Salon de 1874." *Le Pays* (8, 12, 20, 27 May, 2 June, 1 July 1874).

Silvestre 1926
Silvestre, Théophile. *Les artistes français* [1856]. Paris: Bibliothèque Dionysienne; G. Crès et Cie., 1926.

Sloane 1962
Sloane, Joseph C. *Paul Marc Chenavard: Artist of 1848.* Chapel Hill: University of North Carolina Press, 1962.

Snell 1982
Snell, Robert. *Théophile Gautier: A Romantic Critic of the Visual Arts.* Oxford: Clarendon Press, 1982.

Société 1850
Société des amis des arts, Montpellier. *Statuts de la Société des amis des arts de Montpellier.* 1850. Archives municipales de Montpellier, dossier 2R/7.

Spector 1984
Spector, Jack J. "Towards a Deeper Understanding of Delacroix and His Art: An Interpretation of *Michelangelo in His Studio.*" *Gazette des beaux-arts,* no. 103 (Jan. 1984): 19–28.

Strasbourg 1983
Musée d'art moderne, Strasbourg. *Gustave Doré, 1832–1883.* Exh. cat. Strasbourg: Musée d'art moderne, 1983.

Taft 1995
The Taft Museum: Its History and Collections. 2 vols. New York: Hudson Hills Press, 1995.

Thomas 1845
Thomas, Eugène, ed. *Annuaire adminstratif, historique, statistique et commercial du departement de l'Hérault pour l'an 1845.* Montpellier, 1845.

Thomas 1857
Thomas, Eugène. *Montpellier, tableaux historique et descriptif.* Montpellier, 1857.

Thomas 2000
Thomas, Greg M. *Art and Ecology in Nineteenth-Century France: The Landscapes of Théodore Rousseau.* Princeton: Princeton University Press, 2000.

Thompson and Wright 1987
Thompson, James, and Barbara Wright. *La vie et l'oeuvre d'Eugène Fromentin.* Courbevoie: ACR, 1987.

Tinterow 1991
Tinterow, Gary. "Géricault's Heroic Landscapes." *The Metropolitan Museum of Art Bulletin* 48, no. 3 (winter 1990–91): 4–67.

Tochigi 2002
Tochigi Prefectural Museum. *Gustave Courbet*. Exh. cat. Tochigi: Tochigi Prefectural Museum, 2002.

Tokyo 1982a
Galerie Tobu, Tokyo. *Millet, Corot, Courbet: École de Barbizon*. Exh. cat. Tokyo: Galerie Tobu, 1982.

Tokyo 1982b
National Museum of Western Art, Tokyo. *L'Angélus de Millet: Tendances du réalisme en France, 1848–1870*. Exh. cat. Tokyo: Yomiuri Shimbun, 1982.

Tokyo 1989
Odakyu Grand Gallery, Shinjuku, Tokyo. *J.-B. Camille Corot*. Exh. cat. Tokyo: Art Life, Ltd., 1989.

Tokyo 2002
Murauchi Art Museum, Tokyo. *The Courbet Exhibition: A Painter with Hunter's Eye*. Exh. cat. Tokyo: Murauchi Art Musem, 2002.

Toulon 1992
Musée de Toulon. *La paysage provençal et l'école de Marseille, 1845–1874: Avant l'impressionnisme*. Exh. cat. Toulon: Musée de Toulon; Paris: Réunion des Musées Nationaux, 1992.

Toulouse 1865
Ancien couvent des Jacobins, Toulouse. *Exposition des produits des beaux-arts et de l'industrie à Toulouse*. Exh. cat. Toulouse, 1865.

Toulouse 1991
Musée Paul Dupuy, Toulouse. *Eugène Delacroix: Ses collaborateurs et ses élèves Toulousains*. Exh. cat. Toulouse: Le Musée, 1992.

Trento 1993
Museo d'arte moderna e contemporanea di Trento e Rovereto. *Romanticismo: Il nuovo sentimento della natura*. Exh. cat. Milan: Electa, 1993.

Treviso 2000
Casa dei Carraresi, Treviso. *La nascita dell'impressionismo*. Exh. cat. Conegliano: Linea d'ombra libri, 2000.

Valmy-Baysse 1930
Valmy-Baysse, Jean. *Gustave Doré*. 2 vols. Paris: Éditions M. Seheur, 1930.

Vesoul 1981
Musée de Vesoul. *Jean-Léon Gérôme, 1824–1904*. Exh. cat. Vesoul: La Ville de Vesoul, 1981.

Vigne 1995a
Vigne, Georges. *Ingres*. Trans. by John Goodman. New York: Abbeville Press, 1995.

Vigne 1995b
Vigne, Georges. *Dessins d'Ingres: Catalogue raisonné des dessins du musée Montauban*. Paris: Gallimard; Réunion des Musées Nationaux, 1995.

Walter 1973
Walter, Rodolphe. "Un dossier délicat: Courbet et la Colonne Vendôme." *Gazette des beaux-arts* 81 (Mar. 1973): 173–84.

Washington 1984
Grunchec, Philippe. *The Grand Prix de Rome: Paintings from the École des Beaux-Arts, 1797–1863*. Exh. cat. Washington, D.C.: International Exhibitions Foundation, 1984.

Weisberg 1979
Weisberg, Gabriel P. *Bonvin*. Paris: Éditions Geoffroy-Dechaume, 1979.

Wildenstein 1954
Wildenstein, Georges. *Ingres*. London: Phaidon, 1954.

Yeazell 2000
Yeazell, Ruth Bernard. *Harems of the Mind: Passages of Western Art and Literature*. New Haven: Yale University Press, 2000.

Yeide 1998
Yeide, Nancy. "Hector Brame: An Art Dealer in Nineteenth-Century Paris." *Apollo* 147 (Mar. 1998): 40–47.

Zieseniss 1954
Zieseniss, Charles Otto. *Les aquarelles de Barye: Étude critique et catalogue raisonné*. Paris: C. Massin, 1954.

Ziff 1977
Ziff, Norman D. *Paul Delaroche: A Study in Nineteenth-Century French History Painting*. New York: Garland Publishing, 1977.

Zola 1862
Zola, Émile. "Nos peintres du Champ de Mars." *La Situation*, 1 July 1862.

Zurich 1987
Kunsthaus Zurich. *Eugène Delacroix*. Exh. cat. Zurich: Das Kunsthaus, 1987.

Index

Under artists' names, works of art are listed at the end of each entry. Pages with illustrations are indicated in italics.

About, Edmond, 106, 112
Allemand, Louis-Hector, 60–63; *Causeries sur le paysage*, 60; *Landscape at Ain*, cat. 2, 61, 63; *Paysage: Vue du département de l'Ain*, 60; *A Riverbank*, cat. 3, 62, 63; *Twilight-Landscape*, 29, 63; *View of Grangeau, at Saint-Jact-sur-Loire*, cat. 1, 60, 63
Andrieu, Pierre, 29, 132n.1; *Apotheosis of Michelangelo*, after Delacroix, 145n.9; *Self-Portrait of Delacroix*, after Delacroix, 150n.14
Anthon, Berthe, 40, 242; painting of, by Verdier, 230
Antoine, Étienne d', 181n.7
Aubert, Augustin, 217

Balis, Arnout, 127
Balzac, Honoré, 45; *Illusions perdues*, 87
Barbizon school, 60, 200, 211, 222–24
Barye, Antoine-Louis, 24, 64–73, 206n.1, 227; and Bruyas, 64–67, 71–72, 206; Signac on, 57; *Algerian Lion*, 67, 69n.8; Asian and African elephants, 67, 69n.7; *Inkstand with an Owl*, cat. 8, 69, 206; *Jaguar Devouring an Agouti*, 67; *Jaguar Devouring a Crocodile*, 67; *Lion in the Desert*, cat. 10, 71; *Lion with a Serpent*, cat. 4, 64, 65, 67, 206, 242; *Lion with a Serpent* (Tuileries, Paris), 71; lion with a snake, watercolor (Baltimore), 71; rearing bulls, 67; *Seated Lion*, cat. 5, 64, 67, 206, 242; *Senegalese Lion*, 67, 69n.8; *Senegalese Lion and Python*, cat. 9, 70, 71, 242; —lithograph after, by Laurens, 71–72; *Theseus Battling the Centaur Biénor* (sketch), 67, 69n.13; *Theseus Battling the Minotaur*, cat. 6, 66, 67; *Tiger on the Watch*, cat. 11, 71–72, 73; *Turkish Horse*, cat. 7, 67, 68; *Turkish Horse*, 67; *Walking Lion*, bronze, 67, 72; walking lion, watercolors, 72, 72n.10; *Walking Tiger*, bronze, 67, 72; walking tiger, watercolors, 72, 72n.14
Barye, Louis-Antoine, 67, 69n.7, 72
Baudelaire, Charles, 30, 136, 170; and Courbet, 43, 100–101, 116; *Les Fleurs du mal*, 115; *Portrait of Baudelaire*, by Courbet, cat. 25, 30, 41, 56, 100, 101, 242; Salon reviews, 19, 94, 157
Baudry, Étienne, 39
Bazille, Frédéric, 26–27, 112
Bazille, Marc Antoine, 50
Benouville, Achille, 74, 85
Benouville, Léon, 74–76; and Bruyas, 18, 47, 50, 74; Prix de Rome awarded to, 1845, 18, 74, 83n.2, 85; *Christ in the Praetorium*, 74; *Esther*, 85, 87; *The Wrath of Achilles*, cat. 12, 26, 74, 75, 76, 83n.2, 85
Besnard, Albert, 57

Bimar, Auguste, 26, 179
Blanc, Charles, 68
Bonheur, Rosa, *The Horse Market*, 23
Bonington, Richard Parkes, 185; Signac on, 56
Bonvin, François, 38n.32, 76–78, 235; Signac on, 54, 56; *The Low Mass*, 76–78; *On the Pauper's Bench—Souvenir of Brittany*, cat. 13, 29, 76, 77, 78; —sketch for, 78
Bordes, Philippe, 230
Borel, Pierre, 33n.1
Bosio, François Joseph, 67
Boudin, Eugène, 187
Bouguereau, William-Adolphe, 93
Boulanger, Louis, 38n.32, 78–80; *Mazeppa*, cat. 14, 78, 79, 80; *Punishment of Mazeppa*, 78, 79, 80
Bowness, Alan, 100
Bracquemond, Félix, *Portrait of Baudelaire*, after Courbet, 100
Breton, Jules, 78
Bricogne, Henri, 179
Bruyas, Alfred: as collector, 17–31, 46–47, 53, 64, 67, 71, 74–76, 96, 106, 153, 180–81, 238; education of, 18; *Études sur l'art moderne. Solution. A. Bruyas*, 24, 110, 110n.5; as Knight of the Legion of Honor, 31; *Letters on the Exhibition of "The Meeting," Salon of 1855*, 25; as patron, 18–23, 47, 49, 52, 80–82, 85, 93, 96, 110, 113; portraits of: by Doumenjou, 242; by Glaize, 30, 31, 242; by Guillaume, 47, 122; by Matet, 17, 18–19; by Tassaert, 20, 39, 47, 113, 237n.4, 240, 242; by Verdier, 39, 110n.2 (see also Courbet, cats. 29 and 30; Couture, cat. 35; Delacroix, cats. 46 and 47; Glaize, cats. 63 and 64; and Marsal, cat. 76); Solution of, 34, 42, 108, 238; —with Courbet, 18, 23–26, 28, 30, 33–43, 49–50, 53, 105n.1, 108, 118, 123n.4, 150, 240, 242; *Solution d'artiste. Sa profession de foi*, 34, 110n.5; travels of: to Paris, 20–23, 26, 46–50, 96, 122, 147, 162, 209, 242; to Italy (1846), 18, 38n.32, 47, 74, 80, 85, 182, 198, 242; to Italy (1848), 19, 82, 89n.13, 122, 242; to Italy and Pyrenees (1849), 20, 242; see also Courbet, Gustave, and Bruyas; under individual artists, see and Bruyas
Bruyas, Jacques (father of Alfred), 20, 27–28, 40, 50, 179, 181, 242
Burty, Philippe, 132, 142

Cabanel, Alexandre, 34, 53, 80–93, 206; and Bruyas, 22, 26, 38n.32, 40, 47, 50, 55n.11, 74–76, 80, 89n.13, 108–9, 150, 242; in Bruyas collection, 18–19, 22, 50, 53, 80–82, 85, 93, 221; Prix de Rome awarded to, 18, 74, 80, 85, 90n.4, 93; Signac on, 54–55, 55n.11, 57; and Silvestre, 31; *Albaydé*, cat.

17, 18–19, 47, 82, 84, 85–89, 121n.3, 179, 242; *Angel of the Evening*, cat. 20, 19, 90, 91, 179; *The Fallen Angel*, 90; *La Chiaruccia*, cat. 18, 19, 47, 82, 85, 86, 87–89, 160, 179, 182n.3, 242; *Christ in the Garden of Olives*, 18, 157; *Mother of Alfred Bruyas*, cat. 16, 82, 83; "Nourmahal the Redhead," 18, 87; *Portrait of Alfred Bruyas*, cat. 15, 18, 22, 47, 55, 80, 81, 82, 122, 242; self-portrait, Villa Medici, 93; *Self-Portrait (Portrait de l'artiste par lui-même, à 29 ans)*, cat. 21, 92, 93; *A Thinker—Young Roman Monk*, cat. 19, 47, 82, 85, 88, 89–90, 179, 242
Callen, Anthea, 100
Castagnary, Jules-Antoine, 39
catalogues, Bruyas collection: 1851, 22–23, 48, 49, 60, 80–82, 122, 179, 182, 221, 232, 242; 1852, 35n.16, 82, 123n.2, 232, 242; 1853, 35n.16, 122, 232, 242; 1854, 34, 35, 48, 50, 110, 150, 181–82, 232, 240, 242; 1876, 26, 28, 30–31, 41–43, 52, 123, 242; —and Barye, 67, 71; —and Boulanger, 80; —and Cabanel, 90; —and Corot, 96; —and Courbet, 42–43, 108, 115, 118; —and Court, 121; —and Decamps, 124; —and Delacroix, 128, 136, 148; —and A. Devéria, 157; —and H. Flandrin, 168; —and Fromentin, 173; —and Isabey, 196; *Album de la Galerie Bruyas*, lithographs by Laurens, 1875, 221, 242; photographic reproduction of Bruyas works, 22–23, 49
Cézanne, Paul, 45
Champfleury (Jules-François-Félix Husson), 23, 26, 39, 100; portrait of, by Courbet, 25; "The Story of M. T.," 26, 38–39, 43, 115, 118, 150n.9, 242
Chang, Ting, 39, 113, 118, 135, 238
Chardin, Jean-Siméon, 78, 212
Chenavard, Paul, 24, 30, 52, 63, 94–95; *Dante's Inferno*, cat. 22, 56, 94, 95
Chesneau, Ernest, 188–89
Claparède, Jean, 127
Cogniet, Léon, 57, 74, 216
Collot, Jean-Pierre, 50–51
Constable, John, 184–85, 187
Cornelius, Peter, 95
Cornu, Auguste, 20, 47, 135n.1, 162n.1, 209n.5, 242
Corot, Jean-Baptiste-Camille, 24, 34, 48, 60, 72nn. 11 and 14, 96–99, 138, 170; Signac on, 56; *Evening (Fishing with Nets)*, cat. 23, 56, 96, 97, 162; *Matinée*, 98; *Morning, Fog Effect*, cat. 24, 56, 98, 99, 162; *Outside Paris: The Heights above Ville d'Avray*, 98
Correggio, 140
Courbet, Gustave, 23, 76, 100–119, 187, 202; and Baudelaire, 43, 100–101, 116; and Bruyas, 18, 23–26, 28, 30, 33–43, 49–50, 53, 105n.1, 108, 118, 123n.4, 150, 240, 242; in

Bruyas collection, 51–52, 76, 82, 100, 102, 106, 100–119, 162; and Bruyas's solution, 23–25, 28, 33–35, 38, 41–42, 110, 122, 238; and the Commune, 28, 41–42, 80, 104; Delacroix on, 23, 106; Gauguin on, 53; Gautier on, 23, 106, 108; in Montpellier, 24, 26, 28, 35–36, 38, 46, 50, 112, 242; Pavillon du Réalisme, 25, 100, 101n.3, 116, 242; *Realist Manifesto*, 116; self portraits, 36, 102–3, 116; Signac on, 54, 56; and Silvestre, 28, 30–31, 39, 41–43, 100, 102, 104, 110, 118; *After Dinner at Ornans*, 23, 36, 45; *Alfred Bruyas*, known as *Bruyas malade*, 148; *The Bathers*, cat. 28, 23, 25, 28, 34, 36, 38n.30, 40, 43, 49–51, 56, 76, 85, 104, 106, 107, 108–10, 242; *The Bridge at Ambrussum*, 26; *Burial at Ornans*, 23, 25, 45, 109; *The Covered Stream*, 28; *Head*, 35n.16; *Homecoming*, 113; *Man with a Leather Belt*, 36; *The Meeting ("Bonjour, Monsieur Courbet!")*, cat. 30, 24–25, 28, 33, 35–36, 38, 40, 46, 50–51, 53, 56, 85, 108, 110, 111, 112–13, 115–16, 121, 196, 240, 242; *The Painter's Studio*, 25, 36, 37, 38, 100, 113, 116, 240; *Peasants of Flagey*, 45; *Portrait of Baudelaire*, cat. 25, 30, 41, 56, 100, 101, 242; *Portrait of Alfred Bruyas (Painting Solution)*, cat. 29, 23–24, 28, 31, 34, 36, 40, 42, 43n.62, 50–51, 82, 108, 109, 110, 112–13, 181n.5, 242; *Portrait of Champfleury*, 25; *Portrait of the Artist at Sainte Pélagie*, 37n.22; *Return from the Conference*, 39n.40, 40; *Return from the Fair*, 36; *The Sea at Palavas*, cat. 31, 25, 38n.30, 40, 43, 51, 113, 114, 115, 118, 187; *Self-Portrait (Man with a Pipe)*, cat. 26, 25, 28, 36, 38n.30, 40, 51, 56, 102, 103; *Self-Portrait with a Striped Collar*, cat. 32, 36, 38n.30, 40, 113, 116, 117, 242; *The Sleepers*, 104; *The Sleeping Spinner*, cat. 27, 23, 28, 38n.30, 40, 49–51, 56, 104, 105, 106, 110n.1, 242; *Solitude (The Covered Stream)*, cat. 33, 28, 40, 51, 118, 119; *Stags Fighting*, 39n.40; *The Stonebreakers*, 45, 109; —engravings by Vernier after, 40; *Study of a Woman (Portrait of Henriette Bonion)*, 38n.30; *Venus and Psyche*, 39n.40; *View of La Tour de Farges*, 26, 27; *The Wounded Man*, 36; *The Wrestlers*, 23, 51n.18, 104, 106; *Young Women from the Village*, 36, 109, 112, 105n.5; *Young Women on the Banks of the Seine*, 112

Courbet, Zélie, 105n.4

Court, Joseph Désiré, 83n.5, 120–21; *The Death of Caesar*, 121; *Louis XVI, Marie Antoinette et le dauphin...*, sketch for, 121n.4; *Portrait Presumed to Be the Artist's Wife*, 121; *Woman Reclining on a Divan*, cat. 34, 120

Couture, Thomas, 34, 122–23, 221; and Bruyas, 108, 123n.1, 147; Signac on, 55; *Portrait of Alfred Bruyas*, cat. 35, 35n.11, 47, 55, 122, 123, 242; *Romans of the Decadence*, 20, 87, 122; *A Young so-called Bourgeois*, 35n.11, 123n.4

Daumier, Honoré, 57

David, Jacques-Louis, 30, 48, 52, 54, 192

Decamps, Alexandre-Gabriel, 24, 124; *The Road to Toulon*, cat. 36, 124

Degas, Edgar, 57

Delacroix, Eugène, 34, 53, 79, 95, 124–51, 174, 185, 219, 235, 242; and Algerian household, visit to, 131–32, 142; and Barye, 68; and Bruyas, 18, 20–23, 29, 50, 135, 147, 150, 242; in Bruyas collection, 48, 52–53, 108, 135, 221, 242; on Courbet, 23, 106; and Hamlet, 22, 148; and North Africa, travels in, 22, 47, 128, 131–33, 140; and Rubens, copies after, 55, 125–26, 128; Signac on, 53–57; and Silvestre, 24, 42; *Alfred Bruyas*, cat. 47, 49, 54–55, 57, 148, 149, 150; *Apotheosis of Michelangelo*, 145; *Arab Cavalry Practicing a Charge*, 135n.6; *Arabian Charge Before a Gateway to Meknès*, 133, 134; *Arab Woman Seated on Cushions*, 142; *Aspasie the Moorish Woman* (two paintings), 128; *Bouquet of Flowers*, cat. 42, 29, 57, 136, 137, 138; *Christ in the Garden of Olives*, 18, 157; *Combat du Giaour*, 135n.9; *Crucifixion*, watercolor sketch, 157n.5; *Daniel in the Lions' Den*, 22, 43n.62, 49, 55; education of Achilles, sketch, 55; *The Death of Sardanapalus*, 128, 140; *Écorché Study of a Horse's Leg*, cat. 48, 57, 151; *Greece Expiring on the Ruins of Missolonghi*, 129n.1; harem scene (Rouen), 140; *Lion Mauling an Arab*, 126; *Michelangelo in His Studio*, cat. 45, 22, 55, 143, 144, 145, 242; —*Study for "Michelangelo in His Studio,"* 143, 145; *Moroccan Military Exercises*, cat. 41, 22, 47–48, 55, 133, 134, 135, 242; *Muscle Studies of Horses' Legs*, 151; *The Porte d'Amont, Étretat*, cat. 43, 29, 57, 136, 138, 139, 170; *Portrait of Alfred Bruyas*, cat. 46, 22–23; 82, 113, 146, 147–50, 181n.5, 242; *Portrait of Aspasie*, cat. 38, 29, 55, 105, 128, 129; portrait of Niccolò Paganini, 143; portrait of Torquato Tasso, 143; Raphael in his studio, 145; *Scenes from the Massacres at Chios*, 128; *Self-Portrait of Delacroix*, 150; *Socrates and muse*, 57; *Spring* or *Orpheus and Eurydice*, 29, 38n.32, 55; *Study for "Women of Algiers in Their Apartment": Woman Seated à la Turque*, cat. 40, 57, 128, 131, 132; *Study Head of an Indian Woman*, 128; *Two Studies of Algerian Women*, cat. 39, 130, 131–32, 140; *Wild Boar Hunt*, head of a man from, after Soutman, 126; *Wolf and Fox Hunt*, after Rubens, cat. 37, 29, 57, 125, 126–27; —sketches for, after Soutman, 126; *Woman in a Blue Turban*, 128; *Women of Algiers in Their Apartment*, cat. 44, 22, 48, 55, 87, 105, 131, 140, 141, 142, 209n.9, 242; *Women of Algiers in Their Apartment*, 1834 (Louvre), 22, 48, 55, 87, 131, 132, 140

Delaroche, Paul, 30, 52, 152–55, 209; *Assassination of the Duc de Guise*, cat. 49, 30, 152, 153; *Assassination of the Duc de Guise* (Wallace Collection), 152–53; *Assassination of the Duc de Guise at the Château de Blois in 1588*, 152, 153; —lithograph after, by Duriez, 155; *Execution of Lady Jane Grey*, 152; *Head of an Angel*, cat. 50, 152, 154, 155; *Saint Cecilia*, 155

Desgoffe, Alexandre, 192

Devéria, Achille, 156–57, 159; and Glaize, 19, 179; *Crucifixion*, cat. 51, 156, 157; *Crucifixion*, lithograph, 157; *The Hours of the Day*, 157

Devéria, Aglée, 160n.1

Devéria, Eugène, 157–61; and Bruyas, 18, 19n.3, 38n.32, 159–60, 242; and Glaize, 19, 179; *The Birth of Henri IV*, 159; *Harvesters*, cat. 53, 159–60, 161; *Sketch for "The Birth of Henri IV,"* cat. 52, 158, 159; *Two Young Peasant Women of the Ossau Valley*, 160, 160n.1

Diaz de la Peña, Narcisse Virgile, 24, 38n.32, 47, 162–63, 200, 209n.5; and Millet, 209; Signac on, 54, 56; *Claude Frollo and Esmeralda*, 20; *Love's Meeting (Les rendez-vous d'amour)*, cat. 54, 162, 163

Diderot, Denis, 194

Didier, Jules, 38n.32, 83n.5, 164–65; *A Pine Forest at Castel Fusano*, cat. 55, 164, 165

Doré, Gustave, 38n.32, 165–66; battle at Alma, painting of, 165–66; *Evening on the Banks of the Rhine*, cat. 56, 165, 166; *The Prairie*, 165; *Souvenir of the Alps*, 166

Dou, Gerrit, 51

Dupré, Jules, 224, 227

Duriez, Elie-Philippe-Joseph, *Head of an Angel*, after Delaroche, 155

Dutilleux, Constant, 136, 138

Eugénie, empress of France, 23, 28

Exposition Universelle, Paris, 1855, 25, 95, 124, 151, 165–66; and Courbet, 25, 38, 40, 50, 105n.1, 112, 115, 118, 242

Exposition Universelle, Paris, 1867, 28, 40, 216n.7

Fabre, François-Xavier, Baron, 17, 27, 50, Fajon, Pierre-Auguste, 26, 38

Fielding, Thales, 56

Flandrin, Aimée, 38n.32, 168

Flandrin, Hippolyte, 83n.5, 167–71, 216; decoration, Saint Germain de Près, Paris, 78n.3; decoration, Saint Paul de Nîmes, 168, 171n.3; frieze of saints, Saint-Vincent-de-Paul, Paris, 167–68, 168n.6, 169; *A Saint*, cat. 57, 167

Flandrin, Paul, 167, 169–71, 216; *Portrait of Hippolyte Flandrin*, cat. 59, 168n.8, 170, 171; *Souvenir of the Yerres at Brunoy*, 168; *Valley of Hyères*, cat. 58, 168, 169

Flaubert, Gustave, 45

Fontaigne, Joseph, 20, 238–40

Foucart, Bruno, 76

Fourier, Charles, 24, 110, 217; Fourierism, 33, 35, 217, 219n.1

Français, Louis, 179

Fried, Michael, 102, 103n.3, 104

Fromentin, Eugène, 172–73; *Tents of the Smalah of Si-Hamed-Bel-Hadj, Sahara*, cat. 60, 172, 173

Fuseli, Henry, 219

Gainsborough, Thomas, 184
Galerie Bruyas, Musée Fabre, 28–33;
 acquisitions for, 29–30, 42, 52, 80, 155, 176,
 189, 242; Bruyas collection, before
 donation, 22–24, 26–27, 49, 242; Bruyas as
 curator of, 28–30, 39, 51–52, 76, 242;
 donation to Musée Fabre, 27–29, 40,
 41n.41, 43, 46, 50–51, 64, 67, 118, 242;
 installation of, 85, 89, 93, 105, 113, 196; plan
 for, 1868, 29, 105, 113, 121, 150 189, 232, 242;
 see also Bruyas, Alfred, as collector;
 catalogues, Bruyas collection
Gauguin, Paul, 45, 53, 150n.5
Gautier, Théophile, 192; on Courbet, 23, 106,
 108; on Delaroche, 152–53; on H. Flandrin,
 168; on P. Flandrin, 170; on Gérôme,
 178n.4; on Huet, 184; on Ingres, 190; on
 Marilhat, 204; on Tassaert, 230
Géoghéghan, Edward (pseud. of Alfred
 Bruyas?), 42–43, 108n.9, 115
Géricault, Théodore, 30, 52, 55, 79, 127, 174;
 Drowned Woman and Child on a Beach
 (L'Epave), 194, 196; The Raft of the
 Medusa, 29, 174–75; Study of a Severed
 Arm and Legs, cat. 61, 29, 174, 175, 242;
 study of severed limbs (Louvre), 174
Gérôme, Jean-Léon, 30, 52, 93, 176–78;
 Decorative Project for the Library at the
 Conservatoire des Arts et Métiers, Paris,
 cat. 62, 30, 176, 177
Girodet, Anne-Louis, 48, 157, 159, 221
Glaize, Auguste Barthélémy, 179–83, 221; and
 Bruyas, 19, 47, 108–9, 179, 181; Signac on,
 56; The Blood of Venus, 19; Portrait of
 Alfred Bruyas, 30, 31, 242; Portrait of Alfred
 Bruyas (The Burnoose), cat. 64, 19, 22, 122,
 123n.1, 180–82, 183; Interior of Bruyas's
 Study, cat. 63, 19, 22, 37–38, 56, 122, 179,
 180, 181; Souvenir of the Pyrenees, 19, 21
Gleyre, Charles, The Evening, 90
Gogh, Theo van, 53, 150n.5
Gogh, Vincent van, 33, 45; visit to Galerie
 Bruyas, 53, 150n.5
Goncourt brothers, 31, 190
Granet, François-Marius, 76
Gros, Antoine-Jean, 30, 48, 52, 67, 121, 152,
 184, 221
Guérin, Pierre-Narcisse, 184
Guignet, Jean Adrien, 221; Soldiers Playing
 Dice, 20
Guillaume, Eugène, 18, 47; bronze
 medallion, portrait of Bruyas, 47, 122

Haedeke, Marion, 230
Haro, Étienne-François, 193
Hauptman, William, 90
Heine, Heinrich, 153n.3
Henner, Jean-Jacques, 56
Henriet, Frédéric, 230
Herbert, Robert, 211, 212
Hervier, Louis Adolphe, 34; Edge of the
 Wood, 20
Hilaire, Michel, 194, 228
Hommaire de Hell, Xavier and Adèle, 198

Huet, Paul, 124, 184–89, 242; Forest of
 Fontainebleau—The Hunters, 188;
 Landscape—Hunter in the Forest of
 Fontainebleau, cat. 68, 188, 189; Mountain
 Landscape, cat. 65, 184, 185–86; Riverbank,
 Saint-Thomas near Bort-les-Orgues, cat.
 66, 185, 186; Seascape, cat. 67, 186, 187;
 Study of the Sea in the English Channel,
 187
Hügel, Karl von, 204
Hugo, Victor, 78–80, 115n.3, 157; The
 Hunchback of Notre Dame, 20;
 "Mazeppa," 78–79; Notre-Dame de Paris,
 78; "Nourmahal la Rousse," 87; Les
 Orientales, 19, 78, 87–89
Huguet-Molines, 20, 23, 49

Impressionism, 26, 45n.1
Ingres, Jean Auguste Dominique, 87, 124, 145,
 152, 155, 190–93, 216; in Bruyas collection,
 48, 52, 57, 83n.5, 190–93, 221, 242; Signac
 on, 57; Silvestre on, 24, 30; students of,
 167, 169–71, 216; Antiochus and Stratonice,
 22; The Apotheosis of Homer, study of
 heads for, 29, 193; Studies for "Jesus among
 the Doctors," cat. 69, 29, 190, 191, 192–93,
 242; Jesus among the Doctors, 190, 193;
 portrait of Baroness de Rothschild, 87;
 portrait of Madame Devauçay, 19
Isabey, Eugène, 48, 194–96; Signac on, 56;
 The Storm (Shipwreck), cat. 70, 29, 115,
 194, 195, 196

Jacque, Charles, 200
James, Henry, 206n.1
Johnson, Lee, 128, 142, 145

Koch, Joseph Anton, 94–95

La Caze, Louis, 221
La Fontaine, Jean de, The Crow and the Fox,
 43
Lambert, Elie, 132, 140
Lamennais, Félicité de, Les paroles d'un
 croyant, 20, 235
Laurens, Jean Joseph Bonaventure, 17, 26, 171
Laurens, Jules, 26, 38n.32, 171, 197–203; and
 Bruyas, 19, 31, 38, 38n.32, 39–40, 47, 181,
 198; and Bruyas acquisitions, 26, 29,
 38n.32, 40–41, 78n.1, 121, 159, 166, 186, 189;
 and Courbet, 40–41; travels of, 19, 181–82,
 182n.2, 198, 202; Album de la Galerie
 Bruyas, 221, 242; Auvergne Interior, cat. 73,
 200, 201, 202; The Chemin des Sables at
 Fontainebleau, Storm Effect, cat. 72, 199,
 200; The Dream in Life, 181n.9, 230, 232;
 Italienne, 198; Laveuses de Tauves, 202;
 Portrait of a Young Woman, cat. 71, 197,
 198; Près Marlotte (Seine-et-Marne),
 200n.1; Seascape, 200; Senegalese Lion and
 Python, after Barye, 71; Voyage en Turquie
 et en Perse, images for, 198n.2;
 Washerwomen, cat. 74, 202, 203
Laverdant, Desiré, 217, 219n.5
Le Nain, Louis, Antoine, and Mathieu, 78,

Léotoing, Gérard de, 33
Longhet, Alexandre, 179
Lorrain, Claude, 60, 164, 170, 223
Louis XIII, king of France, 159
Louis Philippe, king of France, 48, 121, 131,
 176
Loutherbourg, Philippe-Jacques de, 194;
 Shipwreck, 194–96

Manet, Édouard, 57; Portrait of George
 Moore, 55
Mantz, Paul, 155, 235
Marie-Amélie, queen of France, 190
Marilhat, Prosper, 204–5; Rest of the
 Meharistes, 205; Ruins of the Mosque of al-
 Hākem, Cairo, cat. 75, 204, 205; Ruins of
 the Mosque of al-Hākem, Cairo (Louvre),
 204; Study of a Village in Auvergne, 20
Marsal, Edouard-Antoine, 206–7; Alfred
 Bruyas in His Study, cat. 76, 206, 207
Masaccio, 74
Matet, Charles, 17–18, 26, 85, 93, 206, 242;
 Fragment of the Portrait of Alfred Bruyas,
 17, 19; Portrait of Alfred Bruyas, 17, 18–19
Medici, Marie de, 159
Meissonier, Jean-Louis Ernest, 48
Michel, Ernest, 29, 55n.11, 206
Michel, Georges, 200
Michelangelo Buonarroti, 94, 143–45;
 Apotheosis of Michelangelo, by Delacroix,
 145; Battle of Cascina, 94; Last Judgment,
 57, 94; Lorenzo de Medici, 145n.5; Medici
 Madonna, 143; Michelangelo in His Studio,
 by Delacroix, cat. 45, 22, 55, 143, 144, 145,
 242; Michelangelo in his study, by Robert-
 Fleury, 145; Moses, 143
Michelet, Jules, 20
Millet, Jean-François, 160, 188, 200, 202,
 208–17; and Bruyas, 38n.32; and Diaz, 209;
 Signac on, 57; Cliffs at Gruchy, 209n.9;
 House with a Well at Gruchy, 210, 211; The
 Knitting Lesson, 212; Landscape in Allier,
 cat. 80, 214, 215–16; Landscape near Vichy,
 cat. 81, 57, 215, 216; Offering to Pan, cat. 77,
 20, 29, 208, 209, 216, 242; Peasant Mother
 Feeding Her Child, 212, 213n.5; Peasant
 Woman Feeding Her Child (La Bouillie),
 cat. 47, 79, 57, 212, 213; Sacrifice to Priapus,
 209n.2; The Sower, 209; Well House at
 Gruchy, cat. 78, 210, 211, 212; woman
 feeding a child, sketches (Louvre), 212;
 A Woman Feeding Her Child, 212
Miquel, Pierre, 196
Monet, Claude, 26–27, 45, 165
Montpellier: artists of, 17–18, 46–47, 50, 80,
 85, 179, 198, 206; École des Beaux-Arts, 17,
 38n.32, 50, 242; Salon of, 46–47, 50; —of
 1860, 26, 38–40, 43, 50, 98, 237n.9, 242;
 Société des Amis des Arts, 17, 26, 46–47,
 50; vis-à-vis Paris, 45–52; see also Musée
 Fabre, Montpellier
Moreau-Nélaton, Étienne, 151
Mornay, Charles, Count de, 22, 36, 47, 131,
 133–35, 142n.2,
Murger, Henri, 34

Musée du Luxembourg: acquisitions of, 22, 48, 140; and Bruyas collection, 22, 48–49, 52; catalogues of, 48, *49*

Musée Fabre, Montpellier: catalogue by Michel, 1879, 55n.11; catalogue by Valéry, 1939, 100; donations to, 17, 50–51; foundation of, 17, 28, 50–51; Matet as curator of, 85, 242; State purchases for, 19; *see also* Galerie Bruyas, Musée Fabre

Musset, Alfred de, 53

Napoléon III, emperor of France, 23, 35n.13, 36, 93, 106, 224, 232

neoclassicism, 17, 152, 167, 216

Nieuwerkerke, Alfred, Count de, 36, 118, 128, 148, 157n.4, 242; and Millet, 211, 213, 216; and Rousseau, 225, 227–28

Nochlin, Linda, 103n.3

Nogaret, Xavier, 50

Ockman , Carol, 87

Olivier, Georges, 46–47, 51

Orientalism, 87, 124, 204–5; and Delacroix, 128, 131, 172; and Fromentin, 172–73

Ostade, Adriaen van, 51

Oudiné, Eugène André, 170

Overbeck, Friedrich, *Italica and Germanica*, 181

Pantazzi, Michael, 96

Papety, Dominique-Louis, 24, 83n.5, 216–19; Signac on, 57; *The Death and Burial of Saint Mary of Egypt*, 219; décor for Sabatier palace, Florence, 219n.1; *Dream of Happiness*, 217–19; *Love Conquers All*, cat. 83, 217, *218*, 219; *Temptation*, cat. 82, 216, *217*, 219

Peisse, Louis, 230

Perugino, 155, 217

Phidias, 167–68

Picot, François-Édouard, 74, 85

Pissarro, Camille, 165

Poterlet, Hippolyte, 127

Poulet-Malassis, Auguste, 30, 100

Poussin, Nicolas, 54, 159,164, 169–70; *Winter, or The Deluge*, 194

Proudhon, Pierre-Joseph, 35, 40, 110, 118

Puget, P., 57

Puvis de Chavannes, Pierre, 54, 57

Ranc, Jean, 50

Raphael, 50, 57, 93, 145, 167, 216–17; *Raphael in his studio*, by Delacroix, 145; Stanza della Segnatura, Vatican, 190

Realism: and Courbet, 24, 26, 76–78, 82, 104, 110, 209, 235; in Bruyas collection, 76–78, 85, 193, 209; and Dutch painting, 76–78, 104, 212, 223; Pavillon du Réalisme, 25, 100, 101n.3, 116, 242

Rembrandt van Rijn, 122, 147, 155; *Bathsheba*, 221; *Night Watch*, 54

Renoir, Pierre-Auguste, 54, 56, 165

Renouvier, Jules, 17

Reveil, Achille, *Jesus among the Doctors*, after Ingres, 190

Reverdy, Zoé, 24, 28, 105n.4

Robaut, Alfred, 71–72, 136, 151

Robert-Fleury, Joseph Nicolas, 220–21; *The Death of Titian*, 221; *Galileo before the Inquisition, 1632*, 221; Michelangelo in his study, painting of, 145; *Young Woman at Her Toilette*, cat. 84, *220*, 221

Romanticism, 36, 67, 79, 93, 152, 157, 185, 235; and Bruyas collection, 29, 193

Roqueplan, Camille, 204

Rousseau, Théodore, 34, 48, 57, 60, 188, 200, 222–29; and Bruyas, 38n.32; and Millet, 211; *Clairière au printemps*, 224n.1; *Clairière dans la forêt de Fontainebleau*, 224n.1; *Descent of the Cattle from the Meadows*, 222; *Marsh at Villebussière, Berri*, cat. 86, 224, 225; *Oak Tree in a Marshy Landscape*, cat. 88, 227, *228*; *Path in the Forest, Autumn*, cat. 87, 226, 227; *Pêcheur relevant ses nasses*, 228; *The Pond*, cat. 85, 20, 47, 222, *223*, 224; *View of the Forest of Fontainebleau, Sunset*, 222; *Wooded Riverbank with a Large Isolated Tree*, cat. 89, 228, *229*

Rubens, Peter Paul, 50–51, 56–57, 129n.6, 159, 230; and Delacroix, 55, 125–26, 128; *The Four Philosophers*, 182n.4; *Hippopotamus and Crocodile Hunt*, 126; *Lion Hunt*, 126; Marie de Medici cycle, 159; with workshop, *Wolf and Fox Hunt*, 126, *127*

Rubin, James Henry, 34

Sabatier, François, 24, 26, 217

Saint-Pierre, Bernardin de, *Paul et Virginie*, 196

Salons, Paris: 1824, 185; 1827, 78, 121, 128, 157, 159, 185; 1833, 71; 1834, 22, 140, 152; 1836, 222; 1837, 155; 1839, 169; 1843, 90; 1844, 18, 87, 209; 1846, 19, 94, 237; 1847, 20, 76, 87, 96, 122, 135n.4; 1848, 222; 1849, 22–23, 96, 140, 173, 224; 1850, 209, 232, 235; 1850–51, 23, 230; 1851, 24; 1853, 23, 34, 43, 49, 98, 104, 106, 108–9, 242; 1857, 200n.1; 1861, 39n.40, 187, 212; 1862, 39n.40; 1864, 39n.40, 202; 1865, 168; 1866, 164; 1868, 188, 206; 1869, 164; 1872, 41; 1888, 206

Sarto, Andrea del, 48, 93

Scheffer, Ary, 50, 221; *Study of a Philosopher*, 26

Schnetz, Jean-Victor, 89

Schulman, Michel, 228

Sensier, Alfred, 211, 214

Sérullaz, Arlette, 136, 138

Sheon, Aaron, 102

Signac, Paul, 33; *D'Eugène Delacroix au néo-impressionisme*, 53–54; visit to Galerie Bruyas, 53–57

Silvestre, Théophile, 22; and acquisitions for Galerie Bruyas, 29–30, 41–42, 95, 175n.1, 52, 100, 136, 138, 151–53, 176, 193, 216, 242; and Bruyas, 24, 26; and Courbet, 28, 30–31, 39, 41–43, 100, 102, 104, 110, 118; and Couture, 123; and Decamps, 124; and Delacroix, 42, 143–45, 148, 150nn. 9–10, 151; and Delaroche, 152; and Eugène Devéria, 160; and Gérôme, 176; *Histoire des artistes vivants*, 24; and Ingres, 193; and *La Galerie Bruyas*, 1876, 26–28, 30–31, 41–42, 52, 124,

128, 148, 157n.4, 242; and Millet, 211, 213, 216; and Rousseau, 225, 227–28

Soulier, Charles, 127

Soutman, Pieter Claesz., etchings after Rubens: *Hippopotamus and Crocodile Hunt*, 126; *Lion Hunt*, 126; *Wild Boar Hunt*, 126; *Wolf and Fox Hunt*, 126, *127*

Spector, Jack, 145

Steen, Jan, 51

Stendhal, Henri Beyle, 45

Tanneur, Philippe, 47

Tassaert, Octave, 230–40; and Bruyas, 20, 24–25, 34, 40, 78, 108–9, 150, 230–32, 240, 242; in Montpellier, 40, 46, 237, 240, 242; Signac on, 56; *The Angel and the Child*, 238, 240n.2; *Ariadne Abandoned*, 56, 237n.9; *A Bacchante*, 237n.9; Christian in the catacombs, 39; *Heaven and Hell*, cat. 90, 20, 230, *231*, 232, 238; *The Painter's Studio*, cat. 94, 20, 24, 38, 112, 238, *239*, 240; portraits of Bruyas, 20, 47, 113, 237n.4, 240, 242; *Reading the Bible*, cat. 92, *234*, 235; *Self-Portrait in a Red Cap*, 240n.2; "A Souvenir of Florence (interpretation)," 240; *An Unfortunate Family* (Musée d'Orsay), 20, 235; —replica (Grenoble), 237n.3, 240n.2; —sketch for, 235; *An Unfortunate Family (Suicide)*, cat. 93, 20, 235, *236*, 238, 240n.2; *Young Woman with a Wine Glass*, cat. 91, *233*, 234–37

Thomas, Georges, 143

Thomas, Greg, 225

Thoré, Théophile, 94, 96, 133, 187, 222

Tiepolo, Giovanni Battista, 48

Tintoretto, Jacopo, 54, 162

Tissié, Louis, 142n.2, 179–81; and Bruyas, 18–19, 22, 24, 26, 82, 179, 181n.5, 182

Titian, 22, 35n.11, 93, 122, 162, 217

Tolnay, Charles de, 143

Troy, Jean de, 50

Troyon, Constant, 24, 34, 118; *Histoire des artistes vivants français et étrangers*, 24; *The Watering Place*, 20

Turner, Joseph Mallord William, 184

Valedau, Antoine, 17, 27, 50, 51n.29

Valenciennes, Pierre Henri de, 165

Valéry, Paul, 100

Vaudoyer, Léon, 176, 178

Velázquez, Diego, 48, 110, 122

Verdier, Antoine, 230; Signac on, 54, 56; *Christ Crowned with Thorns*, 39, 110n.2; painting of Bruyas's mistress, 230

Vernet, Claude-Joseph, 194–96

Vernet, Horace, 79, 155n.7 221

Vernet, Louise, 155, 155n.7

Vernier, Émile, 40; *Stonebreakers*, after Courbet, 40

Veronese, Paolo, 147, 162, 217

Vincent, François André, 55

Wouwerman, Philips, 51

Zola, Émile, 176

Zurbarán, Francisco de, 54